"The cut is what gives the form, the curves, the confidence. Every line is meaningful. Clothing is not a drawing, it's a sculpture; you have to walk around it, see it living from all sides at once." — AZZEDINE ALAÏA

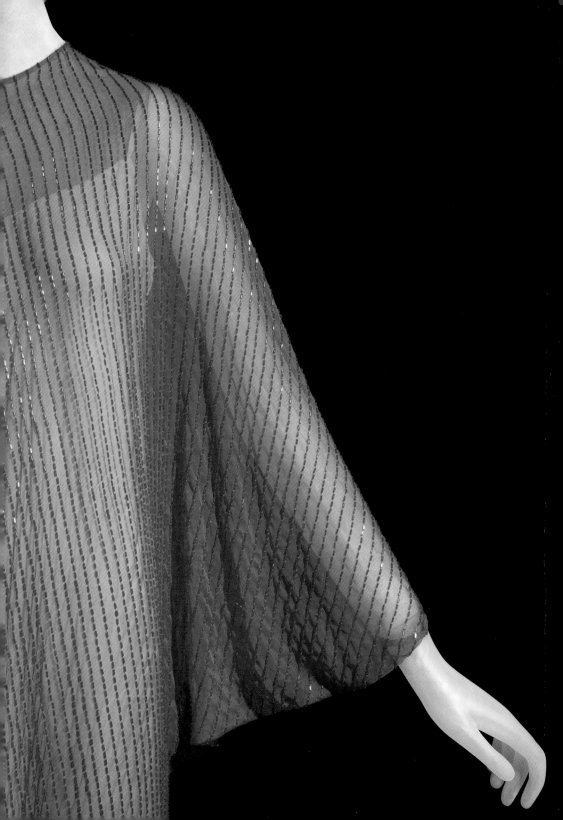

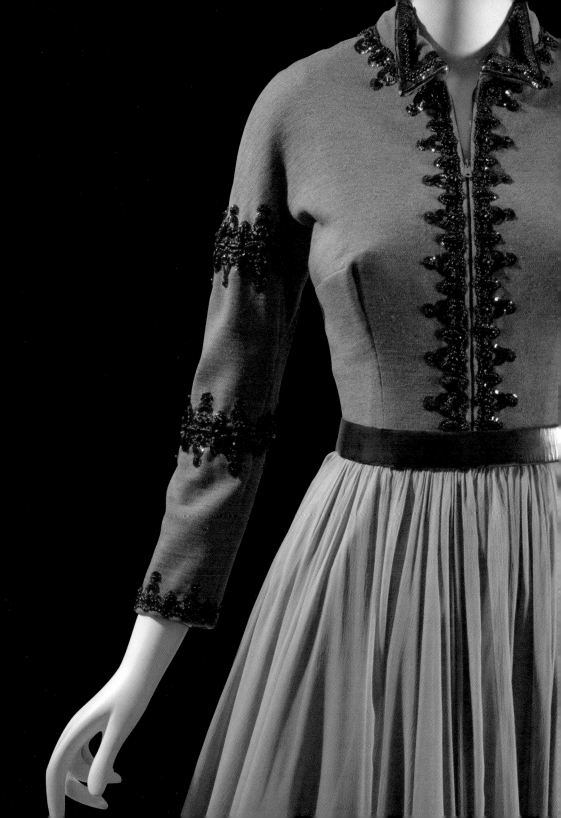

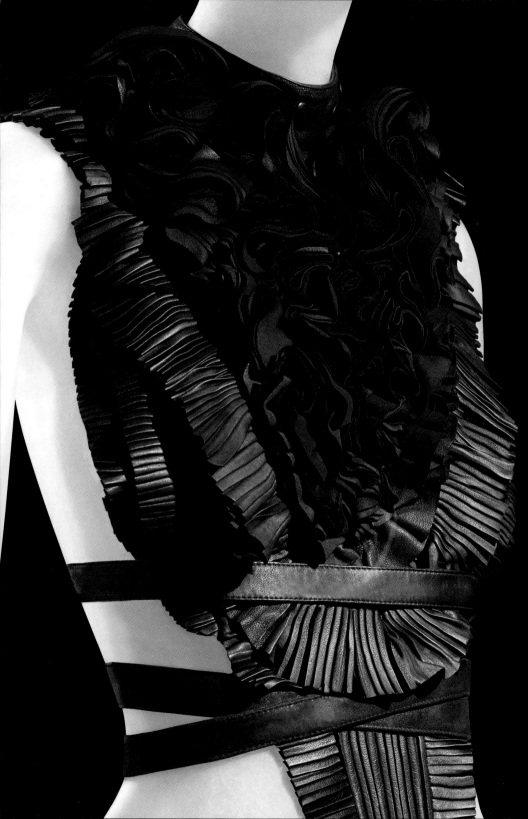

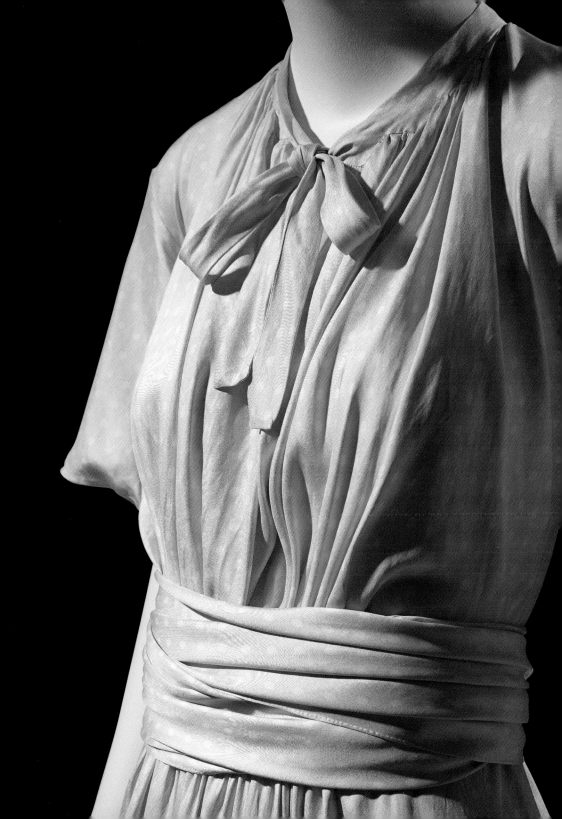

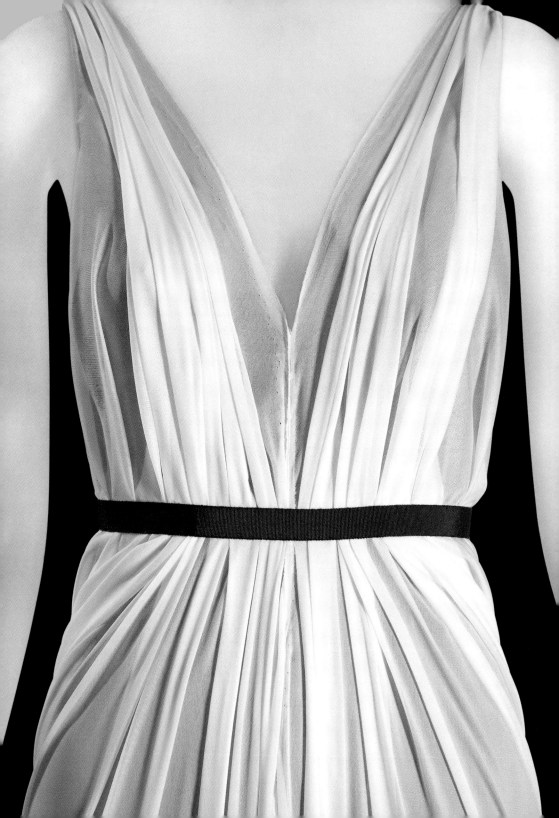

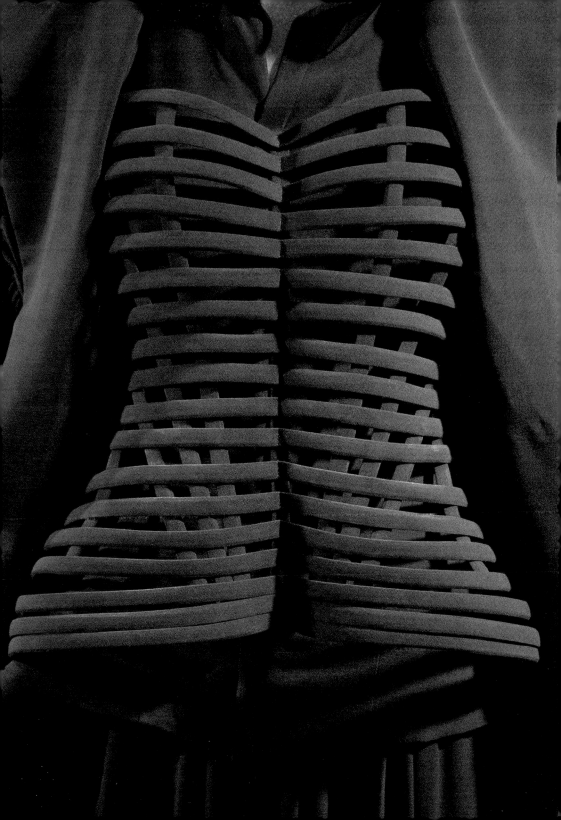

Text by Valerie Steele
Foreword by Suzy Menkes

with contributions by
Fred Dennis, Jennifer Farley,
Colleen Hill, Melissa Marra,
Emma McClendon,
Patricia Mears, and
Elizabeth Way

and illustrations by
Robert Nippoldt

The Collection of the Museum at the
Fashion Institute of Technology

Fashion Designers

TASCHEN

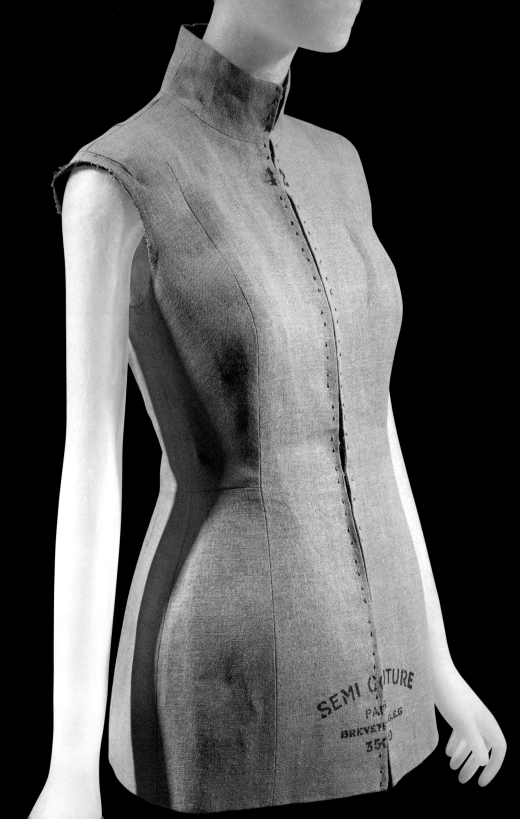

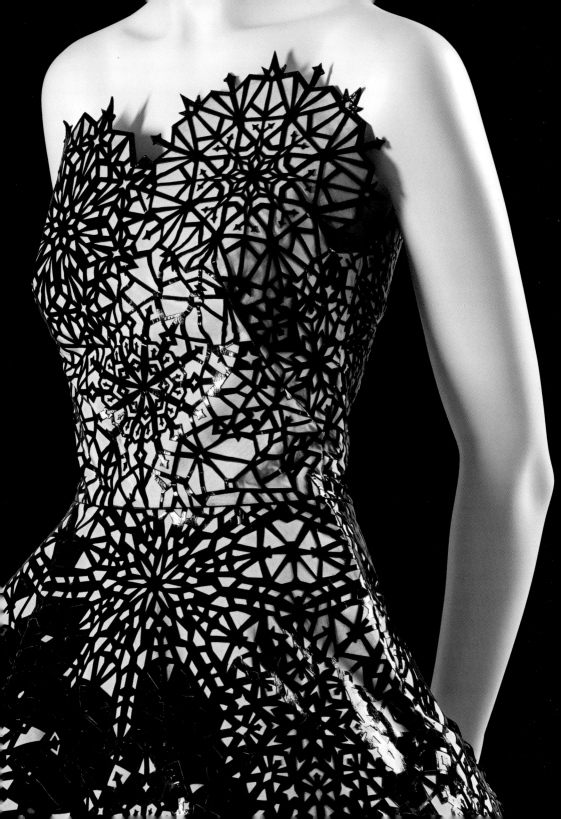

Foreword

Suzy Menkes

FASHION HAS ALWAYS HELD UP a mirror to society. Or should I say an X-ray?

Just as Sigmund Freud analyzed the inner soul within the outer shell, so clothes are now believed to have a far deeper meaning than appearance suggests.

Told through the language of clothes, the twentieth century has been the story of women's liberation—literally, when corsets were unlaced to free the body and Coco Chanel fashioned malleable clothes from men's jersey underwear; and figuratively, when Yves Saint Laurent embraced the pantsuit and women stood shoulder to padded shoulder with men in the workplace.

The American woman has been particularly sensitive to the changing world, whether as a Hollywood beauty, dressed by Adrian on or off the silver screen, or as a free thinker in minimalist Calvin Klein designs that streamlined the career wardrobe and seemed destined to equip the wearer to smash the glass ceiling.

The Fashion Institute of Technology has edited its powerful collection just as today's woman refines her wardrobe, to state who she is and what she stands for.

The museum in New York City has embraced the sculptural style of Cristóbal Balenciaga, for postwar women who still liked it haute; the sweet romance of Christian Dior's nostalgic vision; the famously savage beauty of Alexander McQueen; the punk politics of Vivienne Westwood; and the flat-plane Japanese clothes, breaking dramatically with Western style, of Rei Kawakubo or Yohji Yamamoto.

Men's fashion is also on the agenda: the male icon has gone through radical transformation too, from thin white Ziggy Stardust through Jean Paul Gaultier's man as sex object to rappers and metrosexuals.

As well as selecting five hundred pieces out of fifty thousand in the museum's archives, the curators explain why these are key to the unfolding story of changing style. The museum has thus metaphorically X-rayed its own collection to get under fashion's skin.

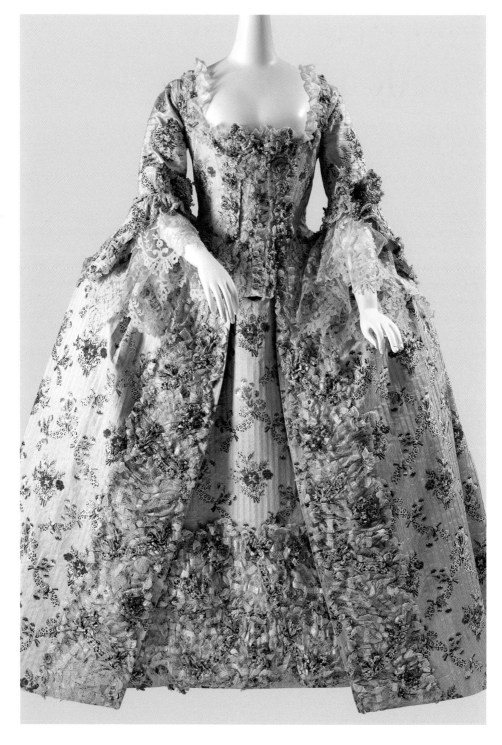

The Rise of the Fashion Museum

Valerie Steele

THE MUSEUM at the Fashion Institute of Technology (FIT) is a specialized fashion museum that has long been recognized for its innovative and award-winning exhibitions. Less well known is the fact that the museum's permanent collection now encompasses more than fifty thousand garments and accessories, dating from the eighteenth century to the present. The creations of modern fashion designers play an especially important role in the collection and in this book. Some designers are represented by only one or two looks, but when the designer has been very influential (Chanel is a good example) and when we have a wealth of examples in our collection (as with Halston), we include many more images. But our efforts need to be placed in historical context. How did fashion exhibitions, fashion collections, and fashion museums begin? And how have they evolved?

THE FIRST FASHION MUSEUM WAS imaginary. In England in 1712, a correspondent to *The Spectator* facetiously proposed the creation of a museum of fashion. The building, he suggested, should be shaped like the Sphinx, "rais'd upon Pillars," and decorated with "an Imitation of Fringe carv'd in the Base," and "curling Locks, with Bows of Riban" filling the cornice. Thus, the Sphinx-museum resembled the body of a stylish beau or coquette of the day. Meanwhile, the inside of the repository was divided into two apartments, one for each sex. "The Apartments may be fill'd with Shelves, on which Boxes are to stand as regularly as Books in a Library. These are to have Folding-Doors, which being open'd, you are to behold a Baby [i.e. a doll] dress'd out in some Fashion which has flourish'd, and standing upon a Pedestal, where the Time of its Reign is mark'd down ... And to the End that these [fashions] may be preserv'd with all due Care, let there be a Keeper appointed, who shall be a Gentleman qualify'd with a competent Knowledge in Cloathes; so that by this Means the Place will be a comfortable Support for some Beau who has spent his Estate in dressing." The idea of hiring as fashion curator some bankrupt fop is an especially nice touch.

Museums originated in the Wunderkammer or cabinets of curiosities belonging to princely collectors in early modern Europe. A number of these collections contained "costumes of foreign nations," as well as "clothing and jewelry associated with the collector's own forebears." Items of clothing associated with famous people (such as Marie Antoinette's shoe or Napoleon's hat) then began to be collected, and sometimes exhibited,

PAGE 14
Robe à la française
France, 1755–1760
From the *Exoticism*
exhibition

BELOW
Corset
France, ca. 1750
From *The Corset:
Fashioning the Body*
exhibition

OPPOSITE BELOW
Boot
England, 1885–1900
From the Fashion &
Textile History Gallery
(First Rotation)

as relics or trophies. Madame Tussaud, for example, tried whenever possible to dress her waxwork figures in clothing that had actually been worn by the celebrities represented. Museums of art, design, history, and ethnography have all collected clothing. The Victoria and Albert Museum, Britain's national museum of decorative arts, collected clothing virtually since its founding in 1852. On the whole, however, dress played only a minor role within museums until late in the twentieth century.

THE SECOND FASHION MUSEUM WAS temporary. The first significant fashion exhibition, which we might describe as a temporary fashion museum, was held in Paris at the Exposition Universelle, which lasted from April 15 through November 12, 1900. More than fifty million people attended the exposition, which included myriad exhibitions, of which one of the most popular was the exhibition of fashion. Housed in a temporary structure, usually referred to as the Palais du Costume, the exhibition consisted of thirty tableaux containing waxwork figures arranged in both historical and contemporary scenes. In addition, there were numerous vitrines filled with related articles of clothing or accessories, such as a group of gloves dating from past centuries. Some of the historical displays, such as "Gallic Women at the Time of the Roman Invasion" featured reproduction clothing (designed by the theatrical costumier T. Thomas). But other historical displays showcased surviving garments, such as a ball gown worn by the late Duchesse de Berry, which was loaned by the Comte de Puiseux.

An even more popular section was devoted to contemporary fashion. Organized by the Chambre Syndicale de la Confection et de la Couture, it featured several gowns by Madame Jeanne Paquin, who even loaned her own dressing table. Another vignette, "Getting Ready for the Opera," showcased the latest couture creations by the House of Worth. The international exhibition was a commercial venture, intended to promote manufacturing and trade. But the significance of fashion went beyond economics, since fashion played such an important role in the French national imagination. A sumptuous catalog illustrated fifty contemporary "masterpieces" of French couture.

"Dress is the expression of society."
— HONORÉ DE BALZAC, *TRAITÉ DE LA VIE ÉLÉGANTE*

THE THIRD (REAL) FASHION MUSEUM was both visionary and ancillary. It was visionary in that its advocates were able to see the significance of a fashion museum, even when bureaucrats regarded the collection and exhibition of fashion as ancillary to the larger museological project. As a result, it took a very long time for specialized fashion museums to be established, and even within art and design museums, fashion collections tended to be marginalized. Thus, although the Société de l'Histoire du Costume was established in 1907, it was not until 1977 that the Musée de la Mode et du Costume de la Ville de Paris was finally established at the Palais Galliera. In the meantime, the fashion historian François Boucher founded the Union Française des Arts du Costume in 1948, but it was only in 1997 that its collection found a home at the Musée des Arts Décoratifs. Specialized fashion museums were also established in other countries, often by individuals with private collections. More typically, however, such collections were incorporated into costume departments within established museums. For example, the philanthropist Irene Lewisohn, together with Aline Bernstein and Polaire Weissman, founded the Museum of Costume Art in 1937. But in 1944, its collection of ten thousand objects was incorporated into a department of the Metropolitan Museum of Art, which was named the Costume Institute.

The Fashion Institute of Technology was founded in 1944, and in 1963, the Brooklyn Museum entered into discussions about lending part of its costume collection to FIT. Already by 1968, a year before the Brooklyn Museum sent over its first shipment of clothes, FIT was already acquiring important donations of fashion for its own collection. The actress Lauren Bacall, for example, gave 142 pieces of clothing to FIT in 1968, including looks by Chanel, Givenchy, Norell, and Emilio Pucci, and she was still donating clothes in 1986. The heiress Doris Duke donated twenty-one garments in 1971, including looks by Balenciaga, Dior, and Fath, as well as a Charles James "La Sirène" evening dress in red. These and many other acquisitions were spearheaded by Robert Riley, the first director of the Design Laboratory at FIT. Thus, despite its initial reliance on long-term loans from the Brooklyn Museum, the Design Laboratory at FIT was also from the beginning acquiring an important fashion collection of its own.

Until the 1970s, most museum exhibitions of clothing were antiquarian in their approach and chronological in their organization. Typically, these exhibitions consisted of

OPPOSITE
Day dress
USA, ca. 1882
From the Fashion & Textile
History Gallery (First Rotation)

a display of upper-class women's fashions (usually referred to as "costumes") organized to show the temporal succession of styles. Attempts were often made to create "realistic" mannequins, placed within historically evocative sets or period rooms. The Victoria and Albert Museum in London mounted perhaps the world's first innovative fashion exhibition in 1971 with Cecil Beaton's *Fashion: An Anthology*. Beaton solicited donations from his legions of stylish friends such as Madame Agnelli, Pierre Cardin, Lady Diana Cooper, the Duchess of Devonshire, Michael Fish, Margot Fonteyn, Mary Quant, Yves Saint Laurent, Diana Vreeland, and the Duchess of Windsor. They donated garments ranging from early-twentieth-century haute couture to 1960s mod styles, and immediately transformed the status of the V&A's dress collection. The exhibition was mounted with great panache. Following closely on Beaton's heels came Diana Vreeland's famous exhibitions at the Costume Institute in New York City. The former editor of *Vogue* set a new standard of drama and excitement, although her shows were also subject to criticism on the grounds of commercialism and historical inaccuracy. Yet for all of their faults, Vreeland's exhibitions succeeded in abolishing the aura of antiquarianism that had previously surrounded most costume displays.

The Design Laboratory at FIT was quick to adopt many of Vreeland's innovations. During the 1970s, Robert Riley organized a number of captivating exhibitions, of which the most important was *Paul Poiret* (May 25–September 11, 1976), the first exhibition in America devoted to the King of Fashion. Born in 1879, Poiret revolutionized fashion in the years just prior to the First World War. The exhibition at FIT included more than seventy-five extraordinary ensembles, including sixteen early creations loaned by Poiret's ninety-four-year-old widow, Denise. In the center of the main gallery was a recreation of Poiret's famous Thousand and Second Night Ball of 1911, which Bill Cunningham described as "a revolution in the soaring heights of display wizardry. The famed Faubourg St. Honoré garden of the designer's house is magically recaptured in the 3,260 square feet of the gallery." The mannequin representing Denise Poiret wore a "Persian" masquerade costume, consisting of a lavender brocade turban, silver lamé tunic, cerise chiffon harem pants, and pink satin slippers. This ensemble had originally been worn by Mrs. Henry Clews, one of Poiret's early clients, and was donated to FIT, at Riley's suggestion, by Mrs. Katheryn Colton. The exhibition was organized by Robert Riley, director of the Design Laboratory, with exhibition design by Marty Bronson, director of the Galleries at FIT.

Probably the most immediately accessible and popular type of fashion exhibition is one devoted to a single famous designer—or other celebrity. Traditionally, only the

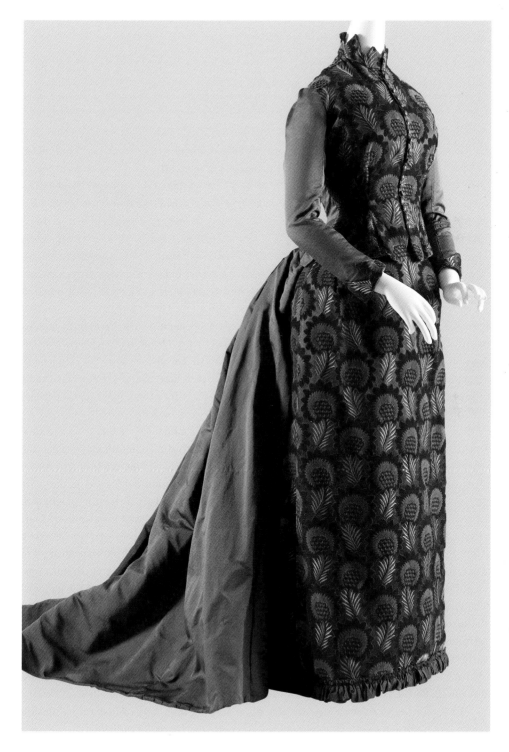

"Fashion is an art."

— LOUIS-SÉBASTIEN MERCIER, *LE TABLEAU DE PARIS*

illustrious names of the past were deemed worthy of retrospective exhibitions. But by the 1980s, individual living designers also began to receive their own museum exhibitions. After Riley retired, the Design Laboratory at FIT was headed by a triumvirate consisting of Laura Sinderbrand, Richard Martin, and Harold Koda. Among their many outstanding exhibitions, several were focused on contemporary fashion designers. The first of these, *Givenchy: Thirty Years* (May 11–October 2, 1982), featured a spectacular array of almost one hundred ensembles by the French couturier Hubert de Givenchy. A year later, in 1983, Mrs. Vreeland's retrospective of Yves Saint Laurent's work at the Costume Institute caused tremendous controversy. As a critic for *Art in America* put it, "Fusing the Yin and Yang of vanity and cupidity, the Yves Saint Laurent show was the equivalent of turning gallery space over to General Motors for a display of Cadillacs." It is interesting to speculate why the press responded so differently to the Givenchy show at FIT and the Saint Laurent show at the Costume Institute, but one issue was probably discomfort with the very idea of exhibiting contemporary fashion within the hallowed halls of an art museum. Single-designer exhibitions are still often controversial. Whether or not they pay for an exhibition, designers will want to be involved in the choice of garments and the way they are organized and displayed. Yet scholarly curatorial work can play an important role in assessing the contributions of individual designers, as well as providing a perspective on fashion that offers an alternative to that of the fashion industry.

Meanwhile, at FIT, Richard Martin, an art historian and critic by training, was blurring the boundaries between art and fashion. The famous exhibition *Fashion and Surrealism* (October 30, 1987–January 23, 1988) was co-curated by Martin, Sinderbrand, and Koda, with a striking exhibition design by Stephen de Pietri. In addition to Surrealist artworks and fashions from the 1930s, such as Elsa Schiaparelli and Salvador Dali's famous "Tears Dress," the exhibition included numerous more recent pieces which were Surrealist inspired. "*Fashion and Surrealism* is a provocative and beautiful exhibition," declared Deborah Drier in *Art in America*. The ideas and implications were "serious," but "the installation was anything but dry and didactic. . . . Stephen de Pietri orchestrated the 400-plus objects into more than a dozen tableaux . . . which managed to convey the fairytale charm of a Cocteau film while at the same time exemplifying certain

Surrealist preoccupations—fetishism, metamorphosis, displacement, woman as incarnation of the Other." In an article on "The Future of Fashion Exhibitions," Bill Cunningham praised *Fashion and Surrealism*, saying "The FIT galleries have a history of exhibits set in elaborate displays that heighten the visitor's visual and intellectual curiosity."

A year after Halston died, with both his career and his reputation in shambles, FIT organized the exhibition *Halston: Absolute Modernism* (October 29, 1991–January 11, 1992), which brought attention back where it belonged—to Halston's brilliance as a designer. MFIT has probably the world's best collection of Halston's fashions, along with many patterns, sketches, and photographs. *Gianni Versace: Signatures* (November 6, 1992–January 9, 1993) was the first and still probably the greatest exhibition devoted to Versace. It filled two entire floors and was a genuine blockbuster, attracting enormous crowds and extensive publicity, all of it highly positive. Shortly after this triumph, Martin and Koda moved uptown to the Costume Institute. Richard Martin's tragically early death in 1999 (when he was only fifty-two) deprived the fashion world of one of its most creative spirits.

Meanwhile, in 1993, FIT's board of trustees changed the institution's name from the Design Laboratory and Galleries at FIT to the Museum at FIT. Dorothy Globus, formerly director of the Cooper-Hewitt Museum, became director at MFIT. She brought in a number of exhibitions on other subjects such as the Royal Swedish Ballet. Some of these exhibitions, like *Hello Again* (about recycling), were innovative, but collectively they moved the museum away from its strength in fashion. Her most popular exhibition was the retrospective *Unmistakably Mackie* (September 24–December 31, 1999), featuring Bob Mackie's costumes for performers such as Cher. I was appointed chief curator of the Museum at FIT in 1997, in large part because I was a fashion historian with a record of scholarly publications. After several years as acting director, I was appointed director in 2003. Patricia Mears, formerly a curator in the costume department at the Brooklyn Museum, came to the Museum at FIT as research curator in 2005, and was appointed deputy director in 2006. Both of us have continued to curate exhibitions and to write, while also mentoring a new generation of curators and building a professional museum team, headed by Fred Dennis and Colleen Hill (curatorial), Ann Coppinger (conservation), Sonia Dingilian (registrar), Tanya Melendez (education and public programs), Tamsen Young (media), and Michael Goitia (exhibitions).

OPPOSITE
Ensemble
France, ca. 1929
From the *Night & Day*
exhibition

BELOW
Perugia evening shoes
France, 1940
From the *Luxury* exhibition

25

As the museum has explicitly refocused on its mission as a specialized fashion museum, it has also placed greater emphasis on a wide range of educational programs. Many of the hundreds of specialized classes and tours offered annually directly support the pedagogical mission of the college. However, the Fashion Culture programs and Fashion Symposia are all free to the public and are dedicated to lifelong learning. The museum also organizes more than a dozen student and faculty exhibitions every year, including the annual Art and Design Graduating Student Exhibition, which extends beyond the museum throughout the college campus. A collaboration with students from FIT's School of Graduate Studies, for example, helps teach students how to produce well-researched exhibitions like *Designing the It Girl: Lucile and Her Style*. Undergraduate students in Art History and Museum Professions can also become museum facilitators.

The Special Exhibitions Gallery is the site for the largest and most important exhibitions, which are usually thematic. Examples include *London Fashion*, *The Corset: Fashioning the Body*, *A Queer History of Fashion*, and *Fairy Tale Fashion*. There have also been exhibitions devoted to a single designer, such as *Madame Grès: Sphinx of Fashion*. These exhibitions draw on the permanent collection, but also incorporate objects borrowed from designer archives, other museums, and private collections. The Fashion and Textile History Gallery is designed to provide historical context by presenting exhibitions that survey up to 250 years of fashion history. It also serves to showcase the museum's permanent collection, since everything in this gallery belongs to the museum. Important exhibitions in this gallery include *Force of Nature*, *Fashion's Global Cities*, *Denim*, and *PowerMode*.

The Museum at FIT has a collecting policy that focuses on aesthetically and historically significant fashion, with an emphasis on contemporary avant-garde or "directional" fashion. Unlike art museums, which may focus on haute couture (which is often regarded as art), MFIT is a specialized fashion museum, so we purposefully seek to acquire fashions that move fashion forward. We are looking for fashions that will remain significant in the cultural memory. That may include couture, of course, especially high-concept pieces, but it may also include street or subcultural fashions. The exhibition

Gothic: Dark Glamour demonstrated that fashion designers were not copying members of the goth subculture, but rather that members of both groups were drawing on similar visual sources, such as vampire films. We are less interested in designer fashions that are merely economically successful, and correspondingly more interested in designer fashions that epitomize a moment in time or that influence other designers. While we continue to acquire great modernist fashions from the early twentieth century, when these come our way, we are more directly focused on acquiring fashions of the late twentieth and early twenty-first centuries.

Fashions by African American designers, such as Stephen Burrows (a graduate of FIT), have long been collected and exhibited at MFIT, but recent years have witnessed a deliberate effort to collect extensively from designers of the African diaspora. The exhibition *Black Fashion Designer*s, curated by Elizabeth Way, marked an important turning point in the museum's focus on BIPOC designers. Fashions by Latin American and Latinx designers have also been a growing focus of attention. The Museum at FIT has traditionally had great strength in Japanese fashion, with significant bodies of work by Issey Miyake, Rei Kawakubo of Comme des Garçons, and Yohji Yamamoto. The avant-garde sensibility of many Japanese designers resulted in the exhibition *Japan Fashion Now*. Black and Japanese designers also played a significant role in the exhibition *Pink: The History of a Punk, Pretty, Powerful Color*. Although the vast majority of objects in the museum's collection are women's fashions and accessories, the museum does have a wide range of men's fashions, as well. A number of these were featured in the exhibition *Ivy Style*.

Like a shark that must keep moving or die, a fashion museum must keep collecting the fashions of the present, searching always for creators who might be the important designers of the future. Moving ahead, we are also looking forward to exploring new paradigms in exhibiting and interpreting fashion.

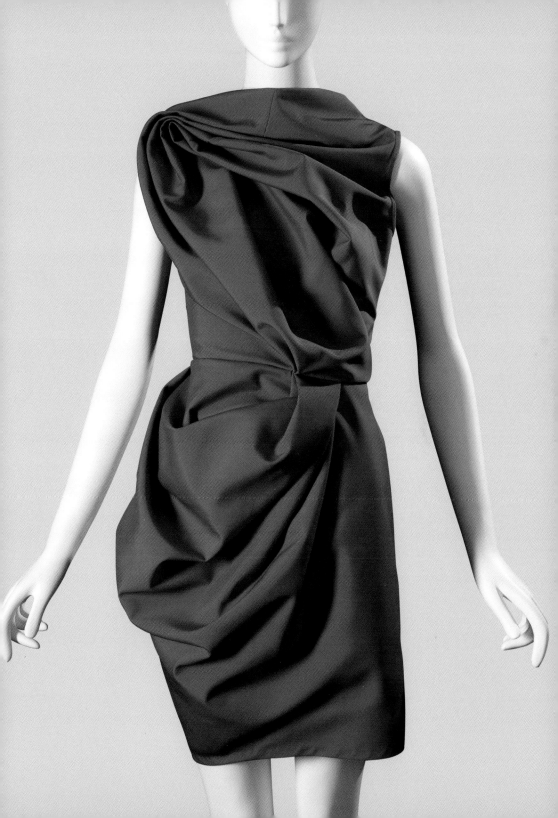

Fashion Designers A–Z

Adrian

ADRIAN ADOLPH GREENBURG (1903–1959)
Hollywood designer Adrian created the most glam-
orous and widely seen clothing in the world dur-
ing the years between the wars. Ironically, the
glittering gowns and flamboyant ensembles made
for Jean Harlow, Norma Shearer, Joan Craw-
ford, and Greta Garbo were film costumes, not
high-fashion. During his tenure as chief costume
designer for MGM, Adrian did more than design:
he transformed leading actresses into glamorous
movie stars.

Born into a family of milliners, the young
Adrian became a film costumer after training at the New York School of Fine and Applied
Art (later Parsons the New School for Design) and working on Broadway. In 1928 he
signed on at MGM. Adrian's great skill was his ability to absorb high-fashion trends from
Paris, modify them for a particular star, and amplify the look to enhance a film's dramatic
story line.

By 1941 Adrian left MGM to open his ready-to-wear and custom salon in Beverly
Hills, where he produced a wide range of brilliantly colored and cleverly cut day and eve-
ning wear that sold well and was frequently featured in high-fashion publications.

One of Adrian's best-known garments was the wool suit, a mid-century wardrobe sta-
ple, and Adrian's versions were unsurpassed. His ability to seam and piece complementary
gradations of striped woolens, varying their widths and placement into seemingly endless
pattern variations, attests to his fanciful genius. This creativity and high level of custom-
made quality were all the more amazing in a wartime era of fabric restrictions. Despite his
success as a ready-to-wear and custom fashion designer, Adrian is best remembered as a
costumer whose film costumes still enthrall viewers today. —*P. M.*

"Every Hollywood designer has had the experience of seeing one of his designs ignored when first flashed on the screen and then a season or two later become the vogue because it had the stamp of approval from Paris." — ADRIAN

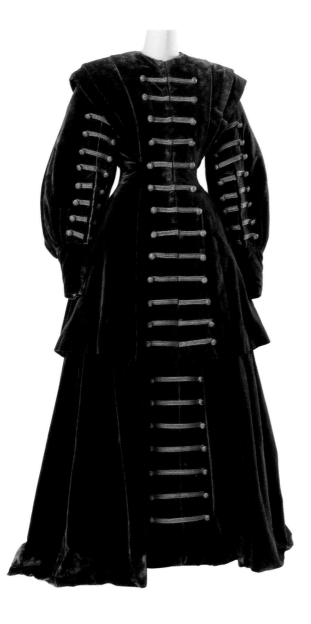

PREVIOUS SPREAD AND LEFT
Adrian for MGM
Suit: Green silk velvet
with gold metallic braid
USA, 1933

This seventeenth century-
inspired suit was worn by
Greta Garbo in MGM's 1933
production *Queen Christina*.

OPPOSITE
Adrian
Suit: Brown-and-ivory
wool houndstooth check
USA, ca. 1946

Tailored suits were integral
to a woman's wardrobe during
and after the 1940s. Many of
the finest suits for women were
crafted by legendary Hollywood
costume designer Adrian.

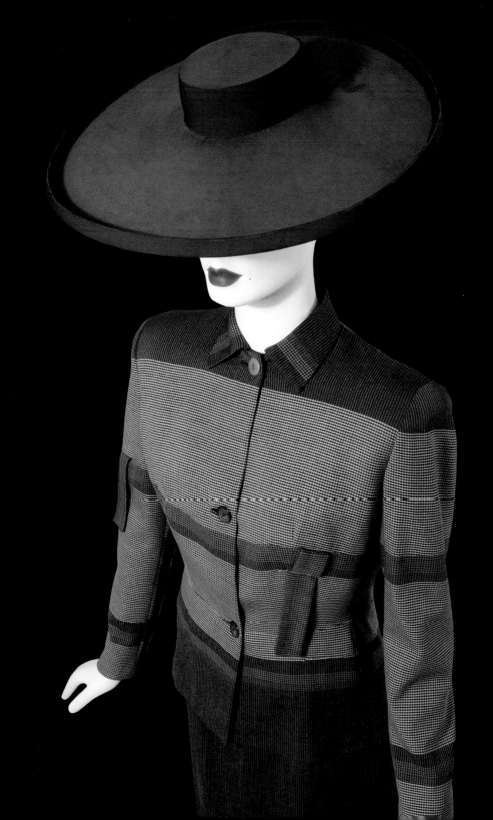

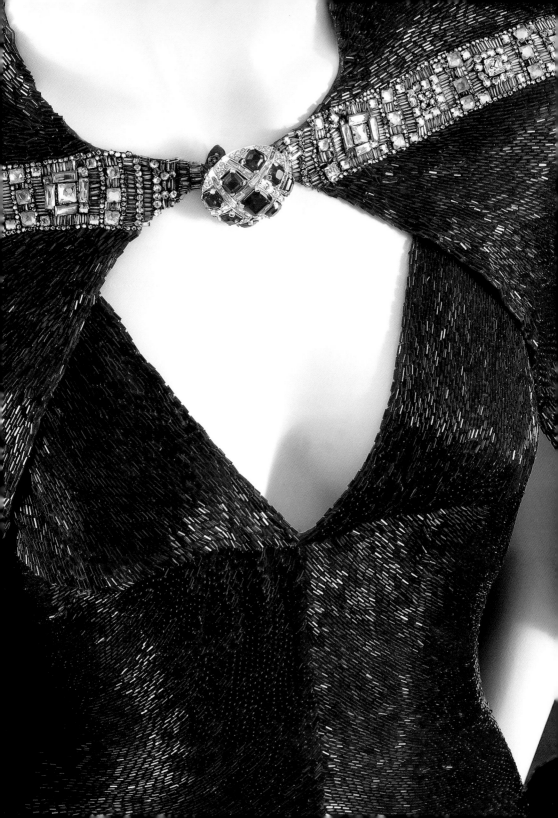

OPPOSITE AND BELOW
Adrian for MGM
Dress and cape: Red bugle
beads, silk crêpe
USA, 1937

The bright-red color of this
hand-beaded dress was lost
on moviegoers in 1937's black-
and-white film *The Bride Wore
Red*. Worn by Joan Crawford,
it became one of Adrian's most
famous dresses.

RIGHT
Adrian
Ensemble: Taupe, rust, tan,
and green rayon crêpe
USA, 1945

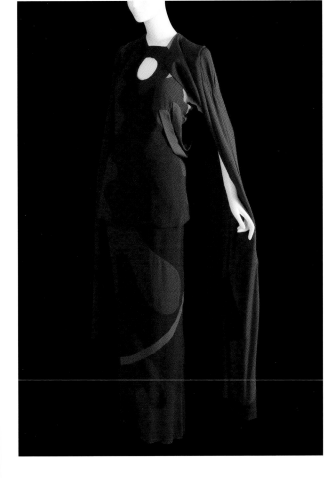

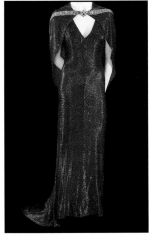

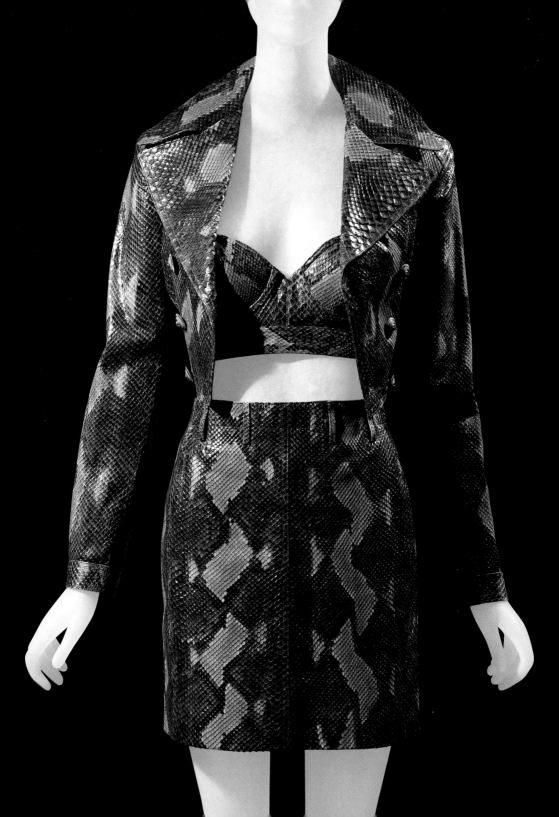

Azzedine Alaïa

AZZEDINE ALAÏA (1940–2017) The body-conscious fashions that defined the 1980s owe much to Azzedine Alaïa, whose "second skin" designs were renowned for displaying and enhancing a woman's figure. A perfectionist about shape and fit, Alaïa cut and draped his garments himself—preferring to work directly on the body—to achieve the ideal silhouette. Combining corsetry techniques with complex spiral and crisscross seaming, some garments contain up to forty individual pieces, all assembled to emphasize womanly curves while ensuring ease of movement.

Born in Tunisia, Alaïa studied sculpture and eventually moved to Paris in 1957 to pursue fashion. After working briefly in the studios of Dior, Guy Laroche, and Thierry Mugler, Alaïa introduced his first prêt-à-porter collection in 1980 and found success, seemingly overnight, as women of all ages scrambled to get on waiting lists for his designs. However, even before opening his shop, Alaïa had been designing custom-made clothes for a small group of actresses and aristocrats, including Greta Garbo, Marlene Dietrich, and Cécile de Rothschild. Throughout the 1980s and early 1990s, Alaïa's fame continued to attract notable clients such as Madonna, Tina Turner, and fashion icon Tina Chow.

Alaïa's quest for perfection led him to rework and refine many of his designs as he experimented with riveted leathers, industrial zippers, and fabrics such as leather, tweed, Lycra, and silk jersey. "He gives you the very best line you can get from your body," Tina Turner once remarked. In 2021, Pieter Mulier was appointed as creative director. —*M. M.*

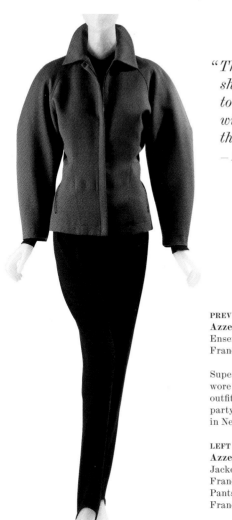

"The moment when a woman can show her body is so short; they have to make the most of it. A young woman with bare shoulders, a low-cut top, that's a gift of nature."

— AZZEDINE ALAÏA

PREVIOUS SPREAD
Azzedine Alaïa
Ensemble: Green snakeskin
France, 1991

Supermodel Veronica Webb
wore this snakeskin Alaïa
outfit to her 30th birthday
party at El Teddy's restaurant
in New York City.

LEFT
Azzedine Alaïa
Jacket: Gray covert wool
France, ca. 1987
Pants: Black wool knit
France, 1985

BELOW
Azzedine Alaïa
Boots: Leopard-print
ponyskin
France, 1991

OPPOSITE
Azzedine Alaïa
Suit: Black wool,
leopard-pattern chenille
France, 1991

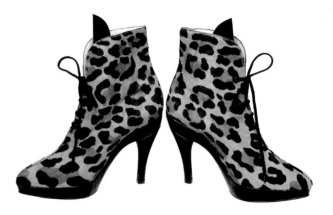

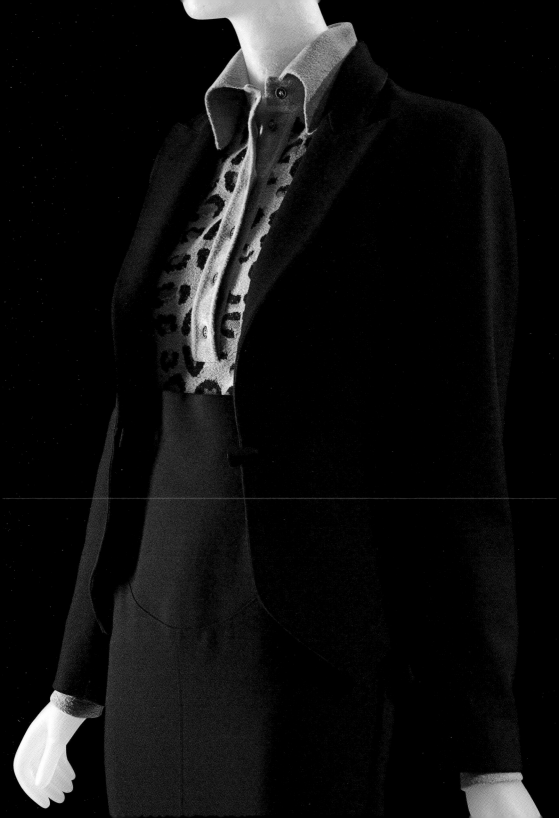

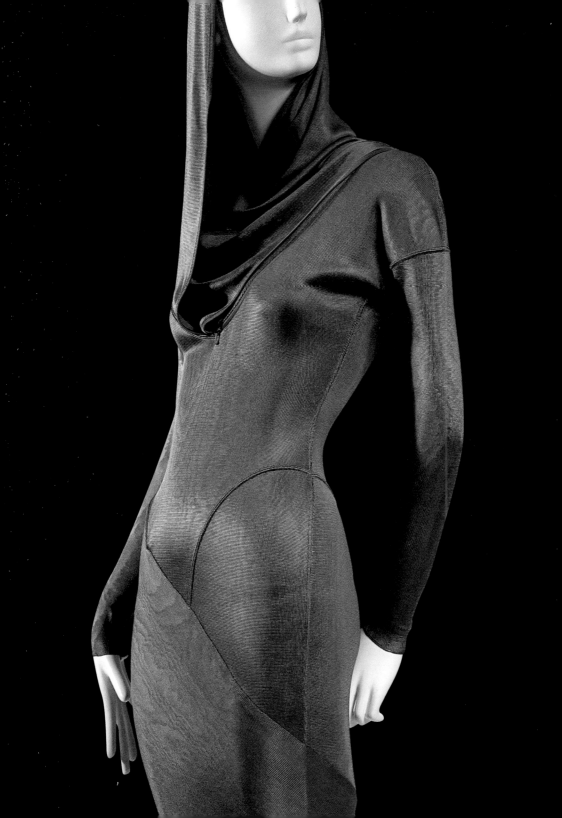

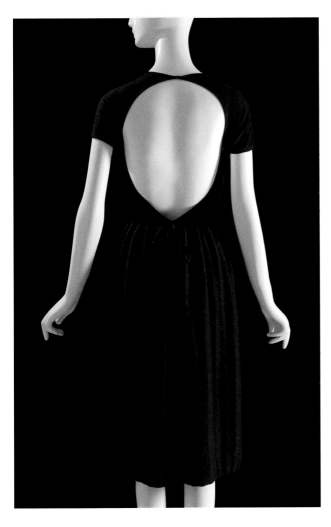

Azzedine Alaïa
Dress: Green acetate knit
France, 1986

Alaïa's clothes are notorious
for fitting like a "second skin."
His strength lies in his tailoring
and cutting skills, enhanced
by his inventive use of seaming.

LEFT AND BELOW
Azzedine Alaïa
Dress: Black wool jersey
France, 2007

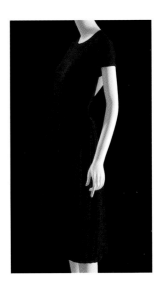

*"You won't find anyone doing what
Azzedine does, even now, after all
these years of everyone studying his
clothes to find out what the secret is."*
— JEANINE VERNES, *HARPER'S BAZAAR*

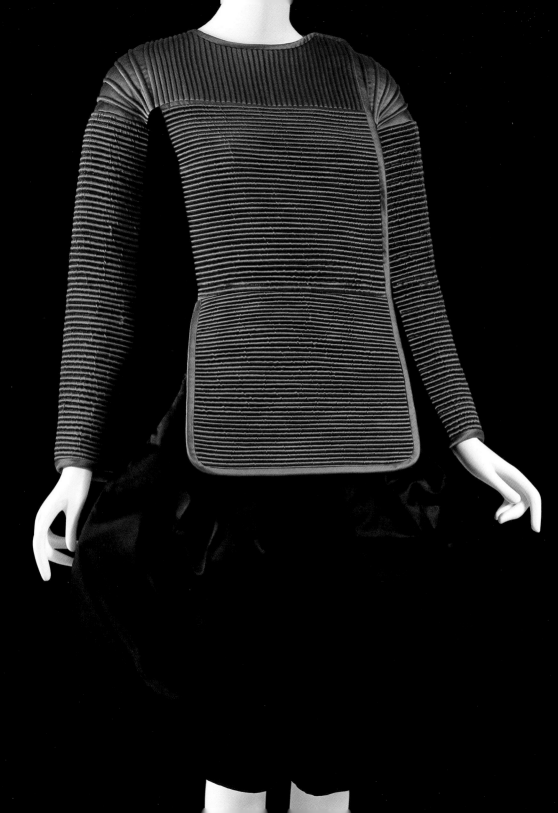

Giorgio Armani

GIORGIO ARMANI (B. 1934) Giorgio Armani's understated yet innovative style transformed fashion in the 1970s. "Even in a country where tailors are supreme, Giorgio Armani is known as a master tailor," pronounced *The New York Times* fashion writer Bernadine Morris in 1980. "To the obligatory mastery of cut, construction and coloring, he has added style and vision." The relaxed quality of Armani's suits provided a familiar, personalized feeling for their wearers, and they were meticulously crafted—despite being sold off the rack.

Armani was born in Piacenza, Italy. Although he was never formally trained in fashion, his innate understanding of clothing was honed by his early work in the industry—first as a buyer for the upscale Italian retailer La Rinascente, then as a designer for textile and clothing manufacturer Nino Cerruti. In 1975 Armani founded his own label in Milan, and later that year showed his first menswear collection.

The designer introduced his unstructured men's suits in 1976—an innovation that quickly established his importance to contemporary fashion. By removing stiff interlinings and modifying standard proportions, Armani created what he described as "a light jacket, just as comfortable as a shirt, sensual even in its construction." His carefully selected color palette was—and remains—subtle and neutral, what he describes as "the colors of dawn and dusk." Armani launched a line of women's clothes that same year, which often utilized the same look and construction techniques as the men's styles.

Armani's importance to the U.S. fashion market was firmly established in 1980 when actor Richard Gere wore more than thirty of the designer's suits in the film *American Gigolo*. He continues to design clothes that remain true to his minimalist origins, but his more recent forays into exotic, embellished designs—described by fashion journalist Suzy Menkes as "symbols of escape from everyday reality"—have proven equally successful. —*C. H.*

"Few clothes speak more eloquently of modern life than those of Giorgio Armani."
— C. R. MILBANK, FASHION WRITER

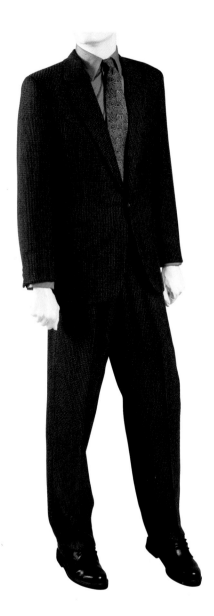

"My fashion is not unisex, but it does insist upon more gentleness for men, and more strength for women."
— **Giorgio Armani**

PREVIOUS SPREAD
Giorgio Armani
"Samurai armor" ensemble:
Bronze silk satin, black
velvet, black silk, sequins
Italy, 1981

LEFT
Giorgio Armani
Man's suit: Brown-
and-gray wool tweed
Italy, 1982

OPPOSITE
Giorgio Armani
(**Armani Privé**)
Evening dress: Silver silk,
"Diamond Leaf" Swarovski
crystals
Italy, 2007

This gown features approximately 100,000 "Diamond Leaf" Swarovski crystals, a new shape designed for Armani by Swarovski.

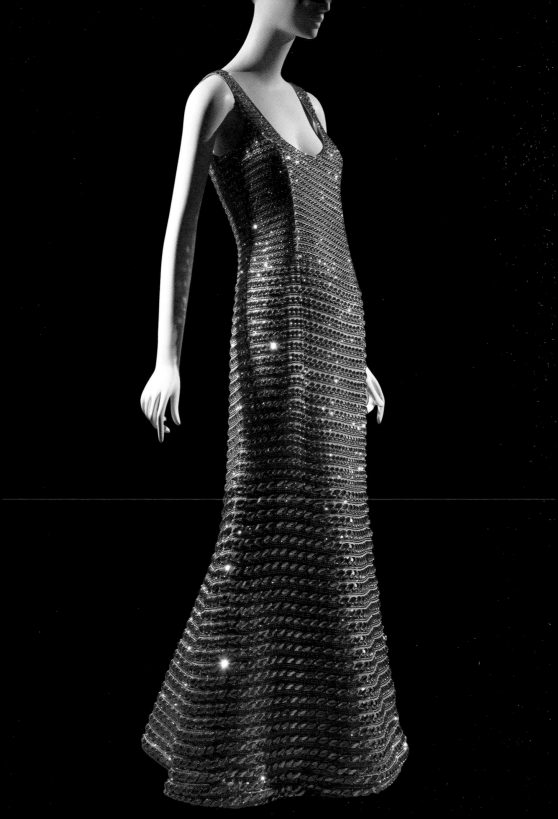

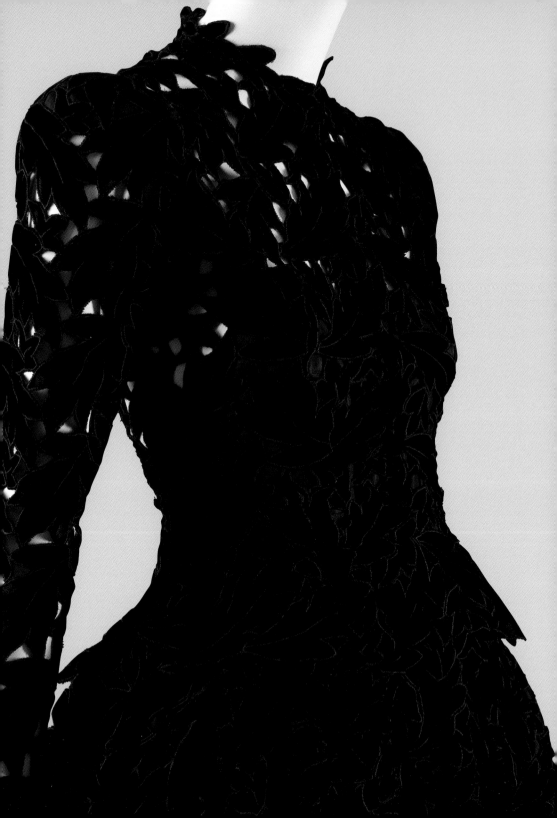

Balenciaga

CRISTÓBAL BALENCIAGA (1895–1972) was one of the greatest couturiers in the history of fashion. Born in the Basque country of Spain, Balenciaga opened fashion houses in Barcelona and Madrid before the Spanish Civil War forced him to move to Paris in 1937. From the beginning, he achieved success with the most discriminating clientele, including the Duchess of Windsor, Pauline de Rothschild, Gloria Guinness, and Mona Bismarck.

Although established for more than thirty years on the avenue George V, Balenciaga remained inspired by the artistic culture of Spain. His famous "Infanta" ball gown of 1939, for example, paid homage to Velázquez's masterpiece, *Las Meninas*. Similarly, his boleros and flaring skirts echoed, respectively, the clothing worn by matadors and flamenco dancers. Later in his career, the voluminous shapes of traditional ecclesiastical dress would be central to his work. While his early work tended to follow the lines of the body (albeit sometimes overlaid with complex constructions of drapery or surface decoration), over time his work acquired an abstract, sculptural simplicity.

By the early 1950s, Balenciaga had developed a semi-fitted jacket with a fluid, comfortable line that flattered a variety of body types. His balloon dresses, sack dresses, and baby doll dresses were equally instrumental in moving fashion away from its obsession with the hourglass silhouette.

Cristóbal Balenciaga closed his couture house in 1968, believing that elegance was irrelevant in the face of a rising youth culture. Yet his explorations in volume, shape, and form revolutionized fashion. His contemporary, Christian Dior, aptly described him as "the master of us all."

When Jacques Bogart S.A. acquired the rights to the Balenciaga label in 1986, he revived the brand as a ready-to-wear line. Designer Nicolas Ghesquière served as creative director from 1997 to 2012. Alexander Wang designed for the house from 2013 to 2015. In 2021, Demna Gvasalia was appointed as artistic director. —V. S.

*"As Balenciaga often said,
'Women do not have to be perfect
or even beautiful to wear my clothes.'
His clothes did that for them."*
— GLORIA GUINNESS, SOCIALITE

Nicolas Ghesquière (b. 1971)

"If Dior is the Watteau of dress-making…then Balenciaga is fashion's Picasso. For like that painter…underneath all of his experiments with the modern, Balenciaga has a deep respect for tradition and a pure classic line."
— **Cecil Beaton, photographer and costume designer**

PREVIOUS SPREAD AND OPPOSITE
Cristóbal Balenciaga
Evening dress: Black silk velvet cutwork
France, 1938

Balenciaga was one of the greatest fashion designers of all time. He opened his couture house in Paris in 1937, and immediately attracted the most discriminating clientele, including the Duchess of Windsor, Pauline de Rothschild, Gloria Guinness, and Mona Bismarck. This exquisite dress comes from the couture collection of the late Tina Chow.

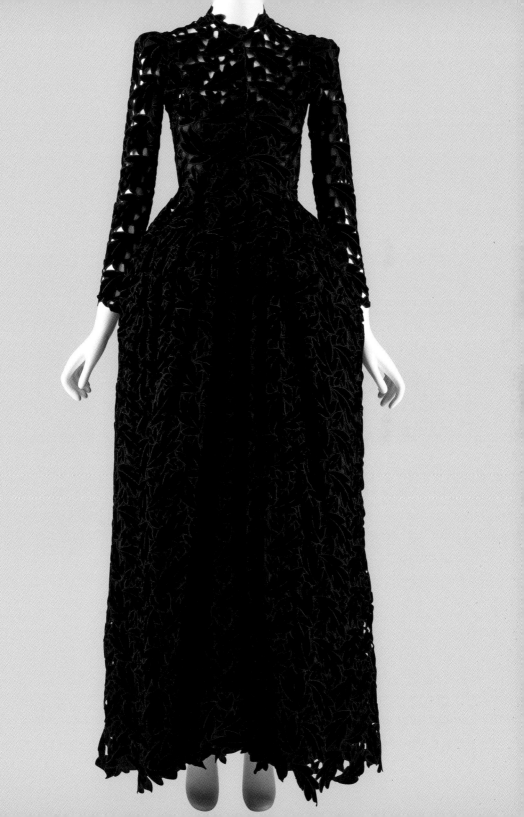

RIGHT
Cristóbal Balenciaga
Coat: Gray, brown, tan,
and black cut-silk velvet
France, 1950

Balenciaga was a true architect
of fashion, who explored
austere and elegant forms,
utilizing materials such as silk
gazar, velvet, and ottoman.

BELOW
Cristóbal Balenciaga
Cocktail dress: Black silk
taffeta; gray, brown, tan,
and black cut-silk velvet
France, 1950

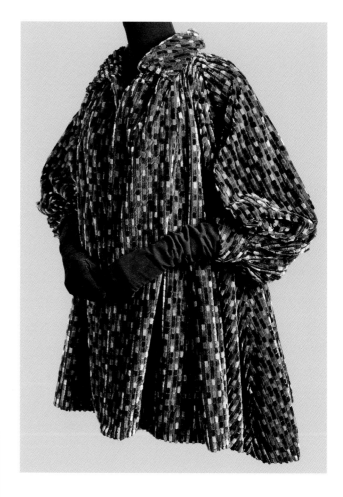

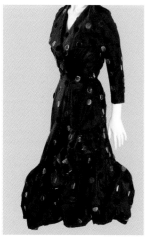

OPPOSITE
**Balenciaga
(Nicolas Ghesquière)**
Coat: Brown, tan, off-white,
and black wool; tan shearling;
black leather, chinchilla,
sequins
France, 2007

Nicolas Ghesquière presented
his first collection for the
house of Balenciaga in 1997.
Building on past Balenciaga
traditions and techniques,
Ghesquière's designs have
firmly planted the house in
the twenty-first century.

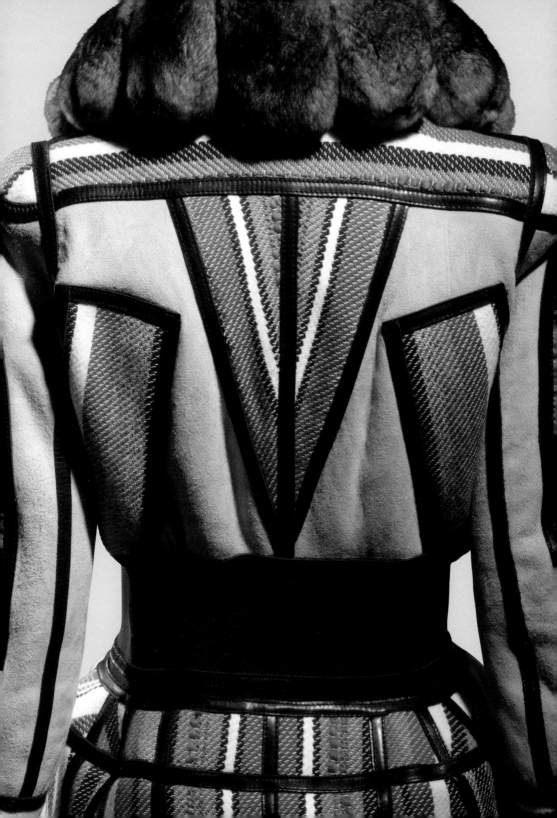

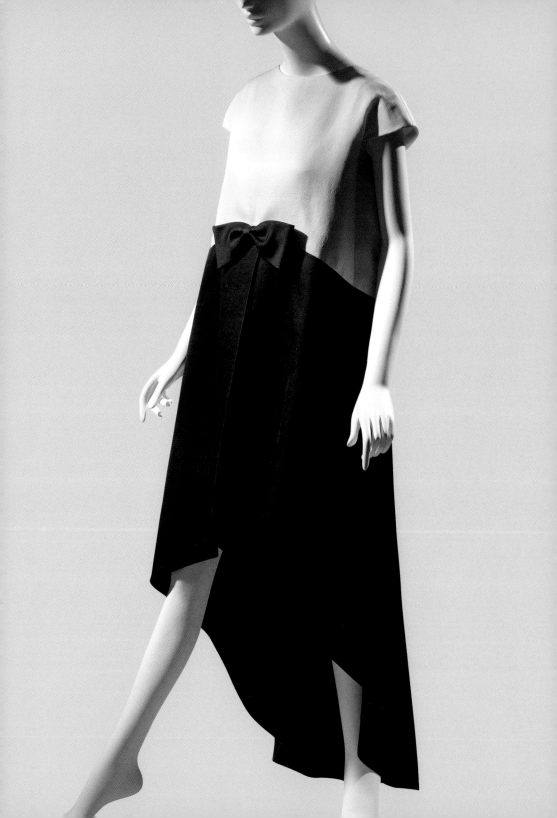

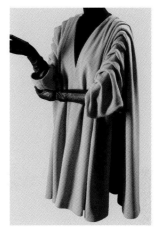

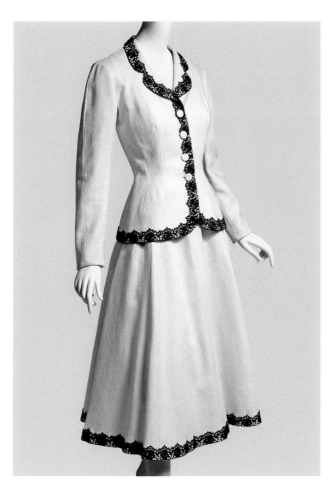

OPPOSITE
Cristóbal Balenciaga
Dress: Black, white silk gazar
France, 1968

LEFT
Cristóbal Balenciaga
Suit: White linen, black lace
France, 1948

ABOVE
Cristóbal Balenciaga
Coat: Beige wool duvetyn
France, 1950

RIGHT
Balenciaga
(Nicolas Ghesquière)
Dress: Red, yellow, black,
and white graffiti print
canvas; black cotton spandex
knit; metal buckles
France, 2004

BELOW
Balenciaga
(Nicolas Ghesquière)
Boots: Brown leather,
suede, metal
France, 2006

OPPOSITE
Balenciaga
(Nicolas Ghesquière)
Dress: Black patent leather,
sheer polyamide
France, 2007

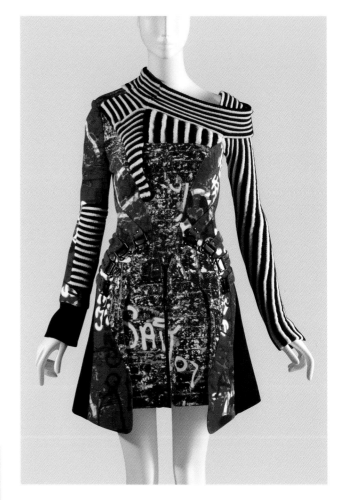

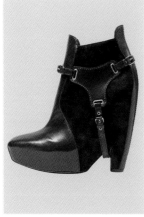

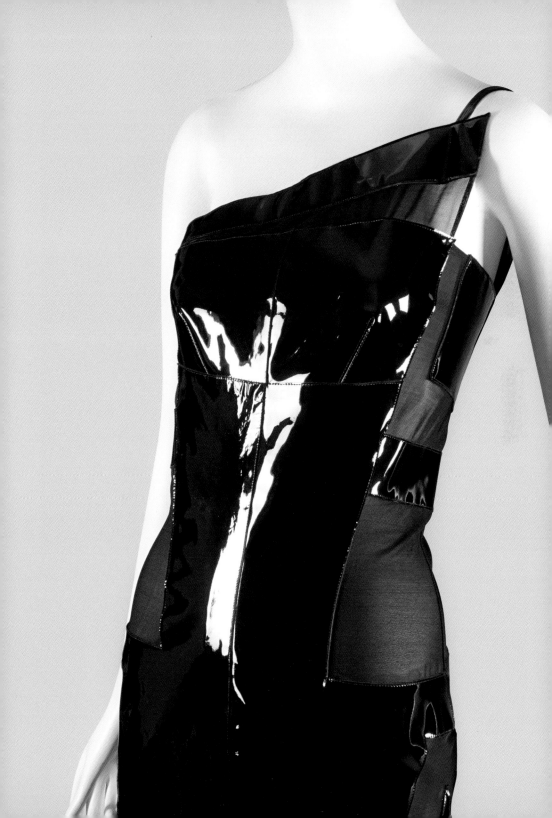

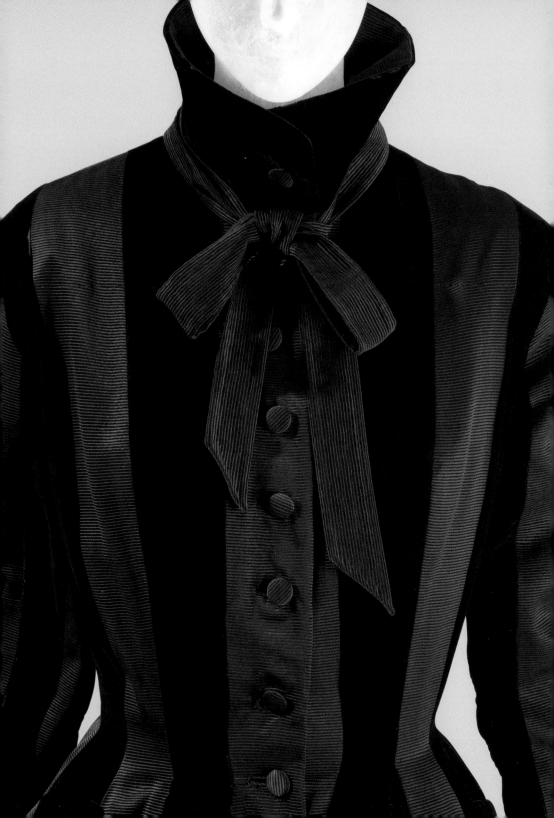

Balmain

PIERRE BALMAIN (1914–1982) "I do not remember a time when I was not interested in dress design and the intriguing play of materials against the feminine form," said Pierre Balmain. He opened his house in 1945, with his premier runway show famously attended by friends Gertrude Stein and Alice B. Toklas. During the following decade, Balmain's designs flattered the womanly hourglass figure so prominent during the 1950s, and he began to use the trademark name "Jolie Madame" in reference to his collections.

During its mid-century heyday, the House of Balmain was noted for fine tailored day wear, along with ultrafeminine evening gowns. *Harper's Bazaar* editor Carmel Snow reportedly told the Fashion Group in 1946 that Balmain's were the "most feminine clothes in the world." (Despite such praise, the often temperamental Balmain admitted to once banning Mrs. Snow from his house for a season.)

After Pierre Balmain's death in 1982, the collections were designed by Erik Mortensen (through 1990) and Hervé Pierre (1990–1992). Oscar de la Renta joined the house as designer in 1993, and during his nine-year tenure was praised for capturing the heritage of the brand by embracing its tradition of elegance. The arrival in 2005 of designer Christophe Decarnin was another turning point in the label's history. Decarnin revitalized the House of Balmain, previously criticized as "dusty" by many in the fashion press, with clothing that had a modern edge. Decarnin's designs were sexy—sometimes rock, sometimes military—but with a dash of sequined, tousled glamour. Some of his more notable collections spearheaded recent trends such as sharp, 1980s-inspired padded shoulders. Decarnin left the House of Balmain in 2011, and was succeeded by Olivier Rousteing. —*J. F.*

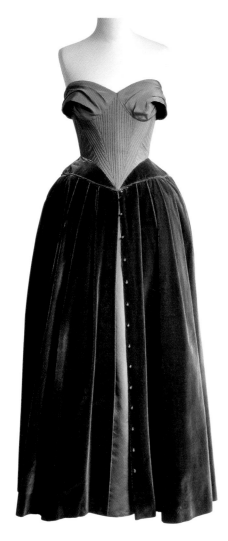

"[Balmain] is the last word in elegance, and encourages all kinds of extravagances so long as they are in good taste."

— CÉLIA BERTIN, WRITER

PREVIOUS SPREAD
Pierre Balmain
Coat: Black silk velvet, black gros de Londres
France, ca. 1948

This coat was worn by tobacco heiress Doris Duke.

ABOVE
Pierre Balmain
Evening dress: Light-blue taffeta, brown silk velvet, silver metal
France, ca. 1951

The bodice of this dress is an intricate boned taffeta corset, emphasizing a hyper-feminine hourglass silhouette.

OPPOSITE
Pierre Balmain
Evening dress: Cream silk satin, black silk velvet
France, ca. 1960

Pierre Balmain credited his mentor, designer Edward Molyneux, with instilling in him "a taste for beige and a horror of gaudy details"— a fact evinced by this opulent, but refined, evening gown.

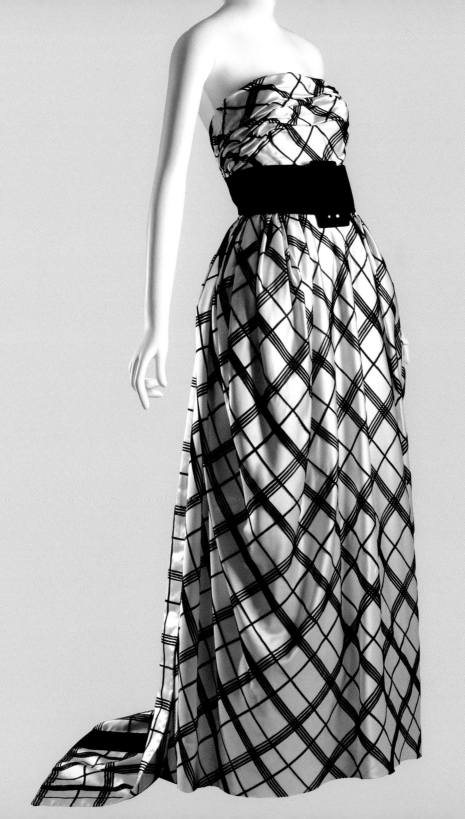

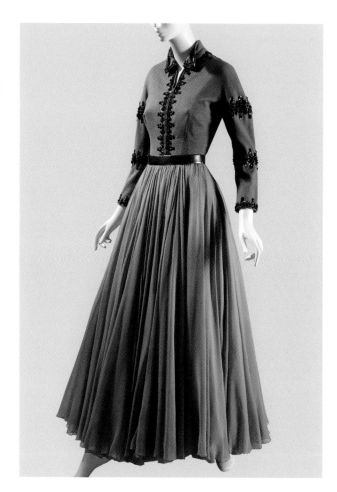

LEFT
Pierre Balmain
Evening dress: Gray wool
knit, gray silk chiffon, metallic
leather, beading
France, ca. 1952

OPPOSITE
Balmain (Oscar de la Renta)
Evening dress: Black silk
chiffon, black silk satin
France, 2002

RIGHT
Balmain (Oscar de la Renta)
Evening dress: Black silk
organza, white embroidery
France, 2002

Oscar de la Renta designed
couture and ready-to-wear for
Balmain from 1993 until 2002,
at the same time maintaining
his own highly successful
label. With the use of elegant
embroidery on this gown, de la
Renta revealed his penchant for
feminine designs, but also gave
a subtle nod to the design heri-
tage of the House of Balmain.

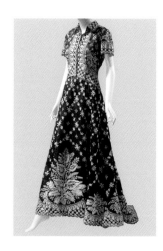

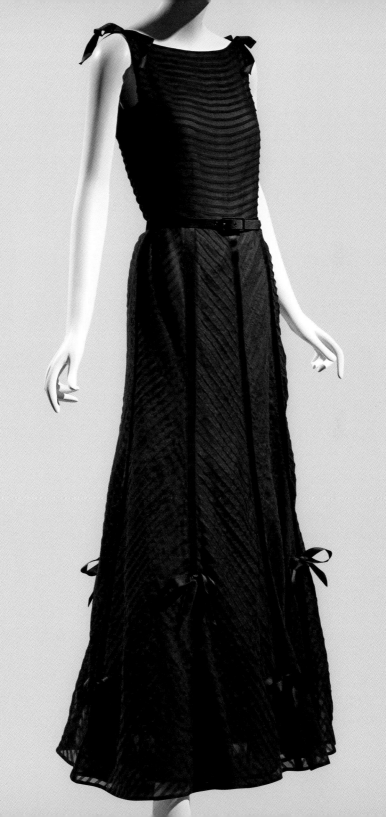

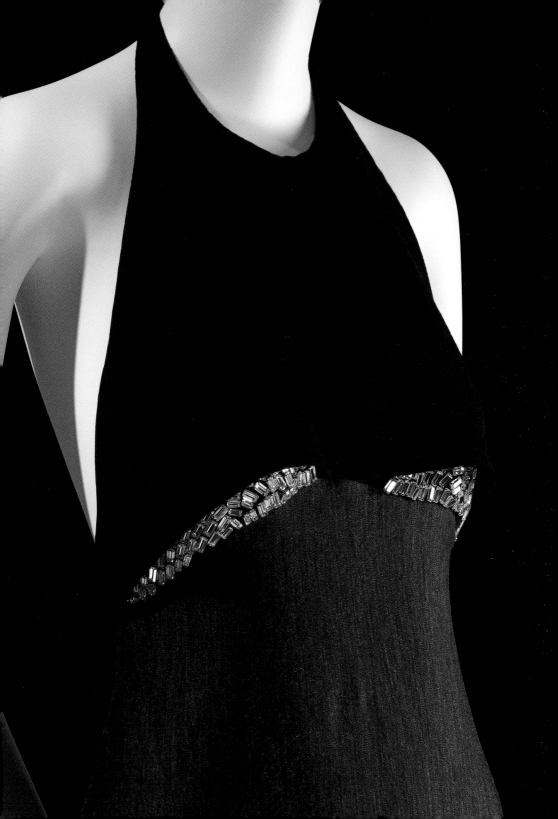

Geoffrey Beene

GEOFFREY BEENE (1924–2004) Geoffrey Beene's inventive geo-metric cuts and understanding of the human body allowed him to produce some of the most innovative clothes of his generation. Regarded as the architect of American cloth-ing, Beene approached fashion design with the preci-sion of a technician and the eye of an artist, creating clothes that glorified the female form.

Beene was born in Louisiana. He studied fash-ion in New York and Paris—where he apprenticed with a tailor for the couturier Molyneux—and in 1965 launched his own company on Seventh Avenue in Man-hattan. During the 1970s, Beene experimented with less structured fabrics in order to produce softer, more fluid designs. However, it wasn't until the 1980s that Beene initiated what he called his "true glorifica-tion of the body."

Beene's use of curved seaming techniques and contrasting panels of fabric accentuated parts of the female body often overlooked by other designers, such as the nape of the neck and the side of the hip. He also found beauty in mixing the high with the low—his 1967 sequined football-jersey evening dress, for example, playfully introduced the idea of sports-wear for evening—and his pairings of contrasting fabrics and textures gave his design a lighthearted, irreverent quality. Such juxtapositions became Beene's signature.

Always putting fashion above commerce, Beene refused to compromise his high stan-dards. He engaged in longstanding feuds with some prominent members of the fashion press, including *Women's Wear Daily*; as a result, Beene's work was seldom covered. How-ever, he was honored with a solo retrospective at the Museum at FIT in 1994. He mentored a generation of designers, including Issey Miyake, Michael Vollbracht, Alber Elbaz, and Doo-Ri Chung. He was a designer who forged his own path, defying conventions through-out a lengthy career, and was still working when he died in 2004. —*M. M.*

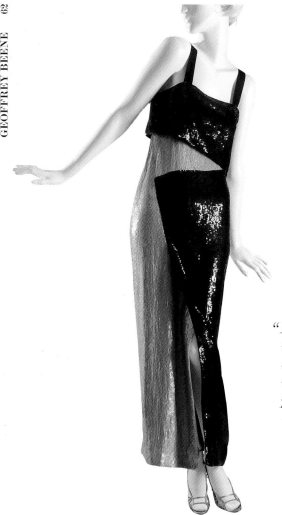

"My clothes are about freedom in a way; they're never confining. I think modernity involves movement; it's the pace at which a society moves."
— GEOFFREY BEENE

"The more you learn about clothes, the more you realize what has to be left off. Cut and line become increasingly important."
— **Geoffrey Beene**

PREVIOUS SPREAD
Geoffrey Beene
Evening dress: Black wool crêpe, dark-gray wool jersey, rhinestones
USA, 1994

ABOVE
Geoffrey Beene
Evening dress: Black and beige sequins, silk chiffon, silk satin
USA, ca. 1993

Geoffrey Beene's designs often explore strategies of concealing and revealing the body. Beene's use of beige sequins on this dress playfully suggests the idea of bare flesh while keeping the body concealed.

OPPOSITE
Geoffrey Beene
Cocktail dress: Gold lamé, tan crêpe, gold braid, and brass filigree
USA, 1969

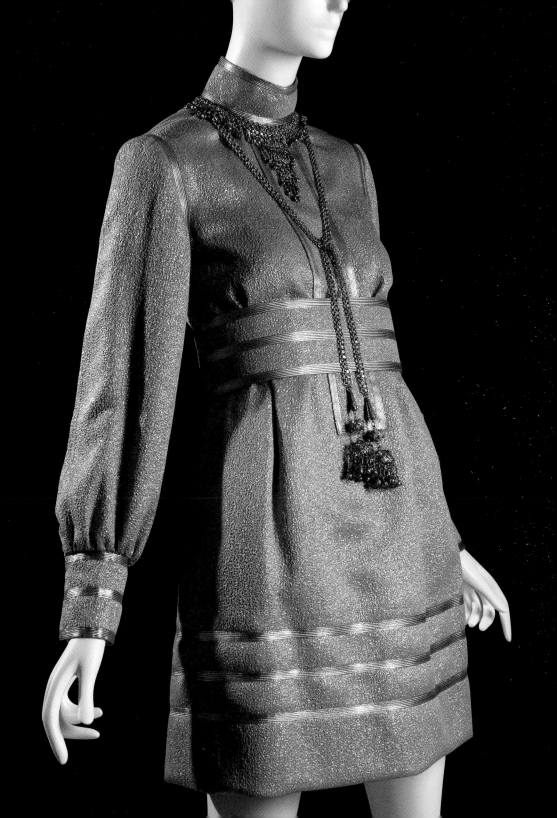

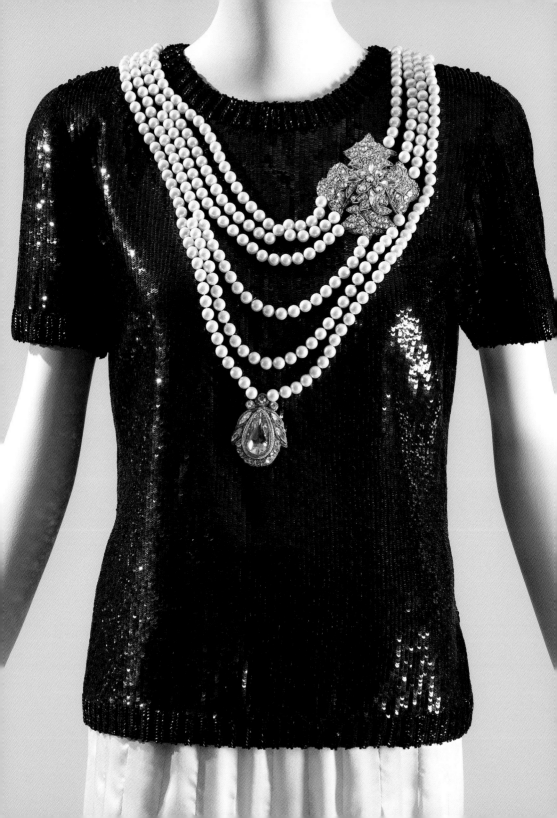

Bill Blass

BILL BLASS (1922–2002) Once described his clothes as having a "jazzy expensive realism." A charming man with good looks and a quick smile, Blass inhabited the glittering world of New York society, dressing many of its elite—women such as Nancy Kissinger, Chessy Rayner, Slim Keith, and Nan Kempner—who were not just clients, but also friends. His name has become synonymous with classic American style. "Blass is as American as—let's not fight it—apple pie," said Bernadine Morris of *The New York Times* in 1971, "and so are his clothes."

His earliest forays into the fashion world were through illustration. He worked first as a sketcher for David Crystal, and then, following his military service in the Second World War, briefly for Anne Klein. In 1949 Blass was hired as an assistant at Anna Miller, a label that later was absorbed into Maurice Rentner, where he remained as designer until 1970. He then bought the company to form Bill Blass, Ltd.

Although many of his early designs have been described as romantic, he is perhaps better known for sleek tailored suits, an adept mix of patterning, and the easy, seemingly effortless glamour of his evening designs. Often drawing on menswear for inspiration, Blass brought luxury to simple sportswear styles such as the cashmere cardigan. He once said, "On Seventh Avenue, anything that isn't covered with paillettes, beads, *and* feathers all at the same time is called understated elegance." A savvy businessman with prolific licensing agreements, Blass sold his company to its backers in 1999 and died three years later.

The company has struggled with financial problems and corporate restructuring ever since its 1999 purchase. *Women's Wear Daily* has called it "a virtual revolving door." In 2000 Steven Slowik was brought on board as head designer, only to be followed by a steady succession of other designers: Lars Nilsson in 2001, Michael Vollbracht in 2003, and Peter Som in 2007. The company was sold again in 2008 to the Peacock International Group (now the Bill Blass Group), and others have designed for Blass since then. —*J. F.*

"He took American sportswear to its highest level and combined it with sexy menswear touches, giving it new, clean, modern, impeccable style."

— ELLIN SALTZMAN, *THE NEW YORK TIMES*

"All my experiences, all my yearnings, have been those of a typical American boy becoming a typical American man, except that my focus was on clothes…It was a typical American success story after all."
— **Bill Blass**

PREVIOUS SPREAD
Bill Blass
Evening top and pants: Ivory silk, black sequins, faux pearls, rhinestones
USA, 1989

ABOVE
Bill Blass
Evening dress: Red cashmere, red silk satin
USA, 1984

Blass liked to use sweaters for evening, and this reverse cardigan was a surprising twist on a formal dress.

OPPOSITE
Bill Blass
Evening dress: Black cashmere, gold metallic embroidery, sequins, black beads, black satin
USA, 1986

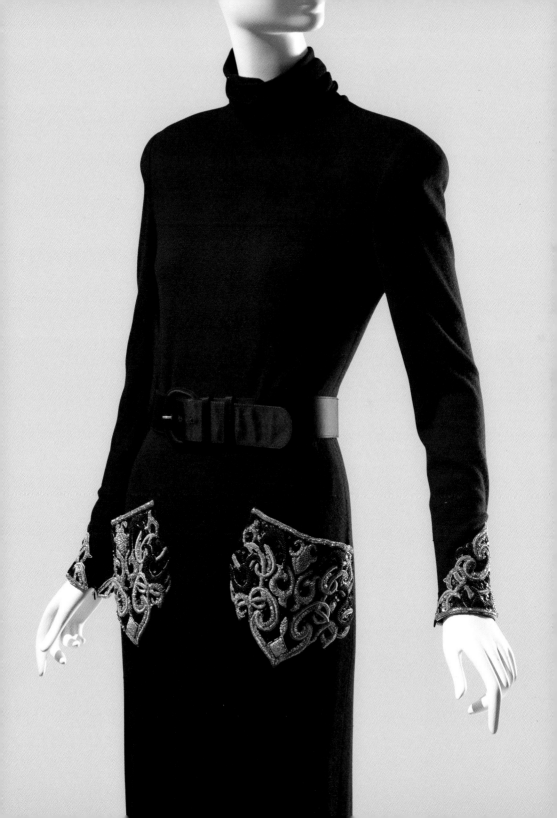

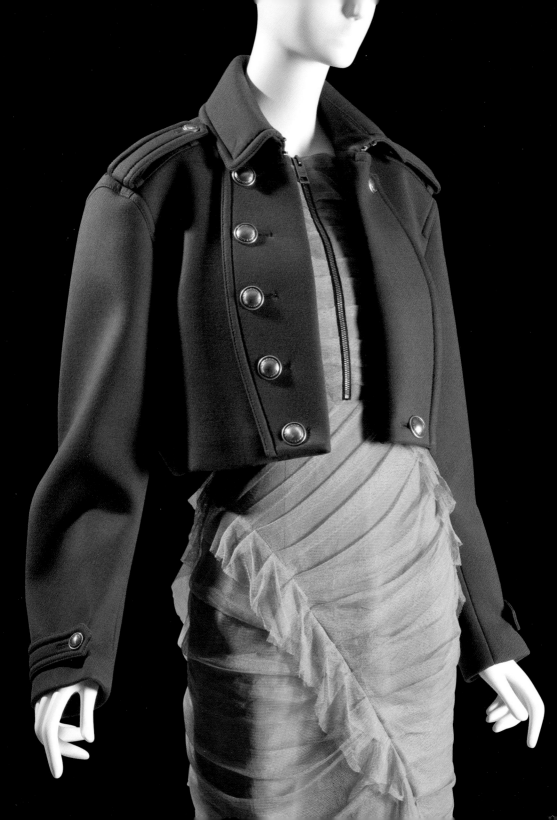

Burberry

THOMAS BURBERRY (1835–1926) Burberry began as a small outfitters' shop in Basingstoke, England. Today it is a coveted luxury brand. In 2006 Sarah Mower called the company's transformation "one of the great corporate wonders of the world: the improbable tale of how a staid British raincoat company became a hot and fashionable multifaceted global brand."

Thomas Burberry opened the doors to his shop in 1856, specializing in functional clothing for outdoor and sport activities. Burberry patented water-repellent, but ventilated, twill gabardine. In the early twentieth century, Burberry also produced outerwear for the British military, including the style that, after the First World War, became known as the trench coat. Burberry's innovations extended to its many designs for active sportswear, such as the "pivot sleeve" for golf, which focused on ease of movement. The company's distinctive check—in beige, red, black, and white—was first used in coat linings during the 1920s, but has since decorated everything from scarves to handbags to bikinis.

CEO Rose Marie Bravo was instrumental in revitalizing the company during her tenure from 1997 until 2005. Bravo hired Italian designer Roberto Menichetti, and later, in 2001, hired Briton Christopher Bailey (b. 1971), who served as chief creative officer until 2018. When Angela Ahrendts joined Burberry as CEO in 2006, she and Bailey worked to position Burberry as a leader in digital innovation. Bailey told *Harper's Bazaar* in November 2005, "I hope the Britishness never becomes pastiche. I would hate for it to look literally like Twiggy or the Mitfords. For me it's always been more of a spirit."

Riccardo Tisci, formerly of Givenchy, was appointed chief creative officer at Burberry in 2018. —*J. F.*

"I love tradition. I love it in everything— in architecture, in industrial design, in fashion. I love taking the idea of something very historical and very classic and using that as a starting point."
— CHRISTOPHER BAILEY

Christopher Bailey (b. 1971)

"[The Burberry trench coat is] a mainstay in outerwear worldwide, that symbolizes all that is Britain: sturdy and unassuming, equally at home in fine hotels and muddy lanes."
— **Andrew Collier**, *Women's Wear Daily*

PREVIOUS SPREAD
Burberry Prorsum (Christopher Bailey)
Dress: Chartreuse silk tulle
Jacket: Olive-green bonded wool and polished metal
England, 2010

OPPOSITE
Burberry Prorsum (Christopher Bailey)
Man's coat: Olive-green wool and polished metal
Shirt and jeans: Denim
England, 2010

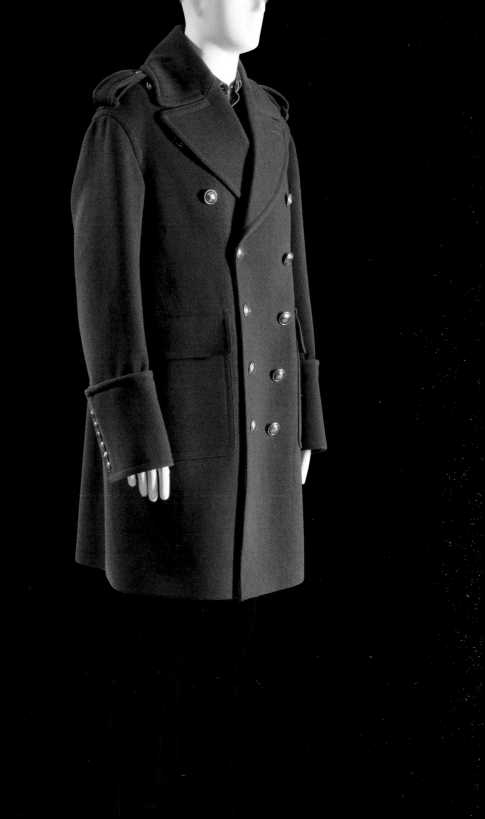

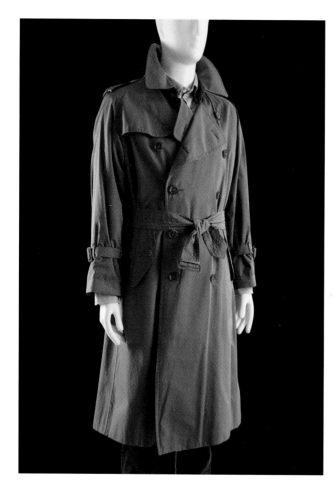

LEFT
Burberry
Man's trench coat:
Tan/green cotton twill,
wool tweed lining
England, 1978

BELOW
Burberry (Christopher Bailey)
Stiletto boots: Black leather,
polished metal, shearling
England, 2010

OPPOSITE
**Burberry Prorsum
(Christopher Bailey)**
Coat: Taupe silk taffeta
Belt: Patent leather
England, 2006

Bailey has transformed the
famous Burberry trench coat
into a modern garment that is
both feminine and luxurious.

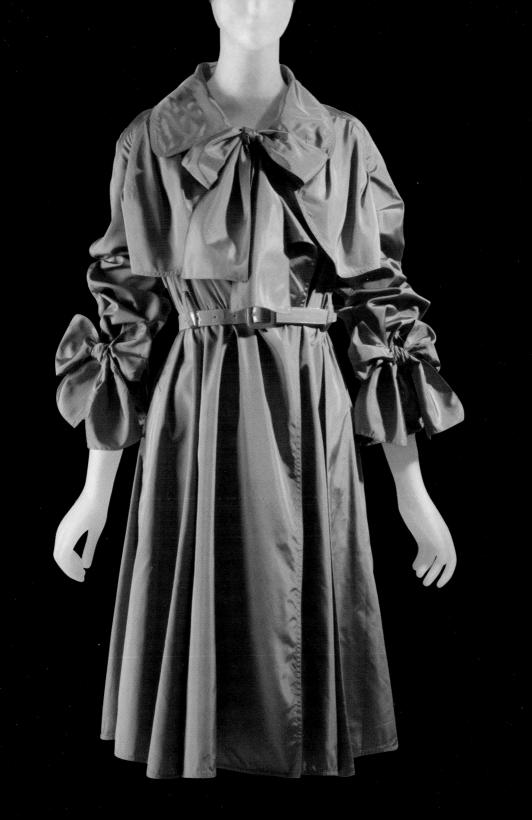

Callot Soeurs

MARIE CALLOT GERBER, MARTHE CALLOT BERTRAND, REGINA CALLOT TENNYSON-CHANTRELL, AND JOSÉPHINE CALLOT CRIMONT Callot Soeurs was a female-run couture house that rose to prominence during the early twentieth century, and was renowned for its high-level craftsmanship and exquisite lacework. The house was founded in 1895 by four sisters who quickly developed reputations as astute businesswomen and "artists of fabric, line, and color."

The sisters came from an artistic family; their father was a painter and antiques dealer and their mother a lacemaker. Marie Gerber, the eldest sister, was trained in dressmaking and is generally regarded the head designer for the house. Madeleine Vionnet, one of the twentieth century's most influential couturiers, worked as head seamstress for Callot Soeurs from 1901 to 1907, and later credited her tenure there as invaluable to her career. Callot Soeurs were among a select group of couturiers chosen to represent haute couture at the Paris Exposition Universelle in 1900. There, they established their prominence within the world of French couture.

The house's early stylistic influences ranged from Renaissance to Rococo, although it was its lavish evening "confections" of silk, lace, and embroidery that were especially notable. By the 1910s the house's style shifted and was influenced by Fauvism, Cubism, and Eastern aesthetics. During this period, Callot Soeurs became the first couture house to show evening dresses of gold and silver lamé.

In his novel *Remembrance of Things Past*, Marcel Proust ranked Callot Soeurs among the top four couture houses in Paris—along with Paquin, Doucet, and Chéruit. Indeed, its designs were fiercely coveted by women on both sides of the Atlantic. As esteemed tastemakers, they cultivated a unique sense of style that promoted women and femininity. —*M. M.*

"Without the example of the Callot Soeurs, I would have continued to make Fords. It is because of them that I have been able to make Rolls Royces."
— MADELEINE VIONNET

PREVIOUS SPREAD AND LEFT
Callot Soeurs
Evening dress: Black silk crêpe de chine, gold lamé, and tulle
France, ca. 1924

OPPOSITE
Callot Soeurs
Evening dress: Black lace, white taffeta, sequins, and rhinestones
France, ca. 1909

Pierre Cardin

PIERRE CARDIN (1922–2020) Pierre Cardin's name is one of the most widely known in the fashion industry, as there are more than eight hundred licensed products bearing the designer's logo. Although Cardin's product line is so diverse that it includes baby carriages, cigarette lighters, and wigs, he will go down in history as a groundbreaking fashion designer, as well as a brilliant businessman.

Cardin began his career as a tailor, and worked briefly for both Paquin and Schiaparelli. In 1946 he managed the coat and suit workroom at Christian Dior; he was involved in the creation of the "bar suit" for the New Look collection. In 1950 Cardin opened his own couture house. His early designs were streamlined and softly sculptural, and he became known for his innovative cocoon-shaped coats and "bubble" dresses.

Cardin's designs from the 1960s became some of his most influential. His futuristic looks, rendered in geometric shapes and bold, colorful fabrics, were particularly significant. In addition to his successful womenswear line, Cardin also launched lines of menswear and children's wear.

His longstanding presence in the industry meant that he did not need to follow the Paris runway schedule, but he continued to organize shows when he felt they were necessary. "I have a reason for existing, a passion—I feel useful," he told *Women's Wear Daily* in 2010. "I have a goal in life, which is to continue working until the very last moment." After designing for more than seventy years, Pierre Cardin passed away in late 2020 at the age of ninety-eight. —*C. H.*

"It was in the sixties that the real Cardin began to emerge. Mesmerized by Sputniks and moon probes, he began making clothes for the space age . . . different from any that had been seen before."
— BERNADINE MORRIS, *THE NEW YORK TIMES*

"My first year of establishing my own designs was difficult because I was thought of as radical. But I never wanted to get my ideas from movies or from some past decade or from the streets. I feel the same way today. I don't feel that people who look at the streets or at movies for ideas are really designers."
— **Pierre Cardin**

PREVIOUS SPREAD
Pierre Cardin
Dress: Fuchsia "Cardine" Dynel
France, ca. 1968

Cardin developed his own type of moldable Dynel fabric, which he called "Cardine." The fabric was used to create the three-dimensional embellishments on this dress.

LEFT
Pierre Cardin
Dress: Black wool knit, white vinyl
France, ca. 1969

OPPOSITE
Pierre Cardin
Dress: Red-orange wool
France, ca. 1968

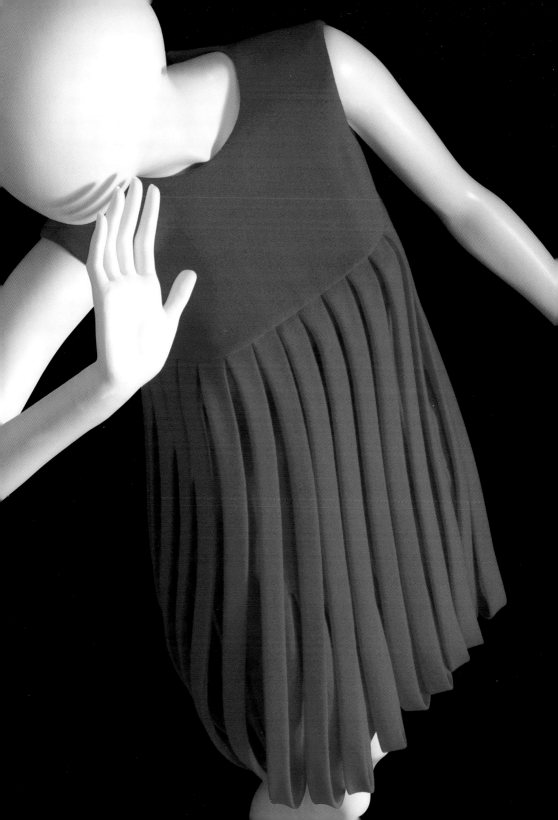

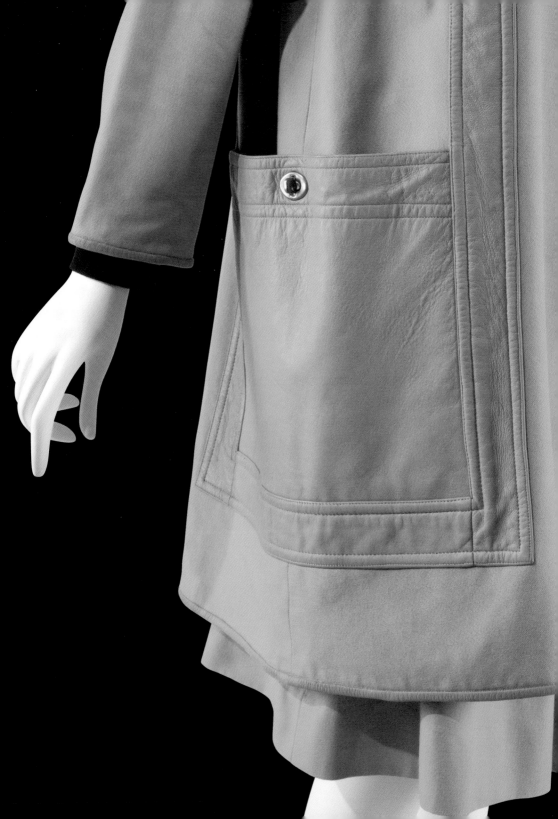

Bonnie Cashin

BONNIE CASHIN (1907–2000) An avid observer of American life, Bonnie Cashin created eminently practical, uncomplicated clothing that catered to the independent woman of the postwar era. Renowned for her loose-fitting sportswear, Cashin pioneered clothing concepts such as modular wardrobes for the modern woman on the go that today are essential fashion concepts. In 1978 *The New York Times* fashion writer Bernadine Morris called Cashin "an American fashion institution."

A California native, Cashin designed costumes for dance and then theater. In 1943 she went to work for Twentieth Century-Fox, where she designed wardrobes for over sixty films. She learned to consider the whole character when designing and would later gear her clothes for a particular lifestyle and "character," proclaiming, "I like to design clothes for a woman who plays a particular role in life." After a number of years working with the ready-to-wear firm Adler and Adler, Cashin opened her own business in 1952. Her design influence was so great that there were Cashin departments in chic stores in Paris and London. In 1962 Cashin became the first designer for the women's division at the leather accessories company Coach, where her handbags and wallets were characterized by their innovative use of hardware materials.

Cashin's design hallmarks included her use of tweed, leather, and canvas. Funnel-necked sweaters (whose collar doubled as a hood), deep pockets, turn-key metal closings, "pocketbook" pockets with latch closures, and leather piping are all key features of her designs. An avid traveler, Cashin adapted a number of basic clothing models from international dress, including the Mexican poncho, the Japanese kimono, and the Arabian aba. Indeed, it was Cashin's form-follows-function approach to fashion that informed her work and made her a pioneering force in American sportswear design. —*M. M.*

*"All I want is to speak simply in my designing;
I don't want the gilt and the glamour."*
— BONNIE CASHIN

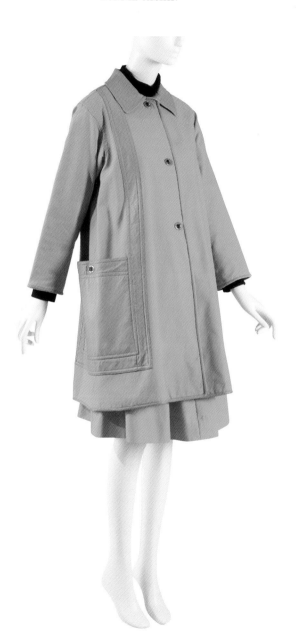

*"I wanted to design every-
thing a woman puts on her
body. I felt that designing
for the entire body was like
an artist's composition."*
— **Bonnie Cashin**

PREVIOUS SPREAD AND LEFT
Bonnie Cashin
Raincoat and skirt: Lime-green
cotton canvas, leather
USA, ca. 1965

Cashin's clothes were both
practical and stylish. The
pockets on this raincoat, for
example, feature distinctive
and functional hardware.

OPPOSITE
Bonnie Cashin
Ensemble: Red-and-pink
wool bouclé, orange wool,
orange suede
USA, ca. 1964

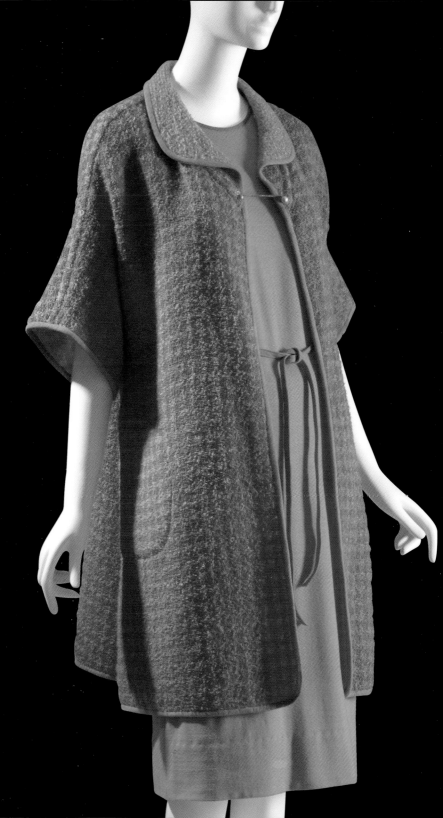

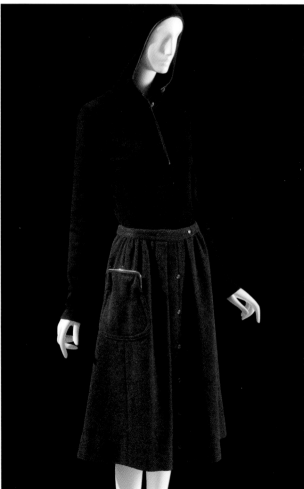

LEFT
Bonnie Cashin
Skirt: Dark-brown wool
tweed, metal
USA, 1961

BELOW
Coach (Bonnie Cashin)
Handbag: Chartreuse
leather, metal
USA, 1967–1968

This purse is an original
sample from the Coach collec-
tion entitled *Cashin Carry*.
The coin-purse pocket on the
front of this bag was a typical
design feature in Cashin's work
for Coach and her own ready-
to-wear designs.

OPPOSITE
Bonnie Cashin
Ensemble: Yellow Thai silk
USA, ca. 1959

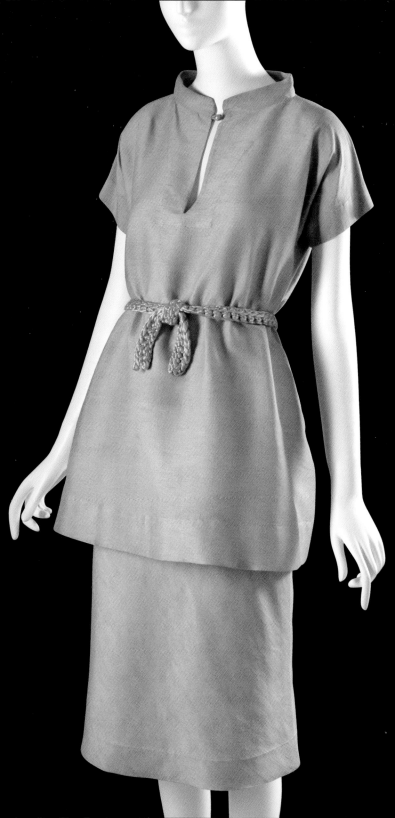

Chanel

GABRIELLE "COCO" CHANEL (1883–1971) "L'Élégance, c'est moi," said Chanel—unless the quotation is apocryphal, like so much else in the Chanel legend. Gabrielle "Coco" Chanel is probably the most famous fashion designer of the twentieth century. But this fame is based not so much on the remarkably enduring appeal of her designs as on the mythology that has surrounded her life and career. The popular image of Chanel is of a unique genius who created her personal style in isolation from the work of other designers, and virtually single-handedly brought women into the modern era.

Her own best model, she created an image of herself as a modern woman of style, dandyish in her simplicity, with a casual chic that made other women look like overdressed dolls. By publicizing this image, Chanel not only achieved a much higher profile than her contemporaries, she also created a prototype for the modern woman.

She began her career as a hat maker in 1910, and within ten years she had established a couture house, selling clothes made from jersey. Although she closed her couture house in 1939, Chanel reopened in 1954, at the age of seventy-one, and positioned herself as the antithesis of the reigning male designers of the postwar era. In contrast to Dior's ever-changing silhouettes, she proposed comfortable, slightly boxy suits, which functioned as stylish uniforms. As Karl Lagerfeld has observed, to some extent Chanel's genius lay in doing the right thing at the right time. The continued success of her perfume, Chanel No. 5, also kept the brand's name in the public eye. Nevertheless, after her death, Chanel's style became fossilized.

In 1984 Karl Lagerfeld brought the Chanel style back to life. Indeed, Lagerfeld once pictured himself as an "emergency doctor" who rejuvenated the famous Chanel suit and other signature styles, introducing new materials such as denim and leather, and techniques like deconstruction. Lagerfeld, who passed away in 2019, was a postmodernist who boldly exaggerated design elements and signature details such as chains, costume jewelry, and the famous double Cs. Virginie Viard was named as Chanel's new creative director shortly after Lagerfeld's death. —*V. S.*

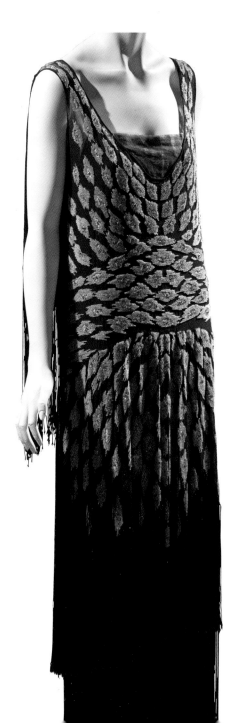

"Fashion is not something that exists in dress only. Fashion is in the sky, in the street, fashion has to do with ideas, the way we live, what is happening."
— GABRIELLE "COCO" CHANEL

"The essence of the Chanel look was Chanel herself."
—*Vogue*

PREVIOUS SPREAD
Gabrielle "Coco" Chanel
Evening dress: Pink silk crêpe chiffon
France, ca. 1925

LEFT
Gabrielle "Coco" Chanel
Evening dress: Black silk chiffon, crystal seed beads, rhinestone, silver leather
France, 1928

OPPOSITE
Gabrielle "Coco" Chanel
Evening suit: Brown, beige, and blue brocaded silk lamé
France, ca. 1960

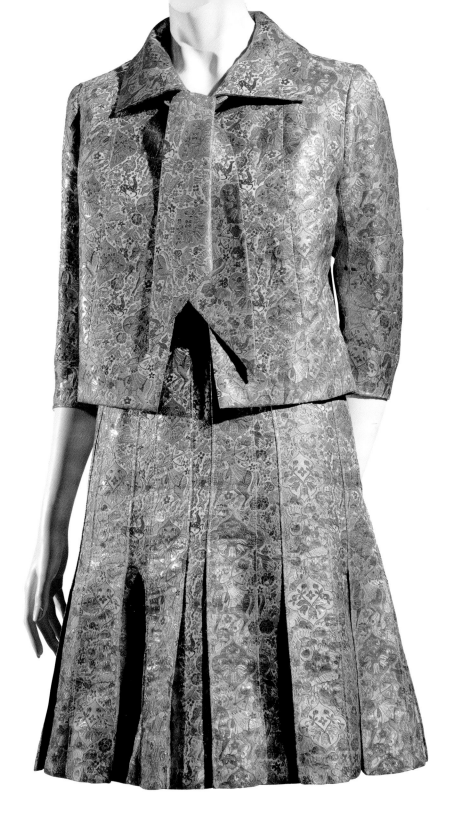

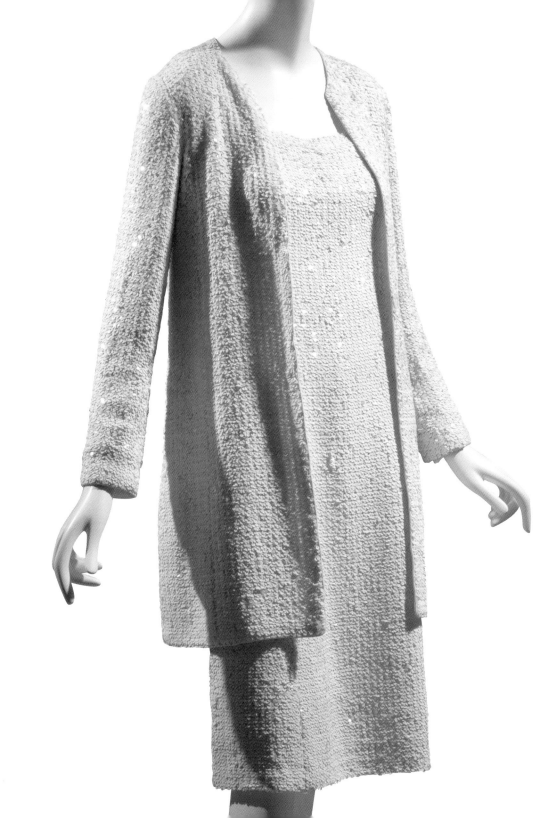

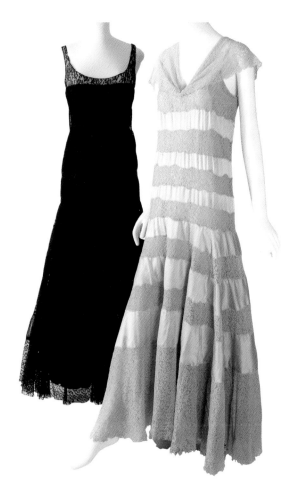

OPPOSITE
Gabrielle "Coco" Chanel
Evening dress and coat:
White sequins, beige silk
France, 1970

Over the course of a long
career, Chanel transformed
fashion with her "less is more"
aesthetic. This ensemble, for
example, which was part of
her personal wardrobe, is at
once luxurious and minimal.

LEFT
Gabrielle "Coco" Chanel
Evening dress:
Cream silk charmeuse,
Alençon lace
France, ca. 1932

BELOW
Chanel
Shoes: Cream silk satin,
black faille
France, ca. 1980

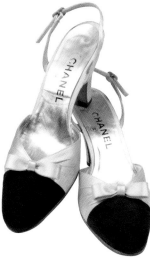

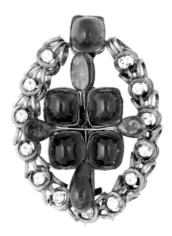

ABOVE
Chanel (Robert Goossens)
Brooch: Rhinestones,
green-and-red glass
cabochons, brass
France, ca. 1960s

RIGHT
Gabrielle "Coco" Chanel
Dress: Blue silk crêpe
France, 1926

Gabrielle "Coco" Chanel is
probably the most famous
and influential designer of
the twentieth century. More
than any other individual,
she launched the modern
style in women's dress.

OPPOSITE
Gabrielle "Coco" Chanel
Cape: Scarlet crinkled
crêpe de chine, feathers
France, 1927

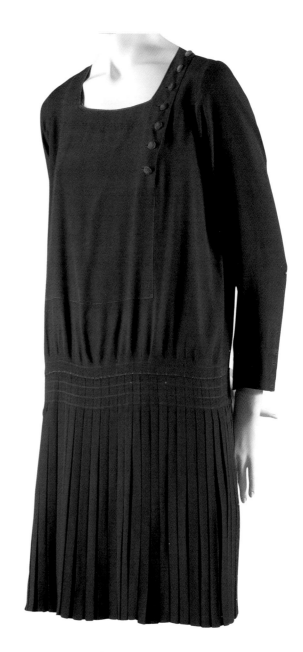

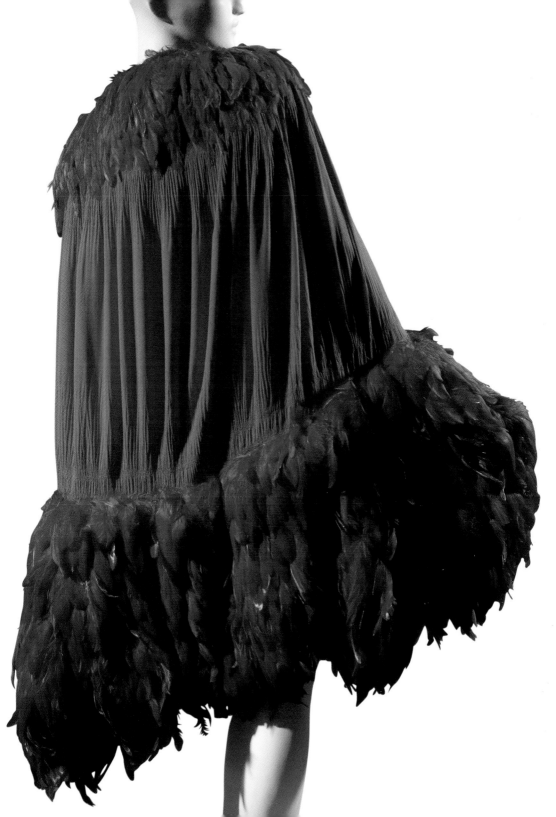

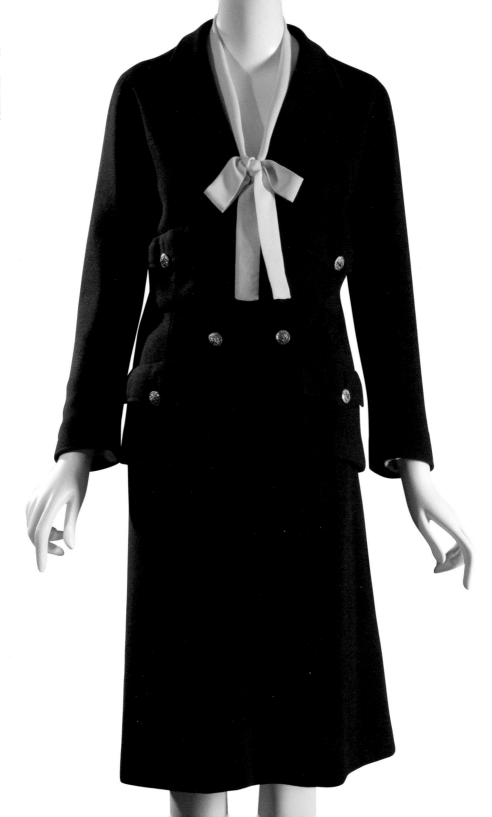

OPPOSITE
Gabrielle "Coco" Chanel
Suit: Navy double-knit wool
jersey, ivory silk, metal
France, ca. 1960

ABOVE
Gabrielle "Coco" Chanel
Suit: Black-and-white Prince
of Wales wool tweed
France, 1959

RIGHT
Gabrielle "Coco" Chanel
Suit: Maroon-and-green wool
tweed, red-and-green printed
silk crêpe, metal
France, 1959

Chanel closed her couture
house in 1939 and remained
closed until 1954. Then, at
the age of seventy-one, she
decided to begin working again.
This tweed suit epitomizes the
Chanel style of the 1950s.

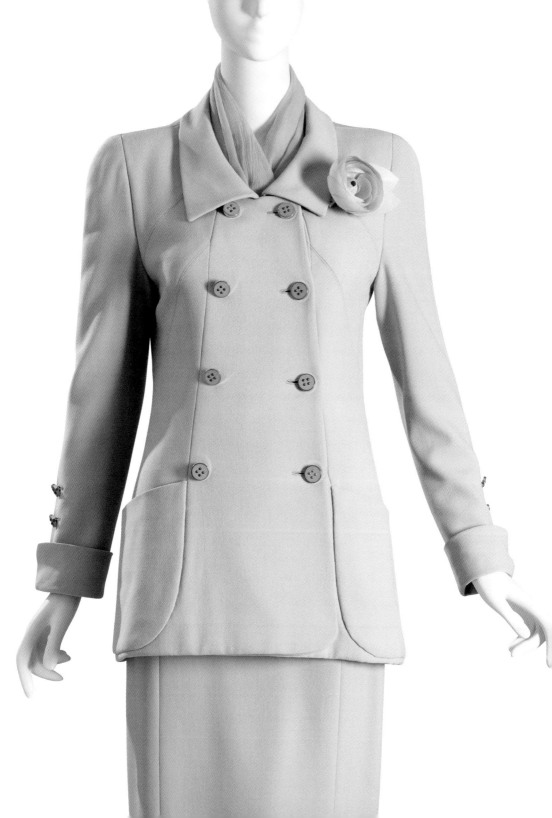

OPPOSITE
Chanel (Karl Lagerfeld)
Suit: Beige wool crêpe,
crinkle silk chiffon, metal
France, ca. 1986

BELOW
Chanel (Karl Lagerfeld)
Evening dress: Black velvet,
satin ribbon, crinoline,
horsehair
France, 1990

RIGHT
Chanel (Karl Lagerfeld)
Evening suit: Black wool,
black satin, brass
France, 1986

Karl Lagerfeld's reign at the
House of Chanel began in 1983.
He successfully rejuvenated
the brand by introducing fresh
takes on classic Chanel designs.
This sophisticated evening
suit features buttons depicting
tiny Chanel shoes.

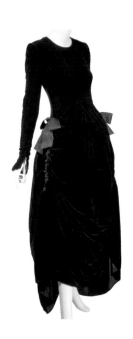

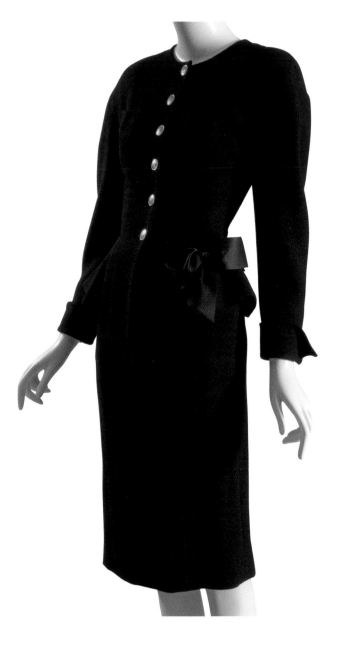

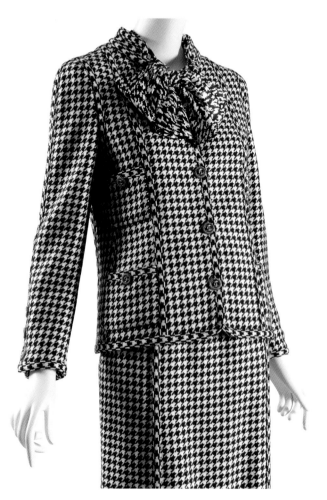

Chanel (Karl Lagerfeld)
Suit: Black-and-white
houndstooth wool, printed
silk crêpe, metal
France, 1983

BELOW AND OPPOSITE
Chanel (Karl Lagerfeld)
Evening dress: Black silk
crêpe, trompe-l'œil embroidery
by Lesage (Paris)
France, 1983

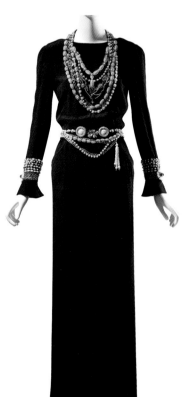

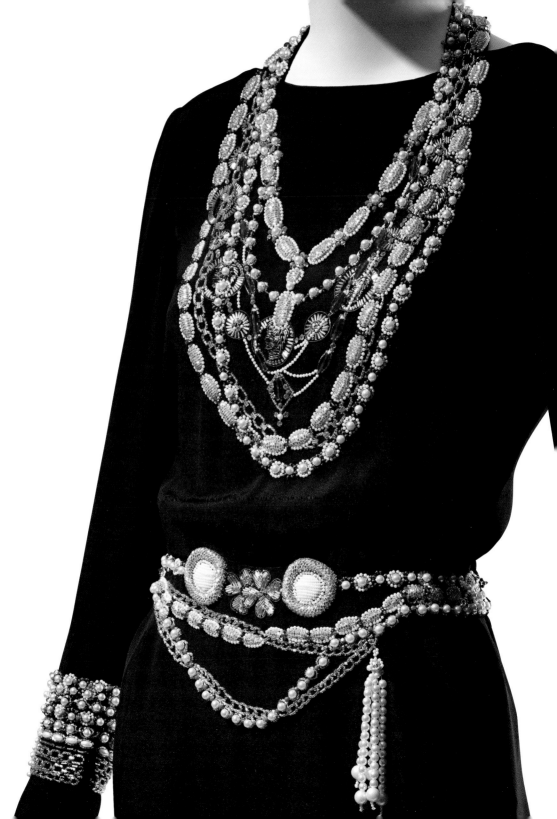

Ossie Clark

OSSIE CLARK (1942–1996) Ossie Clark's designs were characterized by whimsy and romanticism, as well as a heavy dose of sex appeal. Inspired by fashions of the past, he frequently cut his fabrics on the bias in order to emphasize womanly curves, which was unusual for many designers in the sixties. Although he is best known for his slinky, sensuous dresses, Clark also made impeccably tailored suits. "I'm a master cutter," he liked to declare, and his many important clients agreed.

Raymond Oswald Clark was born in Liverpool, England, and showed early ability for making clothes. In 1962 his innate talent for patternmaking and construction led to a postgraduate fashion course at London's prestigious Royal College of Art, where he was introduced to the work of great couturiers such as Madeleine Vionnet and Charles James.

In the mid-'60s, the designer began to sell his clothing at London's fashionable Quorum boutique. Clark worked in tandem with Celia Birtwell, a textile designer whom he had first met at school in Manchester. Birtwell's lively prints informed the cut of Clark's garments, and they formed a close professional and personal relationship. In 1969 they married.

Clark's designs for Quorum were tremendously successful, but he was not an astute businessman and was steeped in debt by the late 1960s. A deal with Radley Fashions temporarily relieved Clark of his financial woes, but he was increasingly beset with personal problems. In addition to his escalating drug use, Birtwell left him in 1975, and Quorum closed its doors that same year. Future attempts to return to the fashion industry were largely unsuccessful. In 1996 Clark was stabbed to death by former lover Diego Cogolato. Gone but not forgotten, Clark's valuable work is now cherished by museums and collectors alike. —*C. H.*

"Fashion isn't just clothes. It's what's happening
at the moment in everything." — OSSIE CLARK

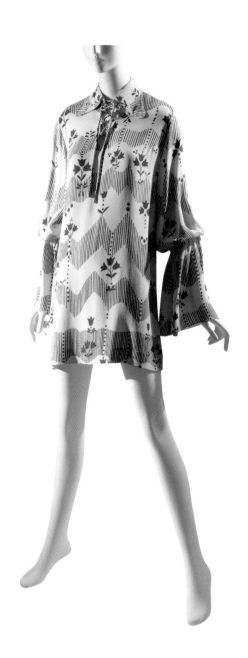

*"For him, fashion wasn't
a business. It was simply
a way to make his friends
the loveliest creatures on
the planet."*
— **Dana Thomas,** *The New
York Times*

PREVIOUS SPREAD AND LEFT
Ossie Clark
Tunic: Printed beige
rayon crêpe
England, 1965

OPPOSITE
Ossie Clark
Dress: White printed
silk chiffon
England, 1969

Ossie Clark worked closely
with textile designer Celia
Birtwell, who created the
motifs for these two dresses.
Birtwell's distinctive whim-
sical patterns complimented
Clarke's designs, resulting
in a true marriage of style.

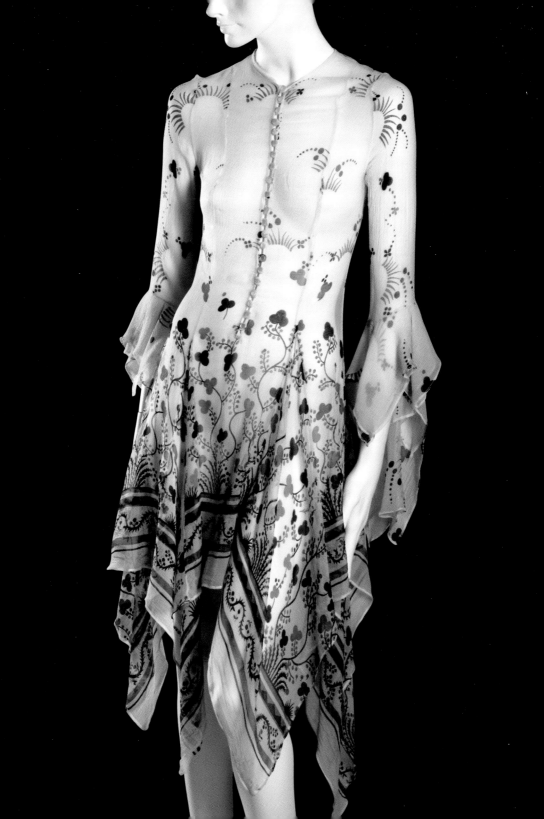

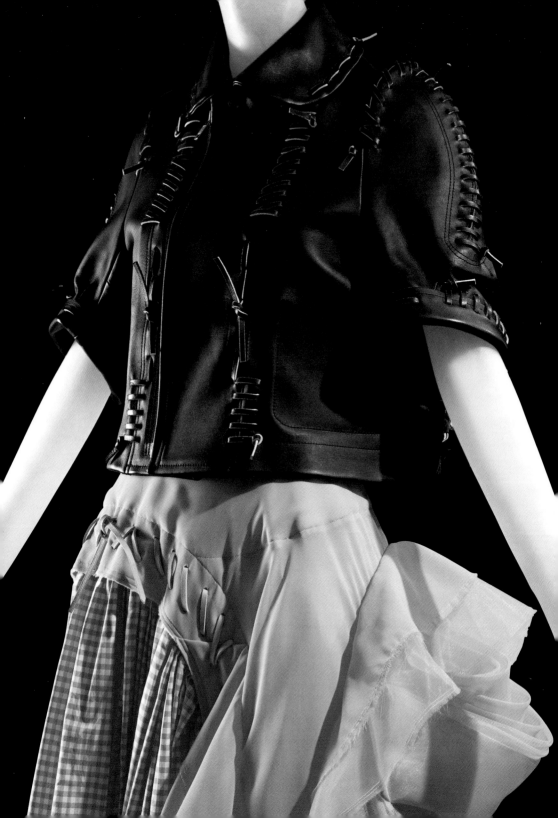

Comme
des Garçons

REI KAWAKUBO (B. 1942) Contemporary high fashion as exemplified by Rei Kawakubo had a seismic, course-altering impact on women's clothing in the late twentieth century. She is, along with Yohji Yamamoto, rightfully credited with instigating the profound aesthetic changes that have since permeated all levels of fashion, such as deconstruction, obfuscation of the body, and a predilection for the color black.

Kawakubo studied literature and philosophy at Keio University before becoming a fashion stylist in 1967. Two years later, she began designing her own clothes. She formed her limited company in 1973, calling it "Comme des Garçons," French for "like the boys." In the 1980s Kawakubo expanded her Comme des Garçons empire to include free standing boutiques, diffusion lines, and collaborative agreements with companies ranging from ballet shoemaker Repetto to swimwear giant Speedo. Most importantly, she hired a "universe" of young designers, "one superstar at a time." This universe included young talents like Junya Watanabe, Jun Takahashi (whose label is Undercover), and Tao Kurihara.

It should be noted that Kawakubo is a designer who had no formal fashion training. This fact is important because, like another great female couturier, Elsa Schiaparelli, her skills reside not in her fingertips but in her ability to engage in theoretical discourse. Despite her lack of technical training, Kawakubo is among the most respected fashion creators in the world. —*P. M.*

*"The woman who wears Comme des Garçons...
is well off but not proud of it, unwilling to dress
herself up so that other people have something
pleasing to look at, and over-burdened by the news
she reads everyday in the paper."*

—HOLLY BRUBACH, *THE ATLANTIC MONTHLY*

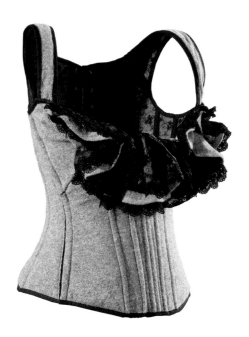

**Junya Watanabe (b. 1961)
and Tao Kurihara (b. 1973)**

*"Rei Kawakubo...confronts the
logic of fashion head on, by
constantly renewing the 'now':
in other words, by accelerating
the change of fashion, or by
producing 'now' before 'now'
is usurped. She moves faster
than Fashion, manufacturing
her 'now' before 'now' ceases
to be."* — **Kiyokazu Washida,
philosopher**

PREVIOUS SPREAD
**Comme des Garçons
(Rei Kawakubo)**
Jacket and skirt: Black leather;
pink, white cotton, nylon tulle,
polyester chiffon
Japan, 2005

ABOVE
**Comme des Garçons
(Tao Kurihara)**
Corset: Gray and black wool,
black lace
Japan, 2005

OPPOSITE
**Comme des Garçons
(Junya Watanabe)**
Dress: Distressed denim
Japan, 2002

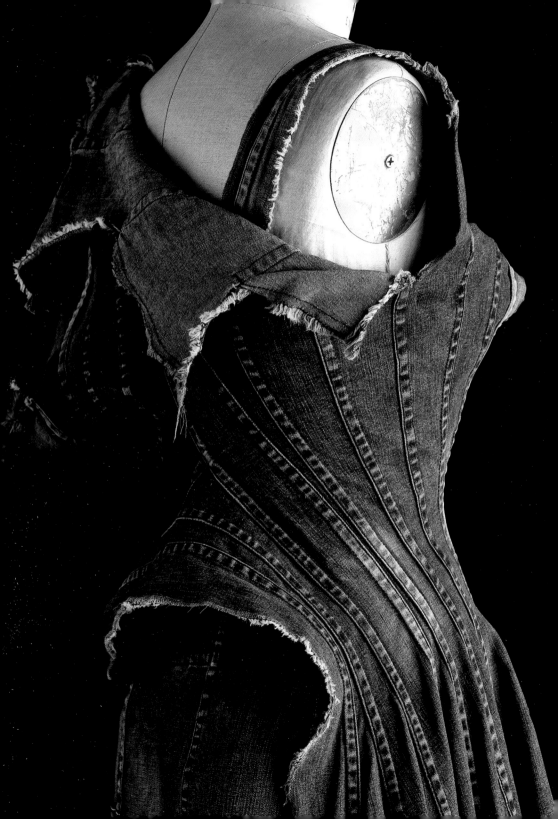

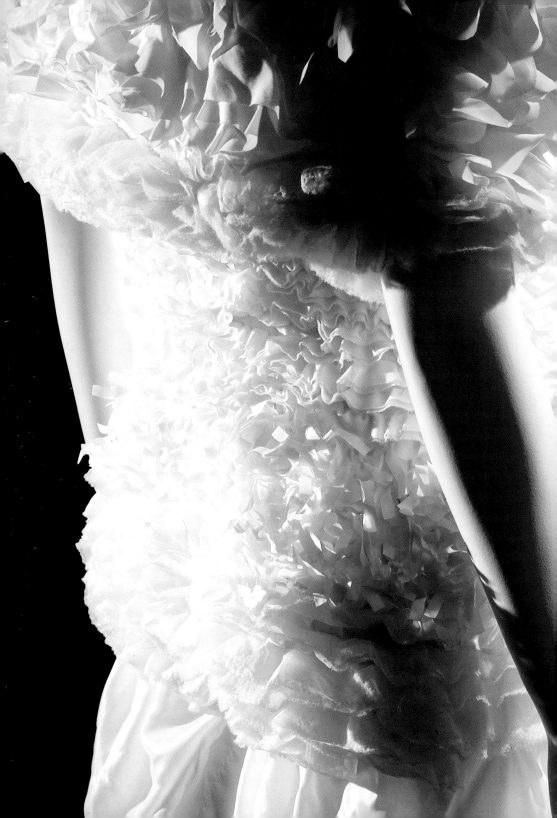

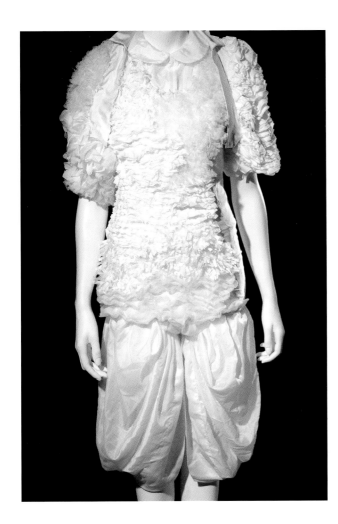

BELOW
**Comme des Garçons
(Tao Kurihara)**
Coat: White embroidered cotton
Japan, 2006

This delicate trench coat is
made from numerous vintage
cotton lace handkerchiefs.

OPPOSITE AND ABOVE
**Comme des Garçons
(Rei Kawakubo)**
Dress and bolero:
White polyester,
polyurethane tulle
Japan, 1999

Rei Kawakubo, of Comme des
Garçons, is known for exploring
new shapes and materials.

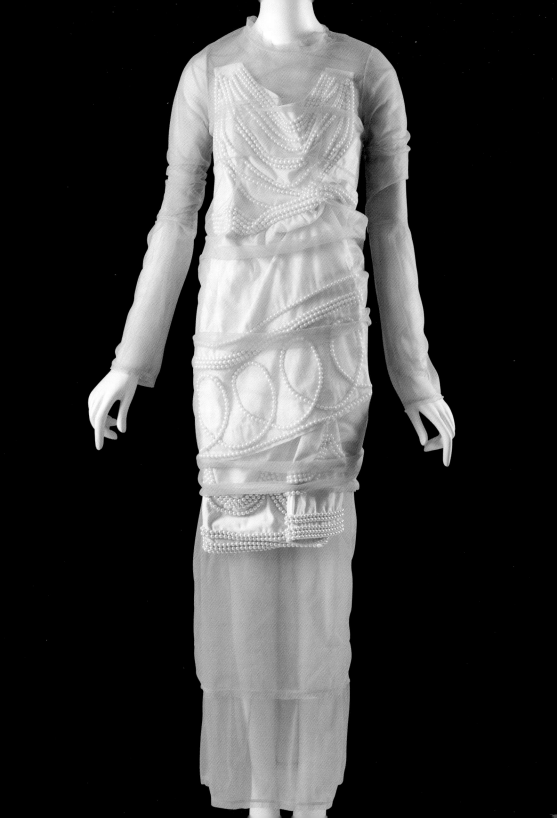

OPPOSITE AND ABOVE
**Comme des Garçons
(Rei Kawakubo)**
Dress: Natural muslin,
nude sheer nylon, faux pearls
Japan, 2009

RIGHT
**Comme des Garçons
(Junya Watanabe)**
Dress: Printed white nylon,
faux pearls
Japan, 2001

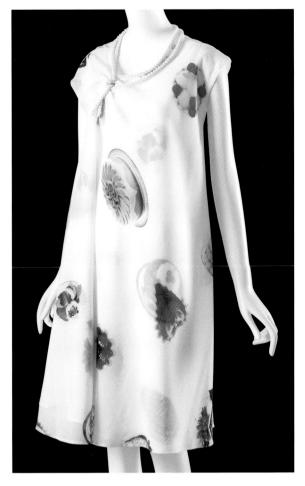

RIGHT
**Comme des Garçons
(Junya Watanabe)**
Dress: Black cotton denim,
metal zippers
Japan, 2005

BELOW
**Comme des Garçons
(Junya Watanabe)**
Jacket: Army-green canvas,
metal, plastic
Japan, 2006

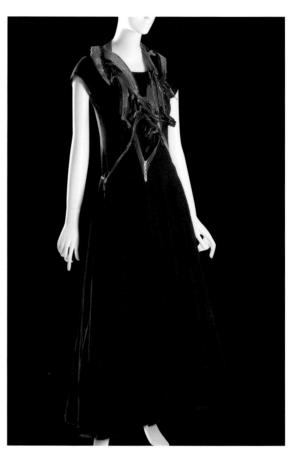

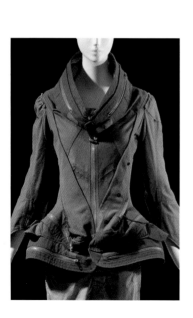

OPPOSITE
**Comme des Garçons
(Junya Watanabe)**
Ensemble: African-inspired
cotton print, denim
Japan, 2009

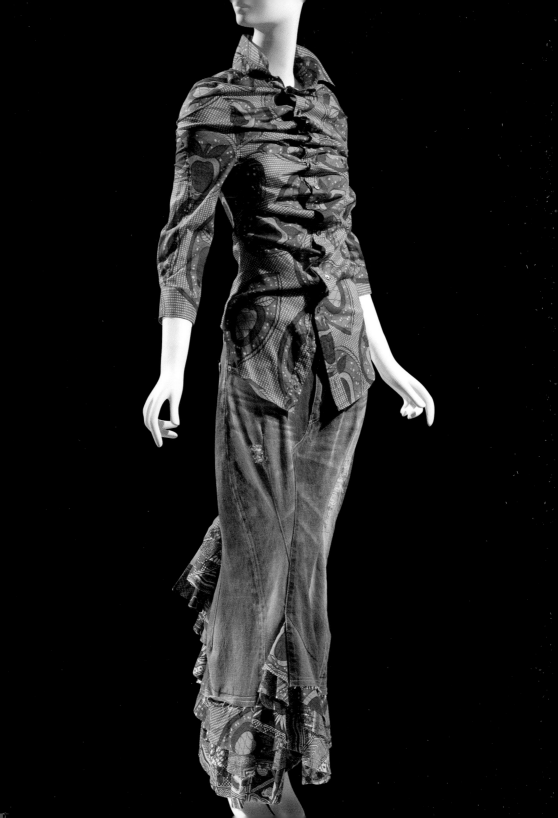

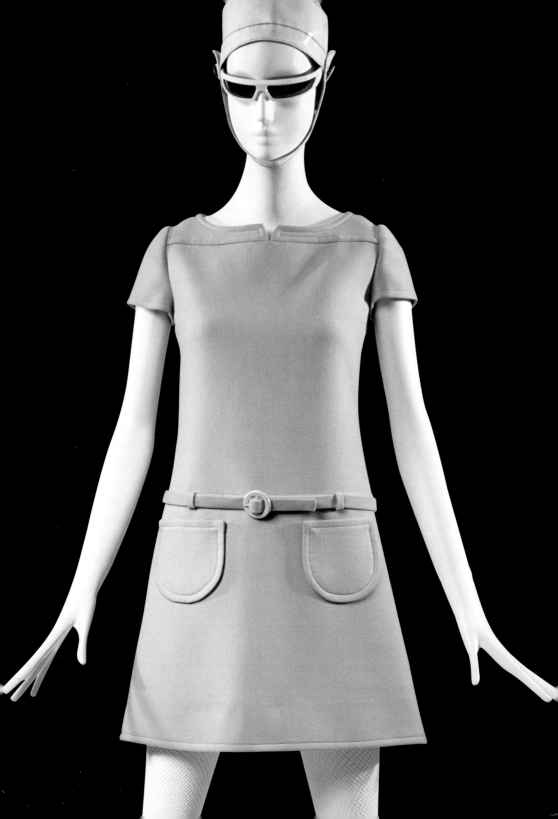

Courrèges

ANDRÉ COURRÈGES (1923–2016) made clothing in the haute-couture tradition, but his best-known work was far from conventional. Characterized by its immaculate craftsmanship and clean geometric forms, Courrèges's style was youthful, sexy, and even scandalous. Along with Mary Quant, Courrèges is credited as an originator of the miniskirt. His work has become synonymous with the futuristic fashions of the 1960s.

Born in the Basque region of France, Courrèges briefly studied civil engineering before deciding on a career in fashion. In 1960 he began working for the great couturier Cristóbal Balenciaga, whose ability he deeply admired. Over the next eleven years, Courrèges mastered the precise and innovative construction techniques integral to Balenciaga's work. With the blessing of his mentor, Courrèges left Balenciaga in 1961 to open his own house.

The designer presented his debut collection that same year. Although the clothes were beautifully made, Courrèges had not yet established his own look. This didn't happen until 1964, when Courrèges showed his revolutionary *Space Age* collection. The streamlined babydoll dresses epitomized youthfulness, but his most shocking designs were slim, sexy trousers for both day and evening. Futuristic white accessories—including his iconic kidskin boots—enhanced the overall effect.

Consumers and the fashion press were excited by his ideas. "He takes you over and makes you his woman, not the woman you already are," enthused *Women's Wear Daily*. By 1965 Courrèges's influence was indisputable. However, in the decades that followed, the designer had difficulty further developing his style, and he eventually closed his couture business in 1986. Nevertheless, Courrèges still had considerable influence. Countless contemporary designers, including Marc Jacobs and Miuccia Prada, have turned to his work for inspiration. Recently, Nicolas di Felice was named artistic director at Courrèges. —*C. H.*

"At first, people were shocked by the airplane ... women don't wear pants to the office yet, but they will."
— ANDRÉ COURRÈGES

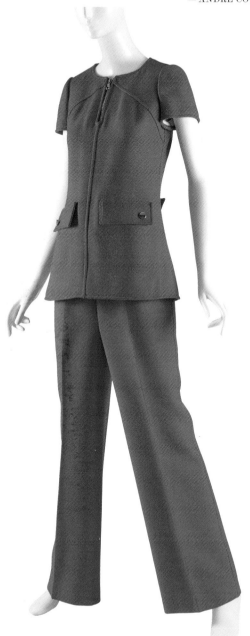

"I found it difficult to break away from traditional elegance and Courrèges changed that."
— **Yves Saint Laurent**

PREVIOUS SPREAD
André Courrèges
Dress: Beige wool
France, ca. 1968

LEFT
André Courrèges
Pantsuit: Orange acrylic
and wool
France, ca. 1968

OPPOSITE
André Courrèges
Suit: Charcoal-and-off-white
houndstooth wool, black suede
France, 1961

This suit dates from
Courrèges's first collection.
Balenciaga's influence is
evident in its sculptural
quality, created by expert
tailoring that allows the
jacket to stand away from
the body.

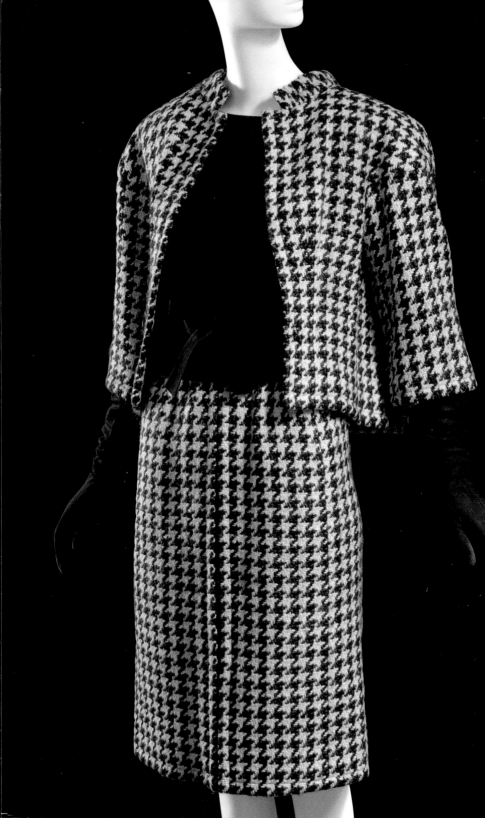

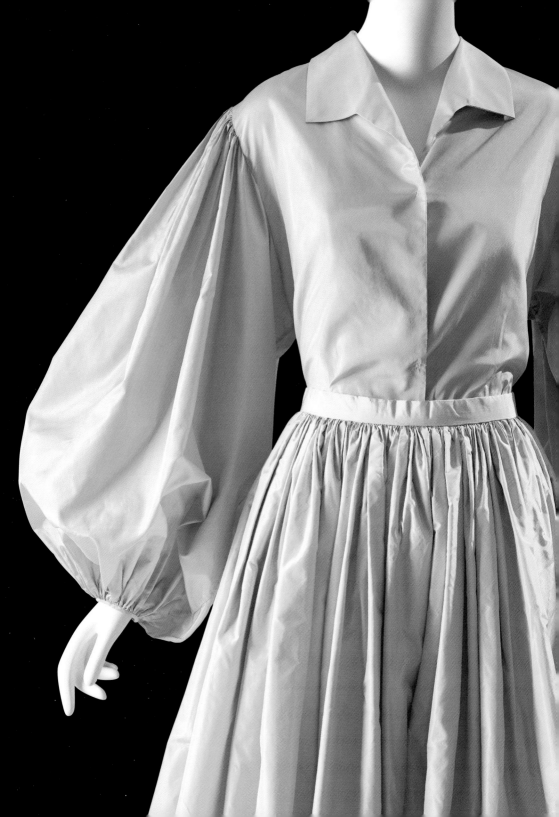

Oscar de la Renta

OSCAR DE LA RENTA (1932–2014) was just twenty-three years old when one of his designs was featured on the July 1956 cover of *Life* magazine. The gown was worn by Beatrice Lodge, the daughter of a U.S. ambassador to Spain, who was making her society debut. Its appearance served as an appropriate start for de la Renta's career: he later became a leading creator of lavish, elegant clothing for some of the most elite women in the world.

De la Renta was born in the Dominican Republic, and moved to Spain at eighteen. He studied painting and drawing, and his fashion illustrations led to an apprenticeship with Cristóbal Balenciaga. De la Renta later moved on to become an assistant designer at Lanvin-Castillo in Paris. In 1963 the young designer's ambitions led him to New York. There he designed custom-made clothing at Elizabeth Arden before joining Jane Derby Manufacturing, where he launched his signature ready-to-wear label. After Derby's death, de la Renta assumed control of the company. Although his ready-to-wear designs were highly successful, de la Renta maintained his couture sensibility. From 1993 to 2002, he acted as head designer for both couture and ready-to-wear at Pierre Balmain, making him the first designer from the Americas to take over a Parisian couture house.

In all of his endeavors, de la Renta designed clothing that was characterized by femininity and romanticism, and he often juxtaposed streamlined silhouettes with opulent fabrics, bright colors, vibrant prints, and embellishments. From 2014 to 2016 Peter Copping, who was handpicked by de la Renta himself, served as creative director of the company. Presently, Laura Kim and Fernando Garcia—the design duo behind label Monse—are co-creative directors. —*C. H.*

"What's wonderful and exceptional about Oscar is that he miraculously embodies and inhabits the fantastic world suggested by his creations."
— ANNA WINTOUR, EDITOR, *VOGUE*

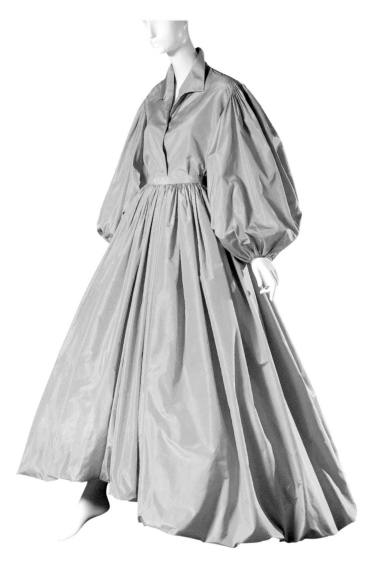

"There are two classes of designers—those who make such a strong impact on a certain period that it's difficult to get out of it, and the survivors. I like to think I'm a survivor."
— **Oscar de la Renta**

PREVIOUS SPREAD AND LEFT
Oscar de la Renta
Evening dress: Green-and-gold
silk tissue taffeta
USA, ca. 1978

Oscar de la Renta's clothes have been worn by some of the world's best-dressed women. His use of bright tropical colors, as in this evening dress, is characteristic of his work.

OPPOSITE
Oscar de la Renta
Cocktail dress: Green silk satin, black velvet, patent leather, rhinestones
USA, ca. 1984

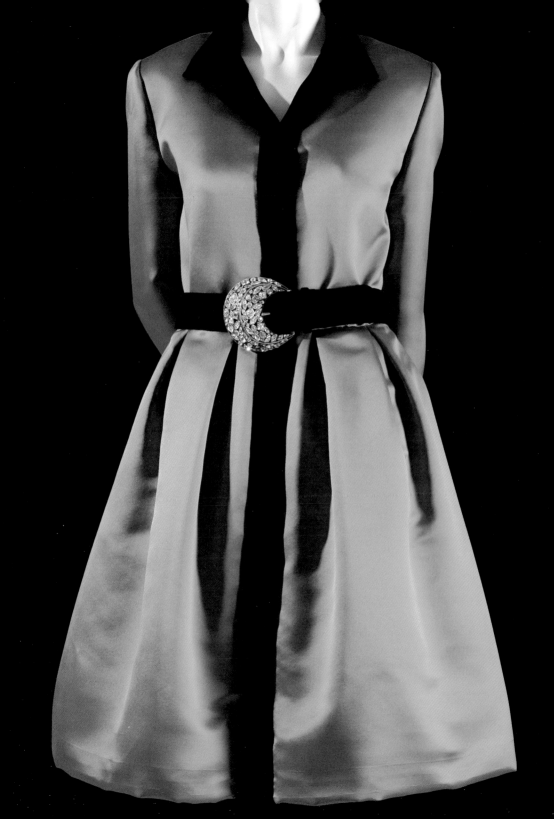

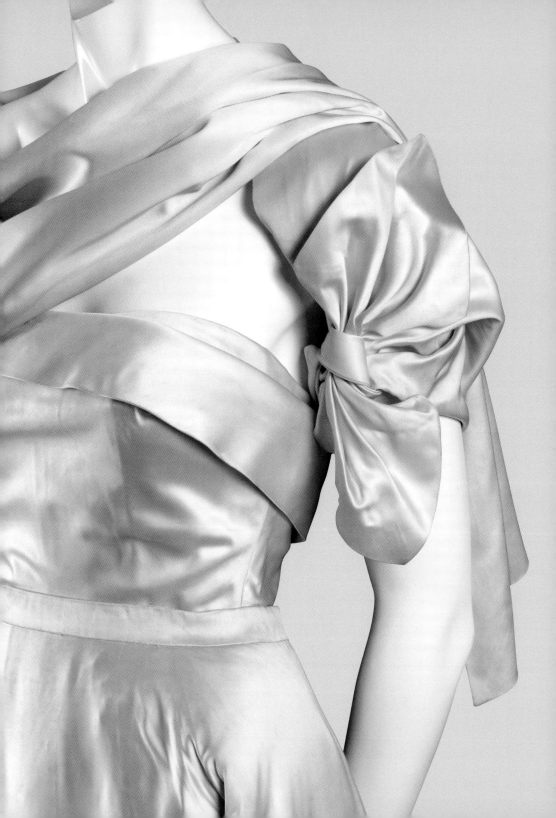

Christian Dior

CHRISTIAN DIOR (1905–1957) Late in 1946, at the age of forty-one, the shy designer Christian Dior resigned from his position at the fashion house of Lucien Lelong and opened his own couture house. Within less than three months, he had designed and produced his much-anticipated first collection, which was shown on February 12, 1947. Afterward, Carmel Snow, editor in chief of *Harper's Bazaar*, rushed to congratulate Dior on his sensational success. "It's quite a revolution, dear Christian," she said. "Your dresses have such a new look." The expression caught on, and Dior's Corolle collection would go down in fashion history as the "New Look."

Looking back, Dior recalled, "We came from an epoch of war and uniforms, with women like soldiers with boxers' shoulders. I designed flower women, soft shoulders, full busts, waists as narrow as lianas and skirts as corollas." Fashion is always about change and novelty, but Dior's 1947 collection marked an especially dramatic and influential transition, away from the boxy jackets and short narrow skirts of the war years, and toward a look of hyperfemininity based on an hourglass figure and long, full skirts.

For the next decade, Dior would dominate Paris fashion the entire world of women's fashion. Almost every season Dior would launch a new silhouette such as the Oblique, the Scissors, the Tulip line, the Y-line, the H-line, and the A-line. In addition to his extraordinary evening dresses, he made his mark with cocktail dresses. Although his style was usually extremely feminine, he also spearheaded the use of traditional menswear materials such as houndstooth. While Balenciaga was revered by connoisseurs as "fashion's Picasso," Dior was the most famous designer in the world. In 1949 75 percent of Parisian fashion exports were by Dior. In one of her letters, Nancy Mitford recalled a Frenchman saying, "I've been a member of the Jockey Club for forty years, and I've never heard anyone mention the name of a couturier—and now, all of a sudden, everybody is talking about nothing but Dior."

After Christian Dior's sudden death in 1957, his twenty-one-year-old assistant Yves Saint Laurent took over at the House of Dior. Saint Laurent's first collection was a great success, and he was hailed as the savior of French fashion. But later collections were received poorly, and Saint Laurent was dismissed abruptly in 1960 after his controversial

Beatnik collection. He was replaced by Marc Bohan, previously in charge of Dior's London branch, who remained at the helm for more than twenty years. The Italian designer Gianfranco Ferré had a brief tenure at Dior, followed by John Galliano from 1996 to 2011. Belgian designer Raf Simons was named Galliano's successor in 2012, and in 2016 Maria Grazia Churi was appointed as the first woman artistic director at Dior. —*V. S.*

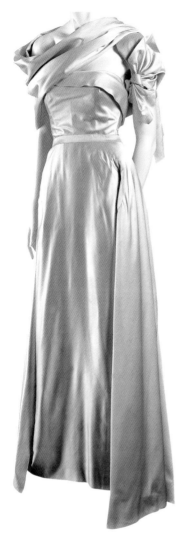

*"Dior is that nimble genius unique to our age with the magical name— combining God and gold [*dieu *and* or*]."*
— JEAN COCTEAU, WRITER

PREVIOUS SPREAD AND LEFT
Christian Dior
Evening ensemble:
Ivory silk satin
France, 1948

OPPOSITE
Christian Dior
Evening dress:
Aubergine silk faille
France, ca. 1953

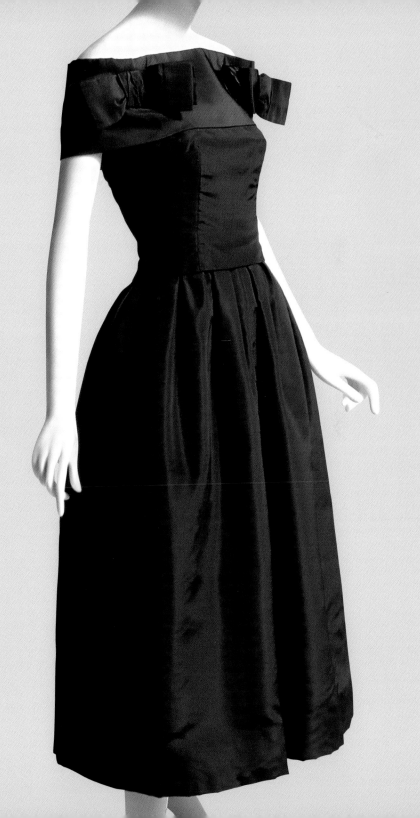

"Fashion is an act of faith. And in an age where no success is sacred, where fabrications and false confidences are the stuff of life, fashion has retained its mystery . . . and never has it been talked about so much—the best possible proof of its power to enchant." —CHRISTIAN DIOR

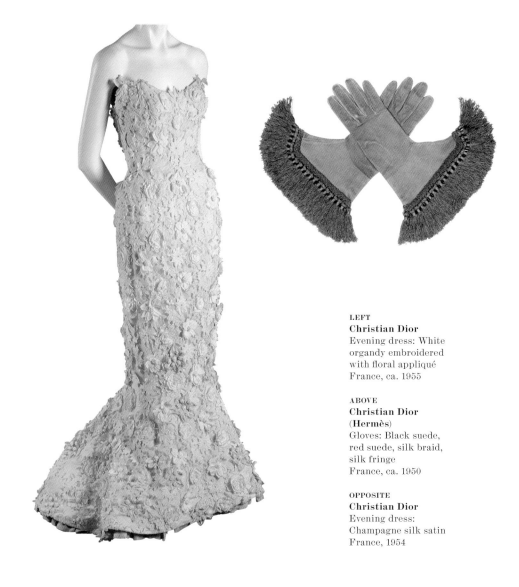

LEFT
Christian Dior
Evening dress: White organdy embroidered with floral appliqué
France, ca. 1955

ABOVE
Christian Dior
(**Hermès**)
Gloves: Black suede, red suede, silk braid, silk fringe
France, ca. 1950

OPPOSITE
Christian Dior
Evening dress: Champagne silk satin
France, 1954

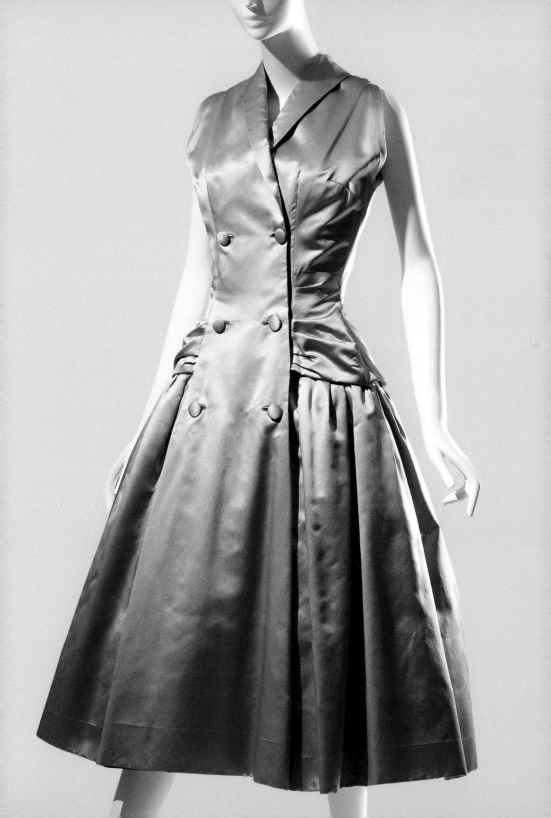

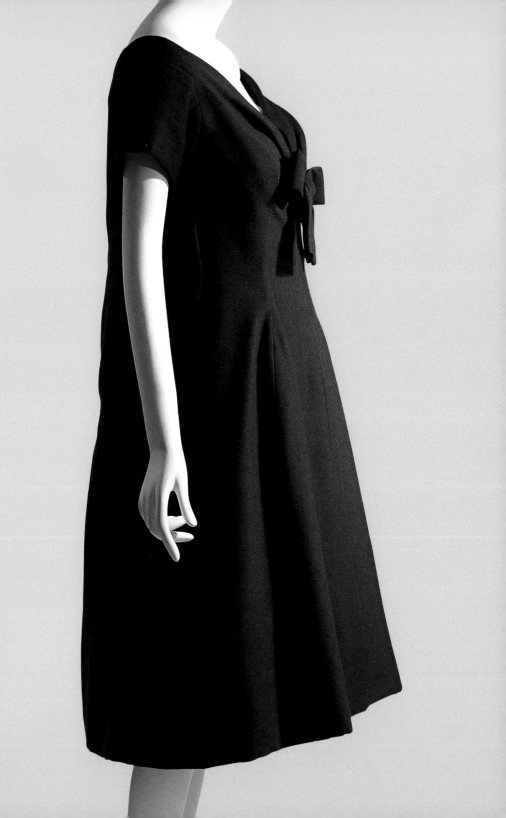

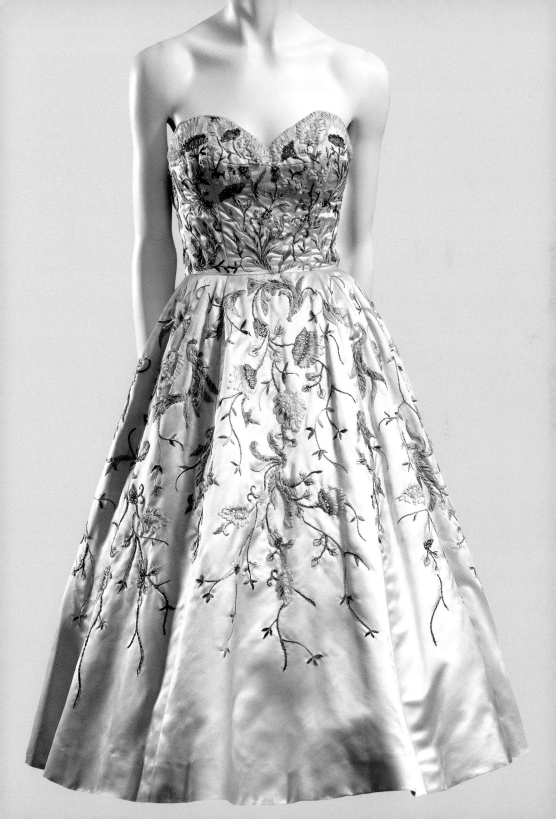

PREVIOUS SPREAD, LEFT
**Christian Dior
(Yves Saint Laurent)**
"Trapeze" dress: Black wool
France, 1958

In 1957, at the age of twenty-one,
Yves Saint Laurent became head
designer at the house of Dior.
For his first collection he experi-
mented with a less fitted look,
and the result was the Trapeze
line, which was a triumph.

PREVIOUS SPREAD, RIGHT
Christian Dior
Evening dress: Cream silk
satin, silk ribbon, and floss
embroidery
France, 1951

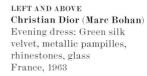

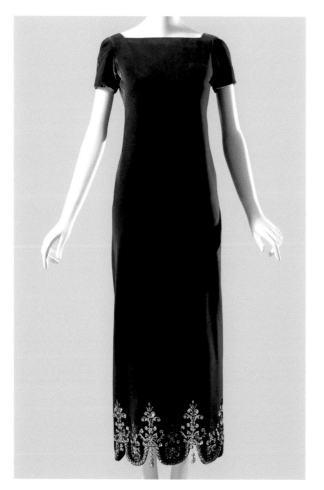

LEFT AND ABOVE
Christian Dior (Marc Bohan)
Evening dress: Green silk
velvet, metallic pampilles,
rhinestones, glass
France, 1963

OPPOSITE AND
FOLLOWING SPREAD
Christian Dior (Marc Bohan)
Evening dress: Printed pink
silk chiffon, metal, faux pearls
France, 1969

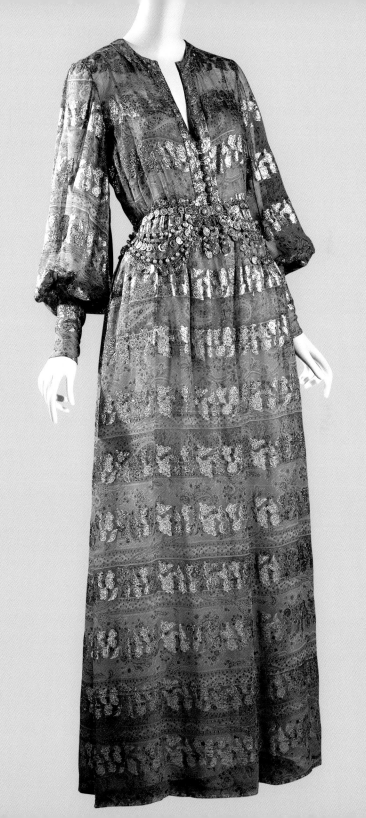

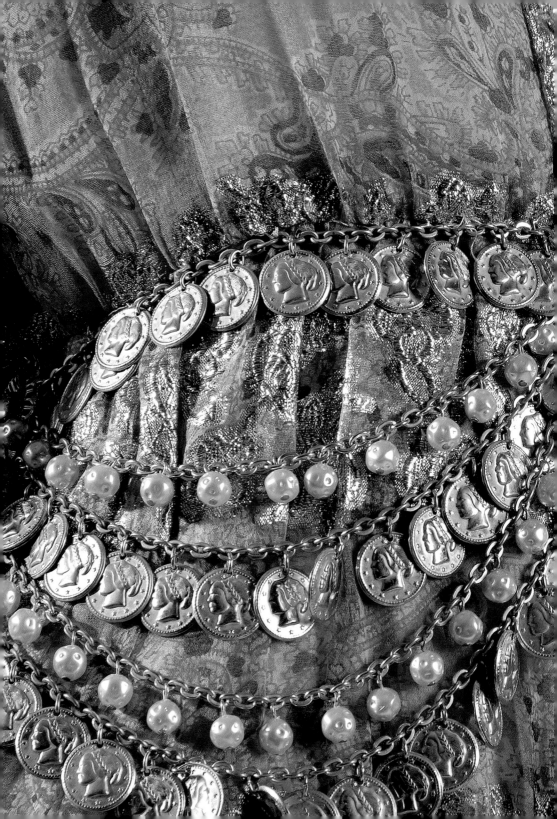

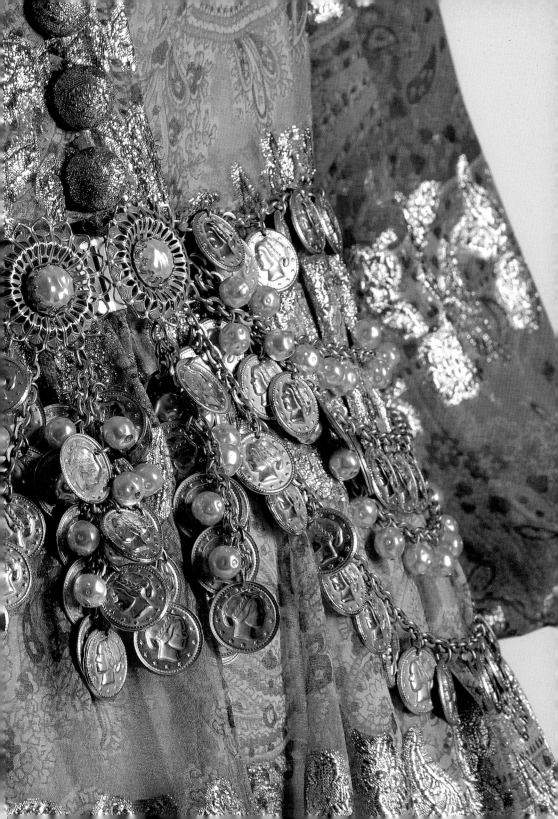

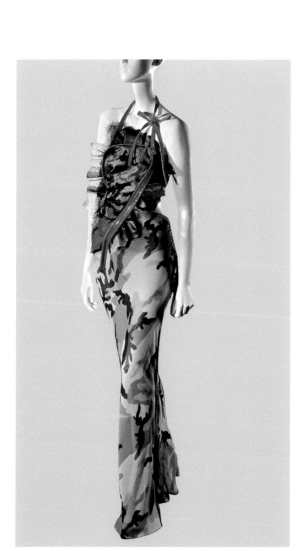

Christian Dior (John Galliano)
Dress: Camouflage-printed
silk taffeta, crêpe de chine,
net, plastic
France, 2001

**Christian Dior
(Stephen Jones)**
Top hat: Red silk satin,
Chantilly lace, metal
France, 2000

Christian Dior (John Galliano)
Dress: Black lambskin, silk
France, 2000

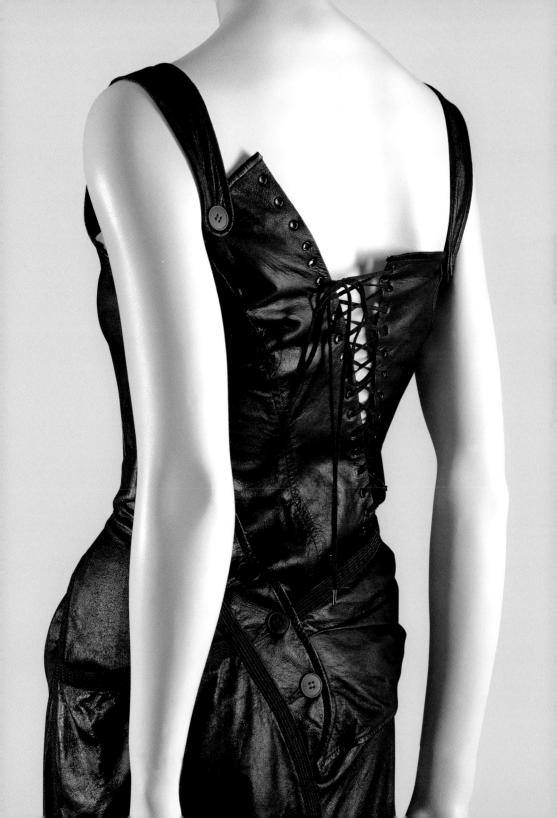

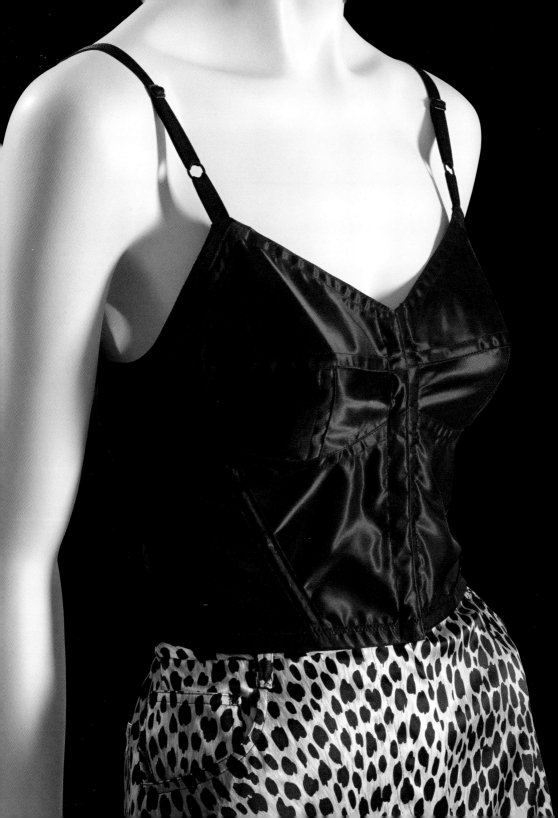

Dolce & Gabbana

STEFANO GABBANA (B. 1962) AND DOMENICO DOLCE (B. 1958) Since arriving on the fashion scene in the mid-1980s, Domenico Dolce and Stefano Gabbana have created clothing that is unapologetically sexy. Their designs are characterized by lingerie styling, vibrant animal prints, and lavish brocades. Despite their provocative overtones, however, Dolce and Gabbana's garments are also designed with regard for tailoring and Italian tradition.

Sicilian-born Domenico Dolce, the son of a tailor, made his first pair of trousers when he was just seven years old. Stefano Gabbana hails from Milan, where his father worked as a printer. Dolce briefly attended fashion school, while Gabbana studied graphic design, but after working in that field for only six months, Gabbana began to seek jobs in fashion. It was then that he met Dolce, who was employed as an assistant at a design house.

The pair soon became involved romantically as well as professionally, and presented their first collection, *Geometrissimo*, in 1985. While many Italian designers focused on power dressing, Dolce & Gabbana's style was intrinsically more feminine and romantic. Each garment was cut and sewn by the designers themselves because at the time they could not afford assistants. In a similar vein, they titled their next collection *Real Women*, and asked friends and relatives to walk the runway in their designs.

From such humble beginnings, Dolce & Gabbana quickly gained recognition as one of the most exciting labels in Milan. During the 1990s, the designers' slinky slip dresses, sultry corset tops, and figure-hugging suits were often commended for their provocative yet empowering aesthetic. In addition to ad campaigns by illustrious photographers such as Steven Meisel, Madonna's regular commission of Dolce & Gabbana designs dramatically increased the label's appeal.

Although Dolce and Gabbana ended their romantic relationship in 2005, the designers have retained their strong professional association. Now in business for over forty years, they oversee fourteen collections, including menswear, children's wear, accessories, and, of course, underwear. —*C. H.*

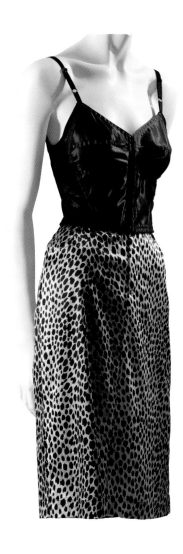

*"It's always the same, all men
and women want to be sexy."*
— STEFANO GABBANA

*"Dolce & Gabbana epitomize
and reinvent the sexy Italian
woman...Domenico and
Stefano's clothes allow you to
change personalities just by
opening your closet!"*
— **Linda Evangelista, model**

PREVIOUS SPREAD AND ABOVE
Dolce & Gabbana
Bustier: Black satin
and stretch lace
Skirt: Leopard-print
stretch satin
Italy, ca. 1992

Dolce and Gabbana are well
known for their sexy corset tops
and use of vivid animal prints,
paired together in this ensemble.

OPPOSITE
Dolce & Gabbana
Dress: Multicolor printed
stretch silk
Italy, 1999

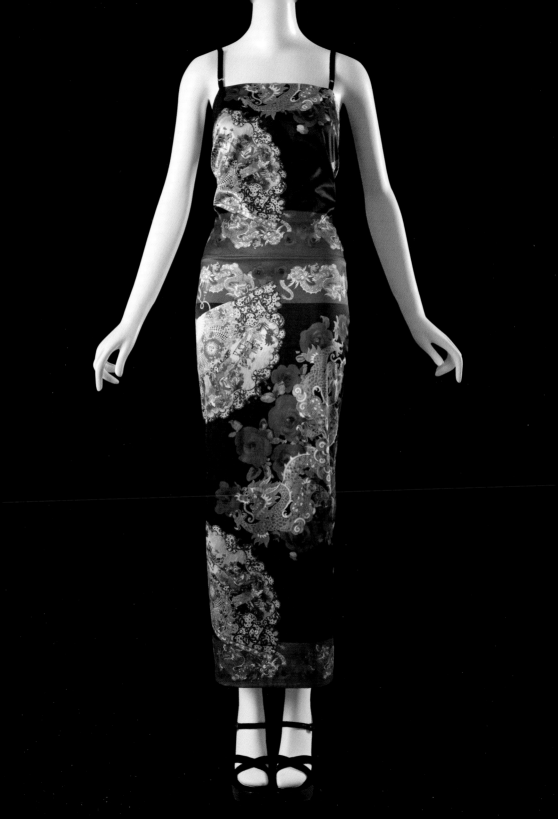

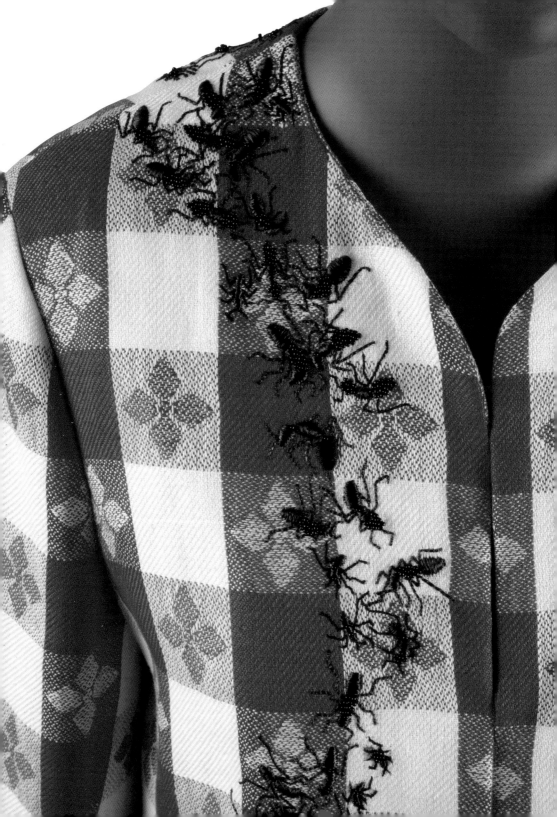

Perry Ellis

PERRY ELLIS (1940–1986) Perry Ellis's fall 1978 collection established him as a new force on the New York fashion scene. The captain of the Princeton University football team charged down the runway, followed by cheerleaders and models. The clothes were classic American sportswear styles in proportions and fabrics unlike anything the New York fashion world had ever seen. A high-waisted front-flap sailor pant was paired with a fitted double-breasted, cropped jacket with long full sleeves, and woolen skirts cut in full circles to the ankle were teamed with oversized, bulky knit sweaters. The result was sophisticated, youthful, and casual. From that first collection until his death in 1986, Ellis received eight Coty Awards and built a business that generated 260 million dollars in sales.

Born in Portsmouth, Virginia, Perry Ellis was an only child who grew up in a comfortable upper-middle-class home. He earned his undergraduate degree from the College of William and Mary and a master's degree in retail merchandising from New York University. After college Ellis went to work as a sportswear buyer for the Richmond-based department store Miller & Rhoads. He returned to New York to design for John Meyer of Norwich and later for print and scarf designer Vera.

Like his runway shows, Perry Ellis's designs were full of wit and irreverence but were never garish. His design aesthetic was always rooted in American sportswear, incorporating preppy, collegiate styles. However, it was Ellis's love for fabrics that created and drove his design vocabulary. He preferred thick wool tweeds, heavy raw silks, fine linen, and cashmere from the best mills in Italy and England, as well as thick, nubby wool yarns from Donegal, Ireland. Ellis died on May 30, 1986, at the age of forty-six, one of the first victims of the AIDS crisis. —*F. D.*

"I was determined to change the course of fashion, to move away from what I call the pretentiousness of clothes— to design clothes that are more obtainable, more relaxed, but ultimately more stylish and witty."
— PERRY ELLIS

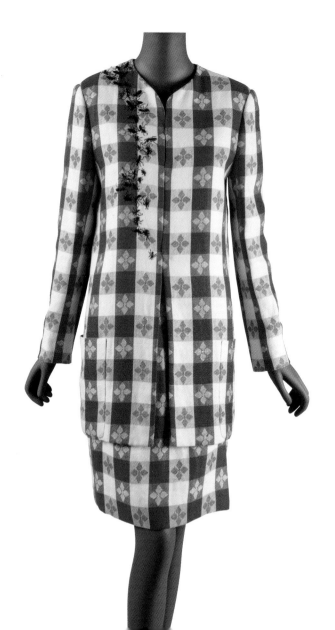

PREVIOUS SPREAD AND LEFT
Perry Ellis (Marc Jacobs)
Suit: Embroidered red
and white linen
USA, 1990

OPPOSITE
Perry Ellis
Suit: Green wide wale
cotton corduroy
USA, 1981

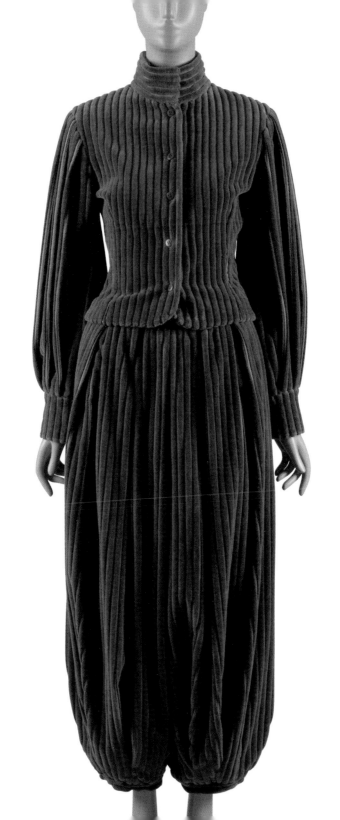

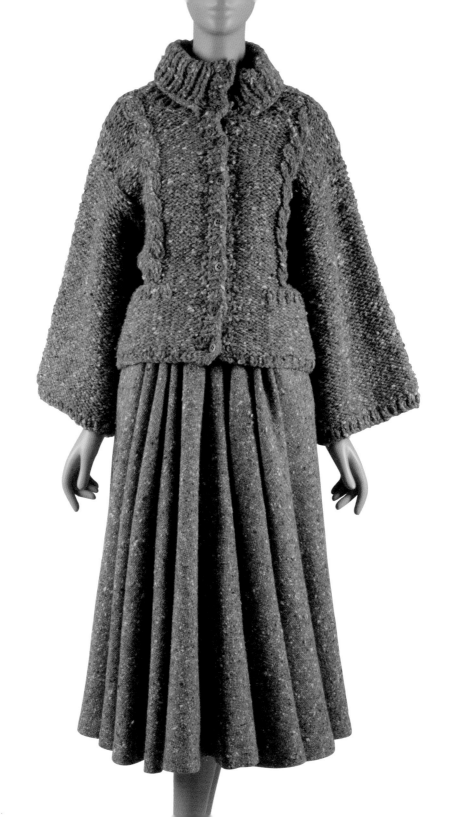

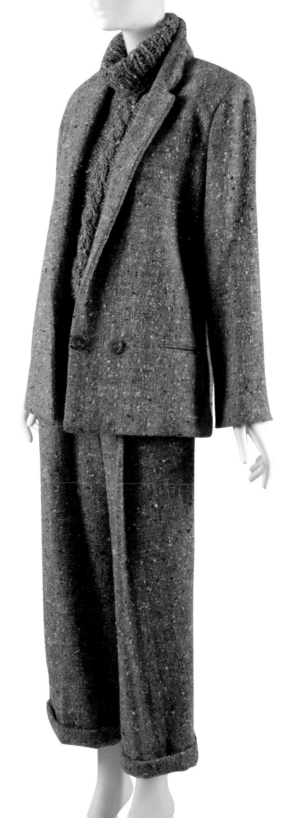

OPPOSITE
Perry Ellis
Skirt and sweater:
Brown tweed and wool
USA, 1981

RIGHT
Perry Ellis
Suit and sweater: Brown
tweed and hand-knit wool
USA, 1981

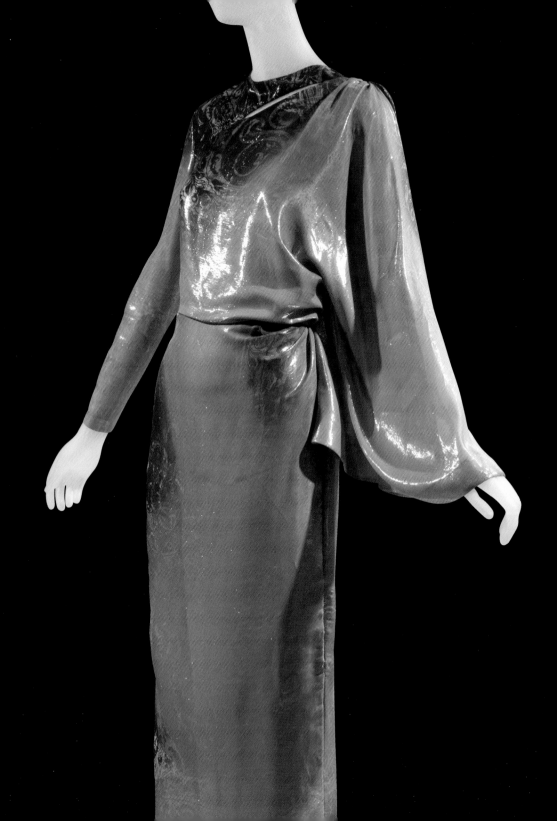

Etro

VERONICA ETRO (B. 1974) Etro is a relatively young label, yet it is rooted in tradition and belongs in Italy's rich history of fine, beautifully crafted textiles. It originated as a fabric design and manufacturing firm, and is perhaps most often recognized for its paisley motifs, which it introduced in 1981. Etro's paisleys are so characteristic of the brand that J. J. Martin, writing in *Harper's Bazaar*, has observed that Etro managed to turn "a paisley print into a discreet, logo-less signifier."

Founded in 1968 by Gerolamo ("Gimmo") Etro (b. 1940), the company has been hailed for its stunning prints and masterful patterning. During the 1970s and 1980s, high-end fashion designers such as Emmanuel Ungaro and Perry Ellis used Etro's luxury textiles in their collections. In a 1982 *New York Times* article, Gimmo revealed that he had mixed feelings about the use of his fabrics: "In fashion, if you work with the creators, the Armanis, the Rykiels, the Montanas, it is their image you give and you have to change with them. It is my product, but, when it is sold, it has their name on it." Perhaps it was concerns such as these that motivated Gimmo to have Etro create its own ready-to-wear line, which was first shown in 1991.

Like many Italian firms, Etro is family owned and operated. Veronica Etro, Gimmo's daughter, has been the label's womenswear designer since 2000. Veronica's approach began with her childhood pastime of making collages from fabric swatches, and she has developed a design style that is equal parts colorful, unconventional, and exotic. She works with a kaleidoscope of patterns, patchworks, and, of course, Etro's signature paisley, which she continually updates in playful and unexpected ways. As Veronica told *W* magazine in July 2004, "The best way to rehash a traditional print is through a good dose of irony." —*J. F.*

*"With Veronica Etro at the helm, the eclectic
and offbeat have become as synonymous with Etro
as the house's signature paisley prints."*
—WOMEN'S WEAR DAILY

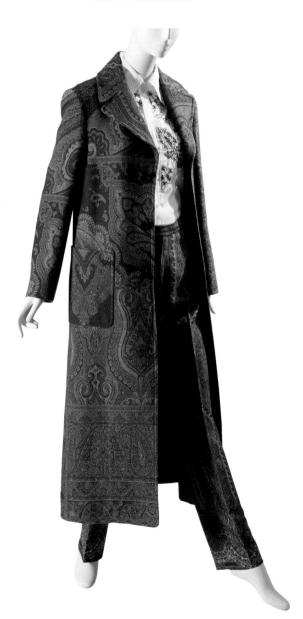

PREVIOUS SPREAD
Etro (Veronica Etro)
Evening dress: Orange, gold,
and black nylon Lurex
Italy, 2011

This golden evening dress
closed Etro's fall 2011 show.
The fluidity of the nylon
Lurex fabric flows sensu-
ously around the body
and adds depth to Etro's
swirling abstract print.

LEFT
Etro (Veronica Etro)
Ensemble: Multicolor paisley
wool challis, white cotton, poly-
chrome embroidery, beading
Italy, 2002

OPPOSITE
Etro (Veronica Etro)
Dress and belt: Cream paisley
wool challis, leather, suede
Italy, 2002

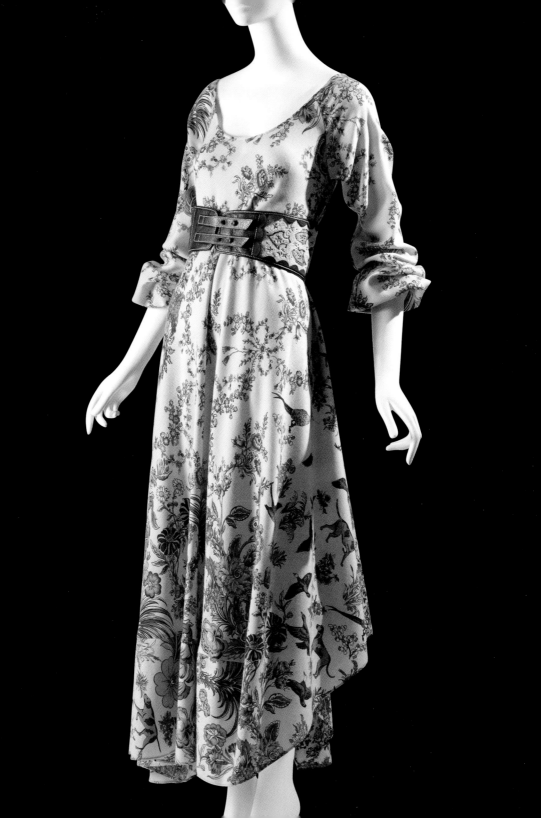

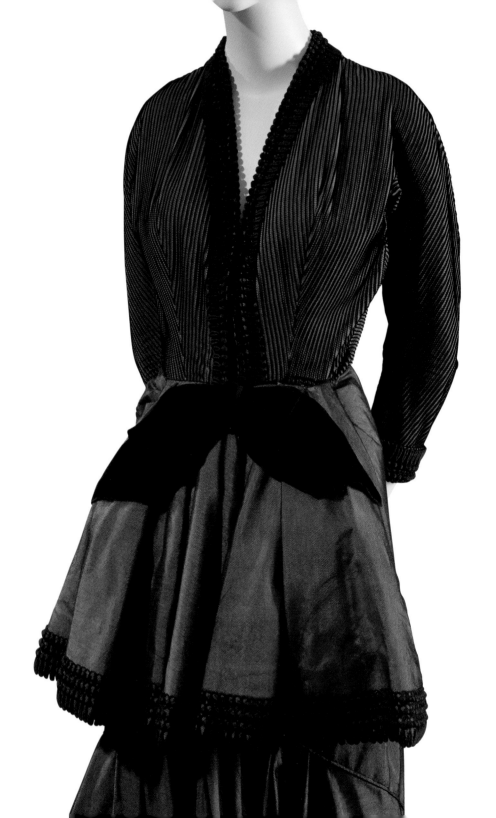

Jacques Fath

JACQUES FATH (1912–1954) was a fashion designer who celebrated femininity and specialized in glamour. *Vogue* editor Bettina Ballard said that the charismatic Fath had a gift for "making women look attractive and very sexy." His tailored daywear and romantic evening gowns highlighted a woman's sensuality, while strategic details such as unusual necklines or peplums emphasized her curvaceous body.

Fath debuted his couture collection in 1937. His career was interrupted briefly (from 1939 to 1940) for military service, but his couture house remained open through the occupation of Paris during the Second World War. He was one of the giants of postwar Paris fashion, and his clothing was very popular in the United States after the war. In 1948 he began a successful collaboration with American ready-to-wear manufacturer Joseph Halpert.

Fath had an acute sense for publicity, and he entertained lavishly, often hosting themed costume parties at his country estate. High-profile guests included such dramatic beauties as movie star Rita Hayworth, who was also a client. *Life* magazine described Fath's fashions as "wearable glamour." Like Fath himself, his designs had vitality and youthfulness. He "knew how to dress young women, and could even contrive to give an air of youth to the not-so-young, for he had something of a magician's qualities of *legerdemain* and conjuring," wrote Célia Bertin in *Paris à la Mode*.

In 1949 *Life* characterized Fath as "a sort of dauphin, or heir apparent, to Dior's throne as ruler of fashion." But Fath died of leukemia only five years later, at age forty-two. His wife, Geneviève, took control of his collections for a while, but the house closed in 1957. Attempts to revive the house have been largely unsuccessful, but Fath himself is remembered for the verve, beauty, and charm he brought to mid-century fashion. —*J. F.*

"His clothes have ideas and flair. He makes you look young . . . he makes you look like you have sex appeal—and believe me, that's important."
— CARMEL SNOW, EDITOR, *HARPER'S BAZAAR*

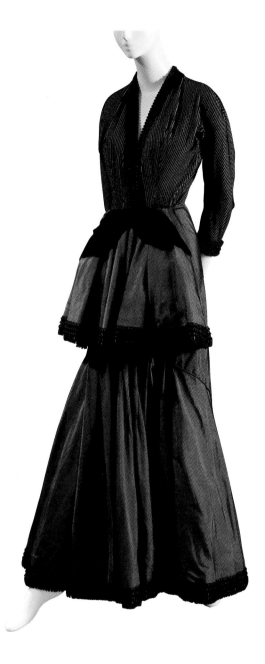

"Jacques Fath was a star. He was full of life, and he loved life. He loved everything that was 'glamour.'"
— **Bettina, model**

PREVIOUS SPREAD AND LEFT
Jacques Fath
Evening dress: Iridescent silk taffeta, black silk velvet, silk tulle, soutache
France, 1948

OPPOSITE
Jacques Fath
Evening dress: Aqua silk georgette, navy-and-mauve silk satin
France, 1953

FOLLOWING SPREAD, LEFT
Jacques Fath
Dress: Black wool twill
France, ca. 1947

FOLLOWING SPREAD, RIGHT
Jacques Fath
Bathing suit: Black wool, polychrome embroidery
France, ca. 1950

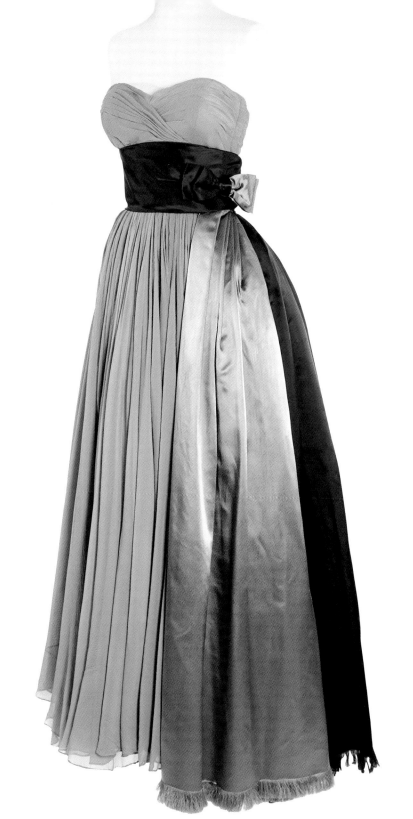

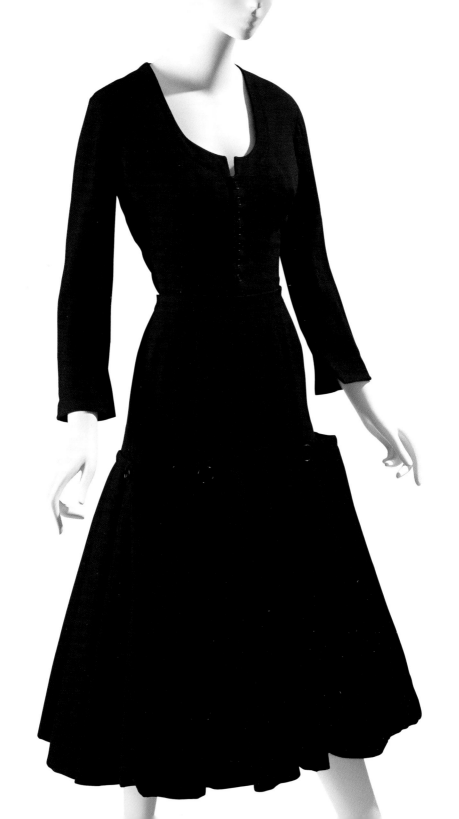

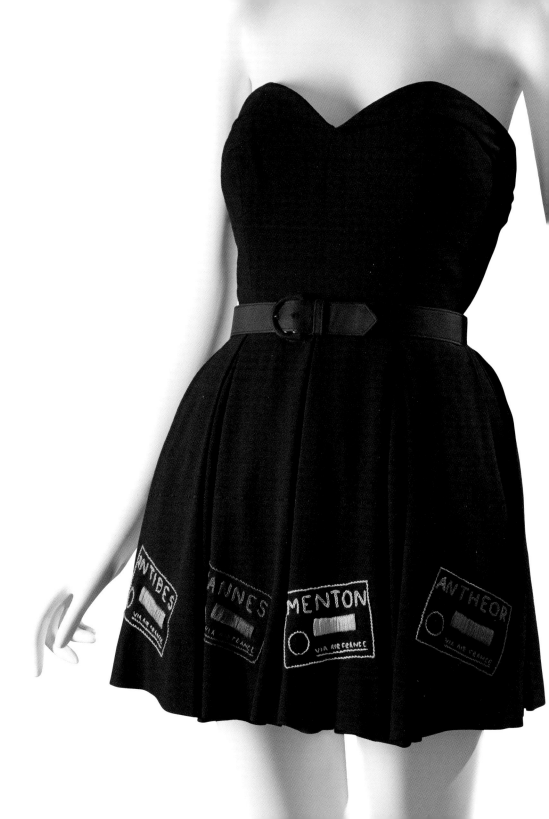

Fendi

CARLA (1937–2017), ALDA (B. 1940), PAOLA (B. 1931), FRANCA (B. 1935), AND ANNA FENDI (B. 1933) Fendi began in Rome as a small furrier and leather goods company, a family business founded in 1925 by Edoardo and Adele Fendi. Karl Lagerfeld has been the company's creative director from 1965 to 2019. He was responsible for Fendi's ready-to-wear and fur collections. From 1978 until 1999, Fendi was controlled by the couple's five daughters—Paola, Anna, Franca, Carla, and Alda—who saw Lagerfeld as part of the family. "He's the sixth Fendi child; our pasts and our future are intertwined," Carla Fendi told *Women's Wear Daily* in 1999.

Lagerfeld explained to *The New York Times* in March 1985 that he prefers to "handle furs as if they were fabric—hairy fabrics." He and the Fendi sisters stripped the fur coat of its weight, both literally, through the removal of heavy interior structures and linings, and figuratively, by eliminating its pretension. Some are dyed in bold, unnatural shades. Unconventional, non-luxe furs such as squirrel and weasel are used as often as mink or sable. A Fendi fur often seems youthful and trendy, as do the company's ready-to-wear garments.

Fendi's status in the luxury market has risen exponentially since the late 1990s, thanks to the success of its accessories line, which has been overseen by Silvia Venturini Fendi (a granddaughter of Fendi's founders) since 1994. She is the force behind the wildly popular—and whimsically named—"Baguette" handbag, which debuted in fall 1997.

Fendi is now owned by the corporate group LVMH, and as Venessa Lau noted in the March 2009 issue of *W* magazine, Silvia is "the last Fendi standing." Silvia, however, remains dedicated to Fendi's legacy of quality and creativity. After joining Fendi in 2020, Kim Jones showed his first couture collection for the house the following year. —*J. F.*

" 'Nothing is impossible'
is the Fendi motto. "
— SILVIA VENTURINI FENDI

PREVIOUS SPREAD
Fendi
"Baguette" evening bag: Gold
metallic silk brocade, multicolor
chenille, lavender snakeskin,
gold metal
Italy, 2001

The Fendi "Baguette," first
shown in 1997, quickly
became a collector's item.

ABOVE
Fendi
Squirrel spy bag: Stone-washed
denim with embroidery, brown
woven leather, rhinestones, silver
Italy, 2007

OPPOSITE
Fendi (Karl Lagerfeld)
Tunic and skirt: Black silk
faille with gray topstitching
Italy, 1980–1981

This Fendi ensemble belonged
to the legendary fashion
icon and model Tina Chow.

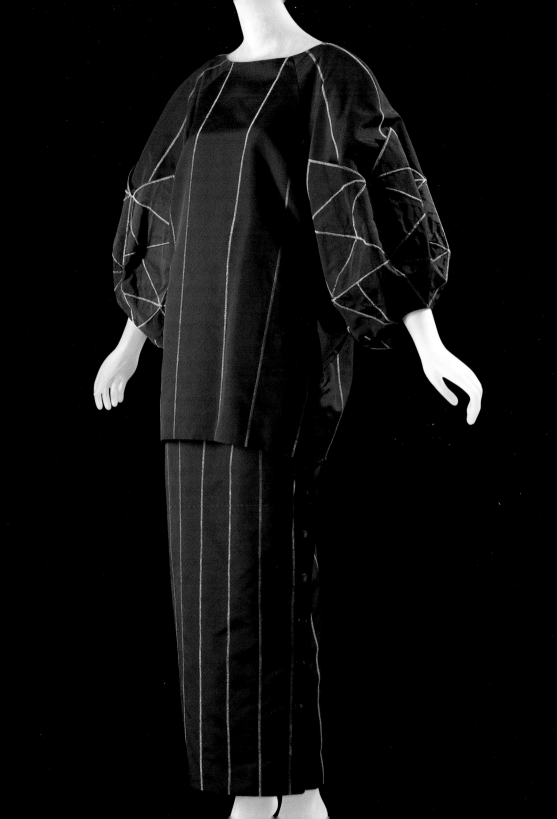

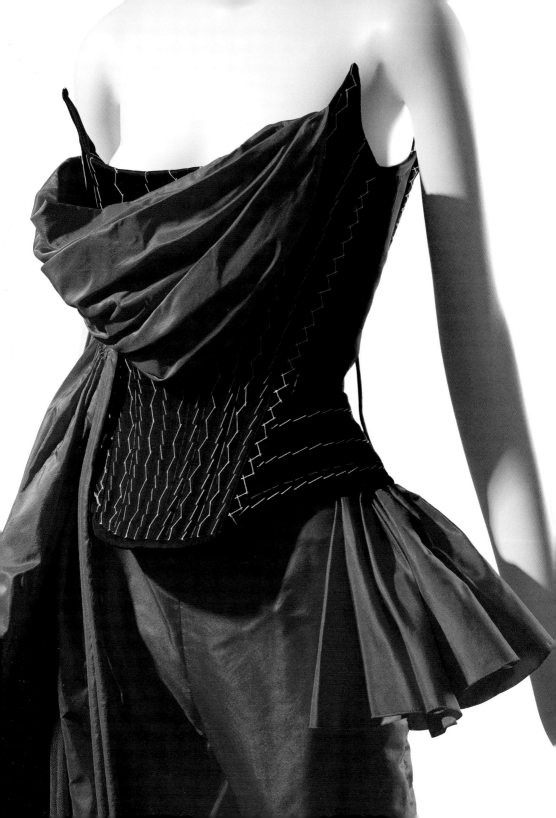

GIANFRANCO FERRÉ (1944–2007) has been called the "the architect of fashion," an appellation that accurately describes creations such as his signature three-dimensional, beautifully crafted white blouses. At the height of his career in the 1980s and into the early 1990s, he was celebrated for the razor-sharp silhouette of his dresses, the crisp lines, exact cutting, and visible seams of his tailored suits, and the luxurious fabrics and rich colors of his structured ballroom skirts.

Born in Legnano, Italy, Ferré earned a degree in architecture in 1969 at Politecnico di Milano, the largest technical university in Italy. A year later he began his fashion career designing accessories and then raincoats shortly after. Like his compatriots Giorgio Armani and Gianni Versace, Ferré was part of the second wave of Italian ready-to-wear designers to emerge on the international scene after the Second World War. He started his own company, Baila, in 1974, and launched his signature collection for women in 1978. His first men's collection appeared in 1982, followed in 1986 by his first *alta moda* (haute couture) collection in Rome. In 1983 he joined the Domus Academy as founding professor of the fashion design department. Ferré expanded beyond Italy when Bernard Arnault, owner of the luxury conglomerate LVMH, appointed him stylistic director of Christian Dior in 1989, where he would remain for eight years.

After leaving Dior, Ferré began his own namesake label. After his sudden death of a massive brain hemorrhage, Lars Nilsson was brought on as creative director of the company. He was replaced in April 2008 by designers Tommaso Aquilano and Roberto Rimondi, who served as creative directors until 2011, and were followed by Stefano Citron and Federico Piaggi, who departed the company in 2014. —*P. M.*

"Fortunately, I am an architect. I like to express myself. Projecting the maximum amount of human experience into the object I am creating is the highest expression. Mine is a sensuous approach." — GIANFRANCO FERRÉ

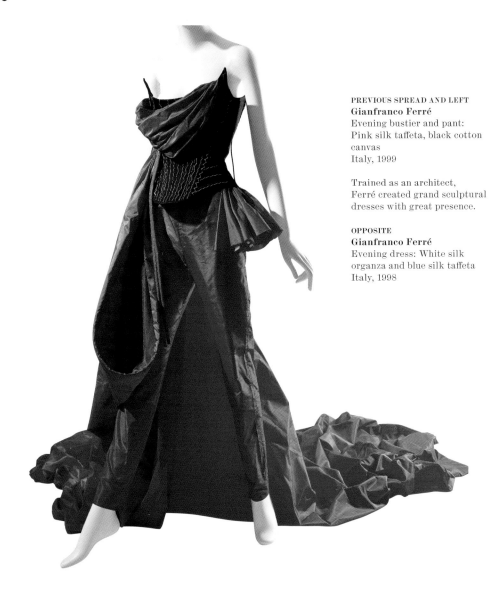

PREVIOUS SPREAD AND LEFT
Gianfranco Ferré
Evening bustier and pant:
Pink silk taffeta, black cotton
canvas
Italy, 1999

Trained as an architect,
Ferré created grand sculptural
dresses with great presence.

OPPOSITE
Gianfranco Ferré
Evening dress: White silk
organza and blue silk taffeta
Italy, 1998

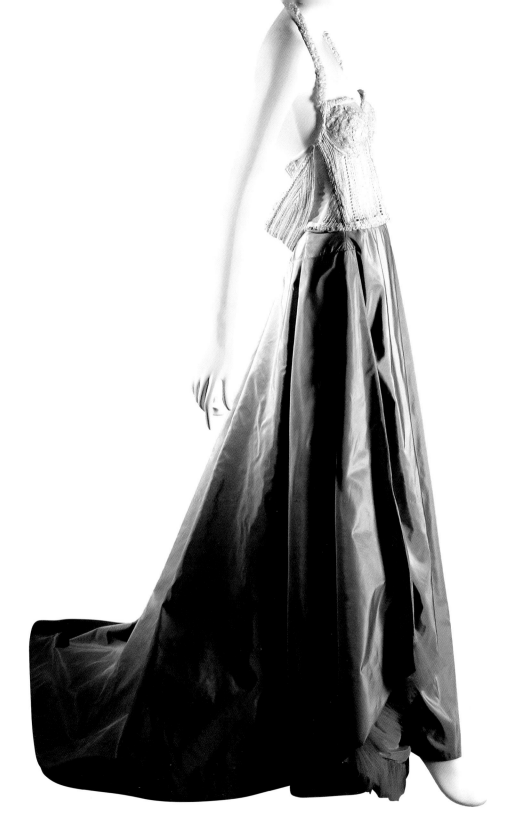

Mariano Fortuny

MARIANO FORTUNY (1871–1949) was a painter, engraver, architect, photographer, lighting technician, inventor, and impresario who became known as the "Magician of Venice." His biographer, Guillermo de Osma, noted that Fortuny "was a rare mixture of scientist, artist, and craftsman who personified the ideal of the Renaissance man in an age of increasingly narrow specialization."

Although Fortuny is often thought of as Venetian, he was born in Granada, Spain, into an illustrious family of painters. Fortuny was just three years old when his father died, and soon thereafter his mother moved the family to Paris. In 1889 they moved again, this time to Venice, the city that became Fortuny's adopted home. As a young man, he traveled throughout Europe, seeking out artists he admired, among them the German composer Richard Wagner.

It was in his Gothic palazzo—home, studio, showroom, and think tank—that Fortuny "invented" his Greek-inspired "Delphos" gown and "Knossos" scarf. Both were made using his mysterious patented pleating process. Fortuny also created new methods of dying textiles, as well as ways of printing metallic dyes on fabrics, primarily silk velvets. While the technical processes were new, his dazzling patterns were culled from centuries past, most of them based on woven Italian velvets dating back to the proto-Renaissance.

Be it a pleated "Delphos" gown or a printed velvet jacket, a Fortuny creation is instantly recognizable. His work can be found in museum costume collections around the world, and clothing connoisseurs avidly collect it, yet Fortuny's designs are not, strictly speaking, true fashion. Something of a fashion anomaly, Fortuny did not design styles that were constantly changing and evolving; rather, he created only a handful of clothing silhouettes that were variations on his finely pleated gowns and T-shaped jackets, and he intended that they be worn almost exclusively in intimate settings. Though his range of clothing types was limited, the colors and patterns Fortuny used to adorn them were seemingly infinite. —*P. M.*

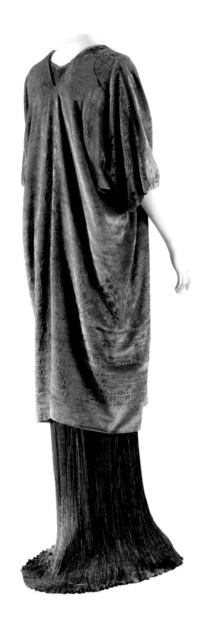

PREVIOUS SPREAD AND LEFT
Mariano Fortuny
"Delphos" dress:
Pleated lavender silk,
metallic printed silk
Italy, 1928
Mantle: Gold silk velvet
and metallic ink
Italy, 1927

Fortuny's classically inspired
"Delphos" gowns were among
his most famous designs.
The finely pleated silk fabric
was made using a process
unique to the designer.

OPPOSITE
Mariano Fortuny
Evening dress: Metallic
stamped gray silk velvet,
silk taffeta, glass beads
Italy, 1924

"*The Fortuny gown which Albertine was wearing that
evening seemed to me the tempting phantom of that invisible
Venice. It swarmed with Arabic ornaments, like the Venetian
palaces hidden like sultanas behind a screen of pierced stone,
like the bindings in the Ambrosian library . . .*"
— MARCEL PROUST, *THE CAPTIVE*

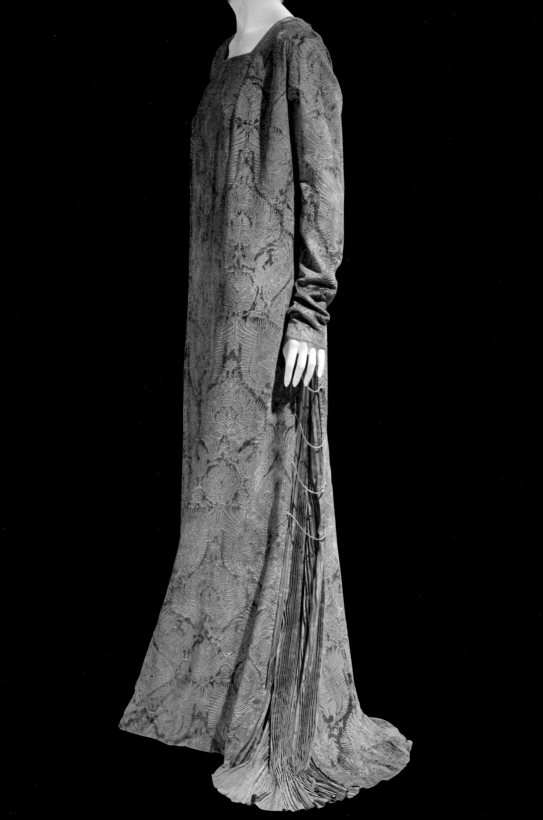

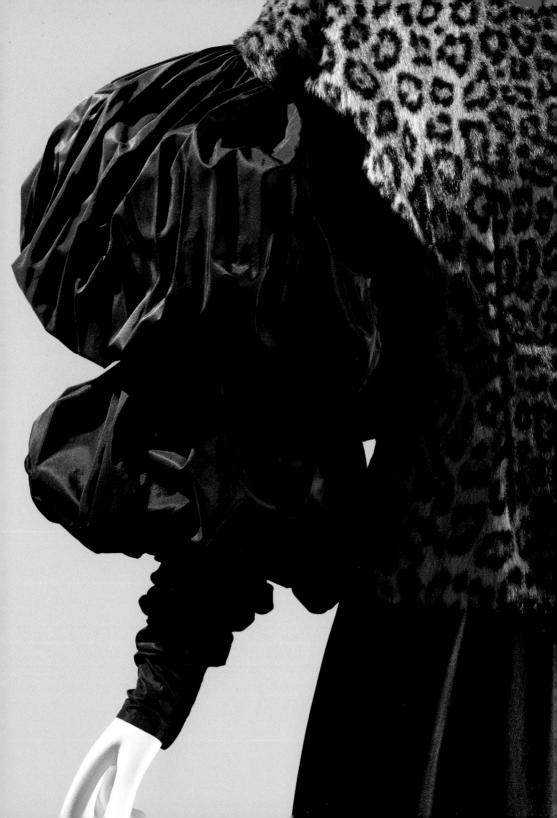

Jean Paul Gaultier

JEAN PAUL GAULTIER (B. 1952) Known as the enfant terrible of French fashion, Jean Paul Gaultier stages theatrical runway presentations featuring clothes distinguished by their combination of sexuality, irreverence, and humor. At the core of Gaultier's work, however, is an appreciation for the artistry of haute couture.

Gaultier was raised in a suburb of Paris, where his early interest in fashion was piqued by the discovery of his grandmother's corset. At eighteen Gaultier received a job offer from Pierre Cardin. Although he also worked briefly for the houses of Patou, Jacques Esterel, and Angelo Tarlazzi, Gaultier found working with Cardin to be the most inspiring. "At Cardin, everything was possible."

Gaultier presented his first ready-to-wear show in 1976, and his work began to receive significant attention by the end of the decade. After receiving funding from the Japanese fashion manufacturer Kashiyama, Gaultier officially established his business in 1982, and he quickly became known as one of the most provocative designers of the late twentieth century. In 1985, he showed his first man's skirt in a collection entitled And God Created Man, an important example of Gaultier's interest in androgyny. His youthful fascination with corsetry frequently inspired clothing that resembled undergarments. Most notably, Gaultier designed the costumes for Madonna's 1990 Blond Ambition World Tour, which featured his iconic cone-bra design.

Gaultier presented his first couture collection in 1997. From 2003 until 2010, he served as creative director for womenswear at Hermès. Gaultier's own brand now includes perfumes, accessories, and a secondary line, JPG. He launched his first line of intimate apparel in 2010, made in collaboration with Italian lingerie brand La Perla. After fifty years in the fashion industry, Gaultier retired in January 2020. A series of guest designers is planned to create the label's new collections. —C. H.

"I believe that beauty has many forms. Sexuality is part of our lives, it is part of who we are. There is nothing wrong in showing it." — JEAN PAUL GAULTIER

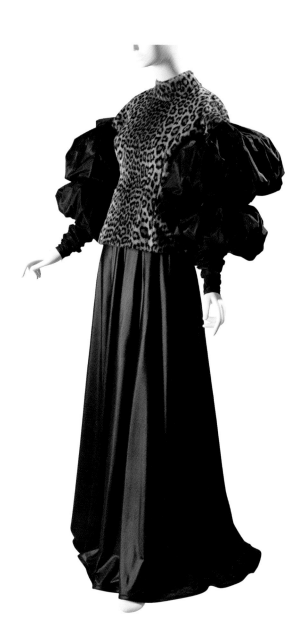

PREVIOUS SPREAD AND LEFT
Jean Paul Gaultier
Blouse: Black silk,
faux leopard fur
France, 1988
Skirt: Black polyamide Lycra
France, 1987

Gaultier was one of the most
influential designers of the
1980s, a period of extreme
fashion silhouettes, as seen
in this dramatic ensemble.

OPPOSITE
Jean Paul Gaultier
Dress: Peach satin,
peach stretch cotton
France, ca. 1987

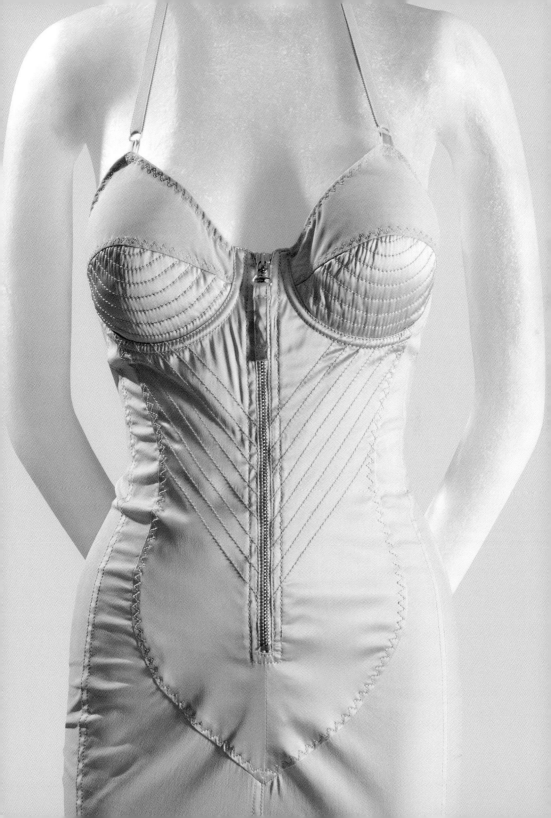

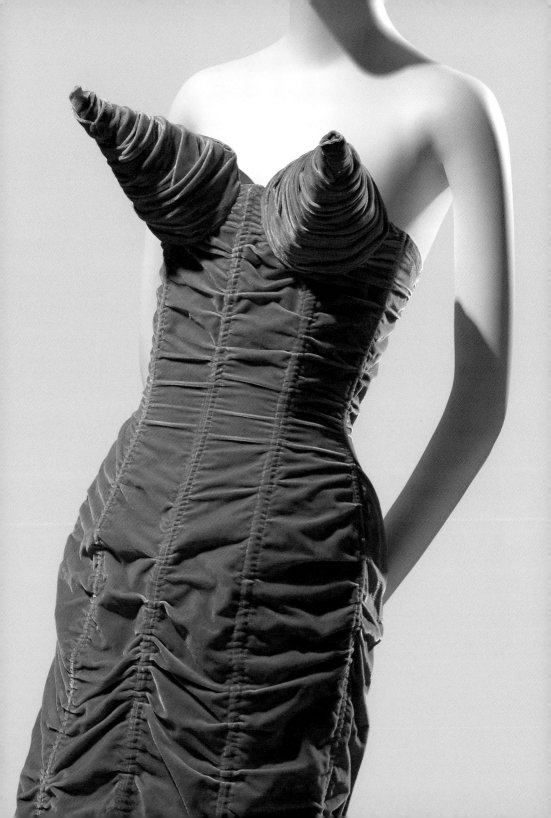

PREVIOUS SPREAD, LEFT
Jean Paul Gaultier
Dress: Orange velvet
France, 1984

Gaultier's youthful discovery
of his grandmother's corset led
to a fascination with women's
foundation garments. Although
he has created multiple
versions of the corset dress,
his exaggerated cone-bra
design is the most famous.

PREVIOUS SPREAD, RIGHT
Jean Paul Gaultier
Man's jacket: black wool
gabardine,
orange striped velvet,
tassels, beads
Pants: Olive-green rayon
France, 1988

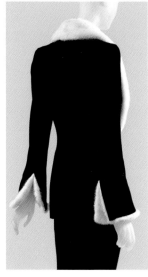

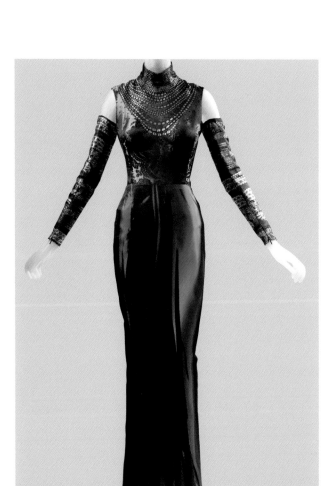

LEFT
Jean Paul Gaultier
Ensemble: Printed Lycra,
teal-and-black silk
France, 2002

ABOVE AND OPPOSITE
Jean Paul Gaultier
Evening ensemble: Black silk
velvet, white mink
France, 2002

FOLLOWING SPREAD
Jean Paul Gaultier
Jacket: Black leather, black
suede, gray pinstripe wool,
black faux fur
France, 1987

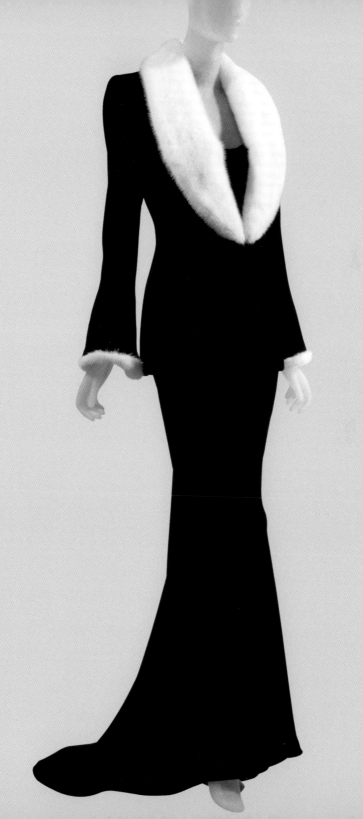

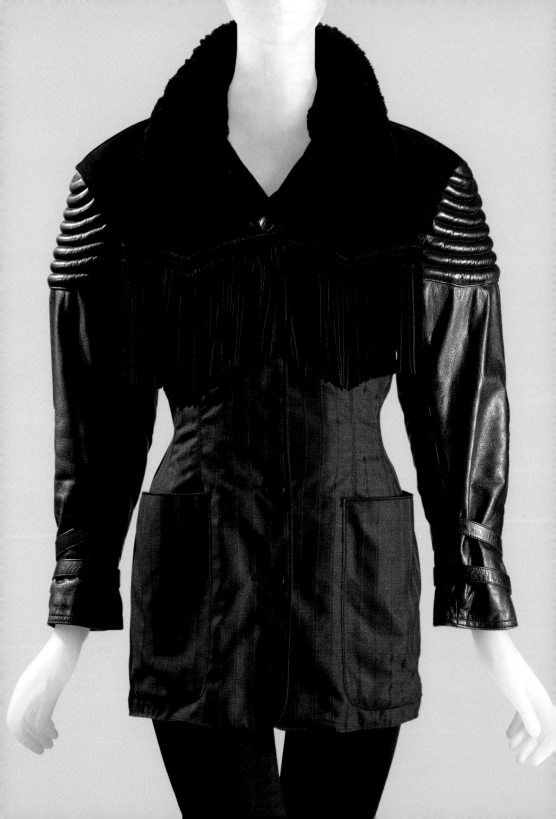

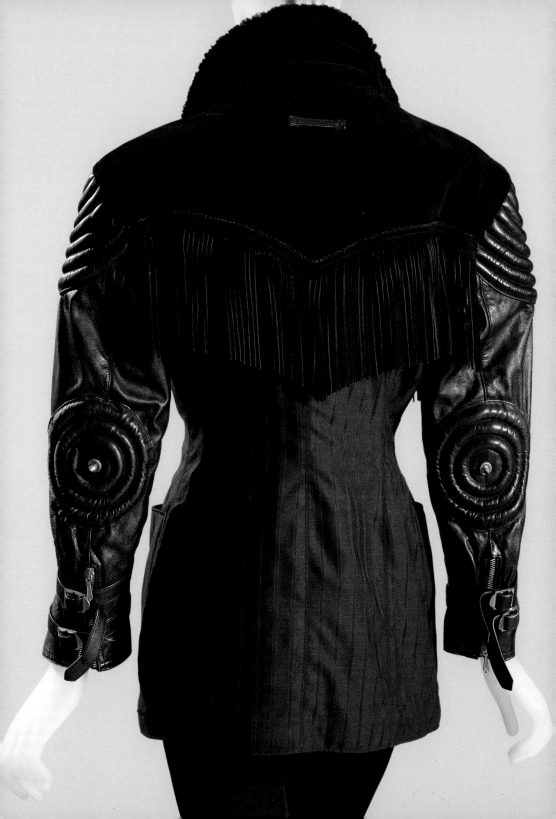

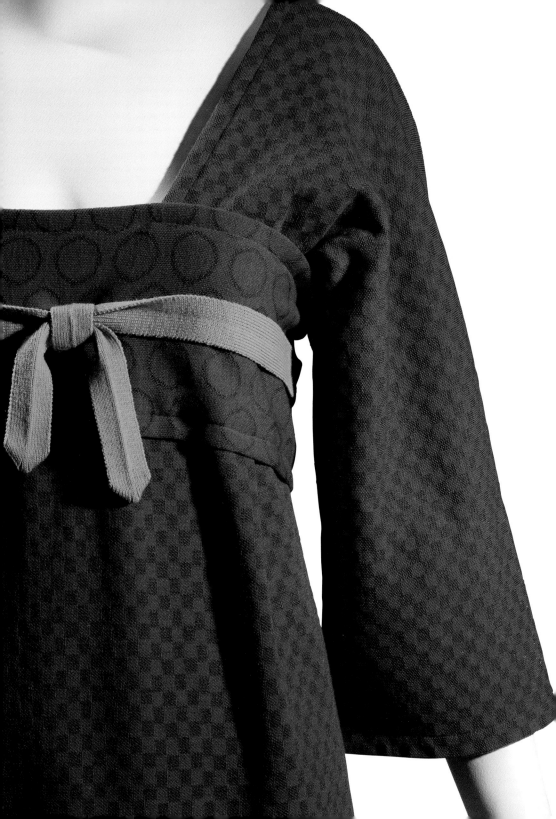

Rudi Gernreich

RUDI GERNREICH (1922–1985) From graphic collections inspired by clowns and Kabuki dancers to the "monokini"—the topless bathing suit introduced in 1964—Rudi Gernreich was best known for his avant-garde and sometimes scandalous designs. Beneath the spectacle of his clothes, however, was an understanding of color, shape, and the needs of the modern woman, underscored by a thirty-year career in fashion.

Born in Austria, the Jewish Gernreich moved to Los Angeles in 1938 as a refugee. He became a professional dancer, but by the end of the 1940s, quit dancing to focus on fashion, and worked for dress manufacturers in California and New York. "I was expected to turn out collections based on Dior and Fath, but I was ready to burst with new ideas," he recalled. In 1952 the clothing manufacturer Walter Bass gave Gernreich his first opportunity to design original creations, followed by a line for the Beverly Hills–based luxury boutique Jax.

Gernreich established his own company in 1960, and also began designing a lower-priced line for Harmon knitwear. Although his topless bathing suit was an extreme example, Gernreich's bold fashions frequently made news. Sheer, unstructured "no-bra" bras, dresses with provocative cutouts in clear vinyl, pant suits with androgynous styling, and Op Art–inspired patterns in striking color combinations were among the most influential of his designs. In 1967 *Time* magazine proclaimed Gernreich to be "the most way-out, far-ahead designer in the U.S."

Although Gernreich closed his company in 1968, he continued to design. In 1970 he produced one of his most conceptual collections. Barely there "utilitarian" clothes that were intended to be unisex illustrated his vision of the future of fashion, in which nudity would be equated with freedom, rather than sexuality. The designer continued to show thought-provoking collections until his retirement in 1981. —*C. H.*

*"Girls who wear Gernreich's
clothes prize them above
all because they leave the body
free to move."* — TIME

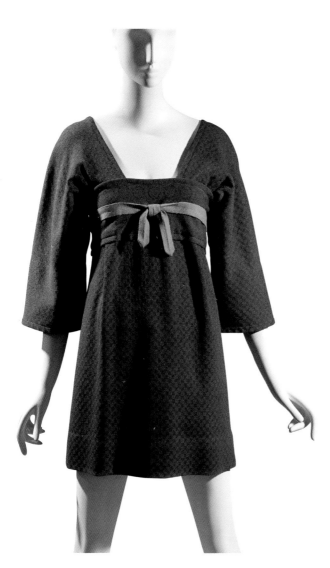

"It is my belief that Rudi
Gernreich designed almost
everything that can be designed
for people in the twentieth
century. His designs are so
logical and pure that they
will work for an elderly
woman and equally well for
a teenage girl."
— **Peggy Moffitt, model**

PREVIOUS SPREAD AND LEFT
Rudi Gernreich
Kabuki dress: Red-and-purple
wool knit, lime-green wool knit
USA, 1963

OPPOSITE
Rudi Gernreich
Top and pants (left):
Brown-and-white
giraffe-print polyester tricot
Tunic (right): Black-and-brown
tiger-print nylon knit
USA, 1965/1966

FOLLOWING SPREAD, LEFT
Rudi Gernreich
Dress: Multicolor printed
silk twill
USA, ca. 1970

FOLLOWING SPREAD, RIGHT
Rudi Gernreich
Monokini: Yellow-and-white
checked wool, yellow wool
USA, 1964

SUBSEQUENT SPREAD
Rudi Gernreich
Ensemble: Black-and-off-white
checked wool, off-white wool,
red wool
USA, 1967

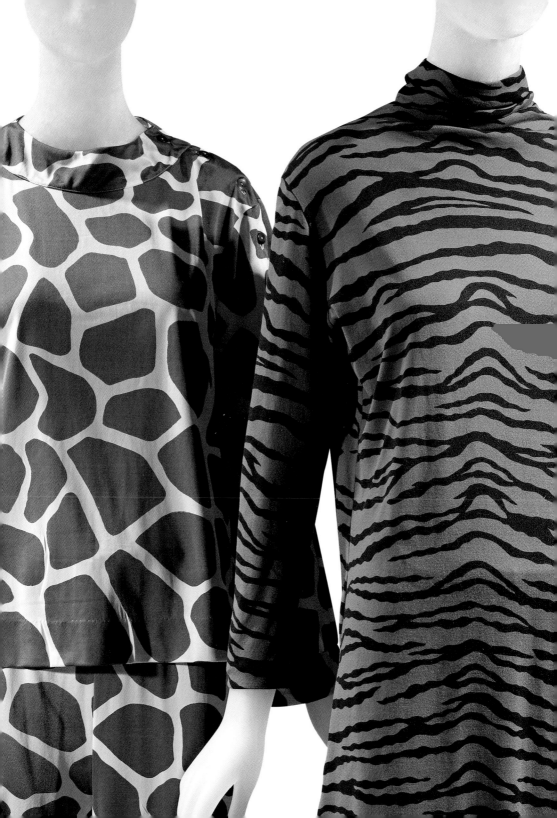

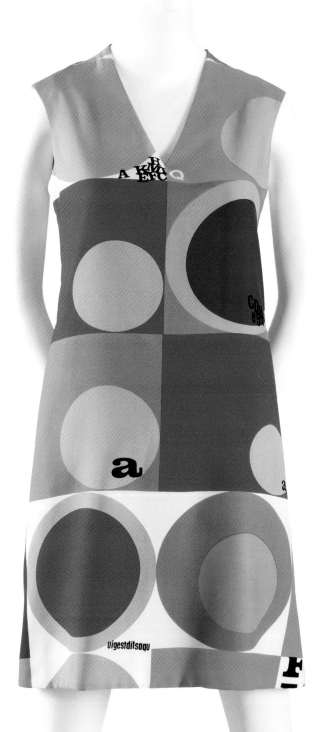

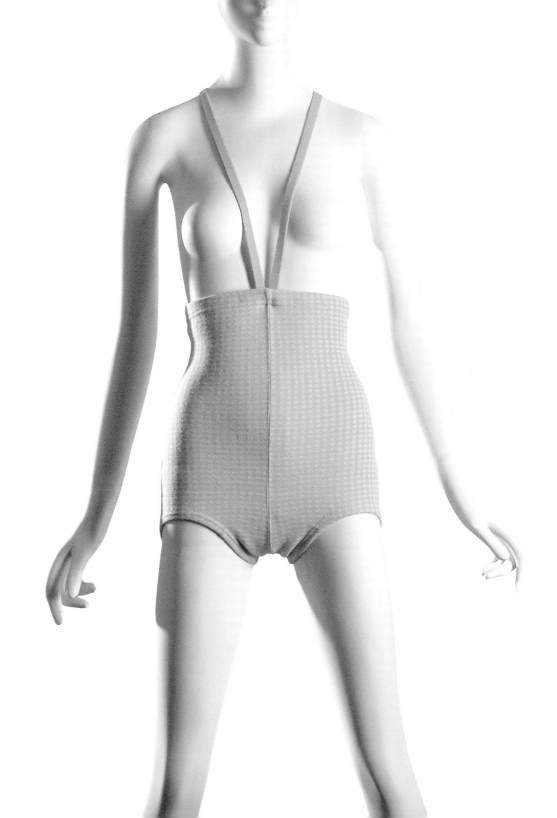

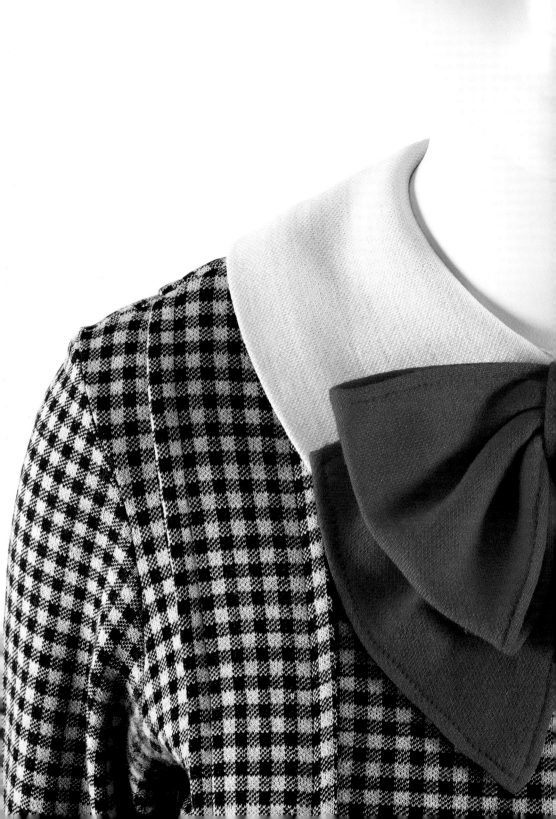

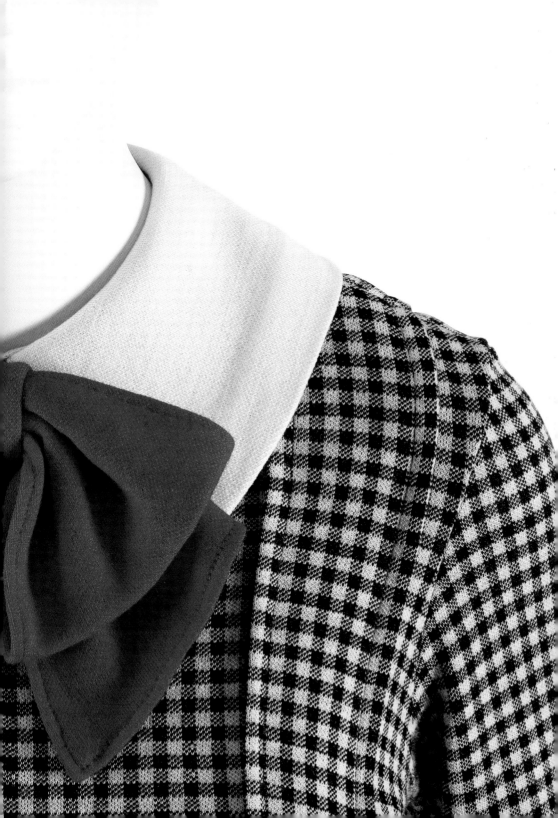

Givenchy

HUBERT DE GIVENCHY (1927–2018) The "handsomest of French couturiers," Hubert de Givenchy is best known for his simplified forms and clean, precise style. Givenchy designed chic dresses, coats, and suits worn by women as diverse as Lauren Bacall, Greta Garbo, Elizabeth Taylor, Jacqueline Kennedy Onassis, and Wallis Simpson. Yet his most celebrated client was actress Audrey Hepburn. Inspired by her youth, gamine look, and elegant spirit, Givenchy dressed her onscreen and off. Their unique partnership established her as a leader in fashion.

Hubert James Marcel Taffin de Givenchy, known as "Le Grand Hubert" in Parisian fashion circles, was born in Beauvais, France. At seventeen he moved to Paris, where he worked for couturiers Jacques Fath, Robert Piguet, Lucien Lelong, and Elsa Schiaparelli. Givenchy launched his first couture collection in 1952, which was comprised of deluxe separates that included cotton skirts and blouses, and lauded for its invigorating spirit.

In 1953 Givenchy was introduced to the couturier he most admired: Cristóbal Balenciaga. The appreciation became mutual, and Balenciaga served as Givenchy's mentor for many years. When Balenciaga retired in 1968, he sent most of his clients to Givenchy. In 1995 Givenchy retired. His successors at his fashion house have included John Galliano and Alexander McQueen, two of the most influential fashion designers of the twenty-first century.

From 2005 to 2017 Italian-born designer Riccardo Tisci served as creative director, designing both ready-to-wear and couture. Tisci infused the house with his darkly romantic style, and his edgy designs catered to a liberated woman confident in her sexuality. In 2017 Clare Waight Keller was appointed the first female artistic director of Givenchy. She was replaced by Matthew Williams in 2020. —*M. M.*

"Givenchy's name is synonymous with elegance and orderly proportions in everything he does."
— ANDRÉ LEON TALLEY, CONTRIBUTING EDITOR, *VOGUE*

Riccardo Tisci (b. 1974)

"His are the only clothes in which I am myself. He is far more than a couturier; he is a creator of personality."
— **Audrey Hepburn, actress**

PREVIOUS SPREAD
Hubert de Givenchy
Evening dress: Black silk satin, black cording, rhinestones
France, 1968

"My woman is so strong, so confident of her sexuality, so confident of her decisions that she can play with both worlds."
— **Riccardo Tisci**

OPPOSITE
Givenchy
Evening dress: Purple fibranne
France, ca. 1967

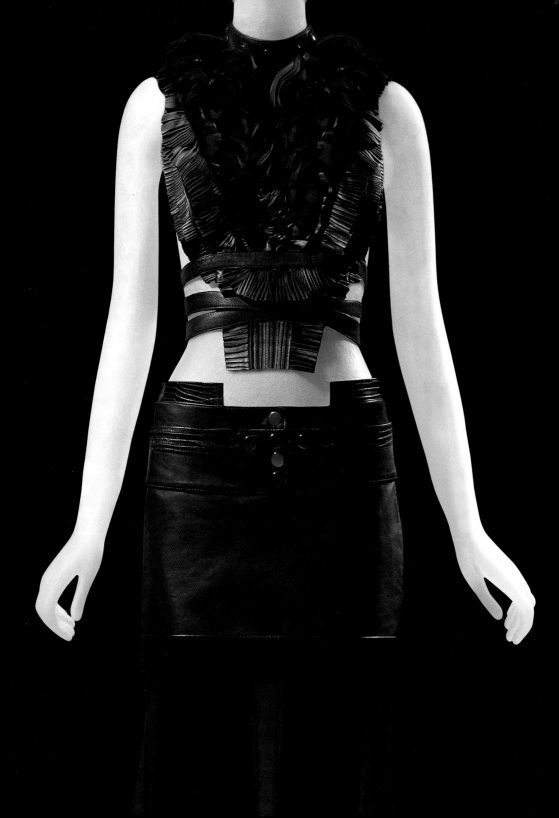

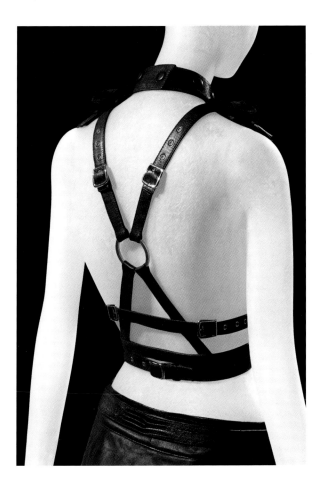

OPPOSITE AND LEFT
Givenchy (Riccardo Tisci)
Ensemble: Black leather,
chiffon, metal buckles
France, 2011

BELOW
Givenchy (Riccardo Ticsi)
Boot: Black leather
France, 2011

Gucci

GUCCIO GUCCI (1881–1953) One of the most widely known luxury brands worldwide, the Gucci we know today bears little resemblance to the modest, family-owned leather goods store founded in 1921 by Guccio Gucci. A Florence native who as a youth held jobs at luxury hotels in France and England, he was inspired to return to Florence—a city known for its artisans—and design his own line of understated, beautifully crafted luggage after noticing the sleek bags carried by the wealthy hotel patrons.

Four of Guccio's sons eventually joined the business, broadened its product line, and opened stores in Rome and abroad. By the 1950s, Gucci's handbags were as well known as its luggage. The brand's unusual styles, such as bags with curved bamboo handles, introduced in 1947, were carried by some of the most fashionable women of the day, including Grace Kelly and Elizabeth Taylor.

The company expanded into ready-to-wear clothes in 1968, and continued to flourish through the 1970s. The chic design and quality of Gucci products appealed to jet-setters. In spite of its history of success, disputes within the Gucci family, as well as overexpansion, brought the company to the brink of bankruptcy in the 1980s. Fashion executive Dawn Mello was brought in to revitalize the Gucci image. Mello triumphed, hiring the talented young designer Tom Ford (b. 1961) to design a ready-to-wear line in 1990. He was appointed creative director in 1994.

Ford had admired Gucci during his childhood in the 1970s, and he infused the vintage styles with modern glamour and potent sex appeal, described by fashion writer Eric Wilson as "louche sensuality." By the end of the 1990s, Gucci was reincarnated as a premier fashion house. Although Ford left the company in 2004, his successor, Frida Giannini, continues to comb Gucci's archives for inspiration. Her chic, sought-after creations maintain Gucci's position at the forefront of contemporary fashion. Alessandro Michele was appointed creative director following Giannini's departure, and presented his first collection for Gucci in 2015. —*C. H.*

"In less than a decade as creative director, the American-born Mr. Ford transformed Gucci ... into a coveted symbol of sex and glamour."
— CATHY HORYN, *THE NEW YORK TIMES*

Tom Ford (b. 1961)

"Quality is remembered long after price is forgotten."
— **Aldo Gucci**

PREVIOUS SPREAD
Gucci
Handbag: Black patent leather, bamboo
Italy, ca. 1975

"I like to think that in the mid-nineties I brought a certain hedonism back to fashion. Sexuality is always present in my work."
— **Tom Ford**

OPPOSITE
Gucci (Tom Ford)
Dress: White jersey, gold metal
Italy, 1996

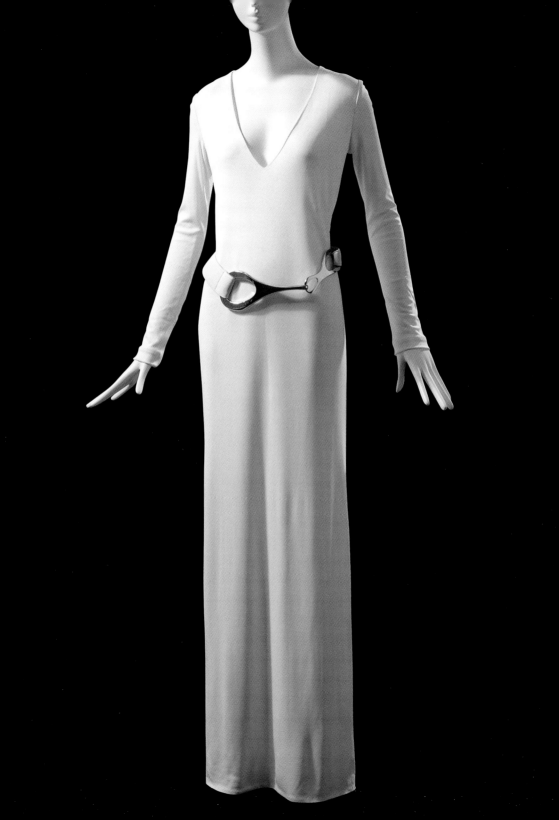

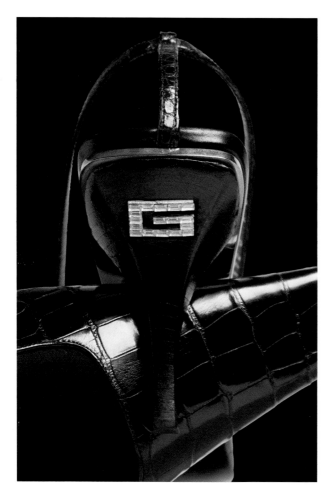

OPPOSITE
Gucci (Tom Ford)
Evening dress and jacket:
Green silk organza, silk, fur,
and sequins
Italy, 2004

Tom Ford's hyper-sexy look
for Gucci is epitomized by
this slinky evening ensemble,
which recalls the glamour
of 1930s Hollywood. The vivid
acid-green materials add
a contemporary flair.

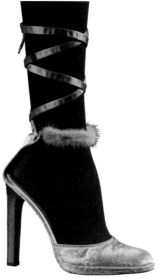

ABOVE
Gucci
Sling-back pumps:
Black crocodile skin
Italy, 1998

RIGHT
Gucci
Evening shoe:
Acid-green velvet, silk, and fur
Italy, 2004

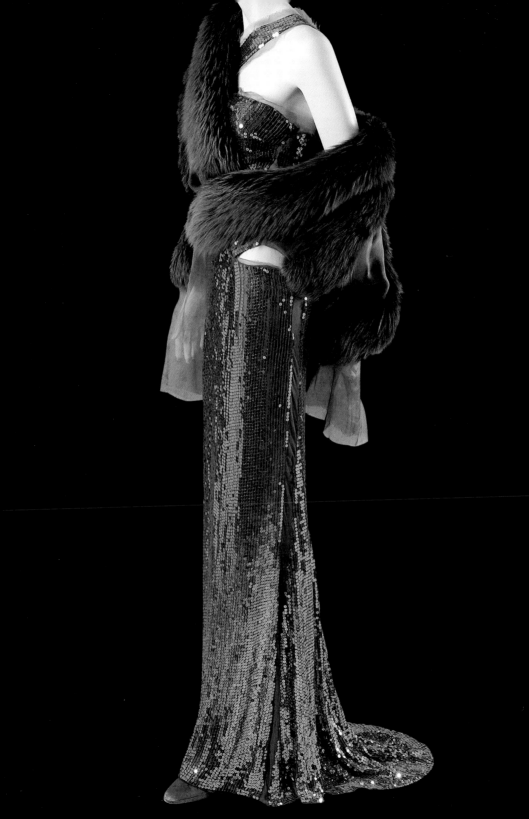

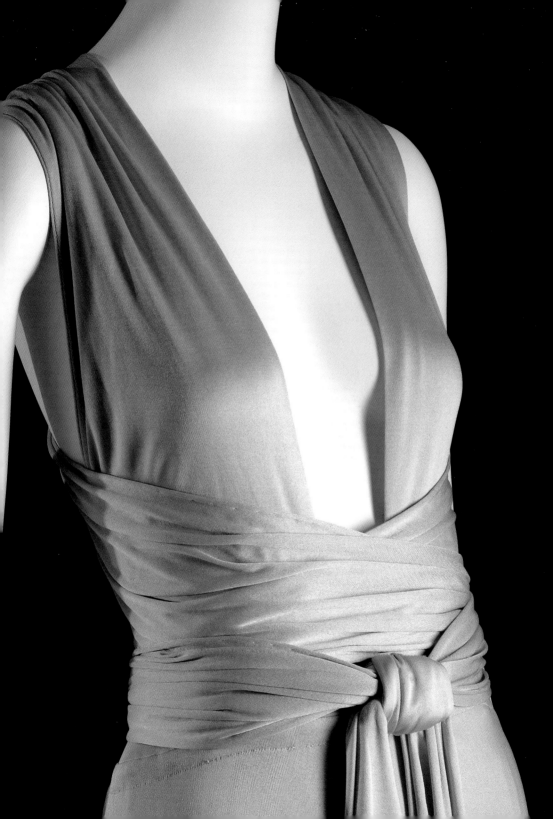

Halston

ROY HALSTON FROWICK (1932–1990) "You are only as good as the people you dress," Halston famously proclaimed. Indeed, Halston dressed some of the world's most fashionable women, including Lauren Bacall, Martha Graham, Bianca Jagger, Babe Paley, Liza Minnelli, and Diana Vreeland. Halston's minimalist approach to fashion offered a casual elegance that has come to epitomize the chic look of the '70s. With an almost devastating simplicity, Halston made women look elegant and sophisticated, yet simultaneously young and sexy.

Born Roy Halston Frowick, he began his career as a milliner. In 1958 he went to work for Lilly Daché, but moved on a year later to the millinery department at Bergdorf Goodman. While there, he created one of his most successful designs—the pillbox hat, which was worn by Jacqueline Kennedy to her husband's presidential inauguration in 1961. By 1966 Halston was designing ready-to-wear collections for Bergdorf's; two years later, he opened his own fashion salon.

Halston's minimalist aesthetic was deceptively simple. He eliminated inner structures and superfluous details that would clutter the lines of his clothing. His signature looks included one-shoulder evening gowns, jumpsuits, chiffon tunics, pajama sets, and revealing jersey evening dresses with halter necklines. He modernized American sportswear by reviving the classic sweater set in fabrics such as cashmere and matte jersey he created separates that could be recombined to produce versatile looks suitable for a variety of occasions; and he successfully reintroduced the shirtwaist dress via the use of a novel fabric, Ultrasuede.

Halston, both the man and the label, epitomized 1970s glamour and sophistication. A regular at the exclusive New York nightclub Studio 54, Halston socialized with the celebrity clients he dressed. He understood the modern woman's lifestyle and designed with her needs in mind. —*M.M.*

"Women make fashion. Designers suggest, but it's what women do with the clothes that does the trick." — HALSTON

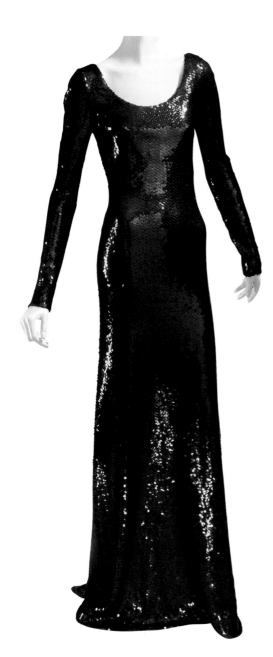

"I'm into clean American beauty...for the woman who works day and night. It's not necessarily a New York look— but for a lady anywhere in this country who wants to look feminine."
— **Halston**

PREVIOUS SPREAD
Halston
Evening dress:
Light-blue silk jersey
USA, 1972–1973

In this evening dress, two long bands of fabric can be wrapped around the body in a variety of ways allowing the wearer to reveal as much—or as little— skin as she chooses.

LEFT
Halston
Evening dress:
Blue sequined jersey
USA, 1972

OPPOSITE
Halston
Evening dress: Red silk, red nylon, red bugle beads, beige silk
USA, 1979

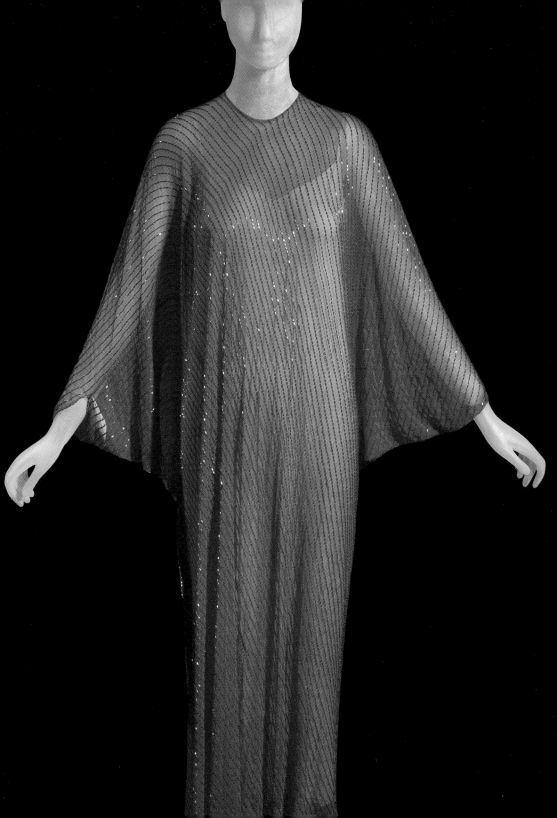

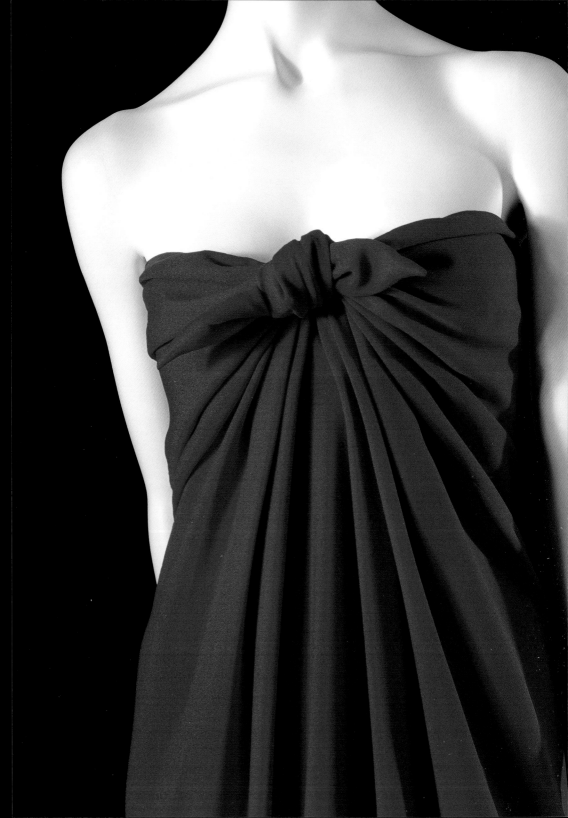

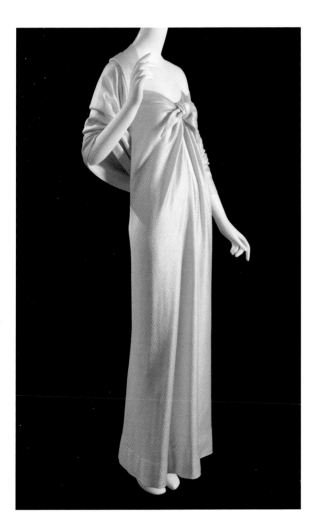

Halston
Evening dress and stole:
Pale peach hammered satin
USA, 1976

Halston rarely spoke of the
technical aspects of his designs,
but the apparent simplicity of
this dress is deceiving. It is cut
from a single piece of fabric on
the bias, and held together by
one single seam that spirals
around the body.

BELOW
Halston
Evening dress and cardigan:
Black Lurex knit
USA, 1973

FOLLOWING SPREAD
Halston
Evening dress:
Red silk organza and
black crêpe
USA, 1981

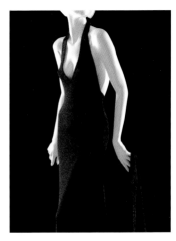

OPPOSITE
Halston
Evening dress: Red silk crêpe
USA, ca. 1976

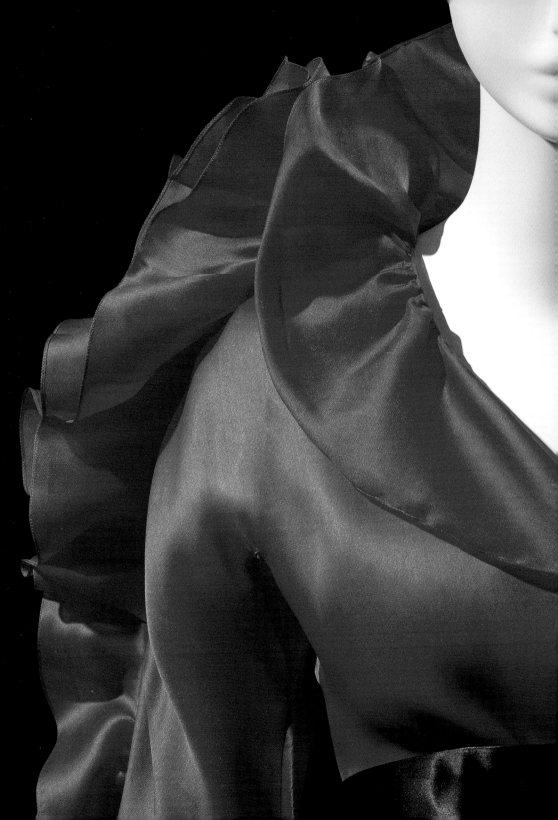

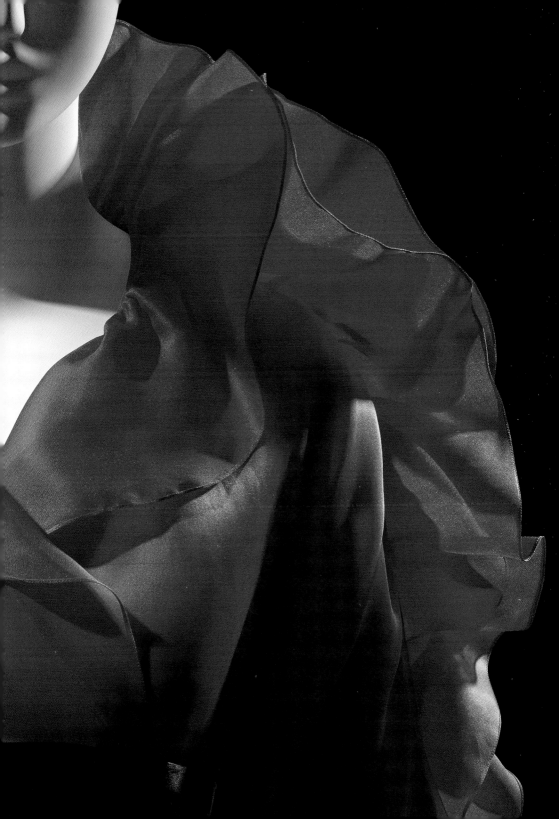

LEFT
Halston
Ensemble: Brown suede,
fur trim
USA, 1970–1971

ABOVE
Halston
Ensemble: Lavender cashmere
USA, 1972–1973

OPPOSITE
Halston
Dress: Beige Ultrasuede
USA, 1972

Halston sold more than
50,000 copies of his versatile
Ultrasuede shirtwaist dress,
and in 1975 *Esquire* magazine
called it "the most popular
pricey dress of all time."

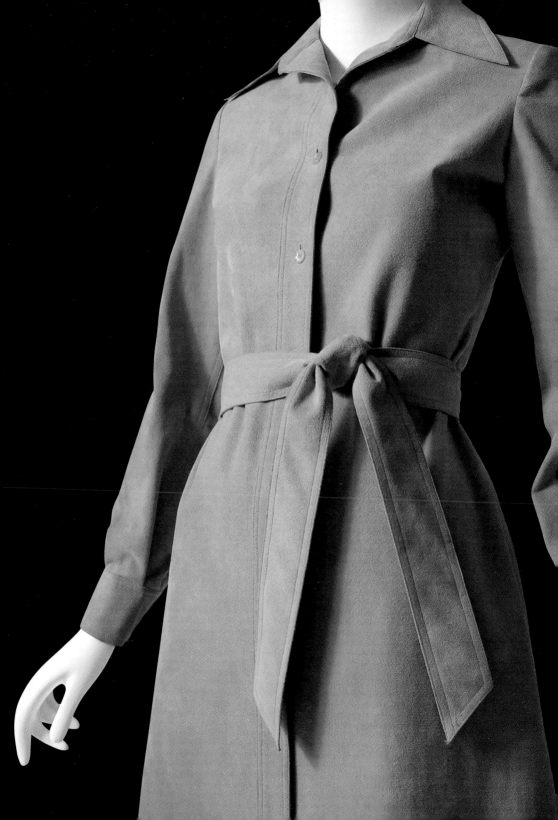

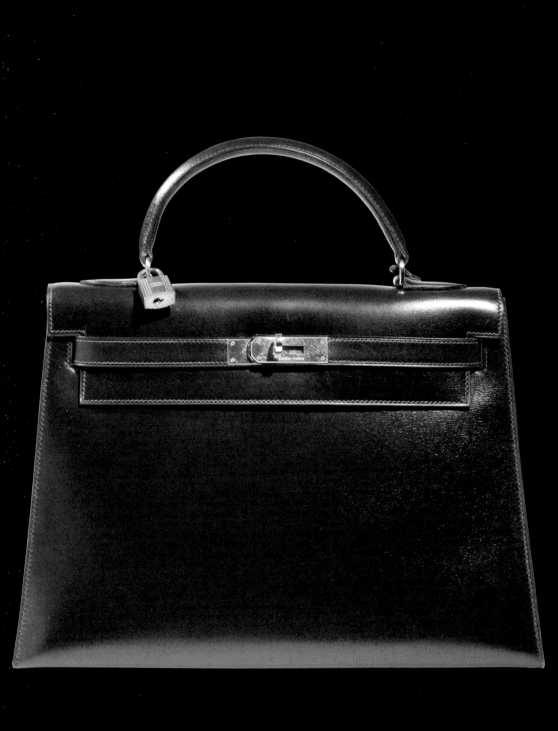

Hermès

THIERRY HERMÈS (1801–1878) The Paris-based luxury leather firm Hermès was founded in 1837 by Thierry Hermès, a German Protestant immigrant. In the beginning, the company crafted finely wrought carriage harnesses and bridles. Today Hermès makes fine women's handbags, along with women's clothing, men's clothing, perfumes, and other lifestyle goods.

In 1880 Thierry's son, Charles-Émile, moved the shop to its present location at 24 rue du Faubourg Saint-Honoré, and produced and sold saddles. The founder's grandsons, Adolphe and Émile-Maurice, added an accessories collection, and Hermès introduced its first leather handbags in 1922. By the end of the decade, the company's first women's apparel collection debuted. In the 1930s Hermès produced some of its most recognized original goods such as the *petit sac haut à courroies* (later renamed the "Kelly" bag) and the Hermès printed silk scarf, first designed by Robert Dumas in 1937 with the *Le Jeu des Omnibus et Dames Blanches* motif.

After the Second World War, Hermès continued to expand and introduce new products such as the perfume Calèche. Sales of the "Kelly" bag took off after Princess Grace appeared with one on the cover of *Life* magazine in 1956. However, by the 1970s Hermès began losing ground to competitors who opted for cheaper materials and means of production. While maintaining its commitment to craftsmanship, Hermès began to target a younger audience. It introduced the "Birkin" bag in 1984, named after the actress and singer Jane Birkin, and like the "Kelly" and numerous other Hermès handbags, the Birkin has become a classic.

For the past two decades, the Hermès clothing lines have become more abstract and architectural. In 1997 Martin Margiela was hired to design the women's line, and was followed in 2003 by Jean Paul Gaultier, whose audacious designs included fringed cashmere coats fitted like horse blankets that had been thrown around the shoulders and belted. In 2010 Christophe Lemaire was named head designer, followed by Nadège Vanhee-Cybulski in 2014. —*P. M.*

*"So intelligently designed and
deeply well made it transcends fashion..."*
— LAURA JACOBS, *VANITY FAIR*

**Robert Dumas Hermès
(1898–1978)**

*"[Hermès] does not boast, does
not use celebrities in advertising,
does not license its name, does
not let imperfect work leave
the atelier (imperfect work is
destroyed), does not get its head
turned by trends."*
— **Laura Jacobs,** *Vanity Fair*

PREVIOUS SPREAD
Hermès
"Kelly" bag: Navy leather,
brass hardware
France, 2000

OPPOSITE
Hermès (Jean Paul Gaultier)
Ensemble: Heather-gray wool,
lambskin, wool felt, and black
leather
France, 2010

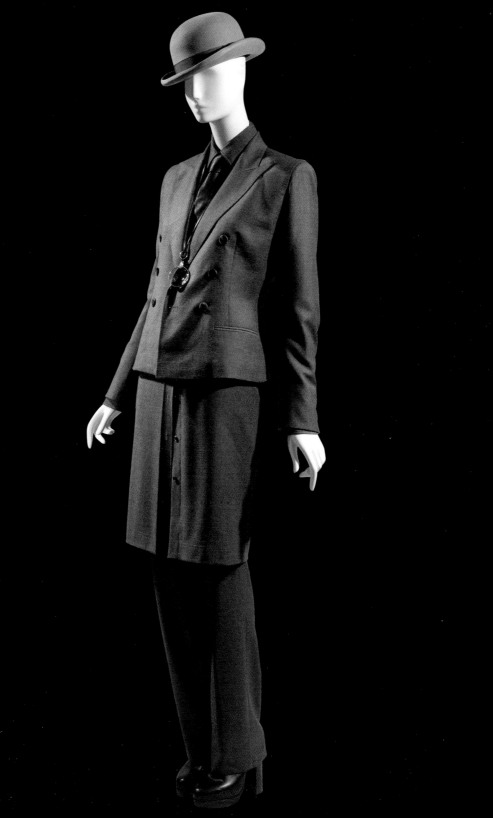

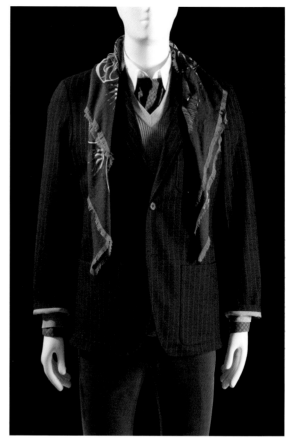

ABOVE
Hermès
Handbag: Red leather,
gold-plated hardware
France, ca. 1938

RIGHT AND OPPOSITE
Hermès (Véronique Nichanian)
Man's ensemble: Navy blue
pinstripe wool, orange cotton,
rose cotton velveteen,
black leather
France, 2010

Hermès was traditionally
a luxury accessory company
known for its printed scarves
and leather goods, but in recent
years its clothing for both
men and women has become
increasingly important.

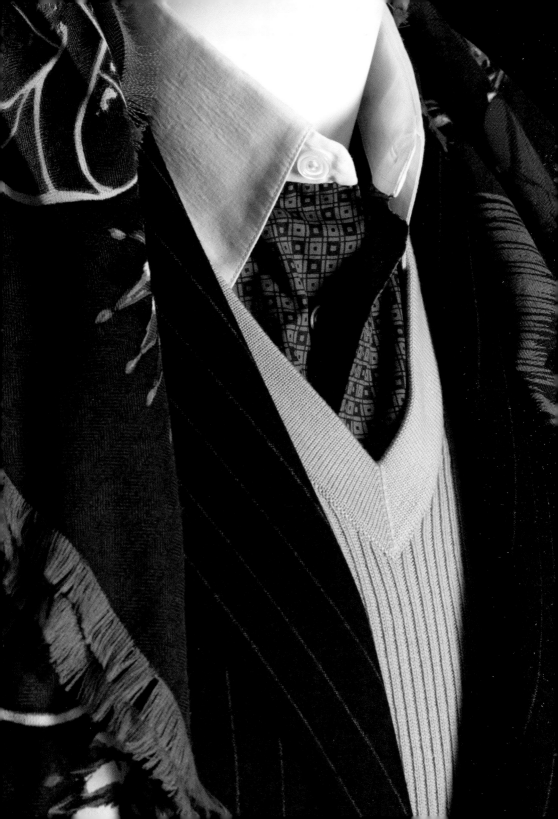

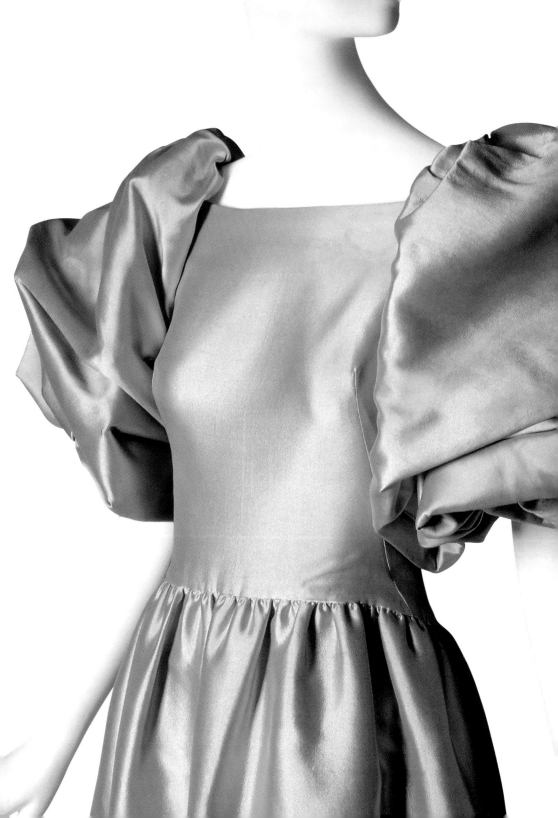

Carolina Herrera

CAROLINA HERRERA (B. 1939) Prior to the debut of her first runway collection in 1981, Carolina Herrera, the aristocratic Venezuelan beauty, had long been one of society's best dressed. However, her first collections appeared at a time when "dressing up" was "the new order of the day," as *The New York Times* put it, and Herrera's lavish evening clothes fit this social climate well.

Sleeves feature prominently in Herrera's work. In fact, her sleeves are so distinctive that early on *Women's Wear Daily* characterized Herrera as "Our Lady of the Sleeves." She told *The New York Times* in 1980 that while a woman is seated, "what is most important is everything that can be seen from the waist up. That is why I pay so much attention to sleeves. They make you important." This understanding of a particular lifestyle enabled Herrera to dress many distinguished women, her friend Jacqueline Kennedy Onassis among them.

Journalist John Duka observed at the end of a November 1981 runway show that Herrera "moved with the assurance of someone who had wrestled with a reputation as a dilettante and won." Over the course of a career that has spanned over thirty-five years (with no end yet in sight), Herrera has unquestionably proven herself as a designer who understands *all* women, and not merely the well-heeled.

Herrera's personal style and her designs go hand-in-hand; both are crisp, polished, and elegant, and her work is beautifully tailored and impeccably finished. In her own words, "very feminine with a certain chic; classic in a modern way." Herrera stepped down as creative director in 2018, and Wes Gordon showed his debut collection in 2019. —*J. F.*

"In a time when true elegance, good manners, and intrinsic femininity are hard to come by, Herrera is an inspirational figure." — ANNETTE TAPERT, *TOWN & COUNTRY*

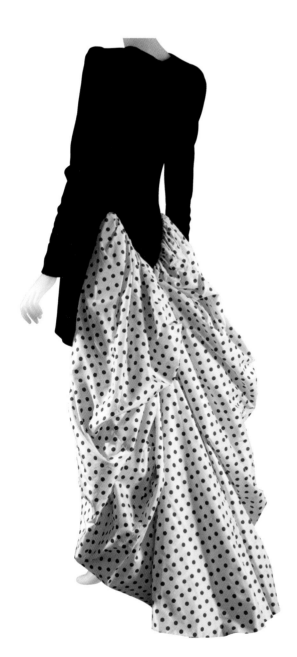

"Carolina is the epitome of class. She has evolved into a key designer for the elegant, well-traveled, worldly client who requires a certain sophistication and subtlety and who is not subject to the whims of fashion trends. We all want to look like her and dress like her."
— **Rose Marie Bravo,**
Town & Country

PREVIOUS SPREAD
Carolina Herrera
Evening dress:
Ecru silk peau de soie
USA, 1981

LEFT
Carolina Herrera
Cocktail dress: Black velvet,
black-and-white silk taffeta
USA, 1988

OPPOSITE
Carolina Herrera
Evening dress:
Blue-and-white striped
silk taffeta
USA, 2004

The designer wore a version of this evening dress—a formal variation on her signature personal look of a simple white shirt—to the Metropolitan Museum's Costume Institute Gala in 2004.

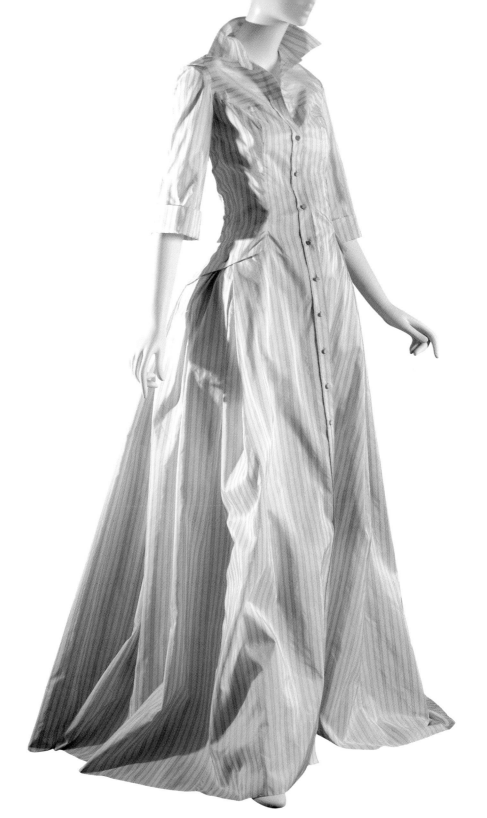

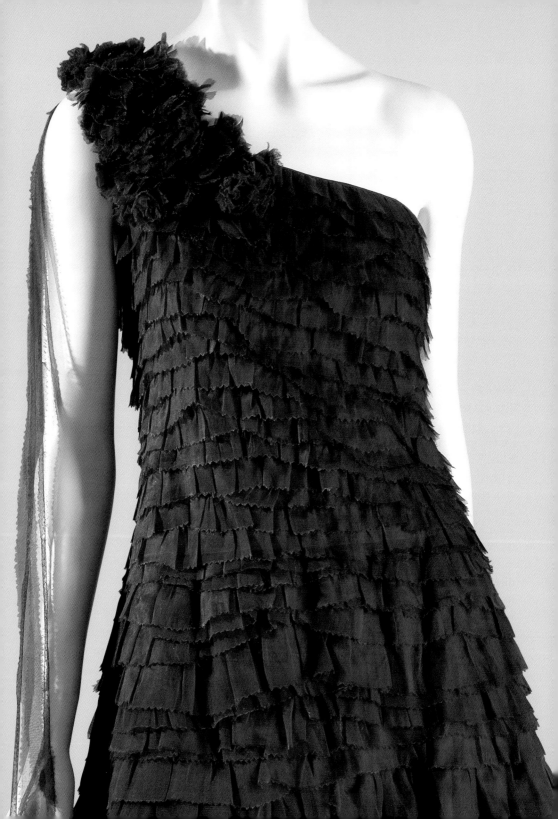

Marc Jacobs

MARC JACOBS (B. 1963) Marc Jacobs's signature fusion of uptown sophistication and downtown street vibe has earned the designer acclaim from fashion editors and other industry professionals. Anna Wintour, *Vogue* editor and longtime advocate of his work, has praised Jacobs's knack for "making the conservative seem cool . . . and making the cool seem conservative."

Although a native of New York City's Upper West Side, Jacobs spent his formative years immersed in the city's downtown scene and club culture. Following his graduation from Parsons in 1984, he launched his first signature collection just two years later; by 1988 he was designing women's wear for Perry Ellis. The following year he was promoted to head designer and achieved uncommon critical success. Jacobs's defining moment came with his now legendary spring 1993 Grunge collection for Perry Ellis, a decidedly antifashion collection inspired by the urban music scene in Seattle, Washington. Grunge resulted in Jacobs's 1993 termination from Perry Ellis; ironically, that same year the Council of Fashion Designers of America named Jacobs its Women's Wear Designer of the Year.

Jacobs has had a cultlike following while working under his own label and as artistic director for Louis Vuitton, where he served from 1997 to 2013. The designs of this relentlessly inventive American designer, in equal parts sophisticated and eclectic, continue to reflect the cultural zeitgeist. He has collaborated with Stephen Sprouse for Louis Vuitton on a graffiti-inspired collection, and his 2003 collaboration with Takashi Murakami for Louis Vuitton paired fashion with anime and helped bring J-pop into high fashion. An ongoing series of advertising collaborations with photographer Juergen Teller has featured pop icons and tabloid celebrities alike, including Winona Ryder, Sofia Coppola, Victoria Beckham, and Dakota Fanning. —*M. M.*

*"No other American designer has so success-
fully fused the street style of New York with a
reverence for making beautiful fashion."*
— ANNA WINTOUR, EDITOR, *VOGUE*

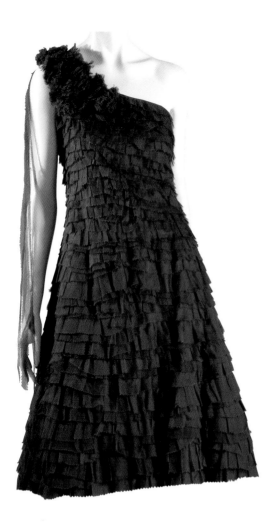

*"I love to take things that
are everyday and comforting
and make them into the most
luxurious things in the world."*
— **Marc Jacobs**

LEFT AND PREVIOUS SPREAD
Marc Jacobs
Evening dress:
Red-violet silk organza
and tulle, taffeta
USA, 2000

BELOW
Louis Vuitton (Marc Jacobs)
Oxfords: Gold leather
with mink and silk
USA, 2004

OPPOSITE
Marc Jacobs
Evening dress: Black
silk chiffon, tulle, and
reembroidered lace
USA, 2008

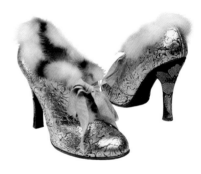

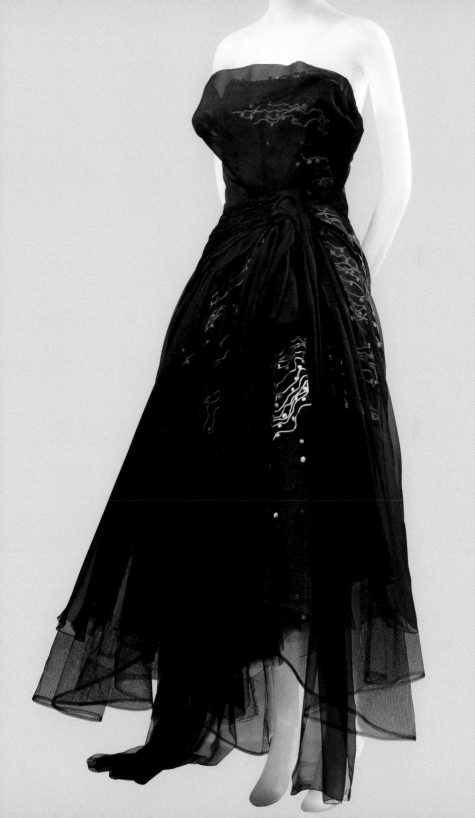

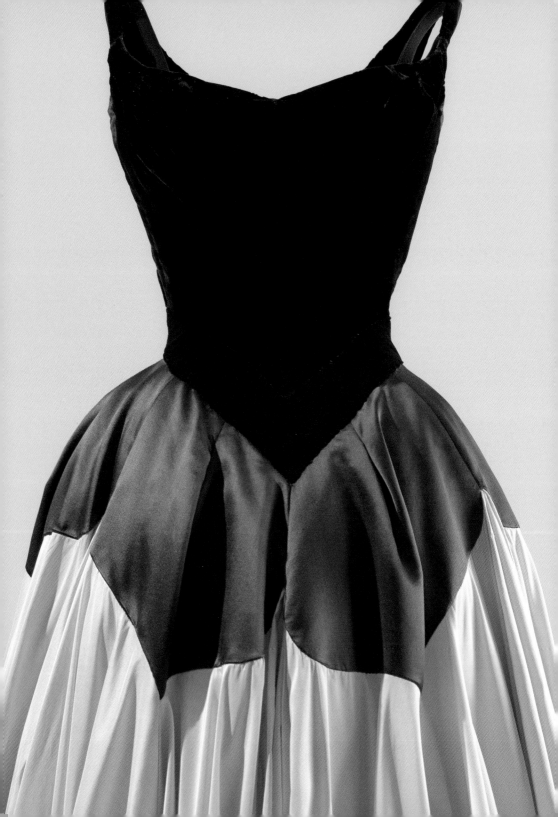

Charles James

CHARLES JAMES (1906–1978) was a designer's designer. Although greatly admired by other couturiers such as Christian Dior and Jacques Fath, he was unknown to the public at large. Indeed, he was often on the verge of bankruptcy, despite creating expensive clothes for some of the world's most discriminating clients. A brilliant designer, but a difficult and tormented personality, he made fewer than one thousand garments over the course of a fifty-year career. The extreme rarity and originality of his existing garments makes them among the most valuable objects in museum costume collections.

Born in England, James was the son of a British military officer and a Chicago heiress. He began his career as a milliner in Chicago, working under the name Charles Boucheron, then moved to New York, where he also began designing dresses. The influence of millinery can be seen in the way he juxtaposed rigid geometrical forms and fluid folds. Many couturiers of the 1950s incorporated boning and padding into their dresses, but James went much further, often creating an elaborate infrastructure, encasing the wearer's torso. A virtuoso with fabric, he would then create a superstructure of artfully draped silk and satin.

James is best known for the intricately cut, often asymmetrical ball gowns that he designed in the 1940s and 1950s, which sold at the time for about $1,500, and can easily fetch one hundred times that figure today. The Museum at FIT owns several gowns that James designed for the actress and singer Lisa Kirk, as well as a beautiful example of his most famous dress, the "Abstract" or "Four-Leaf Clover" ball gown. His quilted, padded evening jackets are also justly famous. Although best known for his ability to "sculpt" with fabric, James was also a brilliant colorist, masterfully juxtaposing unexpected colors such as golden yellow and ice blue. A difficult genius, he counted Babe Paley, Mrs. William Randolph Hearst, and Doris Duke among his clients. — *V. S.*

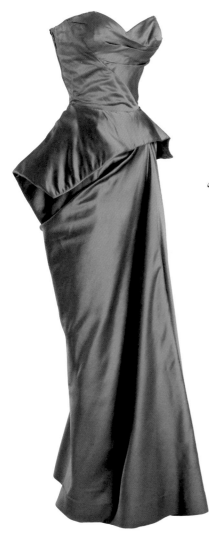

"Charles James is not only the greatest American couturier, but the world's best and only dressmaker who has raised it from an applied art form to a pure art form." — CRISTÓBAL BALENCIAGA

*"The personal quality in Charles James's work is a result of an original sense of cut combined with moulded drapery. The placing of each seam is an anatomic accent emphasized by contrast of colour and texture." —**Vogue***

PREVIOUS SPREAD
Charles James
"Petal" evening dress:
Black silk velvet, black silk
satin, ivory silk taffeta
USA, 1951

ABOVE
Charles James
Dress: Dark emerald-green
silk satin
USA, 1954

OPPOSITE
Charles James
"Four-Leaf Clover" evening
dress: Pink silk taffeta,
pale-pink silk satin
USA, 1953

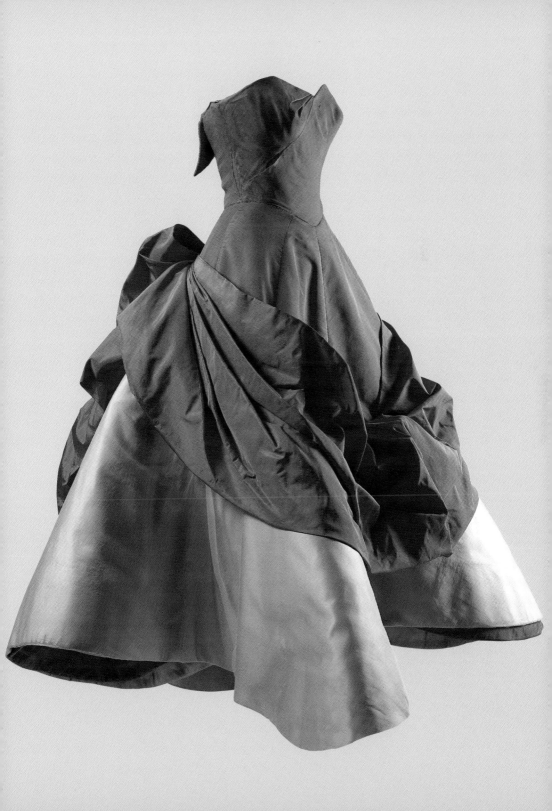

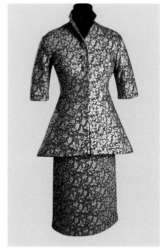

LEFT

Charles James
"La Sirène" evening dress:
Red silk crêpe
USA, ca. 1940

ABOVE

Charles James
"Pagoda" suit:
Red-and-gold metallic floral
brocade
USA, 1955

OPPOSITE

Charles James
"La Sirène" evening dress:
Taupe silk crêpe
USA, ca. 1956

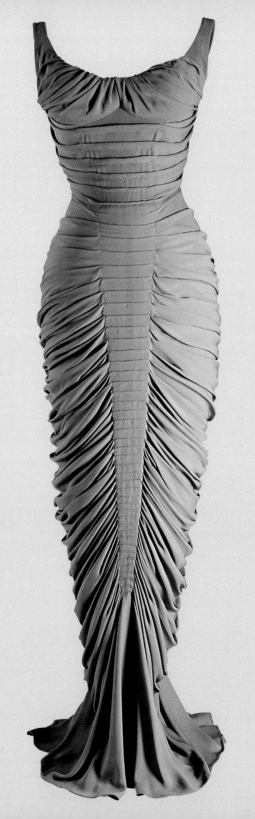

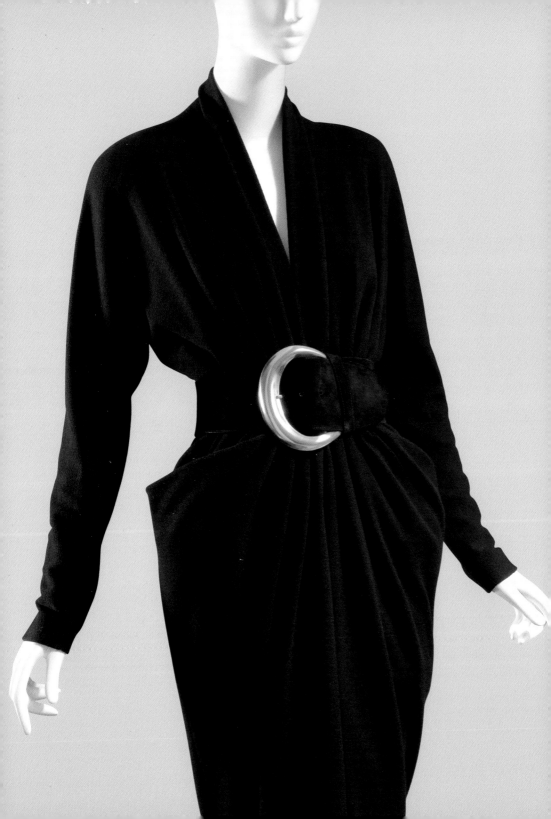

Donna Karan

DONNA KARAN (B. 1948) Donna Karan's father was a custom tailor, and her mother was a model and industry sales-woman. "Basically, I grew up on Seventh Avenue," she has said. A student at Parsons in 1968, Karan left school to work for sportswear designer Anne Klein. Over the next three years, she was fired, rehired, and by 1971 appointed associate designer. During her ten years at Anne Klein, Karan, along with fellow designer Louis Dell'Olio, modernized the company's look.

Karan launched her own label in 1985. She embraced the concept of separates, but her "seven easy pieces" were ideally suited to the urban working woman. Her mix-and-match components were practical and followed the contours of the female body. A bodysuit was often the first layer, and was then combined with other sleek, body-conscious, "easy" pieces such as tights and a wrap skirt. Usually in black or other neutral colors—and rendered in sensual, tactile cashmeres and jerseys—these garments could transition from day to evening with minimal adjustment. Such transformations were often achieved by adding a bold accessory or belt from Robert Lee Morris, a jewelry designer with whom Karan had a longtime collaboration.

In 2005 Karan told writer and editor Ingrid Sischy that she had set out to design for "women, who, like myself, live a hectic life, who are in touch with their own sensuality, who know their own bodies, who know what they want." Karan stepped down as chief designer for her namesake label in 2015. Karan's main line was suspended, and Maxwell Osborne and Dao-Yi Chow of the brand Public School were briefly creative directors of DKNY. —*J. F.*

*"She understands a woman's
body better than her male rivals do.
And she is also totally modern.
Karan is America's Chanel."*

— JOHN FAIRCHILD, PUBLISHER OF *WWD*

Donna Karan
Dress: Black wool knit
Belt: Black suede, gold metal
USA, 1987

Karan frequently collaborated
with jewelry designer Robert
Lee Morris, who created the belt
for this dress.

ABOVE
Donna Karan
Dress: Red silk jersey
USA, 2009

Skilled at draping fabric to
highlight the shape and sensual-
ity of a woman's body, Donna
Karan creates looks that convey
both strength and femininity.

OPPOSITE
Donna Karan
Dress: Dark gray jersey, leather
USA, 2009

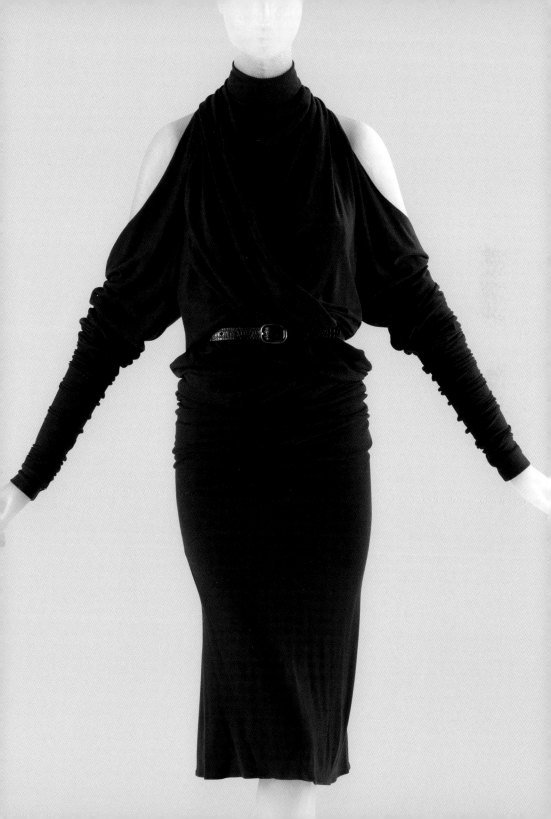

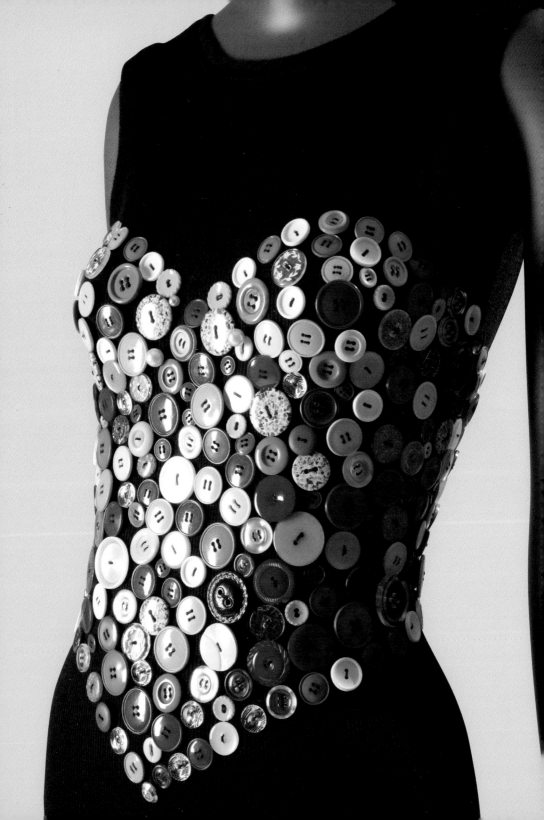

Patrick Kelly

PATRICK KELLY (1954–1990) A Patrick Kelly design is unmistakable: joyful, provocative, and exuberant. Credited as the first American designer admitted to the Chambre Syndicale du Prêt-à-Porter des Couturiers et des Créateurs de Mode, he spent the majority of his professional career in Paris. Although his work was humorous and chic, he also drew design inspiration from his personal experience as a black American, incorporating references to African heritage, African American history, and controversial racist imagery that he reclaimed in his work.

Kelly was born in Mississippi in 1954. His first exposure to fashion and style came through his grandmother, who would be a lasting influence on his design aesthetic. He worked in Atlanta and New York before leaving for Paris in 1979. There he designed costumes for the Palace nightclub and sold his fashions outside boutiques, at flea markets, and to his model friends. These designs—knit tube dresses with colorful and eclectic embellishments—drew the attention of *Elle* magazine, which featured him and his work in a six-page editorial spread in February 1985.

Soon after he established Patrick Kelly Paris with his partner Björn Amelan. In 1987 the company attracted investment from the fashion conglomerate Warnaco, which allowed Kelly to expand his offerings into couture and his sales profits into the millions. Kelly's designs were smart, tongue-in-cheek, and full of attitude, qualities amplified by the energetic fashion shows for which he became known. His clientele included a large range of women from Bette Davis and Grace Jones to the Princess of Wales and Gloria Steinem. Kelly's career was cut short by his untimely death in 1990, however his jubilant, thoughtful, and bold designs had an outsized influence on fashion. —*E. W.*

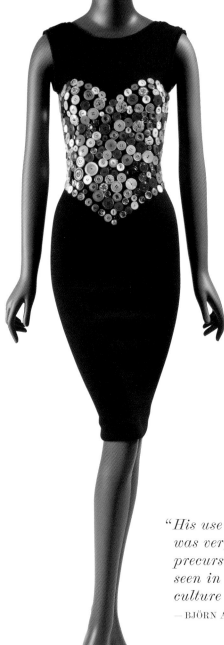

"The heart was his signature, shorthand for 'love', love of women, love of fashion, love of fashion history and the haute couture, and love, as well, of his humble roots in the American South."
— **Laura Jacobs,** *Vanity Fair*

PREVIOUS SPREAD AND LEFT
Patrick Kelly
Dress: Black wool ribbed knit and multicolor plastic
France, fall 1986

OPPOSITE
Patrick Kelly
Dress: Black crushed velvet and gold metal
France, 1987–1988

"His use of very controversial imagery . . . was very original, and it was precursory of a trend that has been seen in African American pop culture and high art ever since."
— BJÖRN AMELAN, ARTIST AND KELLY'S PARTNER

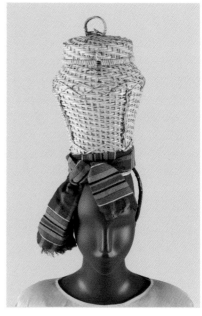

LEFT
Patrick Kelly
Suit and sunglasses:
Gray pinstripe denim,
plastic, and metal
France, spring 1989

ABOVE AND OPPOSITE
Patrick Kelly
Pants and hat: Multicolor
printed spandex, cotton,
and wicker
France, spring 1988

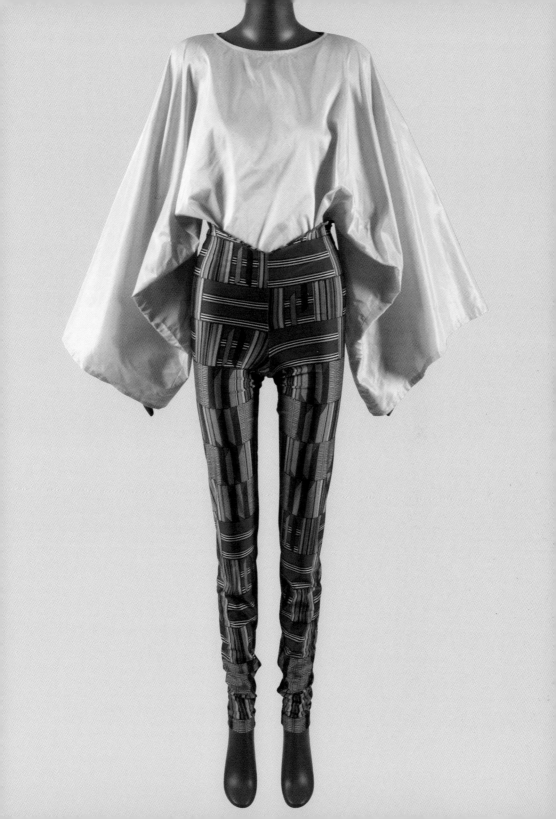

Kenzo

KENZO TAKADA (1939–2020) Credited as the first designer to appropriate the less obvious elements of Japanese dress, such as obfuscation of the body, Kenzo Takada created garments made from yards of billowing cotton fabric that were smocked across the shoulders and breastbone and then fell in full folds around the wearer. His work presaged the 1970s and 1980s trends for oversized sweaters and boxy silhouettes worn by millions, and his smocks served as sources of inspiration for couturiers such as Yves Saint Laurent.

After a short stint at Kobe University, Kenzo enrolled in Tokyo's Bunka Fashion College in 1958, which had only recently opened its doors to male students. After graduating, he moved to Paris, where he began to amass an eclectic collection of textiles acquired from flea markets. As a result, Kenzo's first bold designs were a mélange of fabric pieces sewn together to make one garment. Throughout the 1970s, his collections gained greater media attention as he expanded his company, including his first retail establishment, which he called Jungle Jap. Kenzo retired in 1999.

For all his innovation and influence, Kenzo has remained less well known than his compatriots. His variations on Japanese peasant clothes, such as the *happi*, incorporated bright floral fabrics rather than the frayed, deconstructed, and dark aesthetic typically associated with Japanese fashion design. Nonetheless, his breezy and whimsical folkloric styles set fashion on a new course.

LVMH, the French-based fashion conglomerate, purchased the Kenzo name in 1993. By 2003 the Sicilian-born designer Antonio Marras had been hired to design the women's line, and was named creative director in 2008. In July 2011 Opening Ceremony founders Humberto Leon and Carol Lim took over from Marras. After their departure in 2019, Felipe Oliveira Baptista joined the label on a short-term contract. Kenzo Takada died in 2020 at the age of eighty-one. —*P. M.*

"One needs a lot of folly to work in fashion."
— KENZO

Antonio Marras
(b. 1961)

"Fashion is like eating, you shouldn't stick with the same menu—it's monotonous. You need changes in your dress and your food to have changes in your spirit." — **Kenzo**

PREVIOUS SPREAD
Kenzo
Dress: Multicolor printed cotton
France, ca. 1982

OPPOSITE
Kenzo (Antonio Marras)
Ensemble: Cotton canvas; linen; floral-printed silk gauze; pink, blue, and chartreuse cellophane appliqué; sequins
France, 2011

FOLLOWING SPREAD
Kenzo (Antonio Marras)
Ensemble: Beige silk crêpe chiffon; blue, lavender, and green organza appliqué; jade-green silk satin
Platform sandals: Jade-green silk satin and leather; pink patent leather
France, 2011

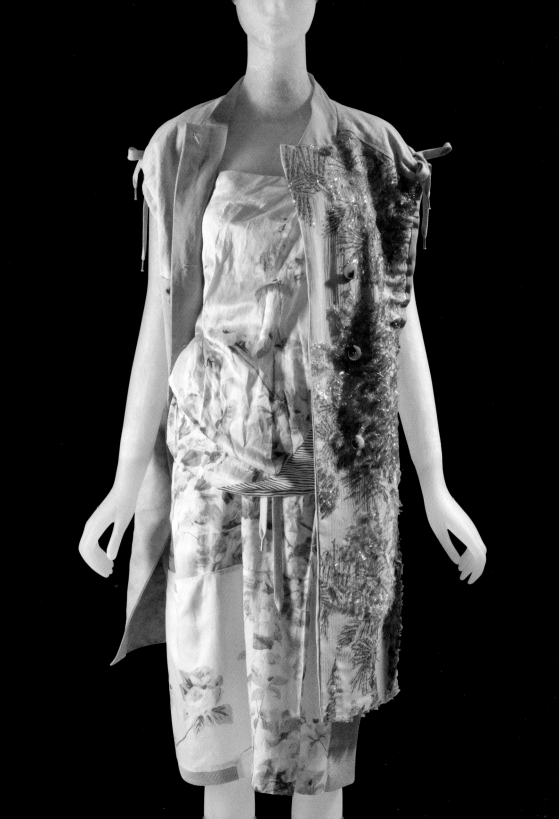

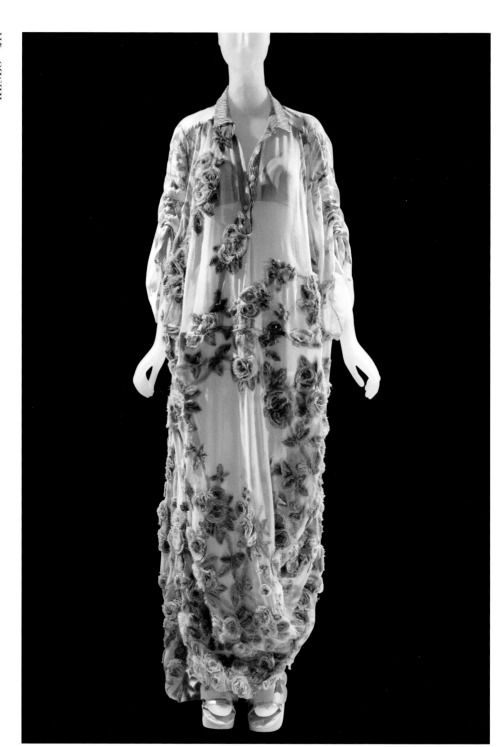

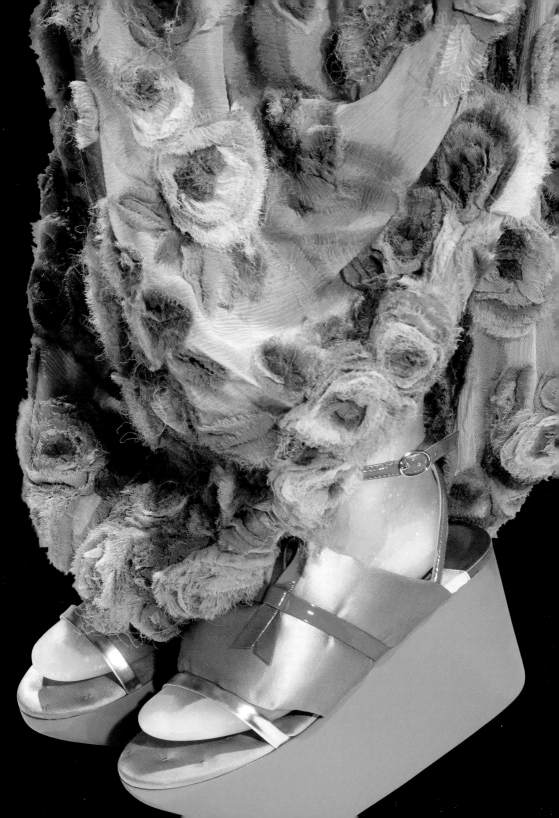

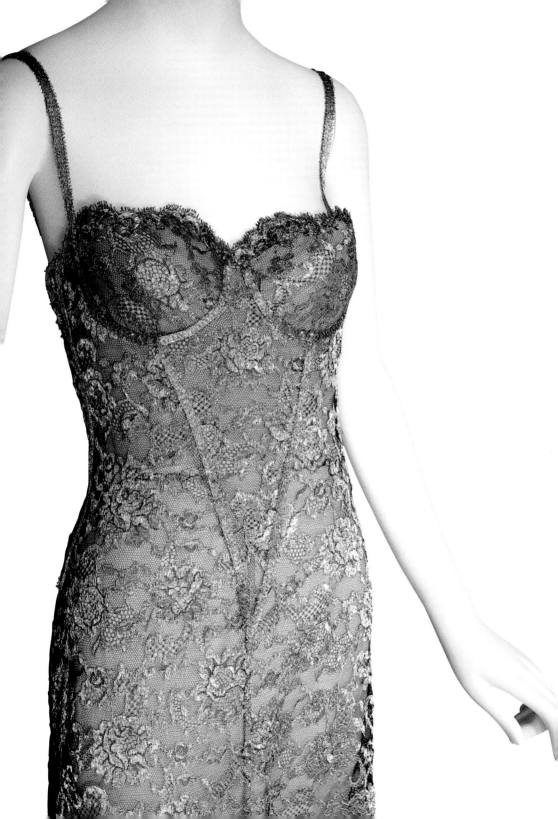

Calvin Klein

CALVIN KLEIN (B. 1942) From the clean-cut coats and suits that launched Calvin Klein's career to the architectural designs of Francisco Costa, the Calvin Klein label has become synonymous with streamlined clothes, muted color palettes, and an apparent simplicity of design. These elements compose fashion designer Calvin Klein's unified vision. His label is an American lifestyle brand, and Klein has earned his reputation as the supreme master of minimalism.

A graduate of FIT, native New Yorker Calvin Klein founded his company in 1967. While Klein's first success was with coats and suits, he quickly broadened his repertoire with sophisticated no-frills American sportswear. Klein is known for using luxurious fabrics in subdued colors, and his signature looks include the pea coat, day-into-night dressing, T-shirts adapted for evening wear, and the slip dress.

Klein's controversial advertising campaigns of the 1980s and 1990s also put him at the center of American cultural life. His 1980 jeans campaign, featuring fifteen-year-old model-actress Brooke Shields, aggressively championed youth and sexuality. During the 1990s, provocative underwear ads featuring Kate Moss and Mark Wahlberg further added to the company's visibility by associating the Calvin Klein label with iconic sexiness.

In 2001 Calvin Klein stepped down as creative director of his company and hired the Brazilian-born Francisco Costa as a designer. In 2003 Costa became Klein's successor when he was named women's creative director of the Calvin Klein Collection. From 2015 to 2018, the Belgian designer Raf Simons joined Calvin Klein as chief creative officer. Jessica Lomax currently leads Calvin Klein's global design strategy. —M. M.

*"Minimalism is spare but really rich;
I find it quite exciting."*
— FRANCISCO COSTA

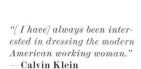

**Francisco Costa
(b. 1964)**

*"[I have] always been inter-
ested in dressing the modern
American working woman."*
— **Calvin Klein**

PREVIOUS SPREAD
Calvin Klein
Evening dress: Metallic
Chantilly lace, chiffon
USA, 1992

OPPOSITE
**Calvin Klein Collection
(Francisco Costa)**
Evening sheath:
Peach knit jersey
USA, 2008

ABOVE
**Calvin Klein Collection
(Francisco Costa)**
Ensemble: Black wool, gray
silk charmeuse, black crystal
paillettes
USA, 2008

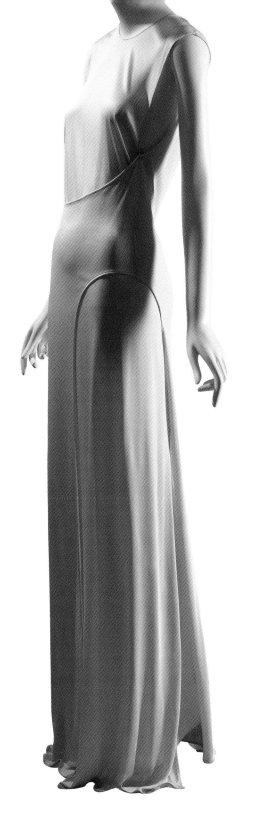

ABOVE
**Calvin Klein Collection
(Italo Zucchelli)**
Man's ensemble: Black wool
blend, black polyester
USA, 2010

Menswear designer Italo
Zucchelli provides a tough
edge to the minimalist
aesthetic and sleek, stream-
lined design for which the
brand is known.

OPPOSITE
Calvin Klein
Ensemble: Navy blue
Melton wool
USA, ca. 1970

Michael Kors

MICHAEL KORS (B. 1959) The name Michael Kors has become synonymous with the best attributes of modern American fashion: clean, sporty elegance and comfortable, easy luxury. Although he follows in the footsteps of past masters who built strong, one-on-one relationships with their clients, such as Norman Norell and Bill Blass, Kors is a thoroughly contemporary creator who has also built one of the most financially successful fashion companies in the world, with a robust retail business and a commanding digital operation.

A self-professed "fashion addict" in his youth, Kors studied briefly at the Fashion Institute of Technology in New York City before designing and merchandising his first collection for a small boutique at age nineteen. In 1981 Kors launched the Michael Kors womenswear line, which sold at leading retailers. Less than a decade later, however, his company was forced to reorganize under Chapter 11 bankruptcy.

After rebuilding his company, Kors launched lower-priced lines, moved into menswear, and focused strongly on his accessories line. In 1997 French fashion house Céline named him to be its first women's ready-to-wear designer. Building on his success, he left in October 2003 to focus on his own brand, and began to build freestanding boutiques around the United States.

His work as a designer has been acknowledged by the fashion industry. In 1999 he won the Council of Fashion Designers of America (CFDA) award for womenswear designer of the year. In 2003 Kors earned the CFDA award for menswear designer of the year. In June 2010 Kors was the youngest recipient ever of the Geoffrey Beene Lifetime Achievement Award from the CFDA and received the Fragrance Foundation's FiFi Award for Lifetime Achievement. —P. M.

*"I've had enough of trends. As far as
I'm concerned all a woman needs today
is a black turtleneck, black mini,
and a long black coat."* — MICHAEL KORS

*"I think to be empathetic is the
greatest gift you can have as a
designer. Hopefully, people will
look at me and say, 'He really
loved women.'"*
— **Michael Kors**

PREVIOUS SPREAD
Céline (Michael Kors)
Evening dress: Off-white silk,
sequins, bugle beads
France, 1998

LEFT
Céline (Michael Kors)
Evening dress: Black silk,
sequins, bugle beads
France, 1998

OPPOSITE
Michael Kors
Jacket and pants:
Black linen gauze
USA, 1993

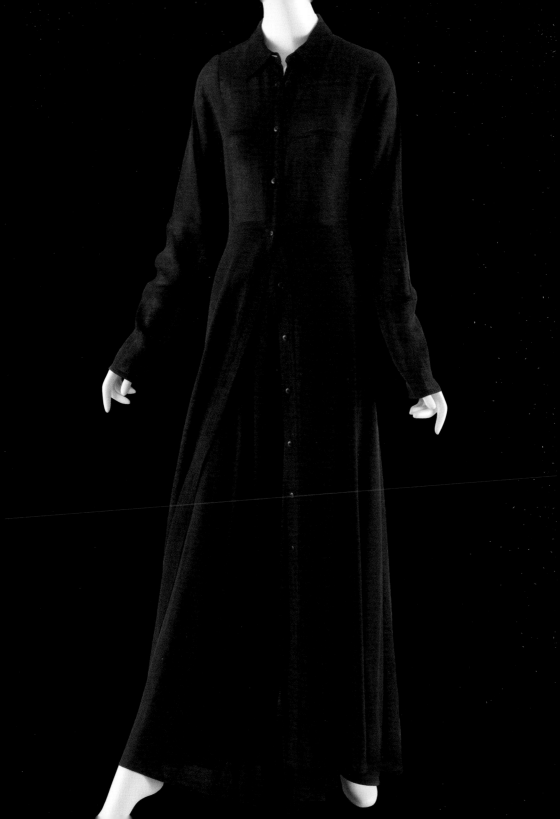

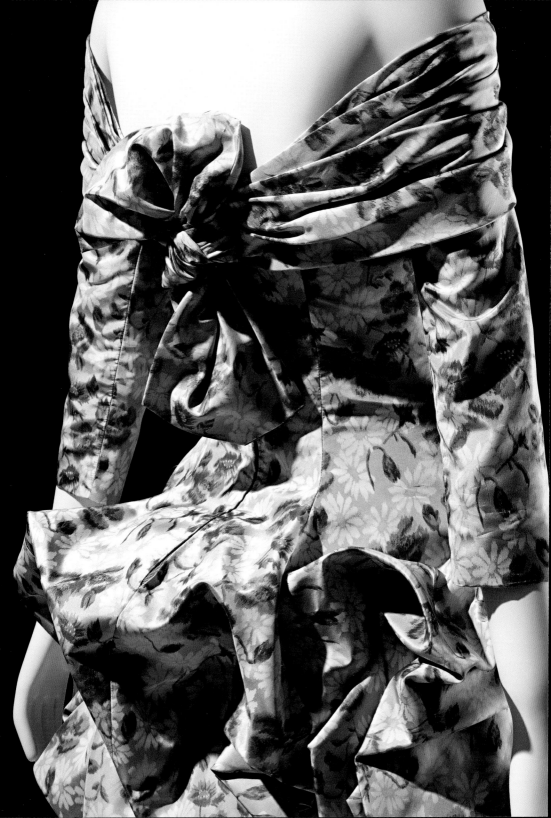

Christian Lacroix

CHRISTIAN LACROIX (B. 1951) With a background in art history and coursework in museum studies at the École du Louvre, Christian Lacroix could have become a curator. Ultimately, however, he became "couture's mad pouf-and-bustle man," as *Women's Wear Daily* affectionately called him in February 1987.

Although he worked briefly at Hermès and Guy Paulin, it was at the House of Patou, from 1981 through 1987, that Lacroix first made his name, designing the aforementioned bouffant styles. He left Patou to found his own couture house, and his first collection, in July 1987, was hugely successful. As he recalled in his autobiography, *Pieces of a Pattern*: "We seemed to have uncovered a latent desire for a return to the luxury, playfulness and excesses of haute couture." Lacroix designed both couture and ready-to-wear through fall 2009.

Lacroix's inspirations have been varied, but one recurring and dominant element of his design oeuvre is his nostalgic interpretation of fashion history. Other strong influences include folklore, Spain, and his upbringing in Arles, France, which Lacroix once described as a place "where the past rubs shoulders with the present." He spoke particularly of his passion for Arles's "mixtures and contrasts." Indeed, mixtures and contrasts—of bold color, pattern, and seemingly incongruous details—are often the elements that make Lacroix's designs extraordinary.

A love for the dramatic and the sumptuous is evident throughout Lacroix's work, but his fashion should not be characterized as simply theatrical. "I shall always oscillate between a chaste delight in purity of form and a rapturous intoxication with ornamentation," he mused, "for couture is both these things at the same time." —*J. F.*

"Couture is a kind of laboratory where everything is allowed. You propose shapes and proportions without thinking about prices." — CHRISTIAN LACROIX

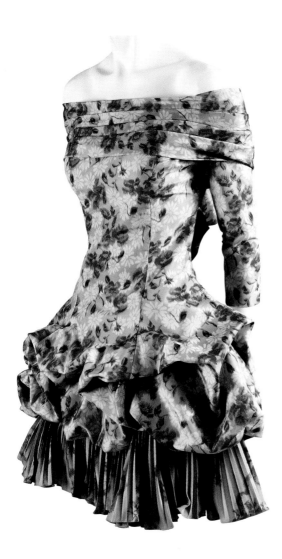

"Since he knows all the good things that have happened in history, when women lived to look beautiful, he has a bigger vocabulary than a normal contemporary couturier. Any one of them has available to him the best embroiderer or flower maker, but Lacroix probably has a bigger sense of the possibilities from having directly studied the past."
— **Caroline Rennolds Milbank,** *Time*

PREVIOUS SPREAD AND LEFT
Christian Lacroix
"*À la folie*" evening dress:
Multicolor printed silk taffeta
France, 1988

The floral textile used on this Lacroix couture dress was printed exclusively for the designer.

OPPOSITE
Christian Lacroix
Evening dress:
Brown silk chiffon
France, 2005

"The fact that I am known as the 'colour couturier' has always been a source of surprise and amazement to me," wrote Lacroix in his book *Christian Lacroix On Fashion*. With this romantic chiffon dress, he evokes the subtle, shadowy hues of twilight.

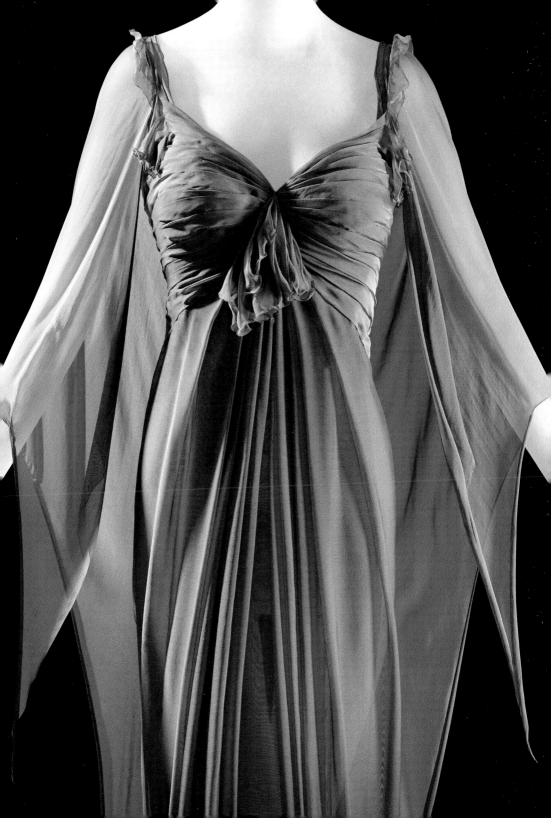

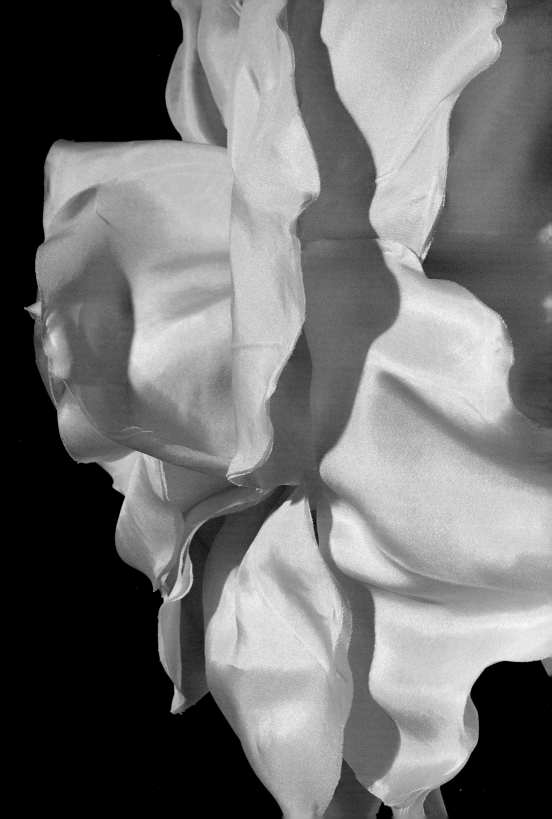

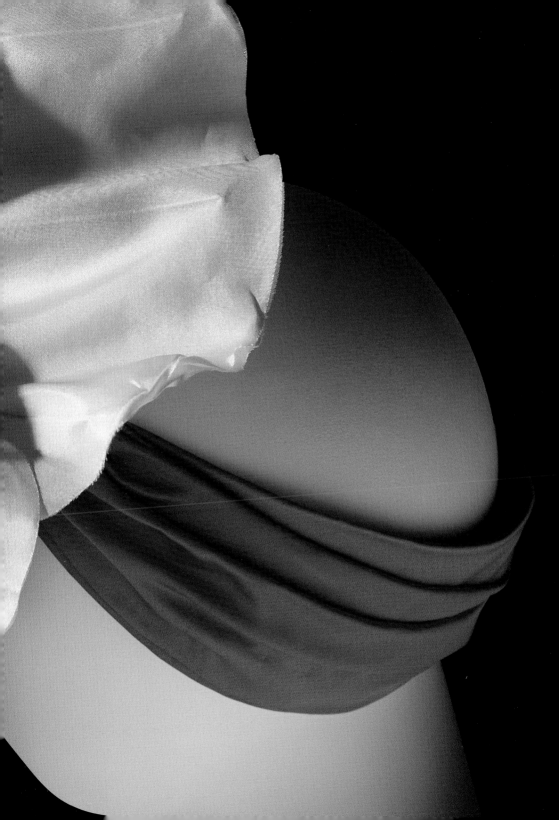

PREVIOUS SPREAD
Patou (Christian Lacroix)
Hat: Pink and magenta
silk satin
France, 1986

BELOW
Christian Lacroix
Beachwear ensemble:
Multicolor stretch nylon, silk
chiffon, metallic synthetic
straw, plastic, metallic leather
France, 1990

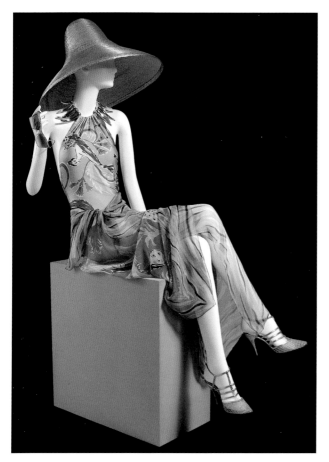

ABOVE
Christian Lacroix
Brooch: Gold metal,
rhinestones
France, 1991

OPPOSITE
Christian Lacroix
Evening dress:
Turquoise silk satin
France, ca. 1988

FOLLOWING SPREAD
Christian Lacroix
Evening dress: Orange silk
faille, orange silk satin,
rhinestones
France, 2005

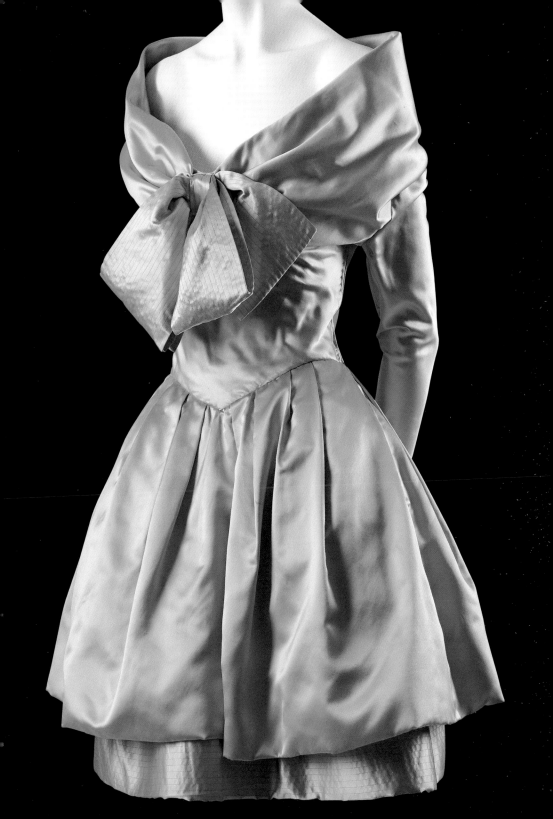

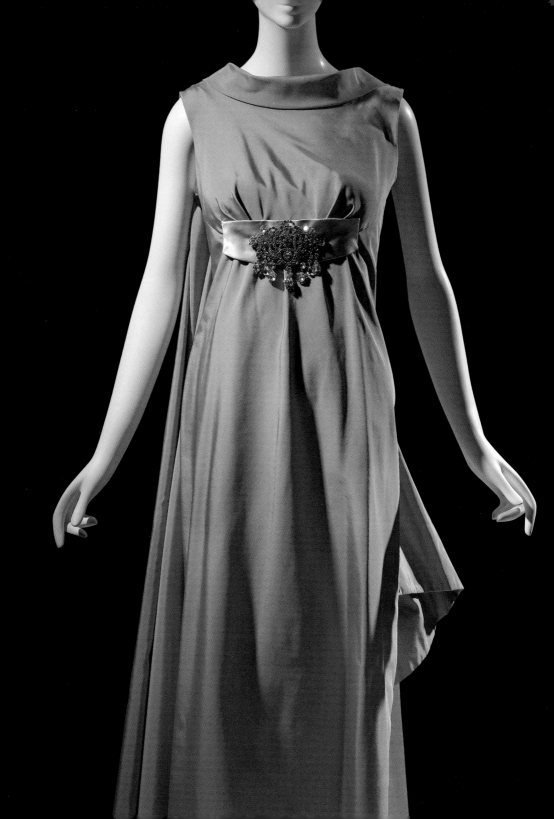

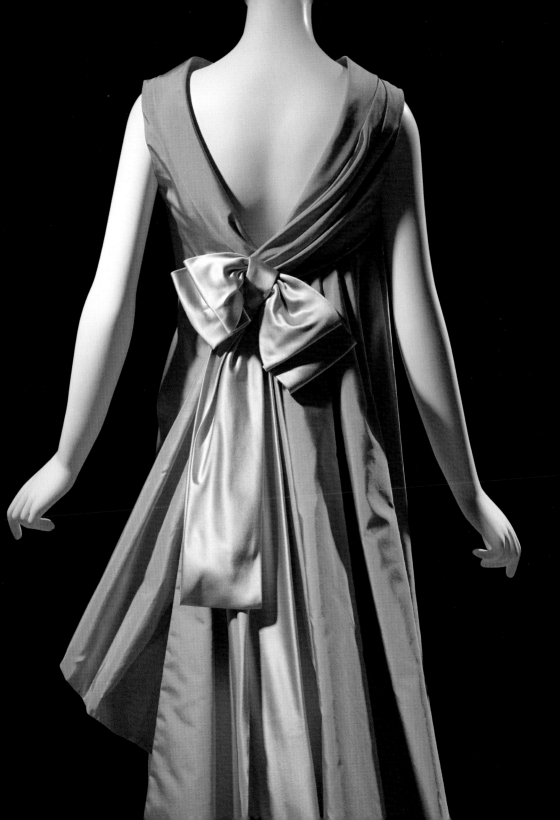

Karl Lagerfeld

KARL LAGERFELD (1933–2019) was one of the most prolific designers working in fashion. Producing more than twenty collections a year, he was the main creative force behind the major fashion labels Chanel and Fendi, as well as his signature label, Karl Lagerfeld. Often described as a postmodernist, Lagerfeld combined historical references with modern-day trends, reinvigorating labels and winning him much acclaim.

Born in Hamburg, Germany, Lagerfeld developed an affinity for fashion at an early age. In 1954 he competed in an international design competition where he won an International Wool Secretariat award in the coat category. He began his career working for the couturiers Pierre Balmain and later Jean Patou, eventually leaving couture for the ready-to-wear business. Believing ready-to-wear offered him greater artistic freedom, he began working as a freelance designer in the 1960s, counting Chloé, Krizia, and Fendi among his clients.

In 1965 he began designing fur collections for Fendi. However, it was his designs for Chloé that brought him the most acclaim, and eventually landed him the role of chief designer. By the 1970s Lagerfeld's work for Chloé, marked by streamlined silhouettes and striking geometric prints, embraced the mood of the decade and established him as a leading international designer. In 1983 Lagerfeld was hired to design for Chanel, and two years later he launched his own Karl Lagerfeld and KL lines.

Lagerfeld's talents extended beyond fashion to photography and illustration. He has also designed bottles for Coca-Cola, a piano for Steinway's 150th anniversary, and he was the first designer to produce a signature capsule collection for the Swedish retailer H&M. "I'm a walking label," he once remarked, "My name is Labelfeld, not Lagerfeld." —*M. M.*

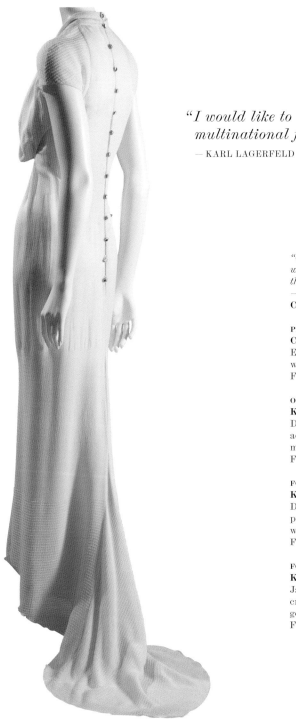

"I would like to be a one-man multinational fashion phenomenon."
— KARL LAGERFELD

"Of all the stylistes I have worked with, Karl was the real intellectual."
— **Gaby Aghion, founder of Chloé**

PREVIOUS PAGE AND LEFT
Chloé (Karl Lagerfeld)
Evening dress: White chiffon, white cotton knit
France, ca. 1977

OPPOSITE
Karl Lagerfeld
Dress and jacket: Black acetate/viscose crêpe, metal filigree button
France, 1991

FOLLOWING SPREAD, LEFT
Karl Lagerfeld
Dress and coat: Multicolor printed wool gabardine, wool crêpe
France, 1984–1985

FOLLOWING SPREAD, RIGHT
Karl Lagerfeld
Jacket and skirt: Black silk crêpe de chine with multicolor geometric print
France, 1984–1985

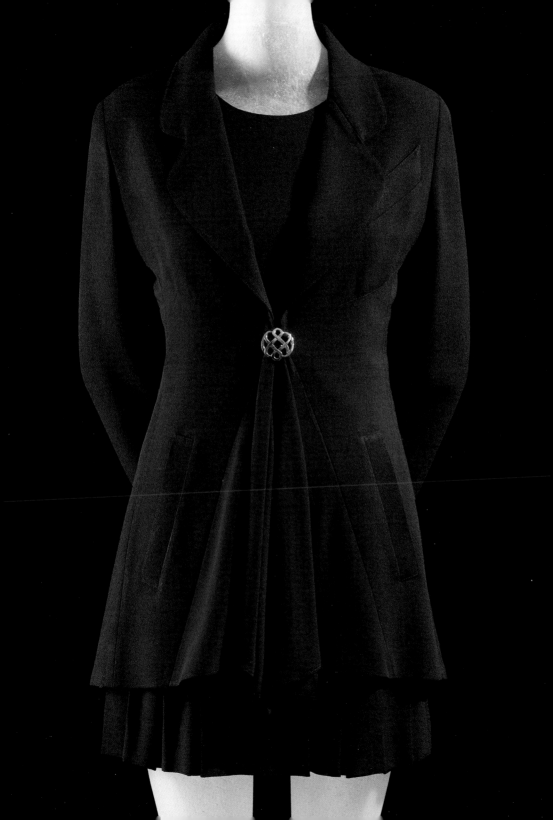

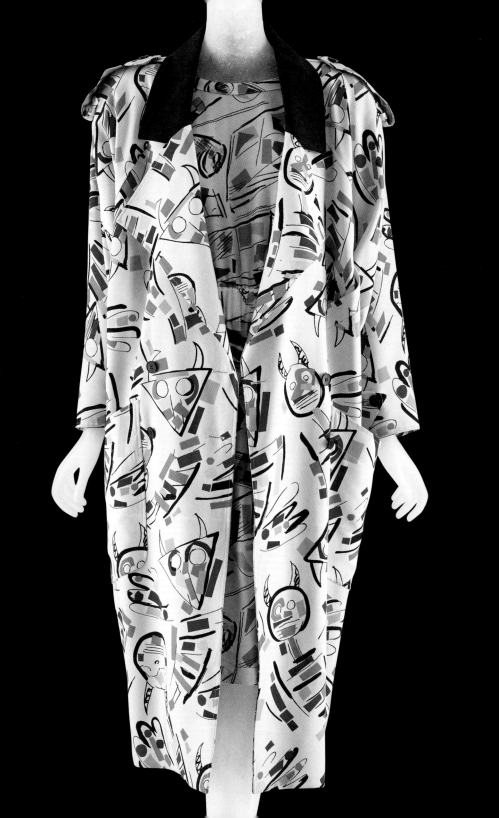

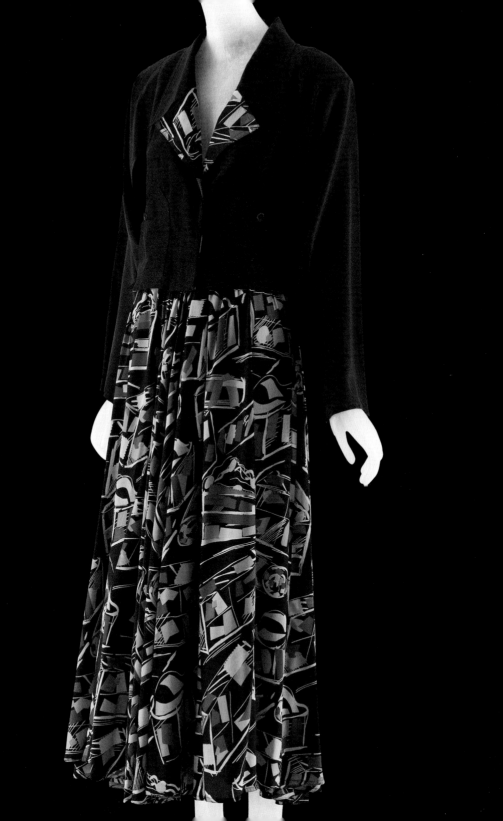

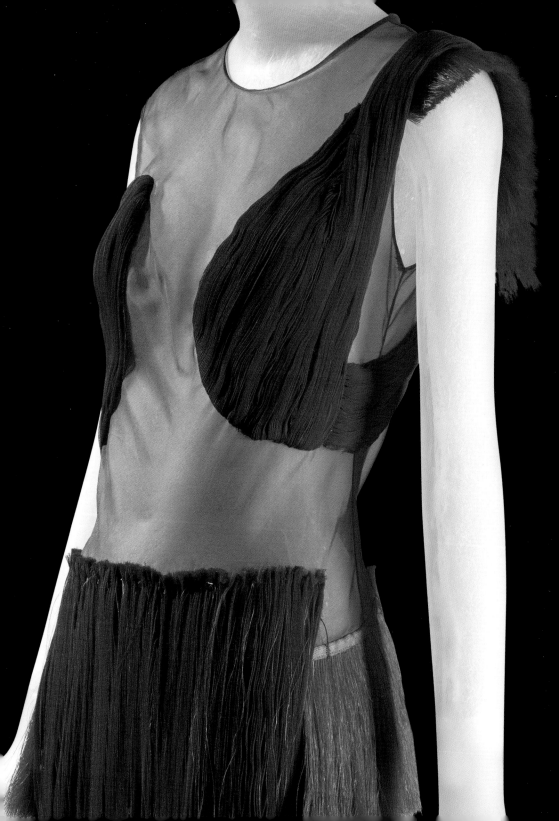

Helmut Lang

HELMUT LANG (B. 1956) was among the first proponents of what is sometimes called the minimalist aesthetic that dominated the 1990s. In 1997 he became the first designer to transplant a major fashion house from Europe to America. By the close of the twentieth century, this Austrian-born designer had become a titan in the world of fashion.

During his heyday in the 1990s, Lang expanded his empire by consistently hitting the pop-culture mark. Upon his arrival in the United States, he chose unorthodox advertising sites such as the tops of New York City's yellow cabs, which were emblazoned with his label. He also became the first designer to run seasonal ad campaigns in *National Geographic* and *Artforum* magazines.

In 1998 Lang abandoned the live fashion show, and decided to livestream his new designs online. Next, he chose to show his spring 1999 collection in advance of the European shows, a breathtakingly bold move that rocked the New York fashion establishment. Immediately, top names like Calvin Klein followed suit. This American leadoff of the international biannual showings has resulted in heightened visibility on the eastern side of the Atlantic.

Lang's conceptual approach extends beyond even his most famous product: the androgynous, functional, razor-sharp suit. For fall 1999, Lang envisioned a high-tech uniform in orange or silver leather, lined with interior straps that turn the jacket into a cloak. Later collections drew on a wide range of inspirations—from marine-biological inspirations to surf references and Eastern European influences. Lang retired from fashion in 2005, and now works as an artist. —*P. M.*

"I approach a piece with a perception or an idea, which then is condensed and layered, broken up and again collected and suddenly taken over by another. It becomes an interactive struggle for balance for the importance of form and the importance of content." — HELMUT LANG

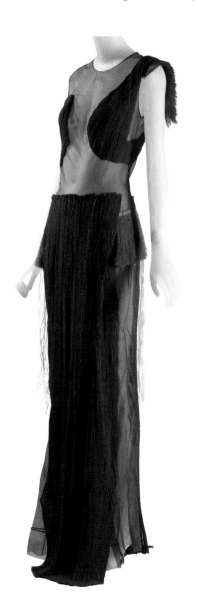

PREVIOUS SPREAD AND LEFT
Helmut Lang
Evening dress: Red silk chiffon,
nylon horsehair
USA, 2004

OPPOSITE
Helmut Lang
Ensemble: Brown, white,
and gray silk organza;
white nylon; plastic
USA, 2003

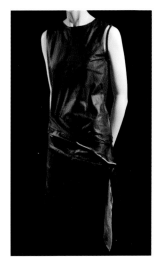

Helmut Lang
Dress: Black polyester,
silk satin, chartreuse silk
gauze
USA, 1997

Born in Austria in 1956, Helmut
Lang established himself as a
designer in Paris before moving
to New York in 1997. A fashion
minimalist, Lang produced
sophisticated, androgynous
interpretations of utilitarian
clothes that appeal to both
men and women.

Helmut Lang
Dress:
Pink polyester chiffon,
white cotton jersey
USA, 1998

Helmut Lang
Ensemble: Black-and-
white cotton knit,
cotton, chiffon, organza
USA, 2003

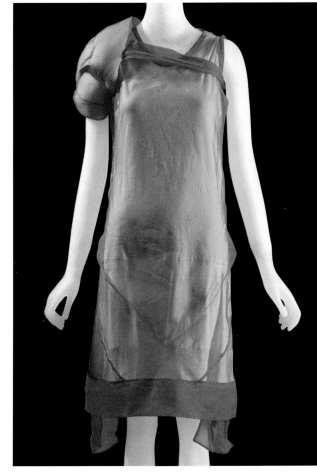

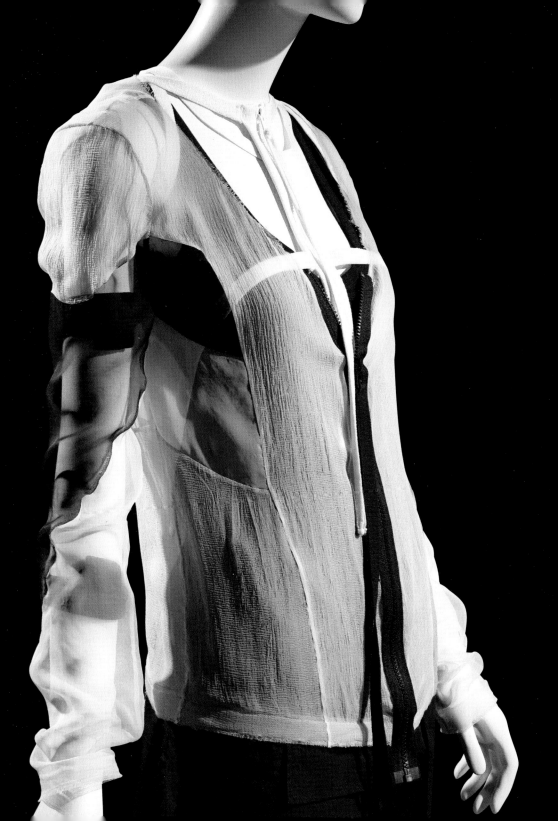

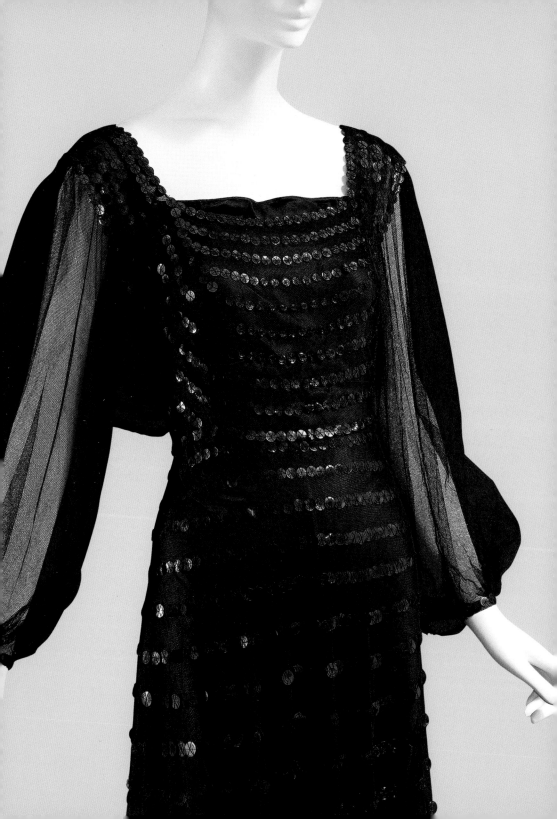

Lanvin

JEANNE LANVIN (1867–1946) The House of Lanvin's symbol is based on a photograph of designer Jeanne Lanvin and her child, Marguerite Marie-Blanche. It is an apt brand image, for their relationship was central to Lanvin's success. Marguerite was her mother's primary inspiration.

Trained as a seamstress, Jeanne Lanvin opened her own millinery salon in 1889. In 1908, at the behest of customers who greatly admired the clothing she made for her daughter, Lanvin began designing children's wear. In 1909 she introduced her first womenswear collection. Over the years, her business grew to include sportswear, menswear, and fragrance.

The *robe de style* of the 1920s is perhaps Lanvin's most famous design. Supremely romantic, this ultrafeminine dress with a low waistline, full skirt, and side panniers was evocative of an eighteenth-century gown. Often adorning the *robe de style* were lavish embroideries, appliqués, or beaded designs, features for which the House of Lanvin was well known. Lanvin also drew influences from other cultures, particularly Japan and China, and hints of exoticism are often present in her designs. In the 1930s, she continued her imaginative and expert use of embellishment and surface texture.

The House of Lanvin survived the 1946 death of its founder, and continued to produce couture collections until 1993. Alber Elbaz served as artistic director for the House of Lanvin from 2001 to 2015. His work was ideally suited to a house so long equated with romance, youth, and femininity. Bouchra Jarrar was appointed creative director in 2016, followed by Olivier Lapidus in 2017, and Bruno Sialelli in 2019. —*J. F.*

"*Mme. Jeanne Lanvin is the dean of
the great couturières of Paris.*"
— JANET FLANNER, *LADIES' HOME JOURNAL*

Alber Elbaz (b. 1961)

PREVIOUS SPREAD
Jeanne Lanvin
Evening dress: Black synthetic
tulle, satin, plastic sequins
France, ca. 1935

The House of Lanvin was known
for exquisite embellishments,
such as the paillettes on this
dress, which are stacked in grad-
uated sizes and add dimension
to the delicate tulle.

*"There are many designers
whose work can make women
look thinner or prettier.
Elbaz seems to have the power
to make women appear more
interesting."*
— **Ariel Levy, *The New Yorker***

OPPOSITE
Jeanne Lanvin
Evening jacket:
Yellow silk satin, silver lamé
France, 1937

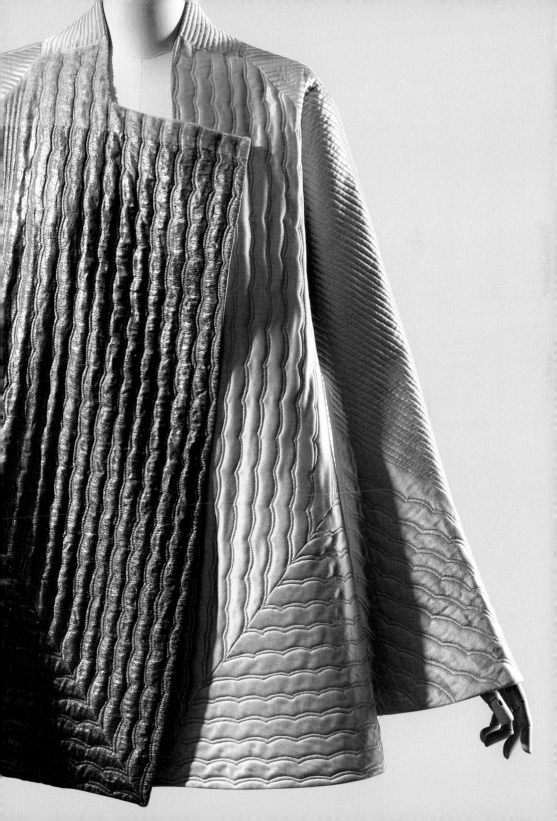

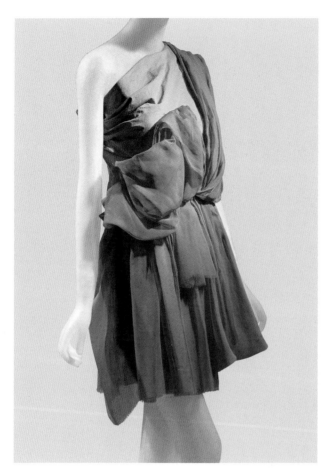

LEFT
Lanvin (Alber Elbaz)
Dress: Tan cotton
and pink polyester organza
France, 2010

BELOW
Jeanne Lanvin
Dress: Pink cotton organdy,
cotton net
France, ca. 1930

OPPOSITE
Lanvin (Lanvin-Castillo)
Evening dress and coat:
Black silk satin
France, ca. 1959

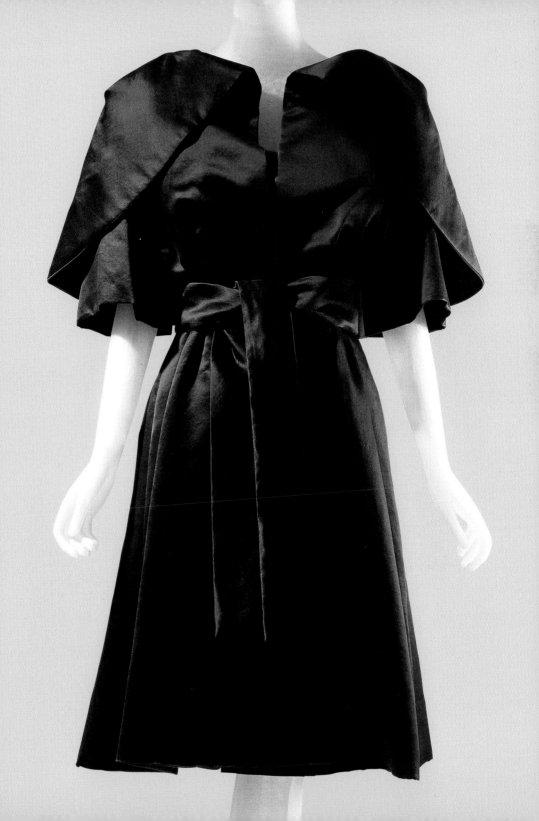

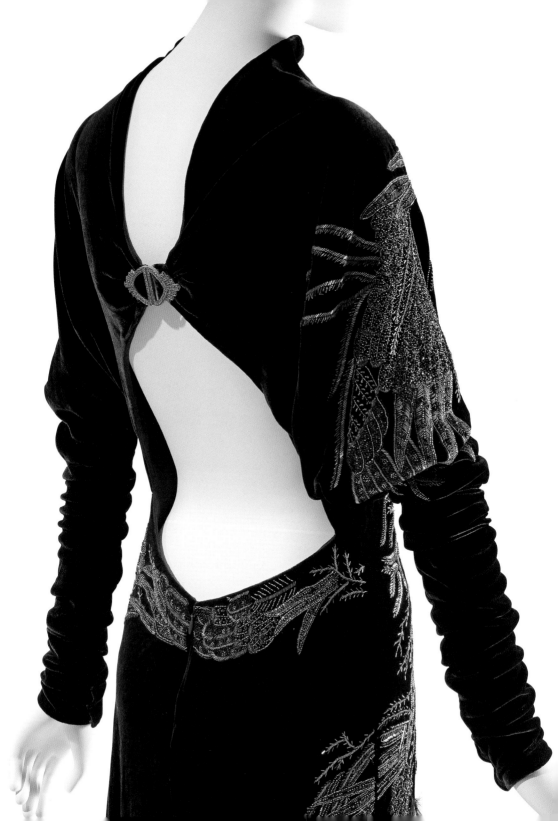

Ralph Lauren

RALPH LAUREN (B. 1939) Over the past half century, Ralph Lauren has built one of the world's most successful fashion and lifestyle brands, cultivating the iconography of America into a global lifestyle corporation. Whether taking inspiration from the rusticity of the New England coast, the natural beauty of the Southwest, or the glamour of Hollywood, his collections for men and women, their children and homes embody an expression of timeless style recognized and celebrated around the world.

Born in New York, Lauren grew up in the Bronx. He didn't know he was going to become a designer, but he knew he had something to say, a passion for living that he was able to express through clothes. In 1967, working alone at a single desk in the Empire State Building, Lauren designed a unique collection of wide ties that transformed the way men dressed. A full line of menswear soon followed, combining the feel of custom-tailored European suiting with an American sportswear sensibility. By 1972 he had won his first Coty award and launched a full line of womenswear, inspired by his men's collections.

Over the next few decades, the company expanded to include fragrances, clothes for children, and bedding, furniture, and accessories for the home. His women's collection walked the runway and his men's Purple Label took sartorial dressing to a new level of luxury. Consistent throughout the company's growth was Lauren's commitment to quality, a respect for heritage, and a love of the American dream.

Today Ralph Lauren is one of the world's most innovative design and business leaders and a true cultural icon. He is still the only designer to receive the Council of Fashion Designers of America's four highest honors—Womenswear Designer of the Year, Menswear Designer of the Year, Retailer of the Year, and the Geoffrey Beene Lifetime Achievement Award—as well as the CFDA's Humanitarian Leadership Award. In June 2007 the CFDA awarded him the first-ever American Fashion Legend Award. In 2015 *The New York Times* reported that Ralph Lauren was stepping down as CEO, but intended to remain active as executive chairman and chief creative officer.

"What I do is about living. I've always believed one could live many lives through the way we dress and the places we travel to, even just in our imagination."
— RALPH LAUREN

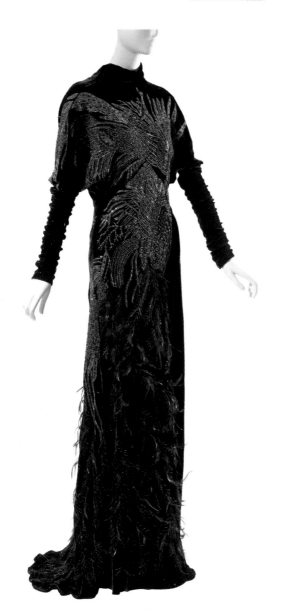

"For me, Ralph Lauren is the American designer. He made the American dream accessible to many people. It's a vision of perfect America, happy America, pleasant America—an America of quality with a strong identity."
— **Karl Lagerfeld**

PREVIOUS SPREAD AND LEFT
Ralph Lauren
Evening dress: Purple velvet, gold beading, metallic gold-bullion embroidery, feathers, sequins, rhinestones
USA, 2008

OPPOSITE
Ralph Lauren
Evening dress: Lamé, embroidered tulle, silver metallic beading, glass beads, rhinestones
USA, 2007

Lucien Lelong

LUCIEN LELONG (1889–1958) was a highly influential and respected arbiter of taste for three decades. Although he did not actually design, he oversaw and approved every product with the Lelong name, including perfumes, jewelry, and accessories. He also helped to launch the careers of several exceptionally talented designers, including Pierre Balmain, Christian Dior, and Hubert de Givenchy.

Lelong's parents owned a small, elite couture house. Their son took over the family business after serving in the First World War, and his work was soon featured in leading French fashion magazines. By 1925 he employed nearly 1,200 people—double that of most other prominent couturiers.

That same year, Lelong introduced his concept of "kinetic" clothing. Designed with the needs of the modern woman in mind, the clothes featured soft fabrics and pleating that allowed for ease of movement. They established Lelong as a leader in sportswear. In 1927 Lelong married Natalie Paley, an exiled Russian princess. A modishly thin, stunning beauty, Princess Paley was Lelong's leading model and ambassador throughout their ten-year marriage.

Lelong saw considerable success in the 1920s, but the 1930s are regarded as his heyday. His clothing moved in a more classical direction, and he embraced supple bias-cut fabrics. In 1937 the couturier was elected president of the Chambre Syndicale de la Haute Couture. When war was declared two years later, it was Lelong's unwavering leadership skills that kept the haute couture industry alive in Paris. Although Lelong resigned from his post in 1945, he was named an honorary chairman for life. Beset by health problems, Lelong closed his house in 1948 and retired to Biarritz, where he remained until his death ten years later. —*C. H.*

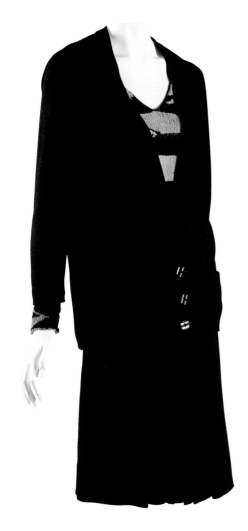

"The more elegant French women appear, the more our country will show that it is not afraid to face the future." — LUCIEN LELONG, DURING THE GERMAN OCCUPATION

"Couturiers instinctively work with volumes to free the forms within them, just like architects and sculptors; and like them, we strive for perfection through a process of progressive refinement."
— **Lucien Lelong**

PREVIOUS SPREAD
Lucien Lelong
Peignoir: Ivory silk chiffon, satin, and ecru lace
France, ca. 1948

ABOVE
Lucien Lelong
Suit: Black wool jersey, black and off-white wool
France, ca. 1927

This casual yet sophisticated suit demonstrates the sporty, functional style Lelong referred to as "kinetic" design.

OPPOSITE
Lucien Lelong
Evening dress: Black silk satin
France, ca. 1938

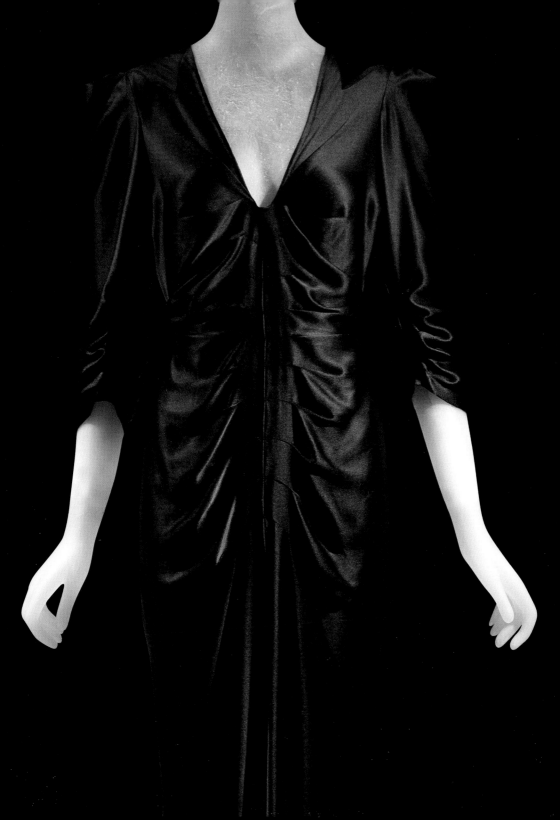

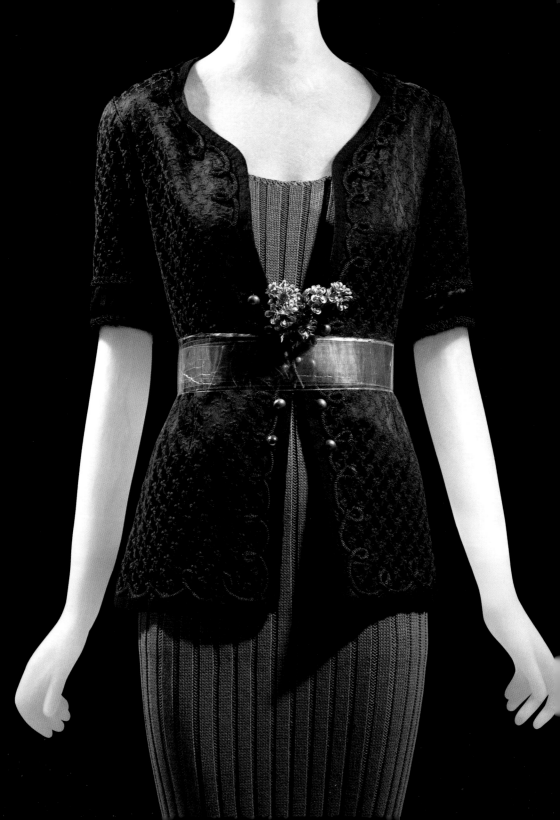

Martin Margiela

MARTIN MARGIELA (B. 1957) In 1989 a contingent of young designers from Antwerp, Belgium, shook the high-fashion world. The most revolutionary among them was Martin Margiela. His new designs looked as if they had been pulled apart, while components like sleeves and pockets were inverted and displaced, then reconstructed with the interfacings and raw edges deliberately on view. Interior elements that are usually carefully hidden, such as linings, shoulder pads, interfacings, and padding, became both structure and ornament for Margiela. These reconfigured elements reflected Margiela's appreciation for reclamation.

Margiela studied fashion design at Antwerp's Royal Academy of Fine Arts. Prior to launching his company Maison Martin Margiela in 1988, he worked as a freelance designer. Between 1997 and 2003, he became a creative director at the venerated House of Hermès.

Margiela is a notoriously elusive figure, and even his clothing labels were discreet: a piece of cloth, printed with only a number from zero to twenty-three (to denote a specific line), is attached to the inside with four little white pick stitches that are visible on the outside of unlined garments. After his company was acquired by the Diesel brand in 2002, Margiela slowly began to retreat from his designer role. By 2009 his break from his company was formally announced.

Margiela has been deconstruction's most catholic practitioner. From his first runway show, held inside a crumbling building in a Parisian working-class neighborhood in 1989, to his seminal 1997 exhibition highlighting items from his archives that he coated in mold and bacteria, to his most recent jewelry pieces made from the crystal drops of old chandeliers, he stands as the preeminent master of redefining beauty through an aesthetic that suggests rag-picking and recuperation. Indeed, Bill Cunningham from *The New York Times* has credited him with the "overthrow of the old regime of fossilized elegant taste." Martin Margiela left his namesake company in 2009. The collections were designed by his atelier staff until the hiring of John Galliano in 2015. —*P. M.*

"He has influenced a whole generation of designers, and will influence generations to come. The frayed hems, the visible darts, he has invented a whole new vocabulary, a vocabulary of construction. Martin Margiela changed the way we make clothes."
— SOPHIA KOKOSALAKI, DESIGNER

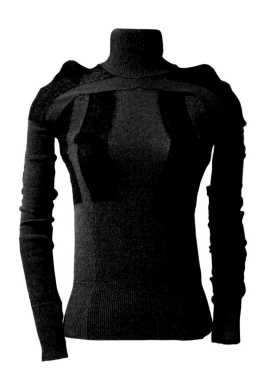

"What Martin Margiela looks like has, for us, little or nothing to do with this process [of reaching the public]. We prefer that people react to a garment through their taste and own personal style and not their impression of the individual or group who created it."
— **Maison Martin Margiela**

PREVIOUS SPREAD
Maison Martin Margiela
Ensemble: Black floral brocade, black-and-purple satin, black braid, khaki cotton rib knit
Belgium, 1993

ABOVE
Maison Martin Margiela
Sweater: Green, black, and olive wool; cotton
Belgium, 1991

OPPOSITE
Maison Martin Margiela
Tunic: Beige linen
Belgium, 1997

One of Margiela's most iconic designs, this tunic evokes the idea of a dressmaker's dummy and, by extension, the pattern for a finished garment.

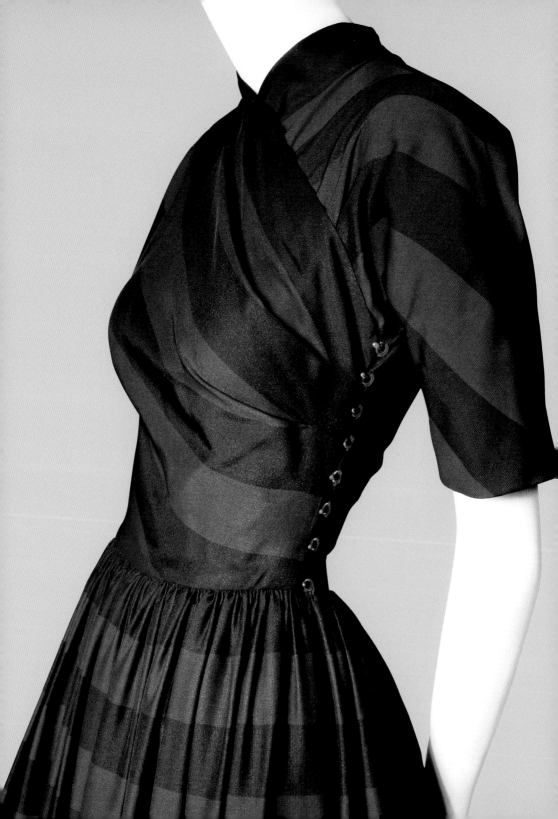

Claire McCardell

CLAIRE MCCARDELL (1905–1958) is a central figure in modern American sportswear. When *Time* magazine featured McCardell on the cover (May 2, 1955), she was described as "the person who understands best how American women want to look." Her clothing had a casual yet functional ease. "I like buttons to button, buckles to buckle, sashes to tie," she said.

McCardell studied at the New School of Fine and Applied Art (now Parsons) in New York. She spent most of her career at Townley Frocks, Inc., where she became head designer in 1932. She left briefly to design for Hattie Carnegie, but her simple designs were not suited to the Carnegie aesthetic. She returned to Townley and was the company's chief designer until her death at age fifty-two.

McCardell followed many of the basic lines of the postwar New Look, but stripped them of their rigidity and formality. A great many of her designs emphasize the waist— by means of a belt, however, not a girdle—and many have full skirts (yet do not require a petticoat). McCardell did not dictate style. Often her designs could be worn a number of ways. Sashes or spaghetti-string ties, for instance, could be styled according to the wearer's preference. McCardell encouraged such individuality.

As McCardell put it: "Clothes are for real live women . . . They are made to be worn, to be lived in." Yet, in museums and on pedestals they now reside, perhaps because the humble McCardell still seems eminently modern. —*J. F.*

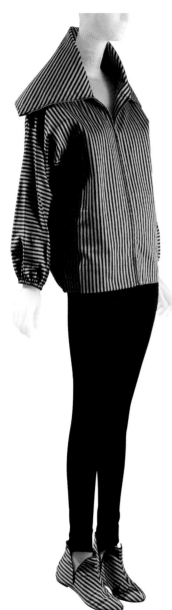

"Claire could take five dollars' worth of common cotton calico and turn out a dress a smart woman could wear anywhere."
— NORMAN NORELL

"In the approaches of Donna Karan, Calvin Klein, and Norma Kamali, one can see the refreshing breeze that McCardell let into American fashion."
— **Constance C. R. White,** *The New York Times*

PREVIOUS SPREAD
Claire McCardell
Evening dress: Red-and-purple striped silk faille, brass
USA, ca. 1955

McCardell regularly reinterpreted the *Popover* dress after its introduction in 1942. More formal versions, like this one, could be worn by the stylish hostess for at-home entertaining.

LEFT
Claire McCardell
(Boots by Capezio)
Ensemble: Beige-and-black-striped cotton twill, black wool jersey, elastic, brass
Ankle boots: Beige-and-black-striped cotton twill, elastic
USA, 1945–1955

OPPOSITE
Claire McCardell
Romper: Black-and-white plaid cotton
USA, ca. 1954
Belt: Red elastic, metal
USA, ca. 1950

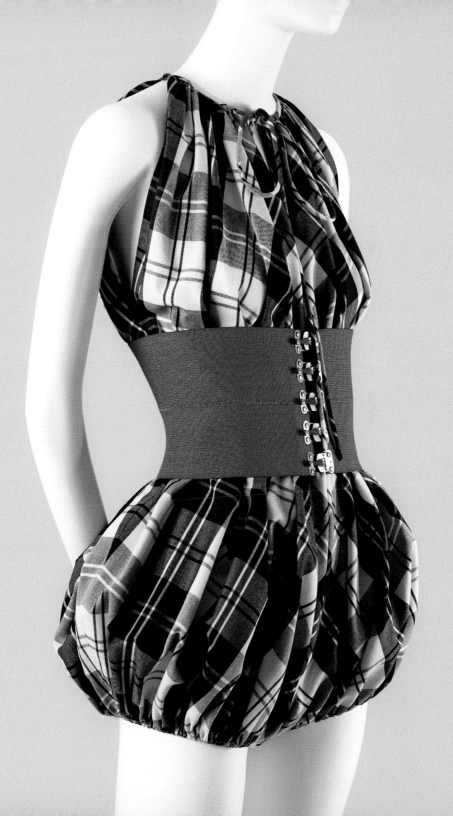

RIGHT
Claire McCardell
Evening dress:
White cotton piqué
USA, 1951

BELOW
Claire McCardell
Dress and sash: Multicolor
striped wool, red wool jersey
USA, 1955

Sally Kirkland, a former
fashion editor for *Life*
magazine, donated many
Claire McCardell garments,
including this dress, to
the Museum at FIT.

OPPOSITE
Claire McCardell
Dress: White printed
cotton, gold metal
USA, 1955

The fabric used in this dress—
printed with Fernand Léger's
Parade Sauvage—is from the
Modern Master Print series by
Fuller Fabrics.

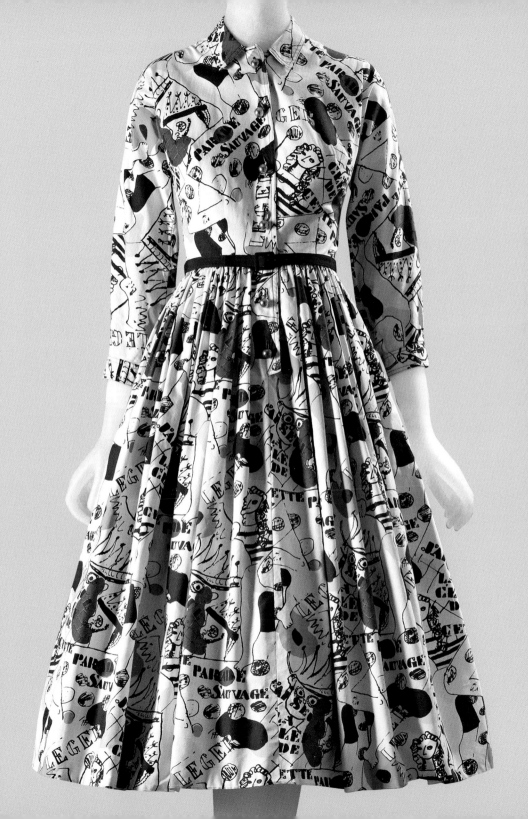

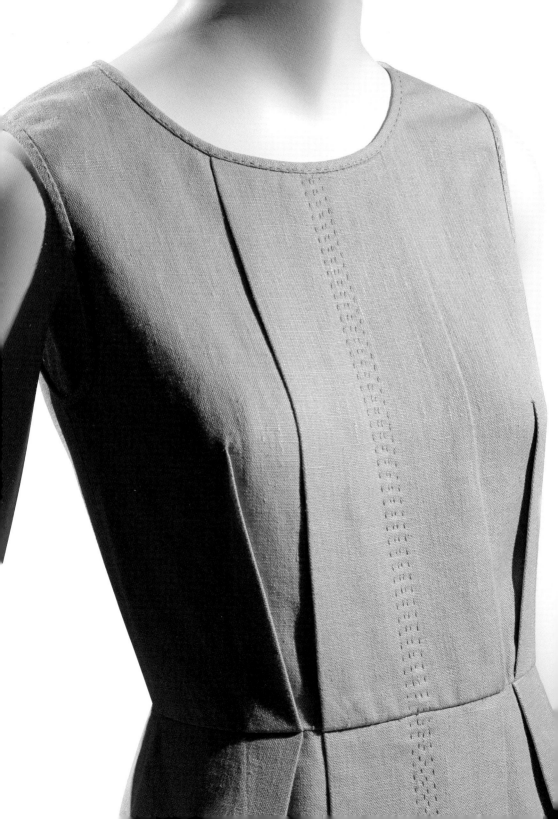

Stella McCartney

STELLA McCARTNEY (B. 1971) is admired not just for her chic, wearable clothes, but for her strong principles: a vegetarian, like her renowned parents Linda and Paul McCartney, she adamantly refuses to use any fur or leather in her work, including her shoes and bags.

McCartney's childhood interest in fashion led her to work with both Christian Lacroix and Savile Row tailor Edward Sexton while still in her teens, and in 1995 she graduated from Central Saint Martins College of Art and Design. The buzz generated by her graduation collection allowed her to sell her work and finance her own label. In 1997, however, McCartney really made headlines. At twenty-five she was appointed chief designer of the esteemed French ready-to-wear house Chloé. Early reviews were mixed, but McCartney reenergized Chloé with her youthful, subtly irreverent designs. She left to start her own label in 2001.

McCartney's style is modern, but never trendy. She freely admits to designing what she would like to wear, and is frequently seen dressed in her own creations. Her taste for feminine, draped silhouettes in dusky hues is balanced by her interest in crisp, sleekly tailored pieces, and she is often lauded for her ability to mix and match seemingly disparate styles into a cohesive look.

Now firmly established as a designer, McCartney has become a respected advocate for positive change within the fashion industry. Her designs are cruelty-free, and her environmental awareness extends to her increased use of organic materials, low-impact dyes, and carbon-neutral store operations. —*C. H.*

"Wearable—it's almost a dirty word in fashion, wearable, but that's what I do. And yeah, it can get a bit boring, but I can push it each season into something better and more relevant for that season."
— STELLA McCARTNEY

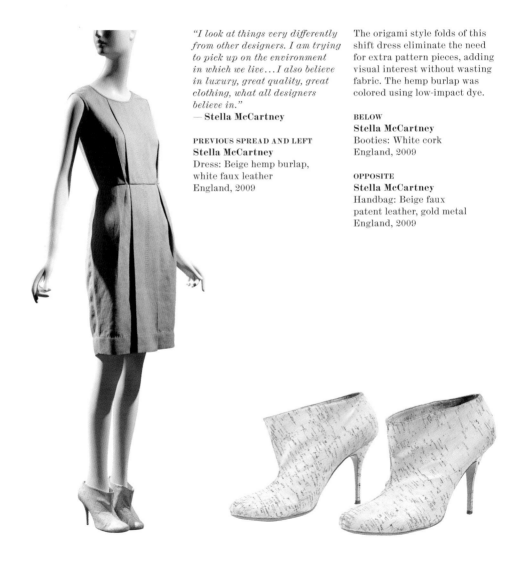

"I look at things very differently from other designers. I am trying to pick up on the environment in which we live...I also believe in luxury, great quality, great clothing, what all designers believe in."
— **Stella McCartney**

PREVIOUS SPREAD AND LEFT
Stella McCartney
Dress: Beige hemp burlap, white faux leather
England, 2009

The origami style folds of this shift dress eliminate the need for extra pattern pieces, adding visual interest without wasting fabric. The hemp burlap was colored using low-impact dye.

BELOW
Stella McCartney
Booties: White cork
England, 2009

OPPOSITE
Stella McCartney
Handbag: Beige faux patent leather, gold metal
England, 2009

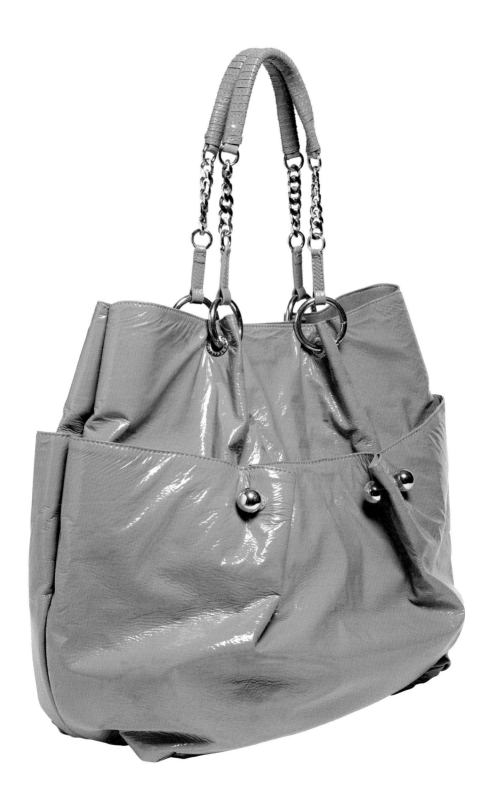

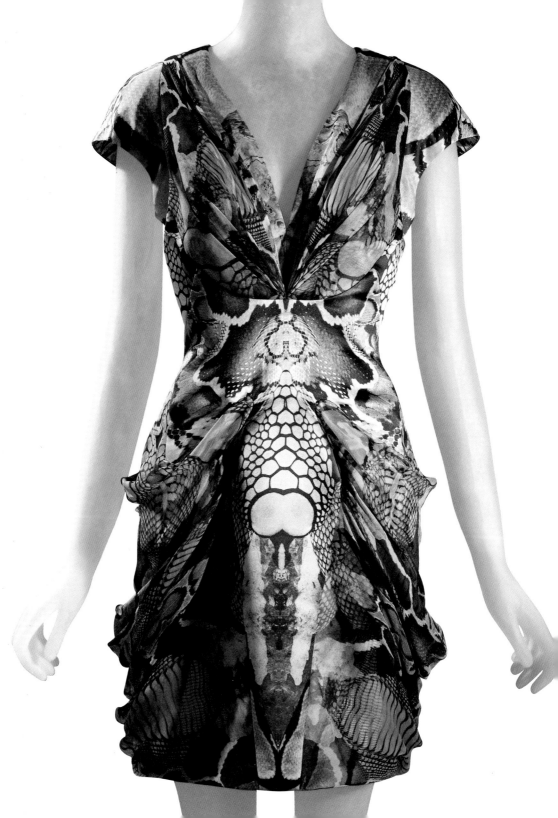

Alexander McQueen

LEE ALEXANDER MCQUEEN (1969–2010) was one of the most creative and influential fashion designers of his generation. Born into a working-class British family, McQueen's talent brought him to the pinnacle of the fashion world. Other designers were more successful financially, but few created fashions of such visual power and savage beauty.

McQueen, who called himself the "pink sheep" of his family, left school at age sixteen to apprentice with Savile Row tailors Anderson & Sheppard, where he allegedly sewed an offensive insult into the lining of a suit for Prince Charles. After applying for a job at Central Saint Martins College of Art and Design, he was encouraged to enroll, later receiving an MA in fashion design. His graduation collection was bought in its entirety by fashion stylist Isabella Blow, who became a close friend and supporter. Just two years later, he was named British Designer of the Year by the British Fashion Council, the first of many such accolades.

In 1996 Bernard Arnault, the president of LVMH, appointed McQueen head designer at the House of Givenchy. Although many of his couture collections at Givenchy were extremely beautiful, McQueen felt creatively constrained there and quit in 2001, having signed a new partnership agreement with the Gucci Group, which acquired 51 percent of the company that bore his name.

McQueen presented his collections in spectacular runway shows that blurred the line between art and fashion. A 1998 show on the theme of Joan of Arc ended with a model in a red hooded catsuit standing alone in a ring of fire. *Voss*, from 2001, took place in a mirrored cube meant to evoke an insane asylum. One model, her head bandaged, wore an avian-inspired dress with a bodice made of microscope slides dyed red. His 2006 show featured a three-dimensional hologram of Kate Moss hovering like a vision over the runway. In 2010 McQueen committed suicide by hanging himself, only days after his beloved mother had died of cancer. His longtime assistant Sarah Burton was appointed designer shortly thereafter. —*V. S.*

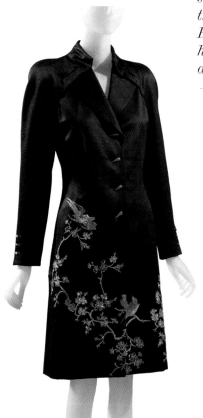

"*He takes ideas from the past and sabotages them with his cut to make them thoroughly new . . . He is like a Peeping Tom in the way he slits and stabs at the fabric to explore all the erogenous zones of the body.*"

— ISABELLA BLOW, FASHION EDITOR

"*[McQueen] created a world for himself where he could do anything he wanted to do, with no constraints.*"
— **Sarah Burton**

PREVIOUS SPREAD
Alexander McQueen
Dress, *Plato's Atlantis* collection: Multicolored reptile patterned digital-printed silk chiffon
England, 2010

McQueen's *Plato's Atlantis* collection featured digitally engineered sea-reptile prints that spoke to "an apocalyptic forecast of the future ecological meltdown of the world."

ABOVE
Givenchy (Alexander McQueen)
Evening coat: Black wool, silk satin, metallic embroidery
France, 1997

OPPOSITE
Alexander McQueen
Evening dress: Black vinyl, white silk faille, black silk tulle
England, 2008

FOLLOWING SPREAD, LEFT
Givenchy (Alexander McQueen)
Boot: Black leather, orange lizard skin
France, 1998

FOLLOWING SPREAD, RIGHT
Alexander McQueen
Boot: Black leather, faux horn
England, 2003

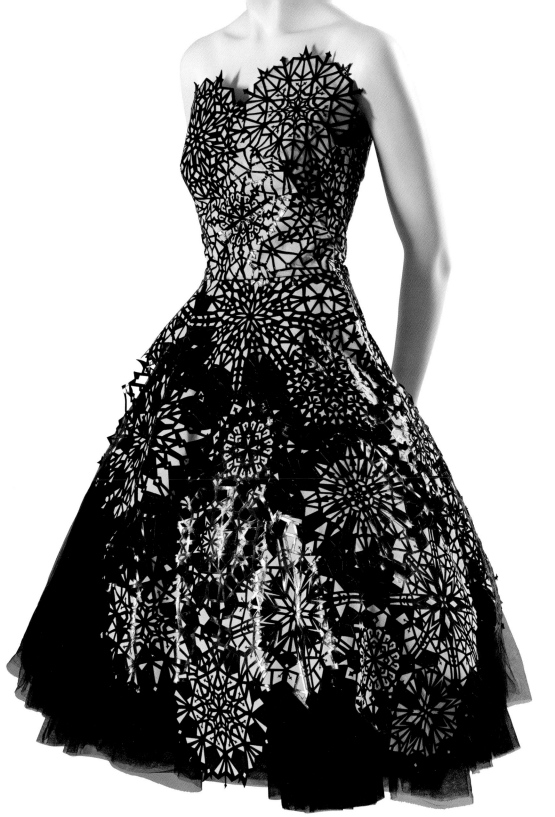

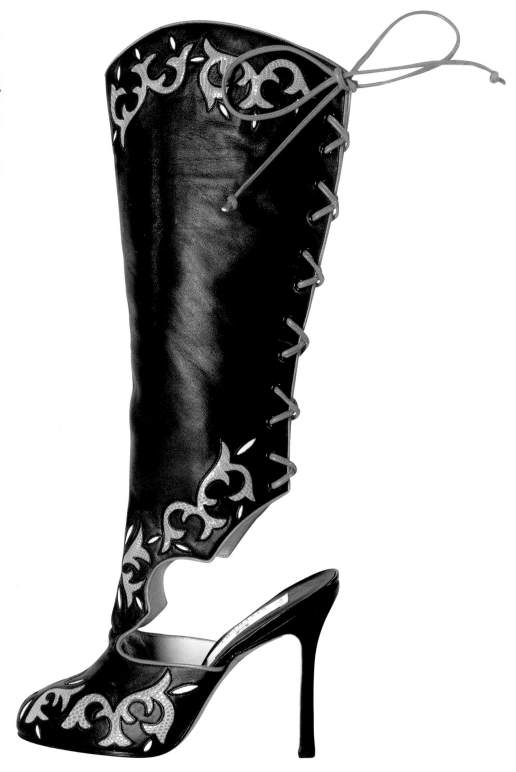

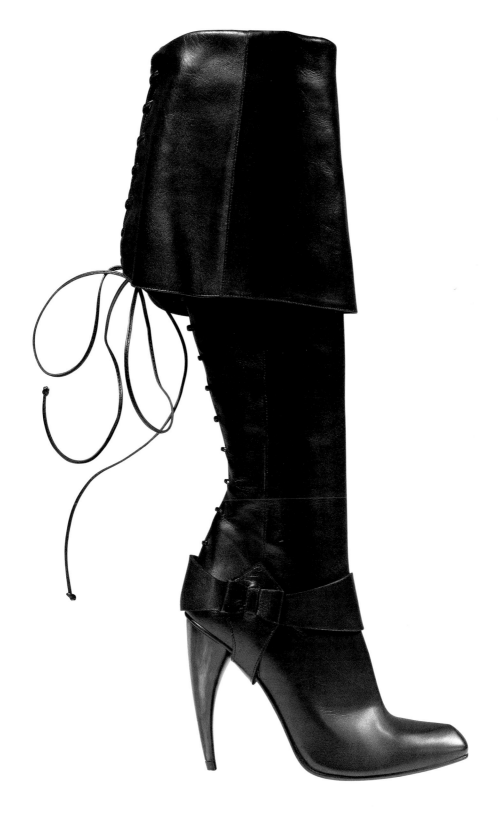

Missoni

OTTAVIO (1921–2013) & ROSITA MISSONI (B. 1931) Founded by husband and wife Ottavio "*Tai*" and Rosita Missoni in 1953, the Missoni company is known for its knitwear's distinctive patterns featuring stripes, chevrons, and zigzags that come together in a kaleidoscope of color. "People have always been attracted to our fashion because it is easy and young," Rosita Missoni told *Women's Wear Daily*. During the 1960s, their artful designs caught the eye of Italian fashion journalist Anna Piaggi and *Vogue* editor Diana Vreeland, who helped promote their knitwear internationally. Today Missoni designs are worn by trendsetters such as Madonna, Kate Moss, and Nicole Kidman.

"Our philosophy since we went into business has been that a piece of clothing should be like a work of art," Rosita told the *New York Post*. Indeed, Missoni's textile inspirations have ranged from the work of Giacomo Balla and Sonia Delaunay to Incan and Guatemalan textiles. Praised by *Vogue* as the "masters of color mix," the Missoni's have used space-dyed yarns since 1969 to flawlessly blend shades of color. "Look! Who said that only colors exist?" proclaimed Diana Vreeland after seeing the collection at the Grand Hotel in Rome that year. "There are also tones!"

The Missoni family has established an iconic aesthetic, which they keep developing season after season. Stylistically consistent, Missoni garments can be mixed and matched regardless of collection or decade, a testament to their timeless quality. Ottavio and Rosita's work was already extremely successful during the 1970s and 1980s, and the company underwent a makeover when their daughter, Angela, took over as creative director in 1997. Ottavio Missoni died in 2013. —*M. M.*

"The idea of trying to explain how I match certain patterns and colors makes me laugh… It's instinctual, almost as if it's in my blood." — ANGELA MISSONI

LEFT
Missoni
Tunic and skirt:
Multicolor striped rayon knit
Italy, 1972

BELOW
Missoni
Assorted knits
Italy, 1971, 1972, 1972,
1972, 1977 (left to right)

OPPOSITE
Missoni
Ensemble: Orange-and-red
space-dyed rayon knit
Italy, 1973

"I have an obsessive need to fit things together in interesting ways. I like to take colors and shapes into my own hands."
— **Rosita Missoni**

PREVIOUS SPREAD
Missoni
Dress: Multicolor printed
silk crêpe de chine
Italy, 2003

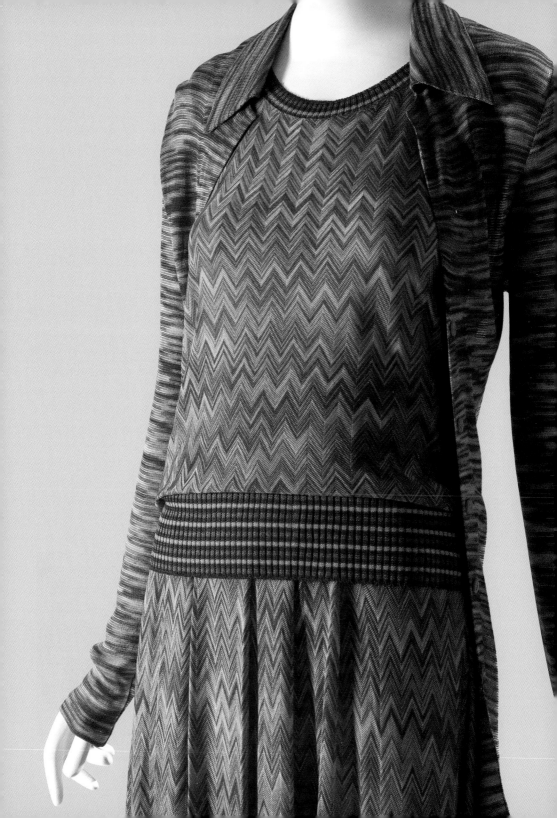

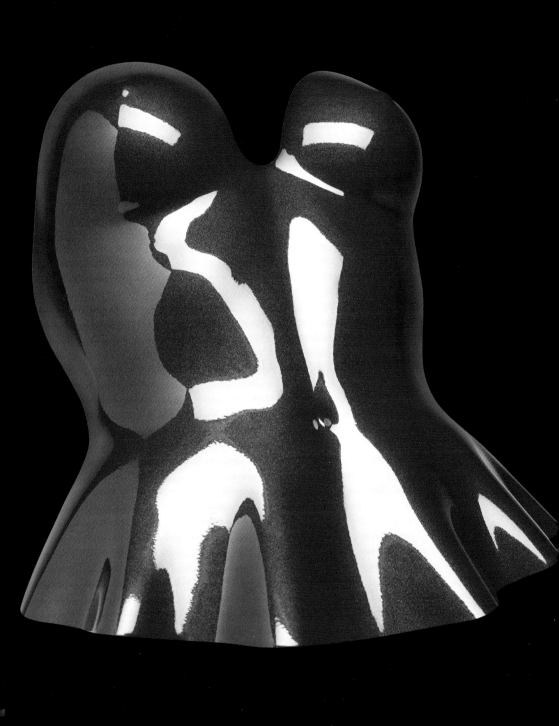

Issey Miyake

ISSEY MIYAKE (1938–2022) In the early 1970s, the world of fashion changed dramatically with the Parisian debut of Issey Miyake. He was among the "first wave" of Japanese designers to capitalize on the great social changes of the late 1960s and the growing influence of ready-to-wear clothing. These cultural changes, and Japan's rise as an economic superpower, were factors in Miyake developing an optimistic and future-oriented approach to design. He also had a healthy respect for tradition and pioneered the use of what were then less fashionable, ethnographic materials, initiating the trend toward abandoning the predictable, manufactured, and stylized forms of "exoticism."

Miyake was one of the first globally influential designers to find creative uses for the latest technologically advanced synthetics being produced in Japan. The use of fabrics such as permanently pleated polyester, combined with his innovative construction techniques, allowed Miyake to make some of the most extraordinary garments ever seen. His fantastic pleated creations that morph from flat pieces of cloth into three-dimensional geometric forms were revelations when they first appeared in the late 1980s. In 1993 Miyake launched the Pleats Please line. The garments were linear in cut, and the surface designs were daringly innovative. From 1996 to 1998, Miyake invited fine artists such as Yasumasa Morimura, Nobuyoshi Araki, Tim Hawkinson, and Cai Guo-Qiang to design unique Pleats Please works.

In 1994 and 1999, Miyake stopped designing his collections, choosing instead to focus on research and other projects such as his specialty line A-POC (an acronym for "a piece of cloth"). The earliest incarnations of A-POC involved a single process in which "frames" containing fully formed garments were created in long tubes of jersey knit. Each garment needed but for the wearer to separate it from its frame using scissors and then customize it to her liking. Today, the A-POC concept has evolved into a more modern interpretation, and this system of producing garments will be applied to all Issey Miyake lines and will be known as A-POC *Inside*. The designer died in 2022 at the age of eighty-four. —*P. M.*

"*When there is no dialogue, no exchange, creativity becomes impossible. This notion is at the heart of my work, and that's why it's quite different from what people call 'pure art.'*"— ISSEY MIYAKE

"*Clothes are of no interest except insofar as they provoke sentiments and reactions in those who wear them.... I create, not to express my ego, my personality, but to try and bring answers to those who are asking themselves questions about our age and how we should live in it.*"
— **Issey Miyake**

PREVIOUS SPREAD
Issey Miyake
Bustier: Red molded resin
Japan, 1983

RIGHT
Issey Miyake
"Bouncing Dress":
Pleated black polyester
Japan, 1995

OPPOSITE
Issey Miyake (Pleats Please)
Dress: Polyester printed
with photo image by
Yasumasa Morimura
Japan, 1997

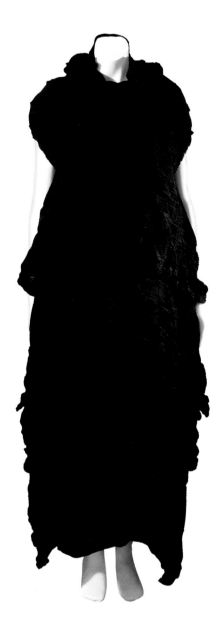

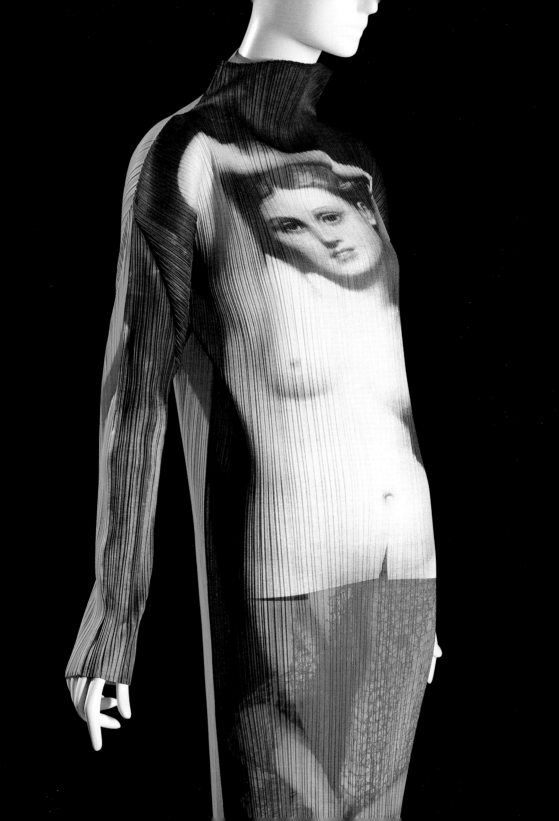

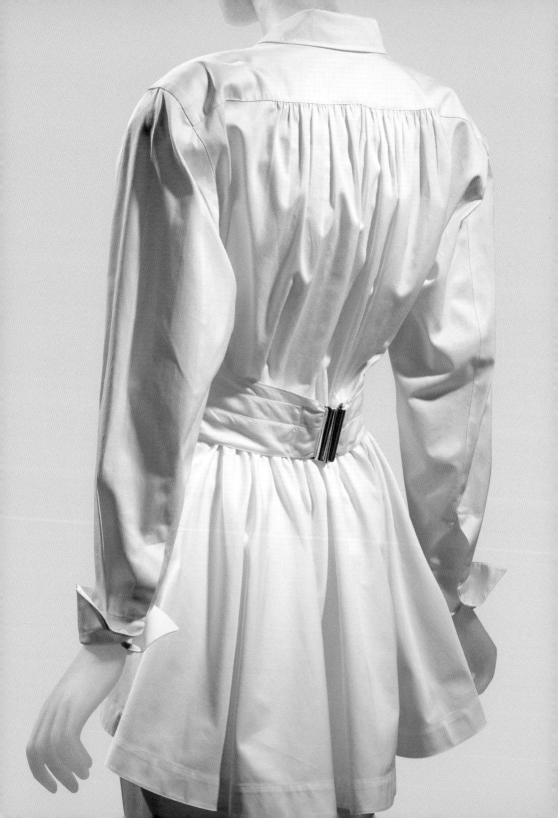

Claude Montana

CLAUDE MONTANA (B. 1947) was an exceptionally creative Parisian designer from the late 1970s through the early 1990s. His fashions were among the most aggressively chic ever produced. Montana's silhouettes were readily identifiable—jackets sprouting portrait collars, enormous shoulders and nipped waistlines; leg-encasing, ankle-length, pencil-slim skirts; and body-obfuscating cocoon coats—and he often blended extreme proportions from both masculine and feminine fashions into a single ensemble. He was an avid colorist who opted for colors such as vibrant purple and lipstick red, and even metallics, as well as neutral tones. While Montana's clothes were dramatic, so were his fashion shows.

Never formally trained as a fashion designer, he made his first foray into the field with a collection of papier-mâché jewelry covered with rhinestones. By the 1970s, he had begun to work with leather, and he developed a variety of complex construction techniques. This material was one of Montana's favorites and was prominently featured throughout his design career. In 1976 he presented his first fashion show. Three years later, he founded his company, the House of Montana, and in 1981 he designed his first menswear line, Montana Hommes. Montana hit a stumbling block in the mid-1990s when he became embroiled in a lawsuit, which he lost. Beset with financial woes, he sold his company in 1997, but continued designing for another ten years.

A high point in Montana's career was his stint as a couturier for Lanvin from 1990 to 1992. He received critical acclaim for his haute couture collections, but despite this, his bold designs—created at a total estimated loss of $50 million—were financially disastrous for Lanvin.

Despite his roller-coaster career, Montana has been an inspiration for many designers and remains one of contemporary fashion's most original creators. —P. M.

"Consistently ranked among the top designers in the world, Montana is famed for the spectacular, MGM-style scope of his fashion shows, always one of the hottest tickets in town, and the shadowy film noir of his backstage life."
— ANNE BOGART, *LOS ANGELES TIMES*

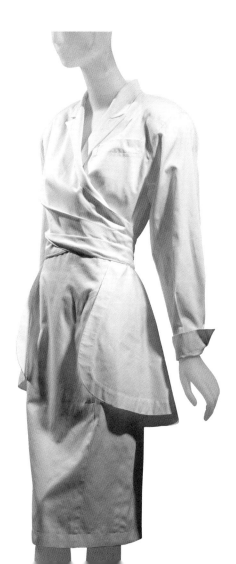

"Few designers today can be equally admired for the surety of cut, the sensuousness of appearance, the femininity that is beneath the bold forms, the luxurious seductions of fabrics more varied than leather alone, and the continuous and consummate mastery of a fashion design that always plays between the abstract forms of art and the conventions of clothing."
— **Richard Martin, curator**

PREVIOUS SPREAD AND LEFT
Claude Montana
Suit: White cotton twill
France, 1986

OPPOSITE
Claude Montana
Dress: Black linen
France, 1983

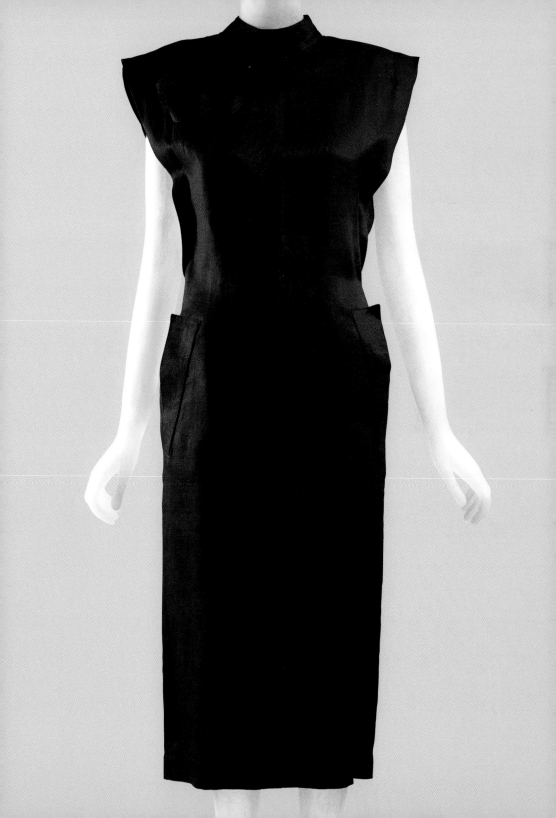

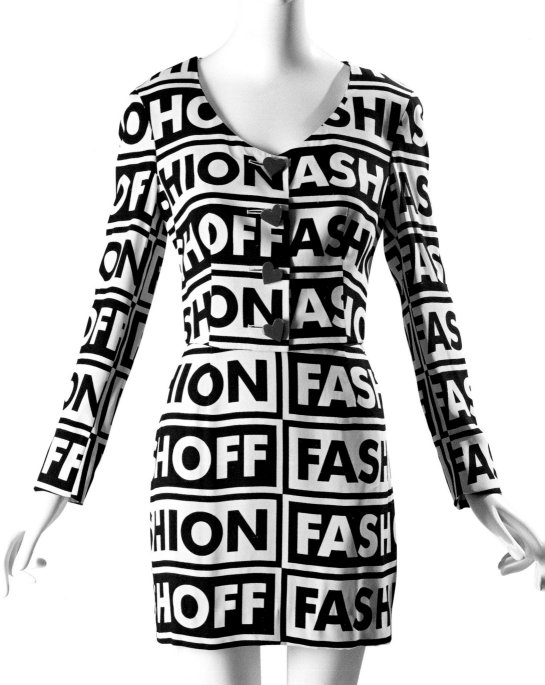

Moschino

FRANCO MOSCHINO (1950–1994) was as much a social commentator as he was a designer. "Fashion should be fun," he once said, "and it should send a message." Throughout the 1980s and into the early 1990s, he used humor and fashion as a platform to promote social awareness and to protest the materialism of the fashion industry: he once made his own version of a classic Chanel suit and in place of the familiar chain belt embroidered the words "This is a Waist of Money." Moschino designed dresses printed with bar codes and made of garbage bags—he even designed a man's shirt intended to resemble a straitjacket, with the slogan "For Fashion Victims Only" written on the back.

Moschino originally studied fine art; however, he soon learned that fashion could be just as convincing a means of expression as paint and canvas. He worked as a freelance designer and fashion illustrator for a number of Italian companies before starting his own in 1983. Several years later, he launched a secondary line, Cheap and Chic. Moschino's fashion shows were quirky, theatrical presentations that showcased his characteristic irony and wit. His models crawled down the runway, impersonating public figures such as Tina Turner and Princess Margaret, and used whimsical props such as rubber pig noses and live geese.

Moschino used traditional methods of clothing construction to produce wearable, sexy clothes, which he would then subvert with surrealistic tongue-in-cheek details. Ironically, his rebellious spirit won him much acclaim within the very industry he criticized. After his death in 1994, his company continued under the direction of Rossella Jardini. Although Moschino's career lasted only a few years, his style is recognized all over the world. In 2013 Jeremy Scott became artistic director of Moschino. —*M. M.*

*"I think fashion is something you can laugh
about forever, but it is the most difficult thing
to laugh at because people take it so seriously."*
— MOSCHINO

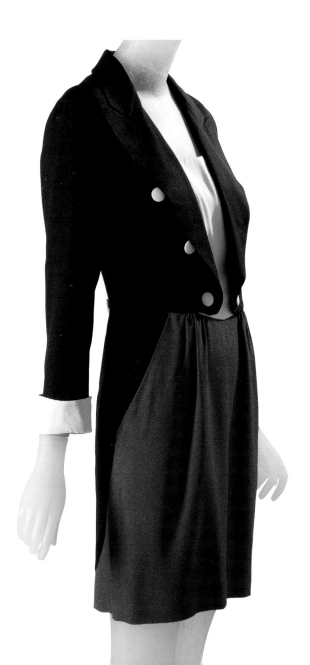

PREVIOUS SPREAD
Franco Moschino
Suit: Black-and-off-white rayon,
red wood buttons
Italy, 1990

LEFT
Cheap and Chic by Moschino
Dress: Black, white,
and red rayon crêpe
Italy, 1992

OPPOSITE
Franco Moschino
Dress: Black rayon crêpe,
faux pearls
Italy, 1989

FOLLOWING SPREAD, LEFT
Franco Moschino
Man's suit: Printed cotton,
black cotton knit
Italy, 1995

FOLLOWING SPREAD, RIGHT
Franco Moschino
Evening dress:
Black rayon spandex,
underwire brassieres
Italy, 1994

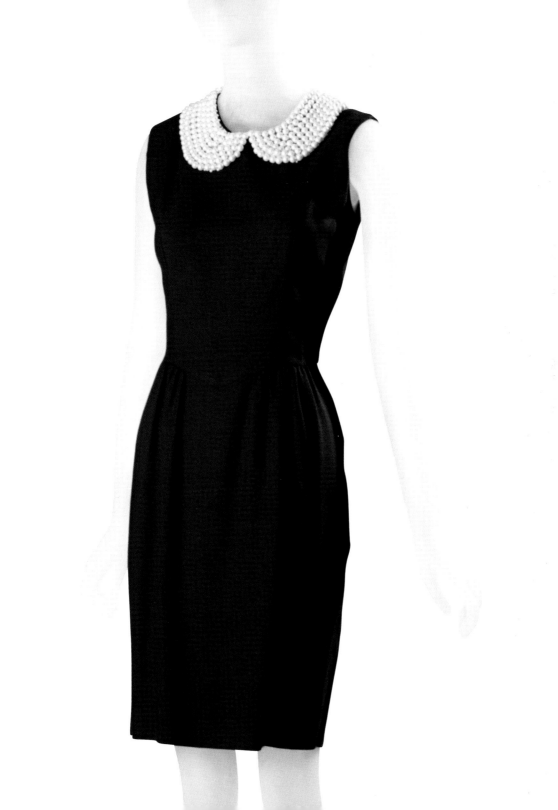

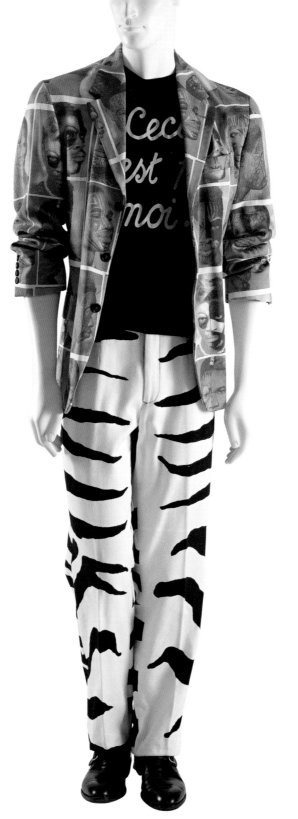

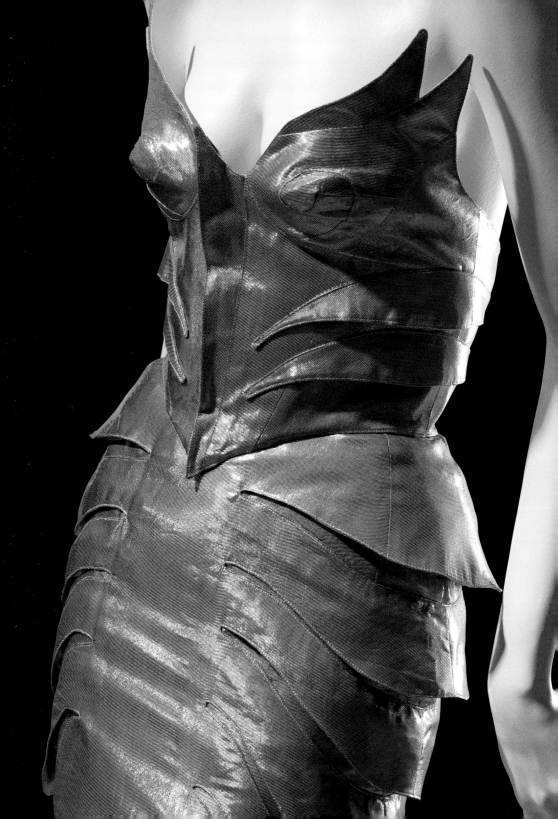

Thierry Mugler

THIERRY MUGLER (1948–2022) believed that fashion should be a theatrical production. In the last two decades of the twentieth century, Mugler often based his collections on an interest in fantasy and fetishism, and his radical vision helped to propel him to superstar status. His mastery of complicated cuts and precise fit proved that he possessed both imagination and technical skill.

At age twenty Mugler was employed as a window-dresser for the trendsetting Parisian boutique Gudule. After taking several freelance design jobs, he presented his first collection in 1973, using the label Café de Paris. His sexy, modern clothes broke from current trends, but proved successful. He started a label under his own name just one year later.

While 1980s fashion often emphasized women's figures, he took the look to the extreme; Mugler power suits had especially wide, angular shoulders that accentuated a wasp waist. His seductive yet wearable suits were commercially successful, but the designer also presented more fantastical styles, including his aggressively sexy "vampire" dresses, and a bustier meant to resemble the metal grille and headlights of a car.

In the 1990s, Mugler collaborated with famed corset maker Mr. Pearl to create some of his most extravagant creations. Long acclaimed for producing ready-to-wear garments of near-couture quality, Mugler presented his first true haute couture collection in 1992. He introduced Angel, his best-selling perfume, that same year.

Mugler stepped down from his brand in 2003 and later pursued photography and costume design. Nicola Formichetti served as creative director at Mugler from 2010 to 2013, followed by David Koma in 2014 and Casey Cadwallader in 2017. Thierry Mugler died in 2022 at the age of seventy-three. —*C. H.*

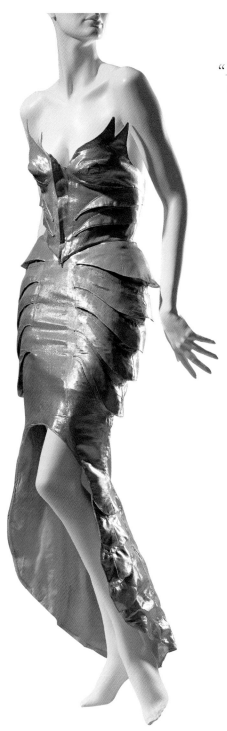

"Every woman has a goddess inside her. I love to glorify her."
— THIERRY MUGLER

"Thierry Mugler is about the power of glamour and walking straight into the future."
— **Nicola Formichetti**

PREVIOUS SPREAD AND LEFT
Thierry Mugler
Evening dress: Silver-lilac lamé, lilac satin
France, ca. 1987

OPPOSITE
Thierry Mugler
Suit: Metallic blue silk and wool, rhinestones
France, ca. 1996

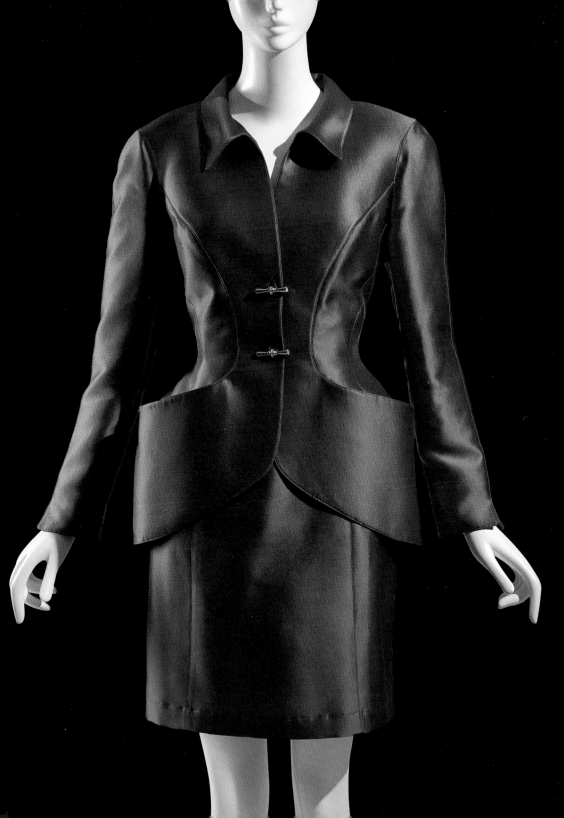

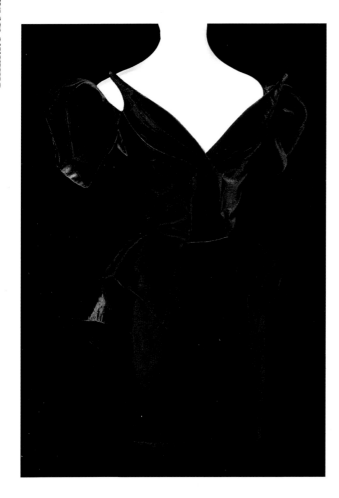

Thierry Mugler
Evening dress: Silver lamé
France, ca. 1979

Mugler's fashions were characterized by fantasy and sexual fetishism. His muse was always a femme fatale—whether a vampire or a mermaid.

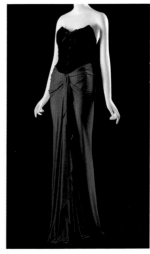

Thierry Mugler
Evening dress: Black velvet
France, 1981

Thierry Mugler
Evening dress: Black velvet,
green silk jersey
France, 1987

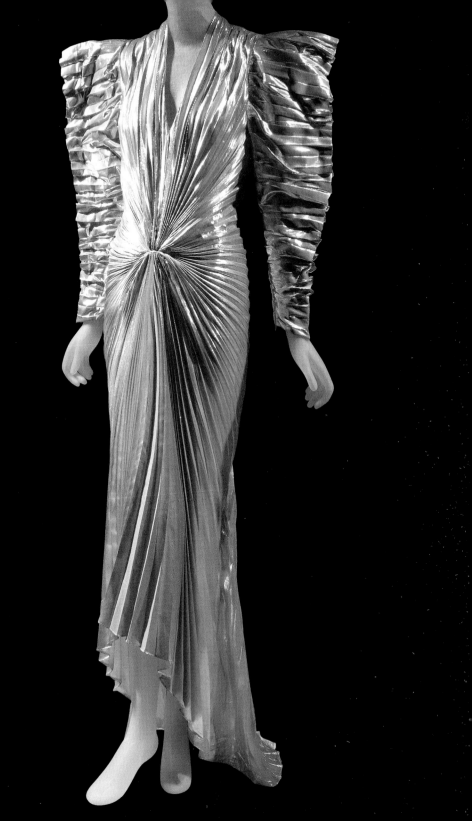

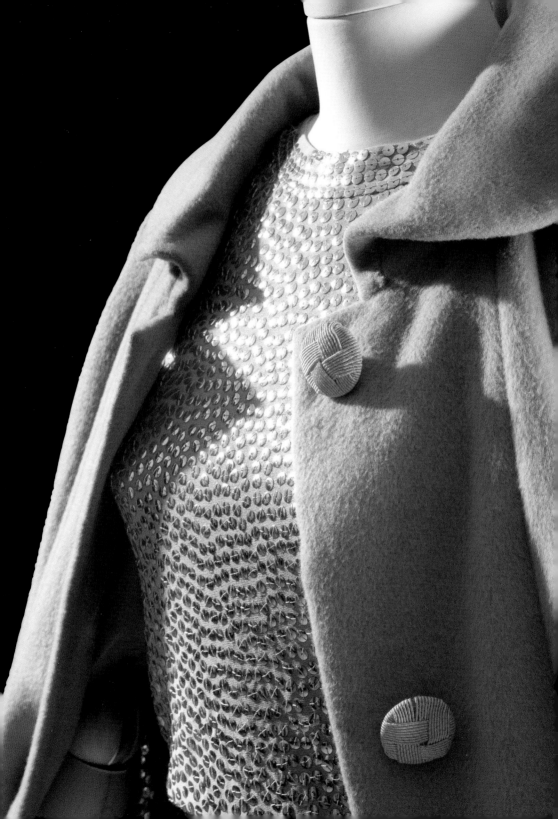

Norman Norell

NORMAN NORELL (1900–1972) proved that American fashion could set its own direction. He produced elegant evening clothes as well as simple daywear, and he treated every part of a garment with care, lavishing as much attention on the linings and interfacings of his garments as he did on their exterior details. It is no surprise that Norell's clothes were frequently referred to as the Rolls-Royces of the American fashion industry.

After studying fashion design at the Pratt Institute, Norell began his career in 1922 as a costume designer for Paramount Studios (then located in Astoria, Queens), dressing silent-screen stars such as Rudolph Valentino and Gloria Swanson. In 1928 Norell went to work for Hattie Carnegie, where he modified elements of Paris couture for American ready-to-wear designs. During these early years, he learned about cut, fit, and quality fabrics, as seasonal trips to view the Paris collections exposed him to couture standards. However, a disagreement with Carnegie led Norell to accept a position with the design firm Anthony Traina in 1940, and for twenty years he designed under the Traina-Norell label. Norell launched his own label in 1960.

Norell popularized Empire-line dresses, culotte-skirted suits, sailor-style dresses, and the chemise dress, which was inspired by his favorite decade, the 1920s. He considered his simple, round necklines—at times embellished with bows or Peter Pan collars—his greatest contribution to fashion. Norell placed a high value on workmanship, and insisted on a prodigious amount of handwork in his designs. Upon his death in 1972, *The New York Times* proclaimed, "Norman Norell made Seventh Avenue the rival of Paris." —*M. M.*

"I loved Norman's clothes; they had the same single-mindedness as Balenciaga's or Chanel's, and the same fanatical attention to quality."
— BETTINA BALLARD, EDITOR, *VOGUE*

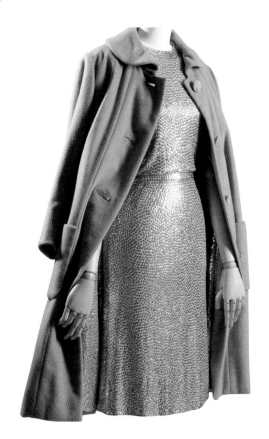

"I've spent my whole life devoted to quality."
— **Norman Norell**

PREVIOUS SPREAD AND ABOVE
Traina-Norell (for Nan Duskin)
Evening coat and dress: Camel cashmere, camel silk jersey, gold sequins
USA, ca. 1958

Norman Norell was known for his understated, discreet elegance. By lining this coat with gold sequins, Norell engaged in a kind of "stealth" luxury before the term was invented. This dress was owned by actress Lauren Bacall, who donated one hundred forty-two garments to the Museum at FIT in 1968 alone.

OPPOSITE LEFT
Norman Norell
Mermaid evening dress: Purple silk jersey and sequins
USA, ca. 1965

OPPOSITE RIGHT
Norman Norell
Mermaid evening dress: Dark-gray silk jersey and sequins
USA, ca. 1968

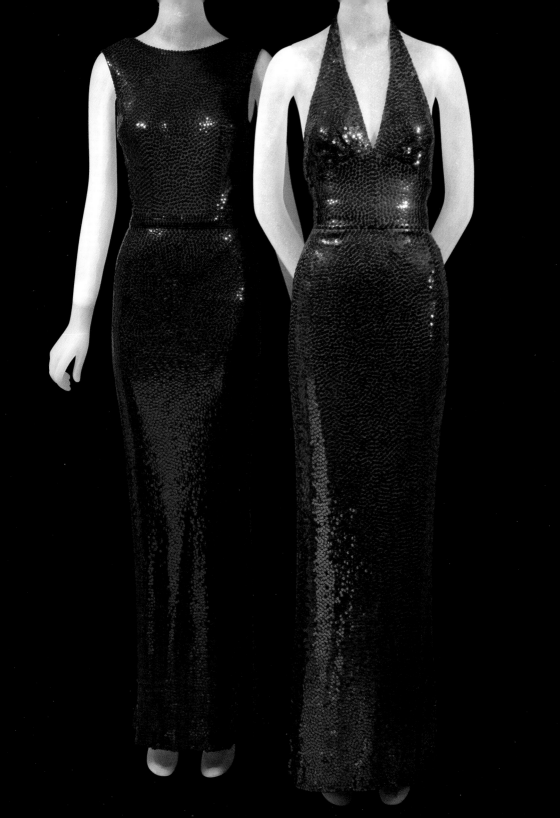

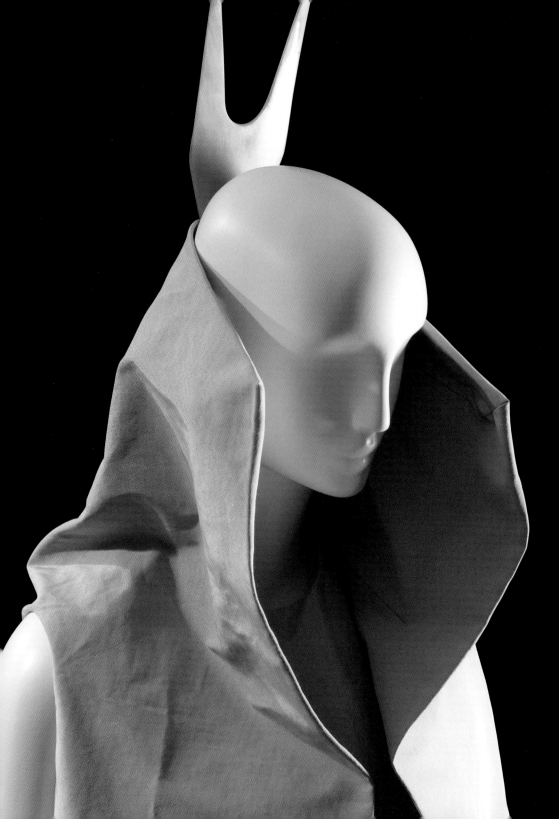

Rick Owens

RICK OWENS (B. 1962) California-born, Paris-based designer Rick Owens creates clothing that has been described as "glamour meets grunge." He crafts sensuous and moodily beautiful garments and specializes in draped jersey dresses and leather jackets. In 2006 this avant-garde designer was hired by the venerated furrier Revillon. A relatively staid producer of high-quality fur garments, Revillon may have seemed an unlikely fit with Owens, as the designer embraces an earthy, even soiled-looking, color palette, a gothic and moody sensibility, and a very lean and narrow silhouette, sometimes counterbalanced with sculptural jackets and coats with sharply angled hemlines. Revillon, on the other hand, was a bastion of tradition and conservative sophistication.

Owens jolted the furrier's look with his first collection, which he presented in 2006. Furs such as mink and fox were combined, in a slew of vests with tightly fitted backs and standing collars that fell into ruffles in front. All the fur and fur-trimmed pieces were paired with his louche, edgy, intricately cut, jersey-wrapped tops and lean trousers. The collection was a critical success.

Owens studied fine arts at Otis College of Art and Design, and after working for some local producers of inexpensive imitations of designer clothing, he launched his own label in 1994. By the early part of the next decade, his work began to appear in *Vogue* and *Vogue Paris*, and he showed his first runway collection in September 2002 during New York Fashion Week. The following year Owens and Michele Lamy, his wife and muse, made the decision to move his studio from Los Angeles to Paris and show during the Paris collections. Since the move, Owens has earned numerous awards, opened freestanding boutiques, and launched several lines of clothing and furniture. —*P. M.*

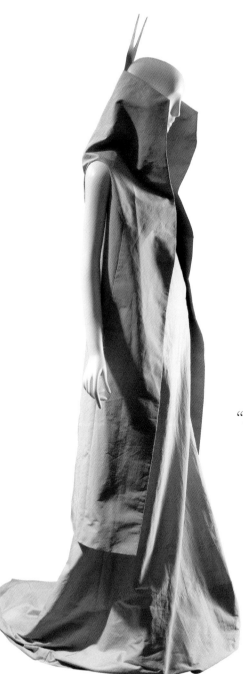

"I try to make clothes the way Lou Reed does music, with minimal chord changes, and direct. It is sweet but kind of creepy. It's about giving everything I make a worn, softened feeling."
— **Rick Owens**

PREVIOUS SPREAD AND LEFT
Rick Owens
Ensemble: Pale-gray washed cotton, silk faille, resin
France, 2011

OPPOSITE
Rick Owens
Jacket: Black denim, wool felt, distressed leather
Skirt: Gray silk crêpe
France, 2008

American sculptor Lee Bontecou, known for her fabric-and-steel constructions, inspired Owens to make striking garments with winglike appendages.

"It's about an elegance being tinged with a bit of the barbaric, the sloppiness of something dragging and the luxury of not caring." — RICK OWENS

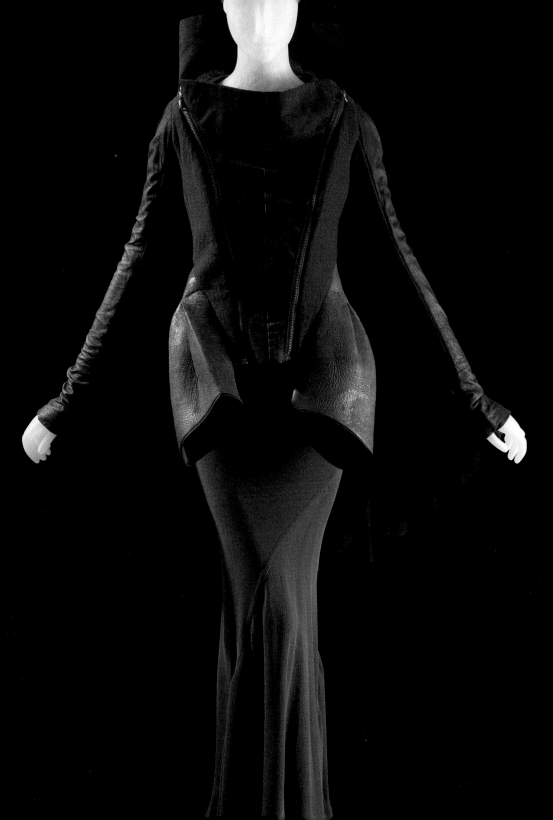

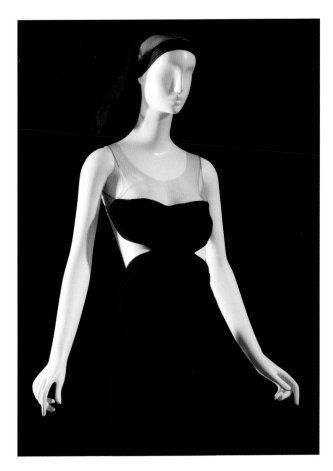

ABOVE, LEFT, AND OPPOSITE
Rick Owens
Ensemble: Black silk crêpe,
beige tulle, black organza,
leather
France, 2009

Rick Owens is one of the
most creative and influential
designers working today.
Working primarily in dark
bias-cut material, he combines
a gothic sensibility with
couture technique.

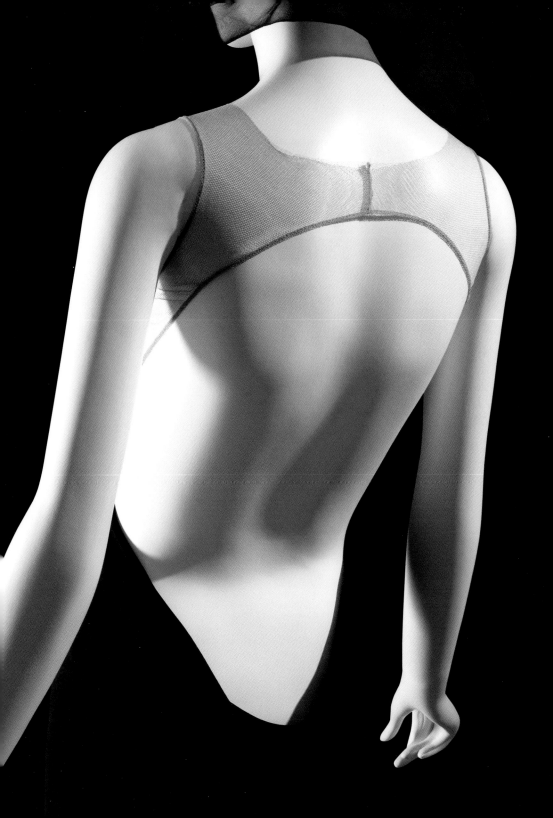

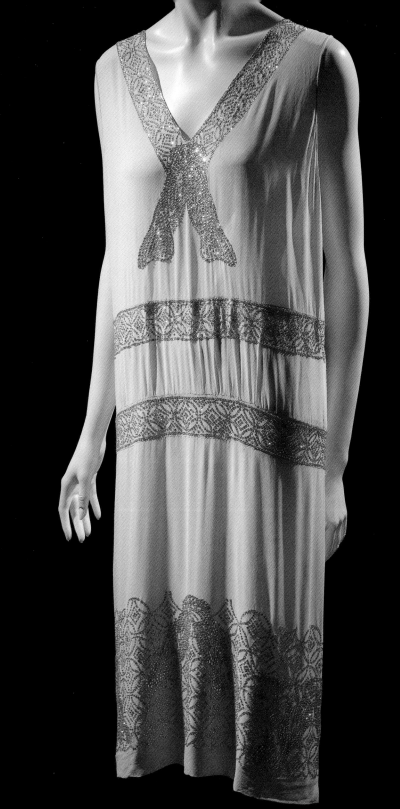

Jean Patou

JEAN PATOU (1887–1936) was born the son of a leather tanner. He first tried working in the fur industry and later struggled to launch a successful dressmaking shop. In 1912, he opened the small couture house Maison Parry, and by 1914 was planning to open a house under his own name. However, Patou's career was interrupted by the First World War, in which he served as a captain in the Zouaves. He reestablished his business in 1919.

Patou had a widespread reputation as a womanizer, a gambler, and—as Elsa Maxwell recalled in her autobiography—"the most flamboyant figure ever to invade the world of couture." In 1924 Patou made international headlines when he visited the United States to study the "American Diana"—the name he gave to his ideal of the fashionable young American woman. He felt that the slender, athletic "Diana" was better suited for some of his designs than the more curvaceous "French Venus," and returned to Paris with several American models. This brilliantly successful scheme attracted buyers, clients, and publicity.

Patou was fiercely competitive. According to fashion editor Edna Woolman Chase, "Patou considered his real blood enemy to be Chanel," and it was Patou, not Chanel, who first dropped hemlines and raised waistlines. This seemingly revolutionary act halted years of dominance for short skirts. Patou was also praised for his keen sense of color, for his ability to manipulate geometric shapes, and—like his rival Chanel—for the sporty elegance of his work.

A string of notable designers have worked for the House of Patou since his death, including Marc Bohan, Karl Lagerfeld, Michel Goma, Jean Paul Gaultier, and Christian Lacroix. In 2018, LVMH acquired the brand which is now known as Patou. —*J. F.*

*"I don't usually like the clothes of M. Patou,
which proves me a barbarian ... "*
— LOIS LONG, *THE NEW YORKER*

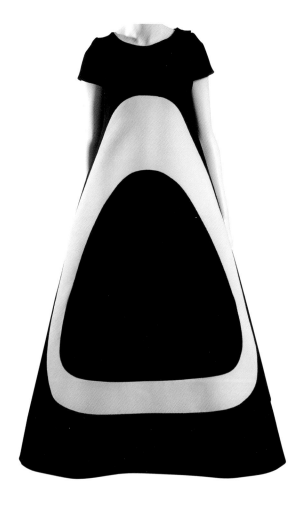

LEFT
Jean Patou (Michel Goma)
Evening dress:
Black-and-white silk
France, 1967–1969

This evening dress, which
reflects the influence of Op Art
on fashions of the 1960s, is a
successful example of Goma's
work for the long-established
house of Patou.

*"M. Jean Patou ... is willing
to take full credit or blame,
according to the point of view,
for having started the present
vogue for femininity which has
turned the whole fashion world
upside down."*
— *The New York Times*

PREVIOUS SPREAD
Jean Patou
Evening dress: Off-white silk
chiffon, rhinestones
France, 1929

OPPOSITE
Jean Patou
Evening dress: Beige silk
velvet, gold metallic lace,
green silk ribbon
France, ca. 1923

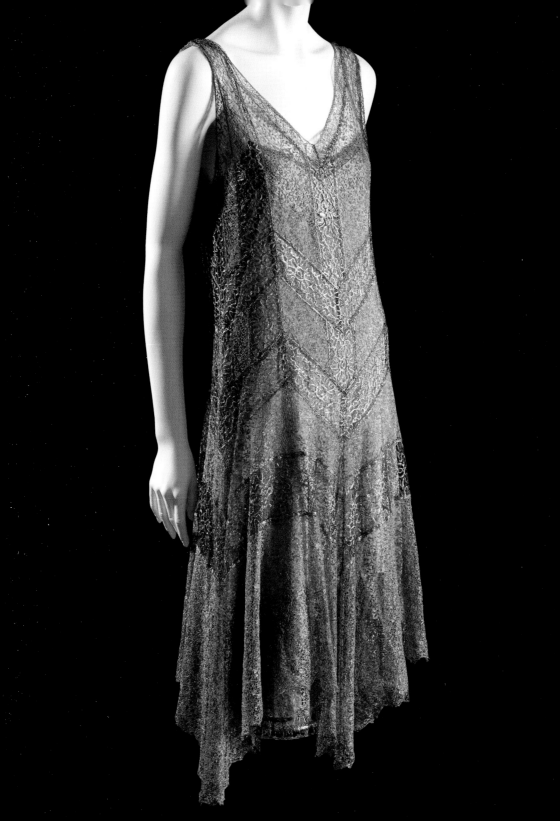

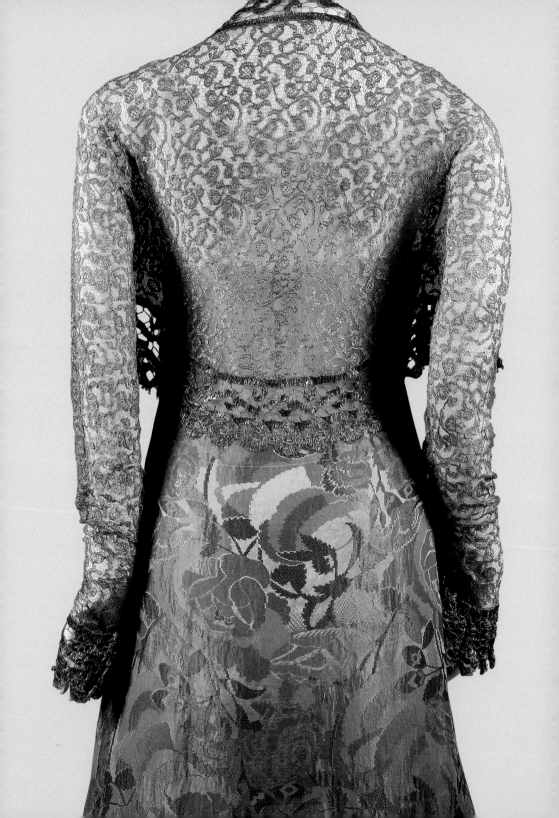

Paul Poiret

PAUL POIRET (1879–1944) in the waning days of the Belle Époque, Paul Poiret was known as the King of Fashion and *Le Magnifique*. While he was not the only celebrated couturier in Paris at the time, he came to symbolize an era that embraced classicism and exoticism, revolutionary change and exquisite workmanship, the heady exchange between artistic disciplines, and the influence of these disciplines (dance, fine art, decorative arts) on fashion. He not only elevated the concept of the fashion designer as artist, but also broadened his creative output to include interior design, perfumes, and the creative marketing of his work.

Poiret's family were cloth merchants, and while still a teenager Poiret sold a dozen of his original sketches to the couturier Madeleine Chéruit. In 1896 he was hired by the preeminent couturier Jacques Doucet. Poiret's first design, a red cape, sold four hundred copies. By 1901 Poiret was employed at the House of Worth, where he was responsible for designing simple, practical dresses called "fried potatoes." However, the reaction of Worth's conservative clientele to his avant-garde designs led Poiret to establish his own *maison de couture* in 1903.

Poiret remains best known for his ravishing Orientalist evening dresses and ball costumes, and his lampshade tunics and harem pants were among the era's most celebrated designs. Poiret also crafted a new, freer silhouette that did not require petticoats and corsets. He began to drape, rather than tailor, longer, less rigid, classically inspired column dresses. But for all his prescient design ideas, Poiret was at heart a traditionalist whose love of the lavish and theatrical put him at odds with the ever-changing modernist aesthetic that overtook fashion after the First World War. Nonetheless, Poiret—the couturier, the man, and his legacy—redefined both fashion and the greater world of design. —*P. M.*

"Am I mad when I try to put art into my dresses, or when I say that couture is an art?" — PAUL POIRET

PREVIOUS SPREAD
Paul Poiret
Fancy-dress costume:
Green silk floral brocade,
gold lace
France, ca. 1912

RIGHT
Paul Poiret
Turkish-style harem costume
ensemble: Silver lamé gauze,
lavender silk and silver lame,
red silk chiffon, faux pearls,
feathers, rhinestones
France, 1919

This harem costume was
originally worn by one of Poiret's
early clients, Mrs. Henry Clews,
to a fancy dress ball given by
Comtesse de Clermont-Tonnerre
in Paris. Madame Poiret wore a
similar ensemble at the famous
1,002nd Night Ball held by Poiret
in June 1911.

OPPOSITE
Paul Poiret
Coat: Black silk faille,
black-and-gold silk fringe
France, 1908

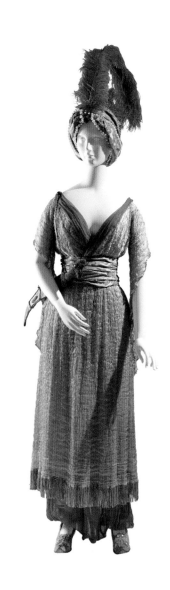

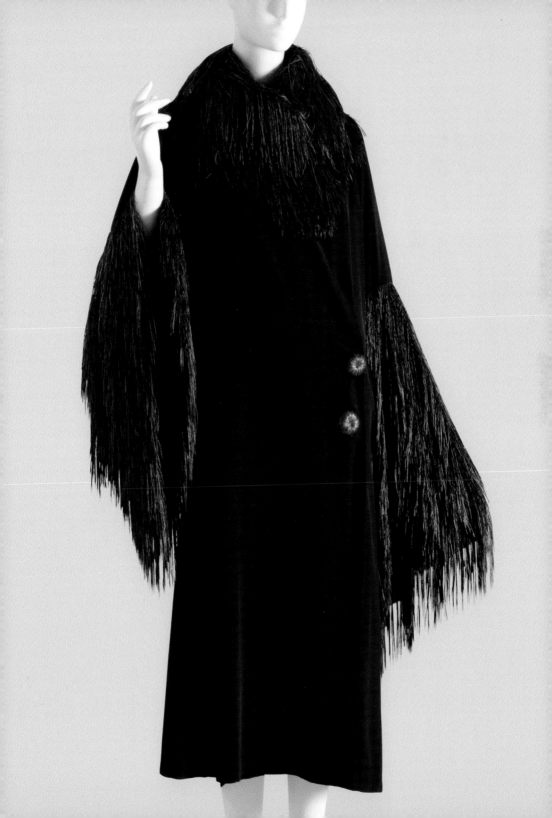

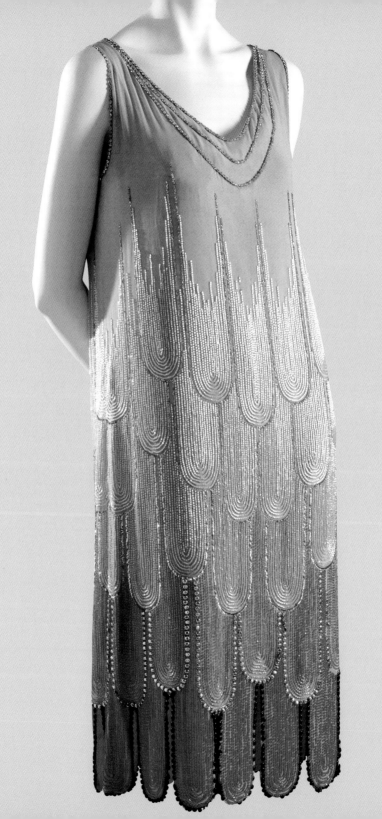

OPPOSITE
Paul Poiret
Evening dress: Pink,
white, orange bugle beads,
gold silk chiffon
France, ca. 1926

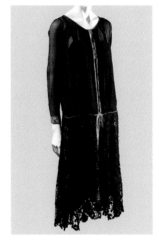

ABOVE
Paul Poiret
Evening dress: Black silk
chiffon, gold lace
France, ca. 1926

LEFT
Paul Poiret
"Sorbet" dress: Mauve-and-
ivory silk satin, pink, purple,
green seed beads
France, 1913

Poiret was famous for his
Orientalist styles. At his
1002 Night party, Madame
Poiret wore harem trousers
under a short hoop skirt,
a costume that inspired the
"Sorbet" dress of 1913.

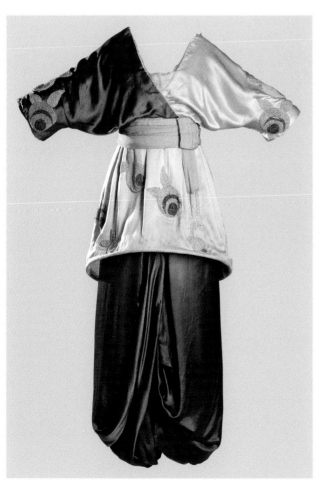

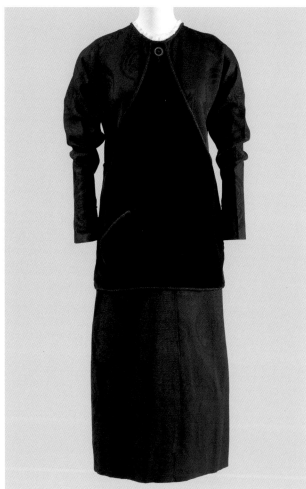

LEFT
Paul Poiret
"Mélodie" dress: Purple silk
jacquard, silk velvet
France, 1912

This dress belonged to Poiret's
wife, Denise, who served as
model and muse for her hus-
band. The narrow, high-waisted
silhouette of the *"Mélodie"*
suited her girlish figure.

BELOW
Paul Poiret
Boots: Olive-green lambskin
France, ca. 1918

OPPOSITE
Paul Poiret
Dress: Brown-and-rose silk
crêpe de chine
France, ca. 1921

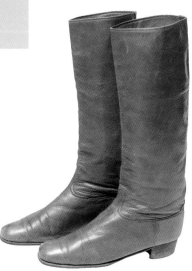

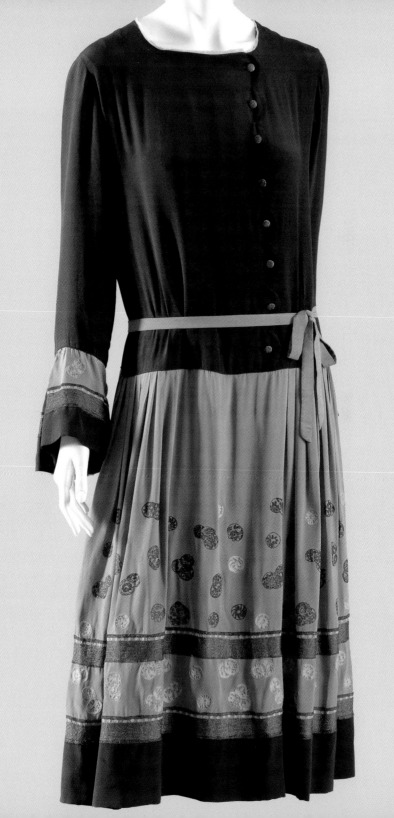

Prada

MIUCCIA PRADA (B. 1949) Noted for its clean, cool, and even quirky sensibility, Prada is one of the most recognized names in fashion. What began as a small leather goods company during the early twentieth century was transformed in the 1990s into one of the world's leading high-end luxury fashion houses—and a worldwide conglomerate—by the founder's great-granddaughter, Miuccia Prada, and her husband and business partner, Patrizio Bertelli. With the 2003 release of the best-selling book *The Devil Wears Prada*, and its film adaptation in 2006, the firm became a pop-culture phenomenon.

In 1913 Fratelli Prada initially manufactured its own leather goods and also imported English steamer trunks and handbags. Miuccia joined the company in 1970, and inherited the company in 1978. With Bertelli, Miuccia developed a wide range of bags and shoes into full clothing collections that have become some of the most influential in the world.

In 1979 Miuccia introduced her now famous backpacks and totes made from tough military-grade black nylon, a fabric that her grandfather had used to cover steamer trunks. By the mid-1980s, these accessories were coveted items. The classic Prada handbag was practical and sturdy, yet its sleek lines and craftsmanship exuded an offhand aura of luxury that has become the Prada signature. A women's ready-to-wear collection was launched in 1989. Its blend of retro-inspired sportswear, designed with clean lines and made with opulent fabrics, was a hit and has come to be known as the Prada look.

Prada's success skyrocketed throughout the 1990s. New lines were added, including menswear and the lesser-priced women's line entitled Miu Miu (Miuccia's nickname). Collectively, these chic, minimalist designs came to symbolize what *The New York Times* called "the Palm Pilot, high-tech, I.P.O. 90's." In addition to business activities, Prada is a major philanthropic player: its foundation funds leading contemporary art projects, architecture, and even a team in the World Cup yacht race. In 2020, Miuccia Prada announced that Raf Simons would join her as co-creative director at the house—a decision that *Vogue* described as "a masterstroke of innovative thinking."—*P. M.*

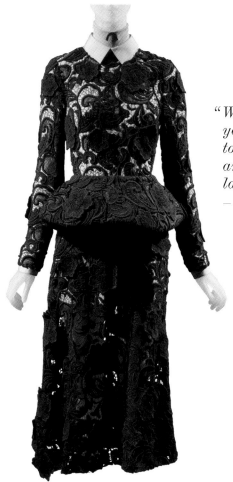

"What you wear is how you present yourself to the world, especially today, when human contacts are so quick. Fashion is instant language."

— MIUCCIA PRADA

"The Prada label has come to mean much more than the black-nylon uniform of the unassailably cool: technology, art, sport and the new—new thing are all entwined with the brand as if to say, with a blasé shrug, 'It is we who are the moderns.'"
— **Julie V. Iovine,**
The New York Times

PREVIOUS SPREAD AND ABOVE
Miuccia Prada
Ensemble: Navy blue cotton guipure lace, light-blue cotton, nude silk knit
Italy, 2008

Miuccia Prada is one of the most influential designers working today. With this ensemble, she radically reinvented the use of lace in fashion.

OPPOSITE
Miuccia Prada
Ensemble: Green silk twill with multicolor print, black silk crêpe, green velvet, patent leather, plastic
Italy, 2008

Though best known for hard, even ugly, chic, Miuccia Prada can also do sweetly romantic

looks, like this ensemble. The textile features a vaguely Art Nouveau fairy print created in collaboration with the artist James Jean.

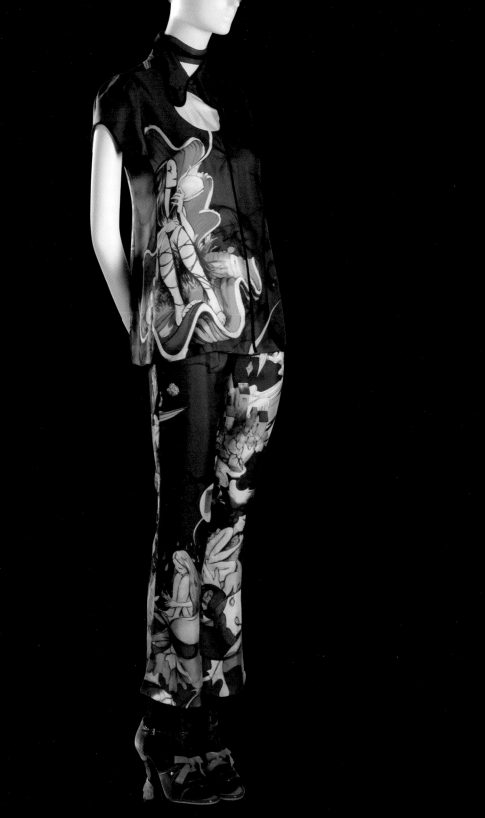

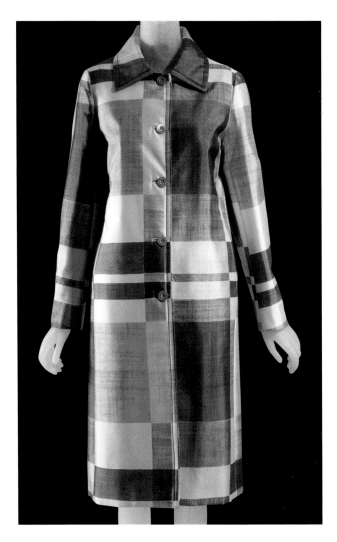

LEFT
Miuccia Prada
Coat: Brown, gold,
green printed silk
Italy, 1996

BELOW
Miuccia Prada
Platform pump: Brown
iridescent patent leather
Italy, 2008

OPPOSITE
Miuccia Prada
Ensemble: Black wool,
plastic fringe orange fleece,
red silk rib
Shoes: Black satin,
taupe satin, black
elastic, metal hardware
Italy, 2007

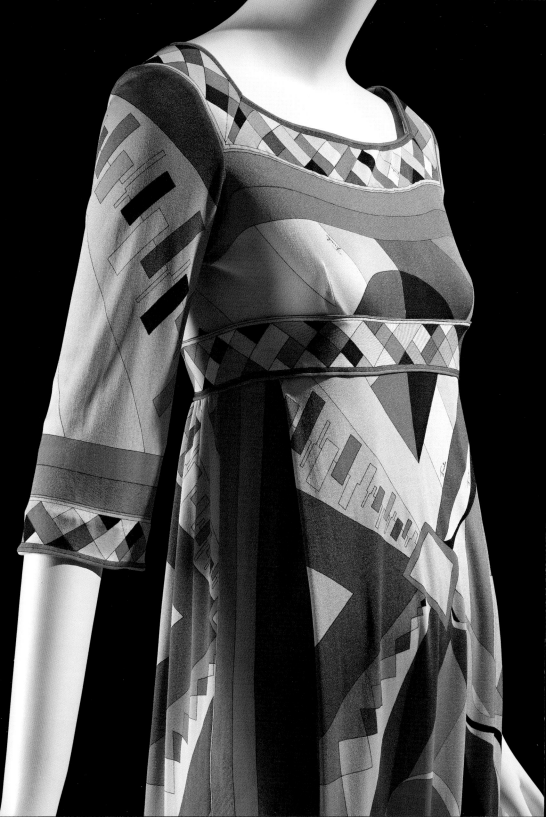

Pucci

EMILIO PUCCI (1914–1992) Pucci fashions are immediately identifi-
able by their dynamic prints and vivid, unusual color combina-
tions. "First people thought it was crazy; then people were
crazy for it," recalled label founder Emilio Pucci. He was
an Italian aristocrat who had never intended to join
the fashion industry. *Harper's Bazaar* photographer
Toni Frisell saw the colorful sportswear worn by Pucci
and a female companion while skiing in Switzerland,
and shortly after her photos appeared in the magazine
in 1948, luxury retailer Lord & Taylor began selling
Pucci's work.

Pucci's understanding of the leisured, upper-class
lifestyle contributed to his success. Throughout the 1950s,
his relaxed yet sophisticated clothes became increasingly fashionable among jet-setters.
Styles made in his signature lightweight, wrinkle-free silk jersey were ideal for travel.
His clothing was also acclaimed for its comfort and lack of structure, which was in contrast
to many 1950s styles.

Pucci's work became synonymous with the youthful vitality of the 1960s, even though
his expressive, self-designed prints had predated the trends for Op Art and bright colors.
The fashion press nicknamed Pucci "the Prince of Prints," and his acclaim was such that
he was asked to design everything from pot holders to airline uniforms, all of which he
infused with his vibrant, joyful style.

"Puccimania" waned over the next two decades, but Emilio Pucci witnessed the
revival of his fashion label shortly before his death in 1992. At that time, his daughter,
Laudomia, took over the business. Under her direction, designers such as Christian
Lacroix, Matthew Williamson, Peter Dundas, and recently Massimo Giorgetti, have con-
tinued the brand's legacy. In 2020, the brand announced that it would introduce a series of
one-off collections with various designers. — *C. H.*

"[Pucci's] silk jersey was almost like wearing nothing."
— **Diana Vreeland, editor, Harper's Bazaar and Vogue**

PREVIOUS SPREAD
Pucci
Dress: Multicolor printed
silk jersey
Italy, ca. 1965

LEFT
Pucci
Handbag: Multicolor printed
silk faille, gold metal
Italy, ca. 1967

OPPOSITE LEFT
Pucci
Jacket: Multicolor printed
cotton velveteen
Italy, ca. 1963
Pants: Black stretch silk
shantung
Italy, ca. 1968

OPPOSITE RIGHT
Pucci
Blouse: Multicolor printed silk
Pants: Red silk
Italy, ca. 1955

Pucci's colorful sportswear
has retained its popularity for
decades. During the 1960s, his
signature prints embodied a
youthful vitality and were worn
by fashionable women all over
the world.

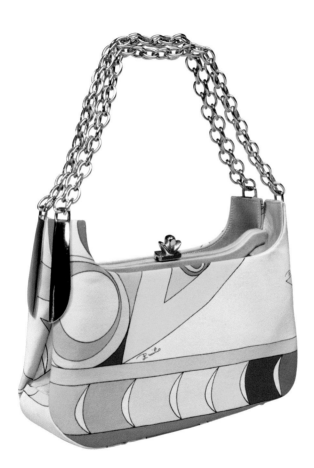

"I revolutionized fashion because of intuition. Certain things were in the air."
— EMILIO PUCCI

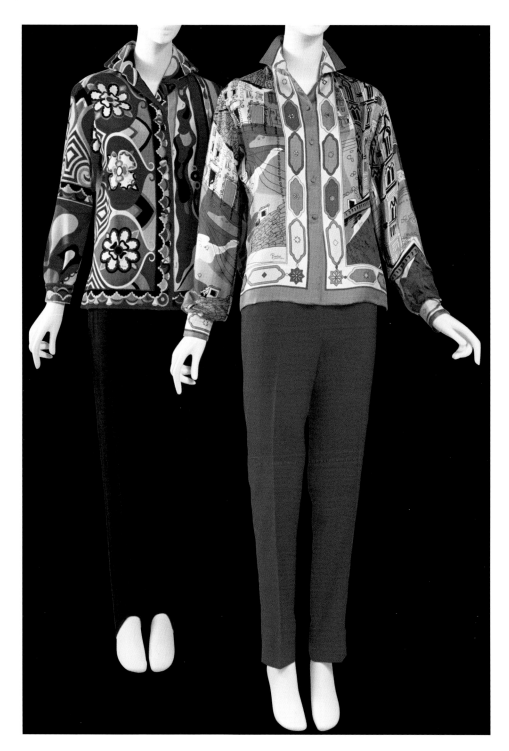

Pyer Moss

KERBY JEAN-RAYMOND (B. 1986) Pyer Moss founder Kerby Jean-Raymond fearlessly embraces politics and social activism on the runway. His work fuses carefully crafted artisanal pieces such as a hand-painted leather jacket or bead-encrusted sheath dress with sportswear items like sneakers, T-shirts, and hoodies that are often dubbed "streetwear." But Jean-Raymond rejects that moniker. As he once explained, "I just want to know what's being called 'street,' the clothes or me?" In 2018 Pyer Moss won the prestigious CFDA/Vogue Fashion Fund Award, bringing a new level of recognition to Jean-Raymond's work. He reacted to the fame with a tweet: "To all the writers newly covering Pyer Moss, thank you and welcome. Please refrain from calling us a streetwear company. It's lazy and singular, we are more, you are more."

This frank talk about race has become a hallmark of the Pyer Moss brand. T-shirts and jackets are emblazoned with slogans like "We already have a black designer," "AS USA AS U," and "Stop calling 911 on the culture." But it was not always a recipe for success. Jean-Raymond launched Pyer Moss as a menswear line in 2013, expanding to include womenswear in 2015. By 2017 Jean-Raymond came close to closing the company and leaving the industry altogether, until a collaboration deal with Reebok came through, which allowed him to buy back full control of the Pyer Moss label and reset his vision for the brand. With each subsequent collection, Jean-Raymond has continued to position Pyer Moss as an ode to black culture—from a collection inspired by nineteenth-century black cowboys to a runway presentation held at the Weeksville Heritage Center in Brooklyn. In his view, "The act of being black and public is unapologetically political... Clothes are our most common tool after music... They are our canvas." In 2021, Kerby Jean-Raymond became the first Black American designer invited by the Chambre Syndicale to present during Paris Haute Couture Week. —*E. M.*

"What these collections really aim to do is to shift the narrative that's constantly being told about what it means to be and look and act black." — KERBY JEAN-RAYMOND

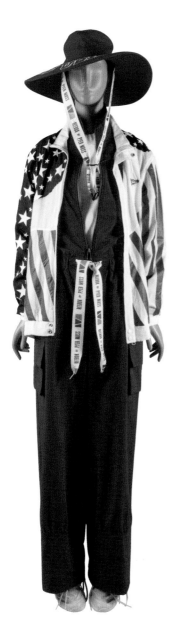

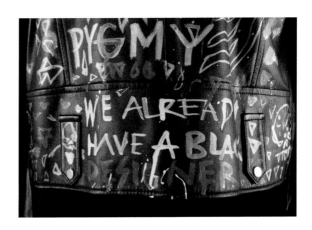

"Everything I've done has been personal."
— **Kerby Jean-Raymond**

PREVIOUS SPREAD AND LEFT
Pyer Moss
(Kerby Jean-Raymond)
Ensemble: White cotton, red canvas, and red polyester
USA, fall 2018

ABOVE AND OPPOSITE
Pyer Moss
(Kerby Jean-Raymond)
Ensemble: Hand-painted black leather, velour, and cotton
USA, spring 2016

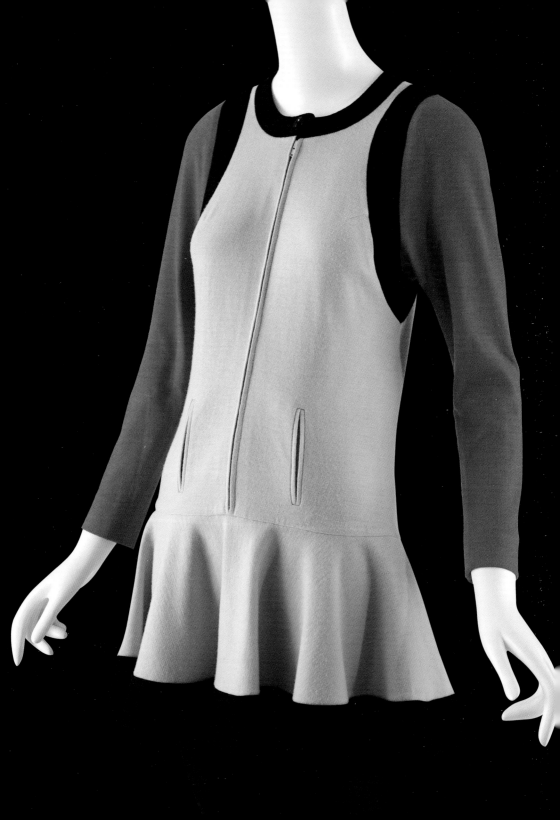

Mary Quant

MARY QUANT (B. 1934) once observed that, "rightly or wrongly," she had "been credited with the Lolita Look, the Schoolgirl Look, the Wet Weather Look, the Kinky Look, the Good Girl Look, and lots of others." But the attributions pleased her. "I like being given the credit for such things," she said. She has also been credited with that quintessential 1960s garment, the miniskirt, although she and André Courrèges actually share that distinction.

Quant was educated at London's Goldsmiths College, where she met her future husband and business partner, Alexander Plunkett-Greene. She briefly worked for the British milliner Erik, and then in 1955 opened Bazaar, her Chelsea boutique, initially only a retail outlet for unusual clothing and accessories. Bazaar became a mecca for young mods and rockers, and Quant, dissatisfied with the clothing options available on the market, began to design her own styles. She had always felt that the young needed a youthful and fun independent style that was far from the stuffy clothing of their parents.

Quant's creations captured the spirit and the vitality of London's burgeoning youth movement. The simplicity of her designs, a classic shift dress with pleats or an A-line jumper with a drop waist, seemed extraordinary in the late 1950s and 1960s. She also created "kooky" tights and coordinating knickers, was the first to use PVC in fashion, designed textiles, and started a cosmetics line. Outside of Britain, her designs were sold worldwide, at venues that included the major United States retailer J. C. Penney. —*J. F.*

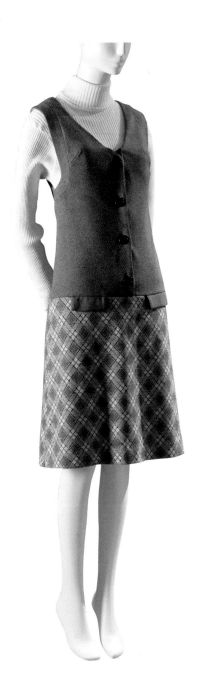

"We were in at the beginning of a tremendous renaissance in fashion. It was not happening because of us. It was simply that, as things turned out, we were a part of it."
— **Mary Quant**

PREVIOUS SPREAD
Mary Quant
Dress: Tan, orange, and black wool jersey
England, ca. 1965

LEFT
Mary Quant
Dress: Gray wool and rayon, argyle knit
England, ca. 1967

OPPOSITE
Mary Quant
Dress: Black rayon crêpe
England, ca. 1962

"Mary was the right age (twenty-one). She chose the right place (the King's Road), and the right time (1955)."
— ERNESTINE CARTER, CURATOR AND JOURNALIST

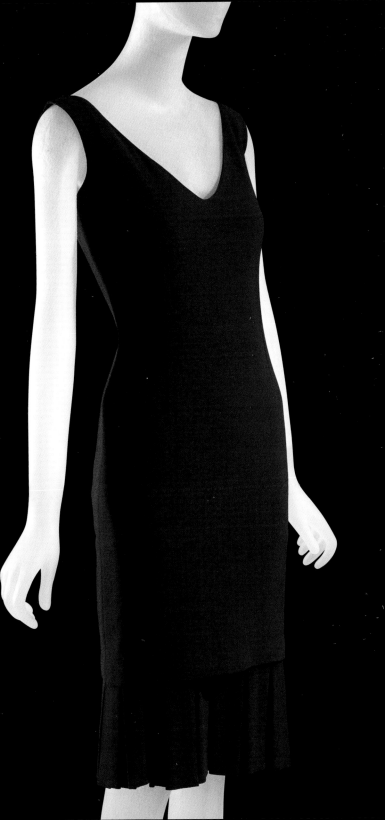

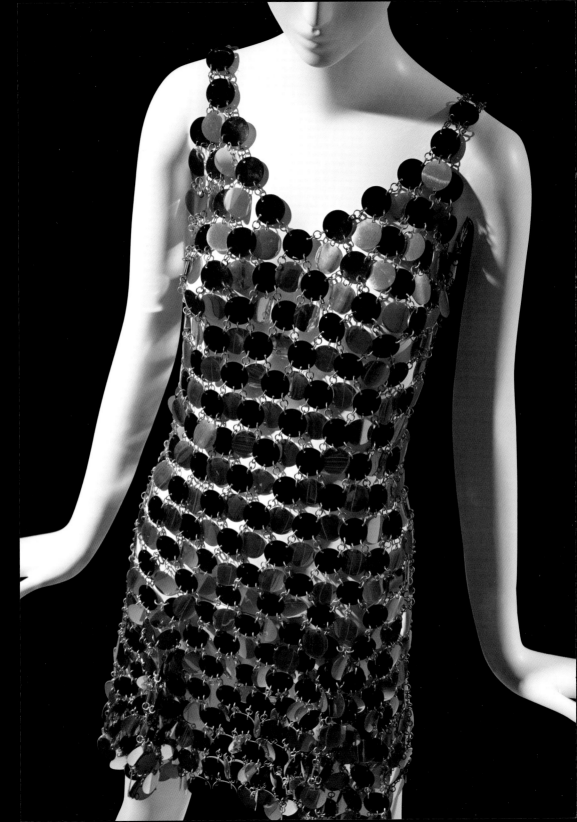

Paco Rabanne

PACO RABANNE (B. 1934) presented his first runway show in 1966, calling the collection "Twelve Unwearable Dresses in Contemporary Materials." Resembling futuristic armor, the garments were made from discs of Rhodoid plastic, joined with metal rings. "We must look for new materials in order to find new shapes," Rabanne said. This idea would establish him as a leading experimental designer.

Rabanne was raised in Spain's Basque region, but political unrest forced his family to flee to France when he was still a child. He studied architecture for twelve years at the École des Beaux-Arts in Paris. Rabanne produced handbag illustrations for Charles Jourdan and Roger Model to pay for his architectural training, and the work sparked his interest in the fashion industry. He began to design unusual buttons, embroideries, accessories, and jewelry in the 1950s, some of which were produced for such eminent French fashion houses as Christian Dior and Givenchy.

Early reviews for Rabanne's fashions, which were inspired by his jewelry's plastic and modern materials, were mixed. While many French fashion journalists were dismayed by the designer's disregard for tradition, American audiences were intrigued. Rabanne continued to present clothing collections, with later work incorporating metal disks, paper, leather, rubber, and even fabric, adding new textures and shapes to his signature chainmail technique.

Although Rabanne's impact had lessened by the mid-1970s, his radical take on clothing materials and construction continues to inspire other designers. Indian designer Manish Arora served as the creative director at Paco Rabanne from 2011 to 2012, followed by Julien Dossena, who continues to carry on the brand's legacy. His spring/summer 2012 ready-to-wear collection was shown at Paris Fashion Week in fall 2011. —*C. H.*

"I am only interested in the research for new, contemporary materials. Shapes do nothing for me."
— PACO RABANNE

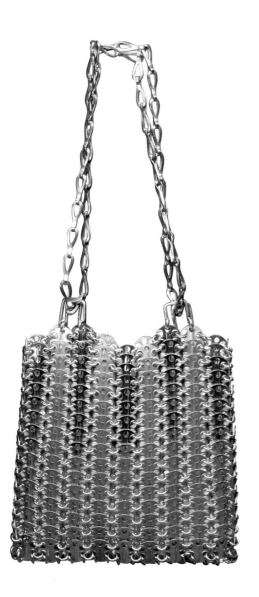

PREVIOUS SPREAD
Paco Rabanne
Dress: Silver plastic,
black plastic, silver metal
France, ca. 1966

LEFT
Paco Rabanne
Handbag: Gold metal
France, ca. 1966

OPPOSITE
Paco Rabanne
Dress: White plastic,
silver plastic, silver metal
France, ca. 1968

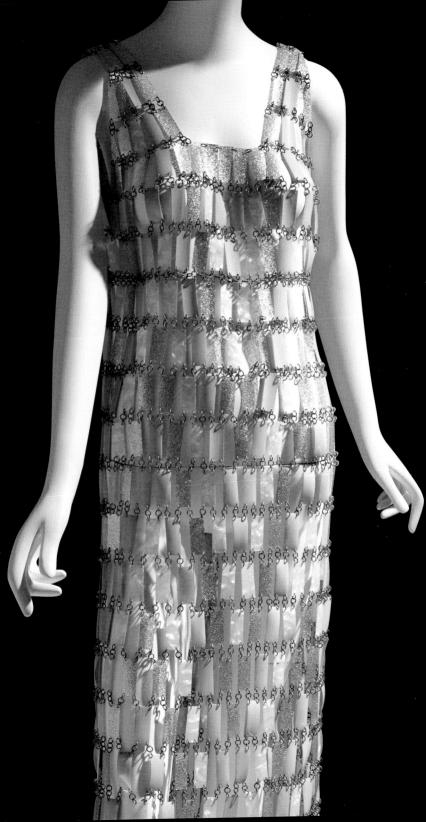

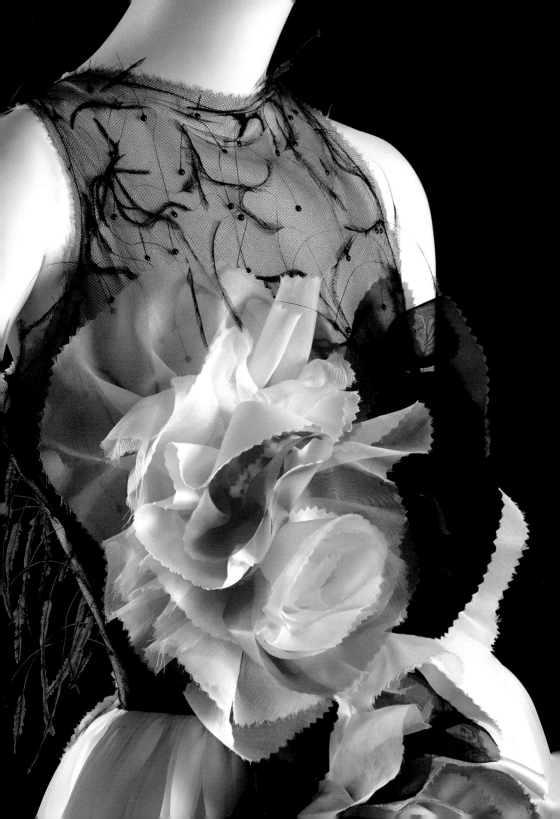

Rodarte

KATE (B. 1979) AND LAURA (B. 1980) MULLEAVY Kate and Laura Mulleavy, known as Rodarte, are beloved by the fashion industry, and also respected by curators, because their clothes have bridged the difficult gap between innovative craftsmanship and commercial appeal. Furthermore, despite their youth, Kate and Laura are highly sophisticated and understand even without professional training how to both craft and ornament a garment.

The Mulleavys founded Rodarte in 2005 in Los Angeles, a few years after earning liberal arts degrees in art history and literature, respectively, at the University of California, Berkeley. Their first pieces were made by the two sisters themselves. Despite such quaint beginnings, the duo was immediately thrust into the international spotlight when major publications such as *Vogue* began to feature their work in editorial spreads. Among the prizes and honors conferred upon the sisters is the CFDA Womenswear Designers of the Year in June 2009.

Rodarte's earliest designs illustrate their remarkable ability to handle delicate fabrics like chiffon and organza and denote their sources of inspiration, such as Gainsborough portraits and the lush rose gardens of the Huntington Library near their home in Southern California. These ravishing confections are festooned with oversized cabbage roses and wisps of feathers and beads. The sweetness implicit in the Rodarte oeuvre is often tempered with more ominous sources of inspiration—modern Japanese horror films, for example. Arresting objects such as gowns covered in layers of hand-dyed silk netting that were made to look like rivers of blood (from their fall 2008 Japanese horror-inspired collection) exemplify Rodarte's perfect blend of aesthetics (the gruesome made beautiful) and innovation (craftsmanship elevated to art). —*P. M.*

"Kate and Laura's work reminds me of my early days—it is free and fearless and not precious." — FRANK GEHRY, ARCHITECT

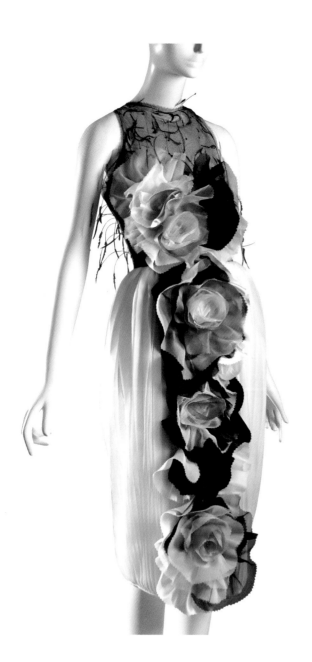

"The Rodarte way of thinking is wonderfully unconstricted by eras or trends. The Mulleavy sisters are gifted and indefatigable cultural hunter-gatherers; their exquisite clothing, fearlessly imagined and precisely constructed, attests to their voracious curiosity and constant discernment." — **Susan Morgan, *The New York Times Magazine***

PREVIOUS SPREAD AND LEFT
Rodarte
Evening dress: White, red, andblack silk organza, feathers, embroidery
USA, 2007

Sisters Kate and Laura Mulleavy of Rodarte create garments that emphasize the craft and tradition of dressmaking.

OPPOSITE
Rodarte
(Boots by Nicolas Kirkwood)
Ensemble: Gray printed marbleized leather, cotton tulle, lace
Boots: Gray leather
USA, 2009

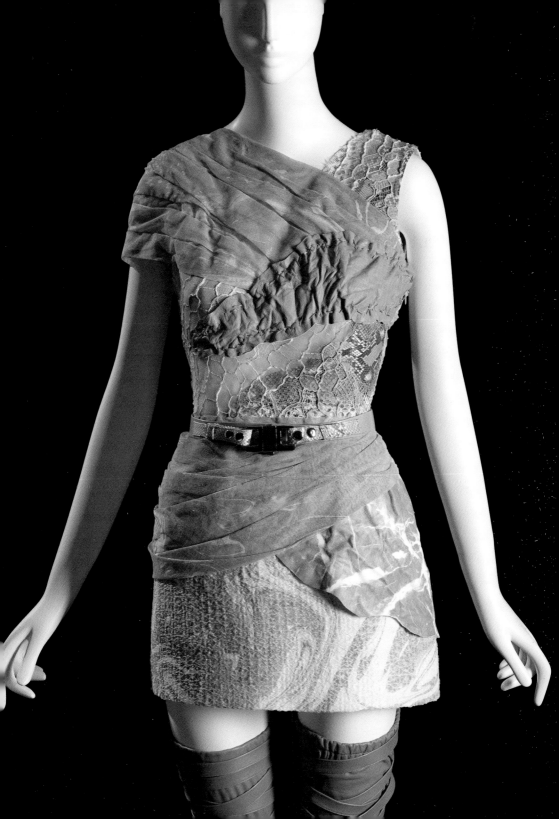

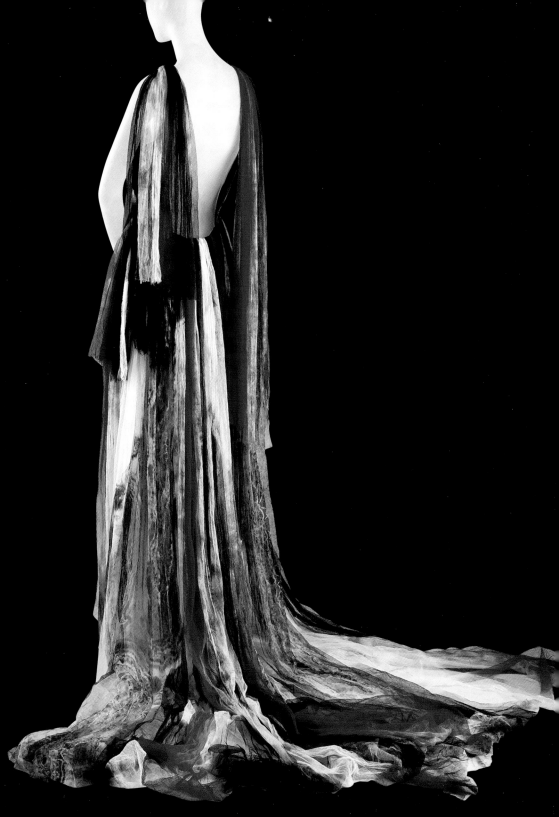

OPPOSITE AND BELOW
Rodarte
Evening dress: Red, white,
black steam-dyed tulle,
black mohair
USA, 2008

The Mulleavys were inspired
by Asian horror films when
they conceived this extraor-
dinary dress. The textile was
hand-dyed to resemble blood
in water.

RIGHT
Rodarte
Dress: Black, white,
and metallic wool
USA, 2008

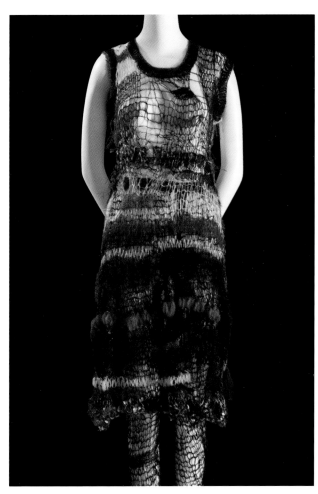

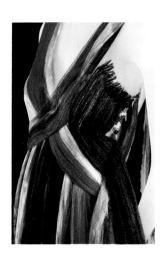

FOLLOWING SPREAD, LEFT
Rodarte
Dress: Black lace; black gauze;
black net; burgundy, black
leather
USA, 2010

FOLLOWING SPREAD, RIGHT
Rodarte
Dress: Black net, wool,
feathers, leather, metallic gauze
USA, 2010

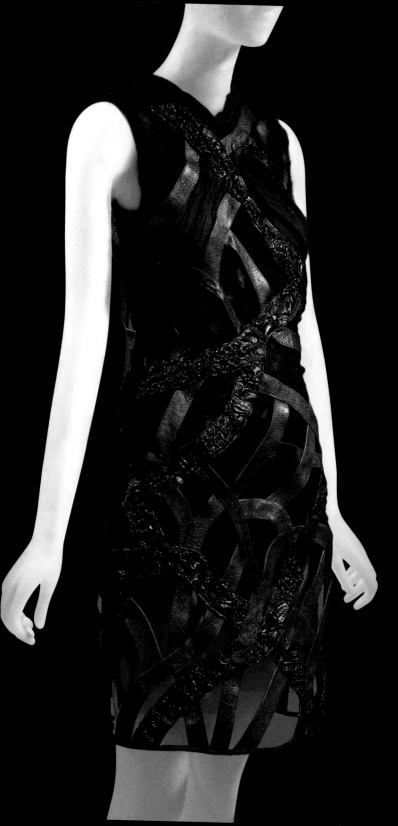

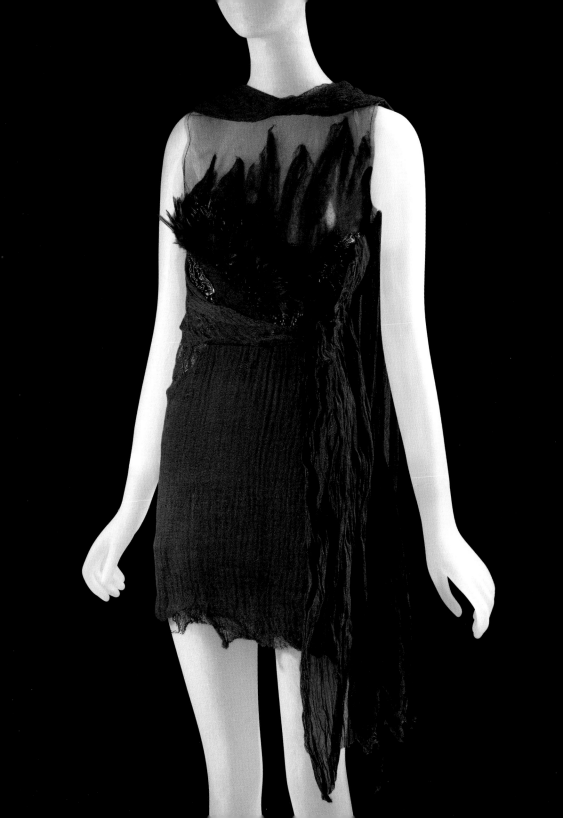

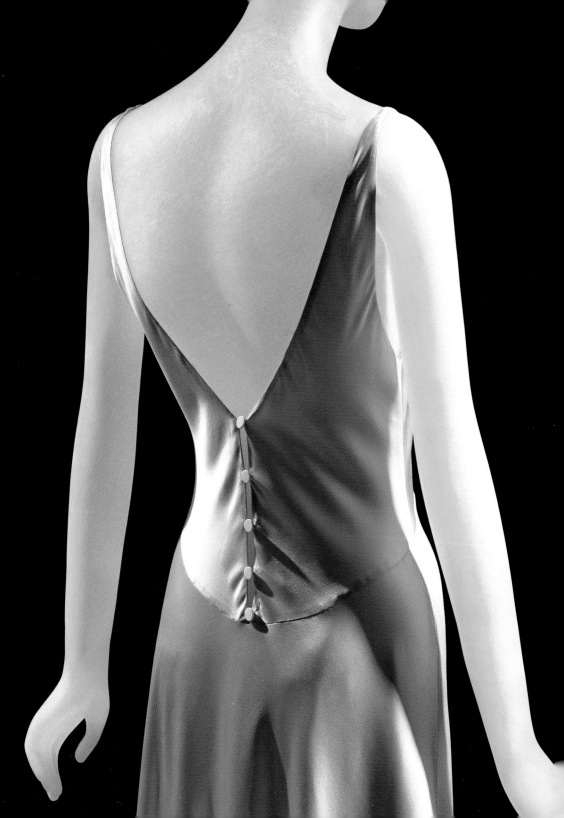

Narciso Rodriguez

NARCISO RODRIGUEZ (B. 1961) On September 21, 1996, Narciso Rodriguez became a fashion star. On that day, on the steps of a tumbledown church on Cumberland Island, off the Georgia coast, Rodriguez's friend Carolyn Bessette appeared wearing a $40,000 bias-cut dress that he had designed for her wedding to John F. Kennedy, Jr.

Described as a "minimalist with heat," Rodriguez, since the debut of his line in 1997, has become rightfully known as one of the most astute sculptors of sharply chiseled dresses, coats, and separates. In many of his best designs, he cuts numerous pattern pieces that are then joined to accentuate the shape of the wearer's body.

The first child and only son of Cuban parents who immigrated to Newark, New Jersey, Rodriguez earned a degree from Parsons, despite his parents objections to his chosen profession. He eventually worked for Anne Klein, under Donna Karan; Calvin Klein, where he designed the women's collection; the Paris-based company Cerruti; and then the Spanish brand Loewe. Rodriguez won the CFDA's Womenswear Designer of the Year Award in 2002 and 2003, becoming the first designer to earn the prize two years in a row. By this time, however, Rodriguez had begun to experience some business difficulties. First, he ended his partnership with his label's manufacturer, Aeffe. Then, in 2007, Liz Claiborne acquired a 50 percent interest in his company—though Rodriguez bought back his name the following year.

Rodriguez remains one of the most important and visible fashion designers in the United States. Aside from a bevy of celebrities that have worn his clothes, his clients have also included former First Lady Michelle Obama. —*P. M.*

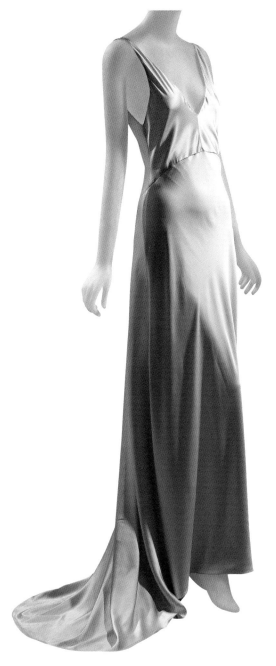

"What I relate to is the creation of a form from structure and material."
— **Narciso Rodriguez**

PREVIOUS SPREAD AND LEFT
Narciso Rodriguez
Evening dress: Pale-pink silk charmeuse
USA, 2011

OPPOSITE
Narciso Rodriguez
Evening dress: Pink and metallic-gold silk; nude silk satin; pink-and-white pearls; sequins
USA, 2005

"I think something can be very classic and be completely modern." — NARCISO RODRIGUEZ

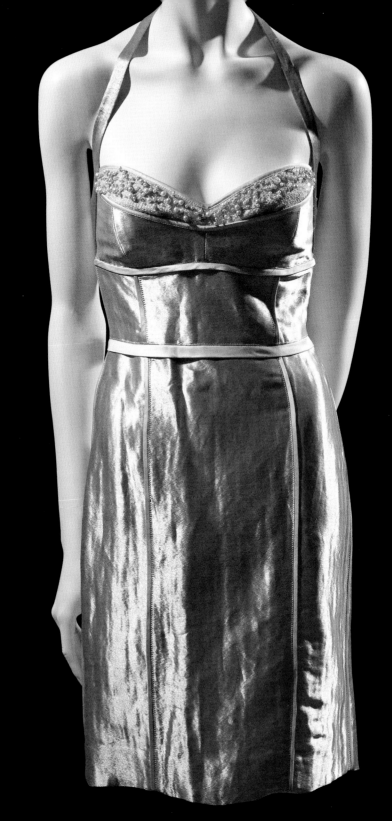

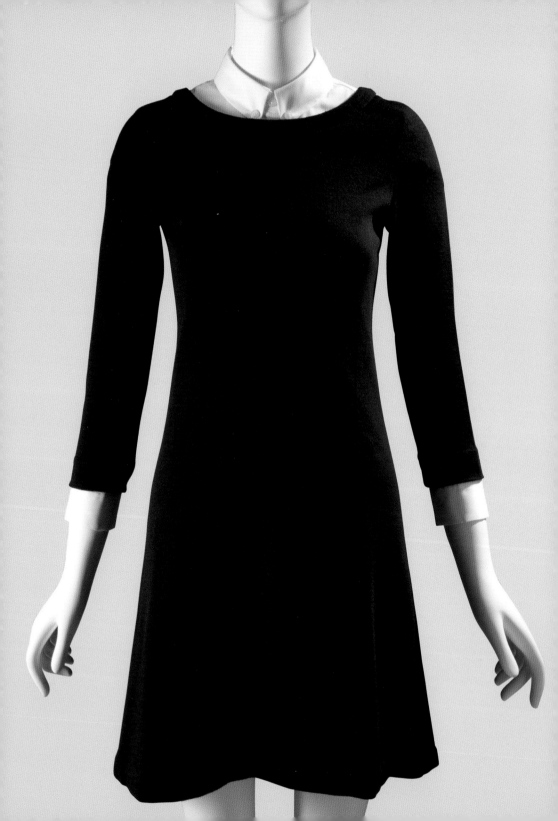

Sonia Rykiel

SONIA RYKIEL (1930–2016) Sonia Rykiel began her career by introducing one of the most ubiquitous designs of the 1960s: the "poor boy" sweater. While working at Laura, the Rykiel family's Paris boutique, she contacted an Italian knitwear manufacturer to create a snug sweater that would suit her petite frame. The sweater—with its high armholes and slightly cropped waist—soon caught the attention of fashion editors, and they flew off shelves despite their high price tag. The "Queen of Knits" had arrived.

Sonia Flis was born in 1930 in Neuilly-sur-Seine to upper-middle-class Jewish parents. She married Sam Rykiel in 1953, and the couple had two children. In interviews Rykiel disclosed that she had envisioned a quiet life as a wife and mother, but her unmistakable talent led her in another direction. She divorced Sam Rykiel in 1968, the same year she opened a boutique under her own name. Many of her early designs were crafted from knit fabric, resulting in comfortable clothes that were both distinctive and effortless.

Rykiel believed that women should not have to make drastic changes to their wardrobes from season to season—an attitude well ahead of its time. She created separates that could be worn for years and mixed-and-matched. Colorful, horizontally striped knits were an early hallmark of the designer's works. Notably, Rykiel began to design clothes with exposed seams in 1974, a style that may have influenced Japanese avant-garde design during the following decade.

Rykiel's daughter, Nathalie, was appointed artistic director in 1995, a position she still held when her mother passed away in 2016. Under Nathalie's direction, the brand expanded to include a children's wear line and a diffusion line. However, after weathering several years of financial difficulties, the label folded in 2019. —C. H.

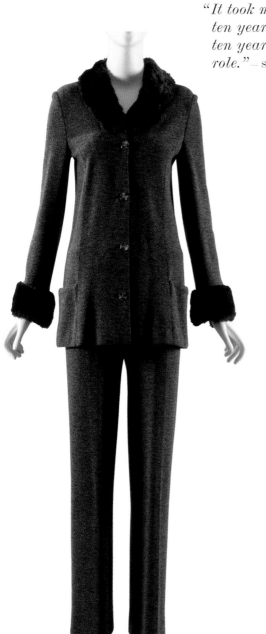

"It took me ten years to define a style, ten years to define an image, and ten years to redefine the woman's role." — SONIA RYKIEL

"My designs are only an expression of myself in color and shape."
— **Sonia Rykiel**

PREVIOUS SPREAD
Sonia Rykiel
Dress: Navy wool jersey and white cotton
France, ca. 1965

LEFT
Sonia Rykiel
Pantsuit: Brown wool knit and brown faux fur
France, ca. 1965

OPPOSITE
Sonia Rykiel
Sweater and trousers: Plum and rose wool knit, plum wool jersey
France, ca. 1975

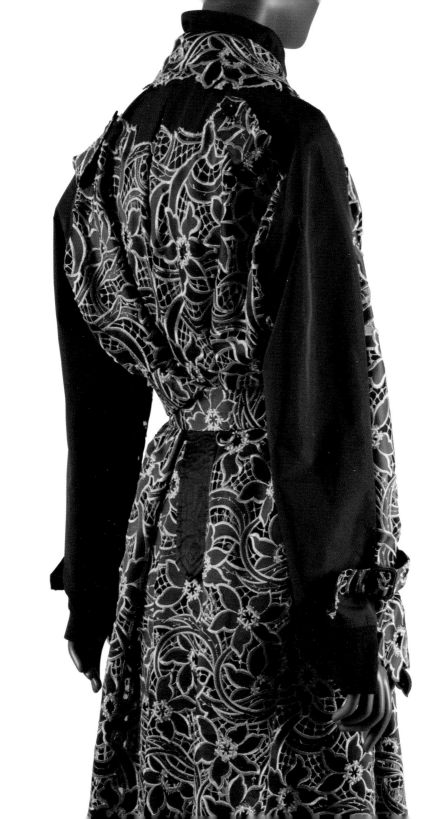

Sacai

CHITOSE ABE (B. 1965) Japanese brand Sacai occupies a unique space between high fashion and street style, which has garnered the label a cultlike following among both men and women. Founder Chitose Abe's distinctive aesthetic employs deconstruction, color contrast, textures, and asymmetry to create pieces that often fuse two recognizable yet disparate garments together (blazer and puffer coat, Breton sweater and lace blouse). The results are looks that *Women's Wear Daily* describes as "surprisingly wearable."

Chitose Abe (born Chitose Sakai) got her start in the industry as a pattern cutter for Comme des Garçons, working under both Rei Kawakubo and Junya Watanabe and eventually joining Watanabe's design team. The influence of their work on her own is undeniable, but Abe's interest in wearability sets her apart. "I make clothes that I want to wear, that fit my lifestyle," Abe explains. "No matter how conceptual the clothing might be, it always goes back to 'Would I wear this?' If the answer is no, then I won't go forward with the design."

A play on her maiden name, Sacai officially launched in 1999 with a tiny collection of pieces Abe made at home. She ran the business on her own for three years before hiring her first employee, and she did not hold her first runway show until 2011. While surprisingly slow within today's industry, Abe felt this pace was vital to her growth as a designer and business owner. Today, Sacai is a globally recognized brand with stand-alone stores and major collaborations with Nike and Birkenstock, among others. But Abe herself remains reserved, preferring to be behind the scenes than in the limelight as a celebrity designer. For her, fashion is about the clothes and the consumer: "There's nothing more rewarding than seeing a non-fashion person on the street wearing my clothes." —*E. M.*

"There is a phrase in Japanese that says 'one instance leads you to many,' which is something I strongly believe in. I was always patient and never gave up on what I wanted to achieve."
— CHITOSE ABE

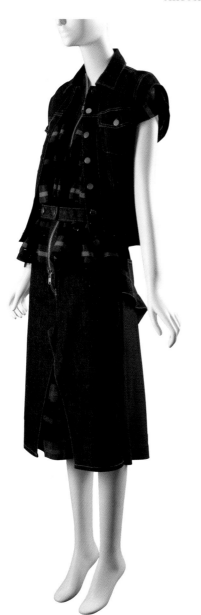

"I just do what I like. That's it."
— **Chitose Abe**

PREVIOUS SPREAD
Sacai (Chitose Abe)
Coat: Blue satin and gold metallic lace
Japan, spring 2016

LEFT
Sacai (Chitose Abe)
Ensemble: Blue denim, black and pink nylon, red velvet, and metal
Japan, spring 2015

OPPOSITE
Sacai (Chitose Abe)
Ensemble: White cotton lace, navy-and-white striped knit cotton
Japan, spring 2015

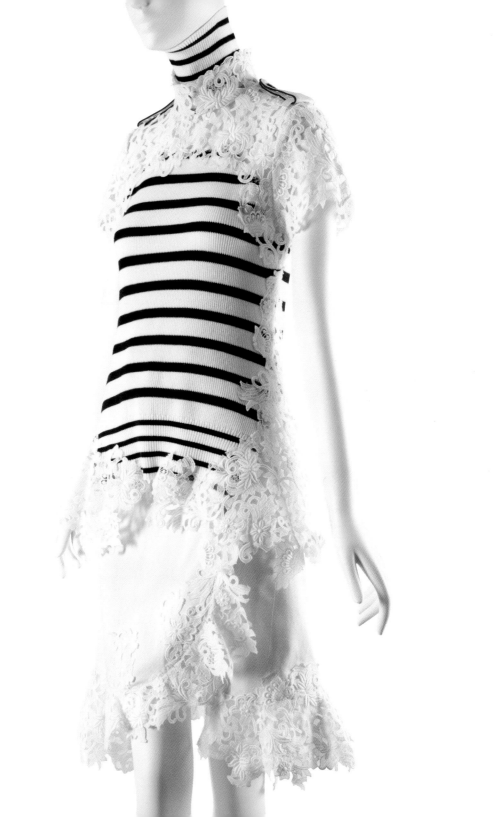

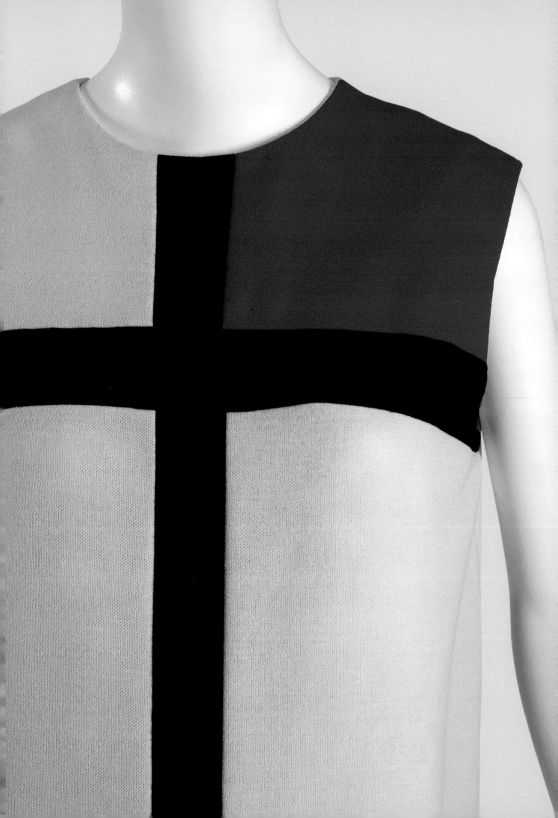

Yves Saint Laurent

YVES SAINT LAURENT (1936–2008) is one of the greatest names in fashion history. Along with Christian Dior and Coco Chanel, he was part of a trio of couturiers who epitomized the best of twentieth-century fashion and style. A prodigious sketcher, he was never an "inventor" of styles, nor was he a master craftsman. Instead, like Chanel before him, Saint Laurent was a modernist who recontextualized many items of functional clothing, such as safari jackets and men's tuxedos, into chic and feminine wardrobe staples. Saint Laurent also produced sweepingly exotic and romantic clothes inspired by such diverse sources as Russian peasantry or the demimonde of the Belle Époque. Few couturiers could match Saint Laurent's blend of perfectly proportioned cuts and brilliant color combinations.

Although known to the world at large by only three initials—YSL—the designer was born Yves Henri Donat Mathieu-Saint-Laurent in Oran, Algeria. A precocious talent, he moved to Paris to pursue a fashion career. When he was just seventeen, Saint Laurent was hired as Christian Dior's assistant; a mere four years later, following Dior's sudden death, he was named head of Dior's house. While his first collection was a triumph, subsequent seasons were viewed as too avant garde. After a traumatic stint in the army and his firing from Dior, Saint Laurent opened his own fashion house in 1961 with Pierre Bergé, his longtime partner.

His ready-to-wear line, Rive Gauche, which debuted in 1966, set the template for other French couturiers, and for four decades, until his retirement in 2002, Saint Laurent changed the course of fashion. He created a number of landmark styles: his odes to art, from Piet Mondrian shift dresses in 1965 to his 1980 Picasso collection; his "*Le Smoking*" women's tailored tuxedo suit in 1966; his spring 1971 collection, inspired by 1940s fashion; and his *Ballets Russes* (1976–77) and Chinese (1977–78) collections. Saint Laurent was also noted for his use of ethnic models at his runway shows and for the bevy of inspiring women—from Betty Catroux to Catherine Deneuve to Loulou de la Falaise—who were enmeshed in both his designing and personal lives.

In 1983, he was the first living fashion designer to have a solo exhibition of his work organized by the Metropolitan Museum of Art. Saint Laurent died in 2008. Hedi Slimane served as creative director from 2012 to 2016, and was succeeded by Anthony Vaccarello. —*P. M.*

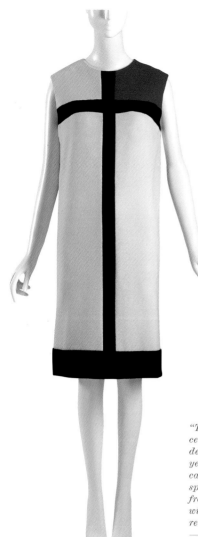

"Follow Yves down the garden path, there's always a pot of gold at the end."
— DIANA VREELAND,
EDITOR, *HARPER'S BAZAAR* AND *VOGUE*

"The most consistently celebrated and influential designer of the past twenty-five years, Yves Saint Laurent can be credited with both spurring the couture's rise from its sixties ashes and with finally rendering ready-to-wear reputable."
—**Caroline Rennolds Milbank, author**

PREVIOUS SPREAD AND LEFT
Yves Saint Laurent
"Mondrian" dress:
Ivory, red, black wool jersey
France, 1965

OPPOSITE
Yves Saint Laurent
Suit: Black wool, lace
France, 1990

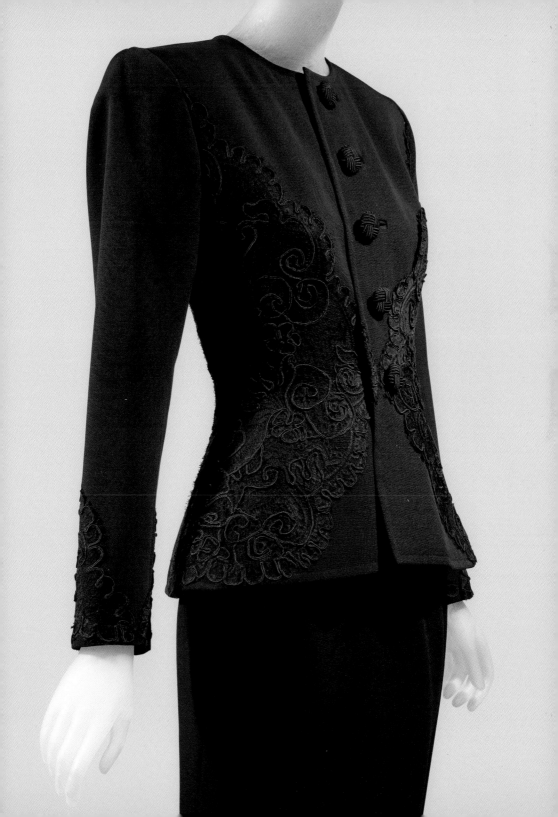

"The most beautiful clothes that can dress a woman are the arms of the man she loves. But for those who haven't had the fortune of finding this happiness, I am there." — YVES SAINT LAURENT

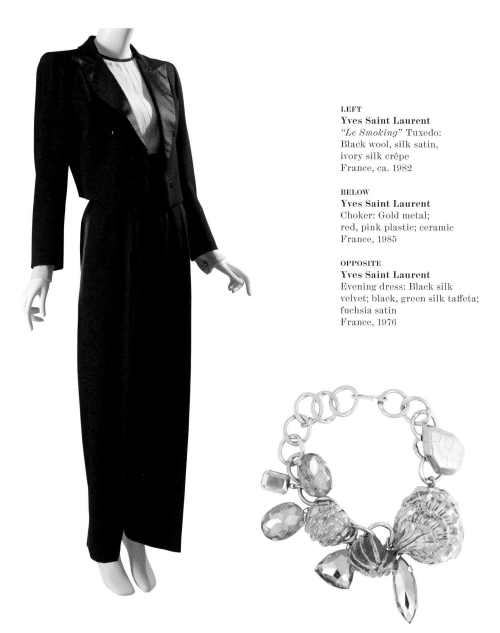

LEFT
Yves Saint Laurent
"Le Smoking" Tuxedo:
Black wool, silk satin,
ivory silk crêpe
France, ca. 1982

BELOW
Yves Saint Laurent
Choker: Gold metal;
red, pink plastic; ceramic
France, 1985

OPPOSITE
Yves Saint Laurent
Evening dress: Black silk
velvet; black, green silk taffeta;
fuchsia satin
France, 1976

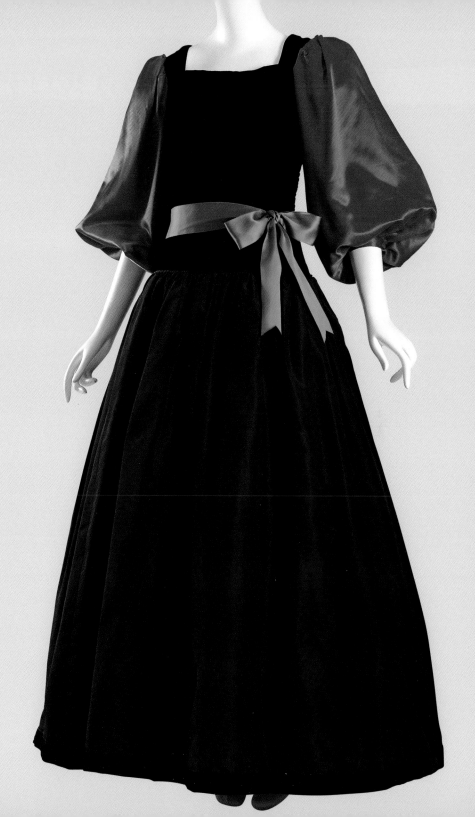

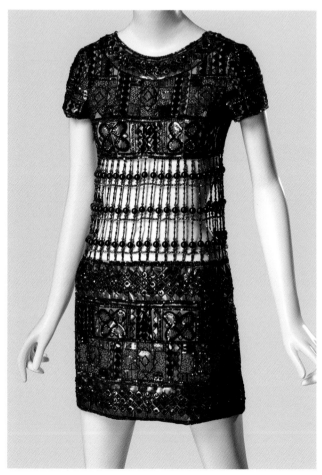

ABOVE LEFT
Yves Saint Laurent
Hat: Burgundy velour felt,
black fur, cording
France, 1975

ABOVE RIGHT
Yves Saint Laurent
Evening dress: Brown silk
organza, brown and black
paillettes, bronze-tone
and gold metallic beads,
wooden beads, and black
seed beads
France, 1967

Yves Saint Laurent was one of
the most influential designers of
the twentieth century. His love
of "exoticism" was expressed in
collections famously inspired by
China, Russia, the Middle East
and, in this case, Africa.

OPPOSITE
Yves Saint Laurent
Evening dress: Multicolor
silk jacquard
France, 1977

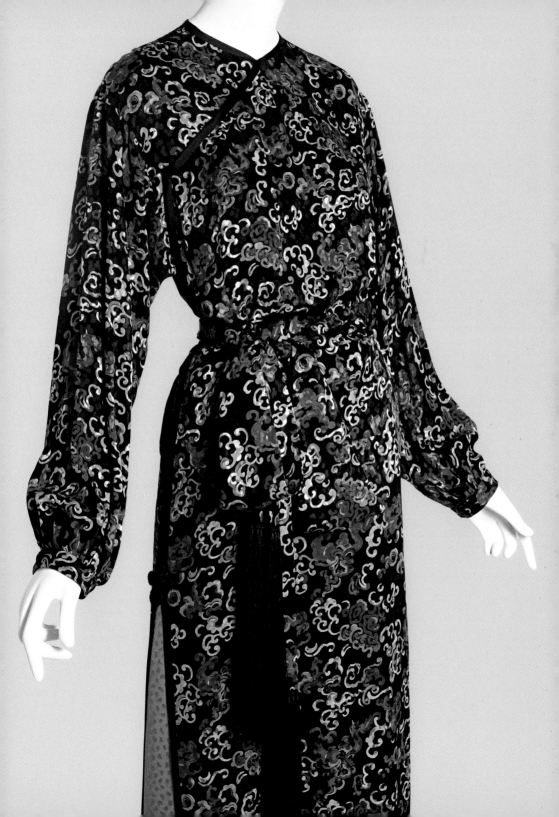

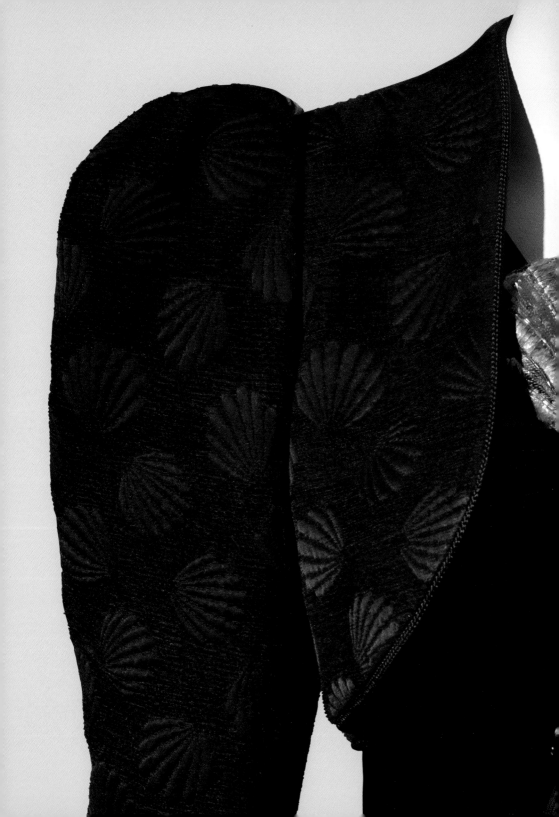

OPPOSITE AND LEFT
Yves Saint Laurent
Evening dress and jacket:
Black silk chenille, silk satin
matelassé, black silk velvet,
gold lamé
France, 1978

ABOVE
Yves Saint Laurent
(**Roger Scemana**)
Brooch: Red diamanté,
baroque pearls, metal
France, ca. 1962

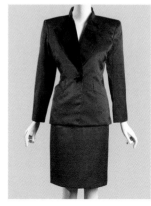

LEFT
Yves Saint Laurent
(Rive Gauche)
Suit: Navy pinstripe wool
France, 1967

ABOVE
Yves Saint Laurent
(Rive Gauche)
Evening suit: Fuchsia, red,
and black silk satin
France, 1988

OPPOSITE
Yves Saint Laurent
(Stefano Pilati)
Jumpsuit: Black leather
France, 2009

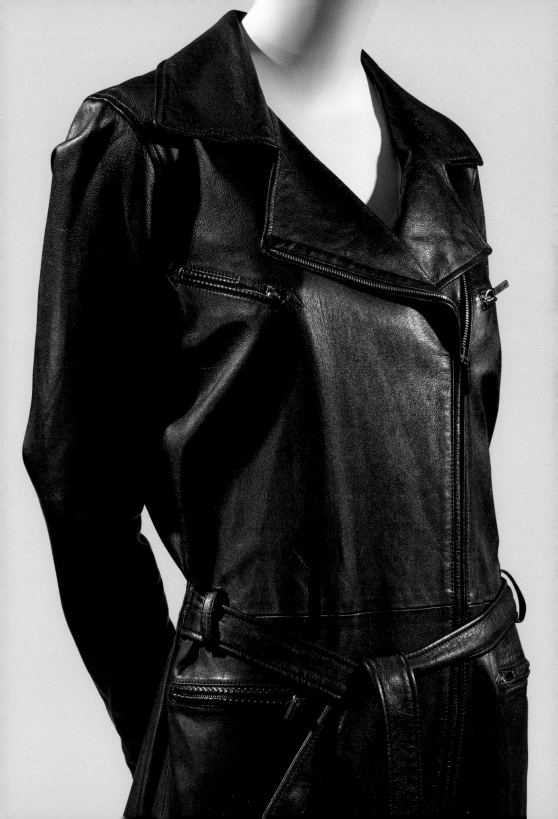

Schiaparelli

ELSA SCHIAPARELLI (1890–1973) is among the most original figures in the history of twentieth-century fashion. She had a forty-year career that began in 1926, but she is best remembered for her Surrealist-inspired designs of the 1930s. Despite the fact that Schiaparelli worked in the traditional method of applying decorative, two-dimensional images to the surfaces of her clothing rather than employing innovative construction techniques, she was a revolutionary designer who became the first couturier to integrate sophisticated and complex artistic concepts into highly wearable material. Schiaparelli viewed the creation of clothing in terms of artistic inspiration and regarded fashion as much more than a craft, stating in her autobiography, *Shocking Life*, that "dress designing . . . is to me not a profession, but an art."

Born to a conservative, aristocratic Roman family, Schiaparelli exhibited early signs of rebelliousness and artistic inclination that would become the cornerstones of her creativity. At age fourteen, for example, she was sent to a convent for publishing a set of erotic poems; she was released only after going on a hunger strike. Ten years later, she married the eccentric theosophist Count William de Wendt de Kerlor, a mere two days after hearing his lecture in London on "the powers of the soul over the body, magic, and eternal youth." Within two years, the couple moved to New York, had a child, and divorced. With no money and an infant to support, Schiaparelli took a series of odd jobs that in 1922 landed her in Paris, the city she would thereafter consider her home. By 1926 she began a business selling chic and playful sportswear. Five years later, at the height of the Depression, Schiaparelli opened her couture house on the rue de la Paix.

During the apex of her creativity, the years 1934 to 1940, Schiaparelli incorporated Surrealist motifs in her designs and collaborated with such artists as Salvador Dalí and Jean Cocteau, as well as artisans such as Albert Lesage and Jean Clément. Schiaparelli was enthralled by the Surrealists' exploration of the unconscious and their creation

of works filled with strange, and sometimes shocking, dream imagery. Unlike the male Surrealists, however, she did not focus on issues of sexual repression and violence. Instead, she explored questions of female disguise and masquerade, distancing herself from Dalí and Max Ernst, among others, by incorporating the more playful and witty aspects of Surrealism's eroticism. Beginning in 1937, Schiaparelli pioneered the concept of seasonal collections created around a single, unified theme such as *Circus*, *Butterflies*, *Pagan*, *Astrology*, *Commedia dell'arte*, and *Music*. Bertrand Guyon served as creative director for the relaunched Schiaparelli label from 2015 to 2019, and was succeeded by Daniel Roseberry. —*P. M.*

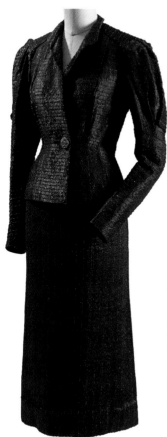

"In difficult times fashion is always outrageous."
— ELSA SCHIAPARELLI

"Schiaparelli is above all the dressmaker of eccentricity... Her establishment in the Place Vendôme is a devil's laboratory. Women who go in there fall into a trap, and come out masked."
— **Jean Cocteau, writer and filmmaker**

PREVIOUS SPREAD
Elsa Schiaparelli
Bag: Violet, yellow, and white silk velvet
France, ca. 1938

LEFT
Elsa Schiaparelli
Suit: Black wool, red metallic yarns, jet beads
France, 1935

OPPOSITE
Elsa Schiaparelli
Suit: Black and red wool, plastic
France, ca. 1935

Elsa Schiaparelli may have been best known for her Surrealist fashions, but she also created "hard chic" tailored suits.

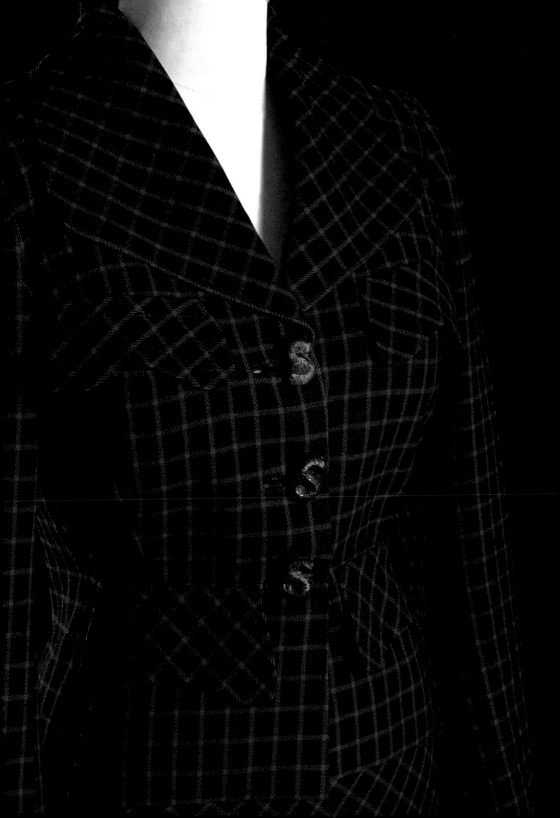

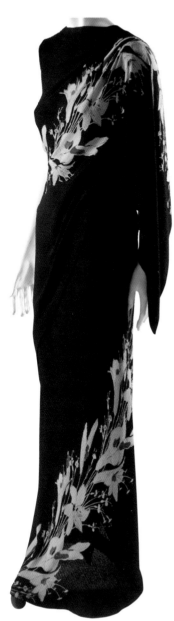

*"She slapped Paris. She smacked it.
She tortured it. She bewitched it.
And it fell madly in love with her."*
— YVES SAINT LAURENT

LEFT
Elsa Schiaparelli
Evening dress: Beige, brown,
blue printed on black rayon noil
France, 1935

BELOW
Elsa Schiaparelli
Gloves: Black silk duplex,
black silk chenille
France, ca. 1946

OPPOSITE
Elsa Schiaparelli
Bag: Black quilted satin,
purple, green satin ribbon
France, ca. 1938

RIGHT
Elsa Schiaparelli
Brooch: Gold metal enameled
in ivory and red
France, ca. 1940

BELOW
Elsa Schiaparelli
Suit: Gray wool
France, ca. 1948

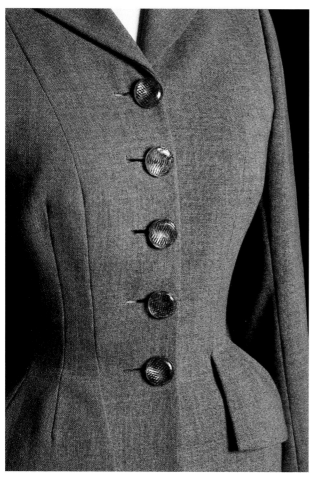

OPPOSITE
Elsa Schiaparelli
Evening dress:
Rust silk faille, pink silk satin
France, ca. 1955

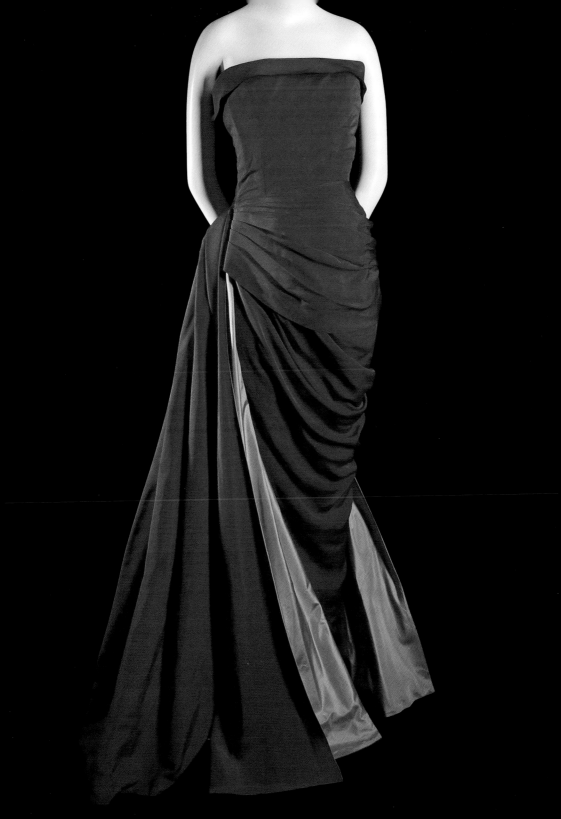

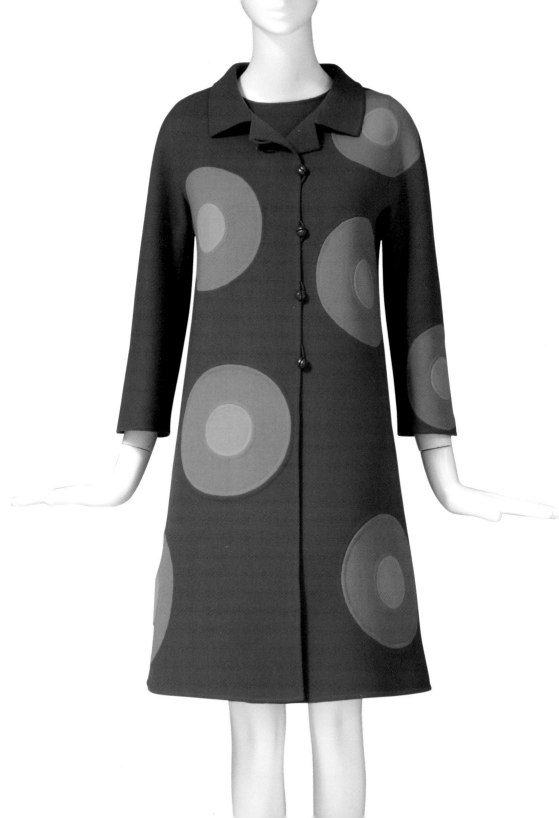

Mila Schön

MARIA SCHÖN (1916–2008) Italian label Mila Schön was founded in 1958 by Maria Schön. Best known for her colorful tailored pieces in double-faced wool, the designer attracted fashion's most elite clientele, including Jacqueline Kennedy and Lee Radziwill. Over the course of her decades-long career, Schön was a pioneering force in the Italian fashion industry as both an early adopter of ready-to-wear and a promoter of "made in Italy" designs around the world.

Schön had no formal training in dressmaking, but she brought an intimate knowledge of French couture to her designs from her days as a client after the Second World War. While inspired by her favorite French houses, including Dior and Balenciaga, she eventually developed her own style. One of her signature features was the double-faced wool in her tailored pieces. Instead of a traditional lining, Schön stitched two pieces of wool back to back. "I created clothes like I wanted them—without lining, with the inside just like the outside," Schön once explained. "Double-faced fabric gave me the idea of order and cleanliness." This approach gave the fabric a more structured, sculptural quality.

Another key feature of Schön's work was color. Vibrant hues and geometric shapes punctuated her designs. She was heavily influenced by modern art, particularly by the works of Alexander Calder, Kenneth Noland, and Lucio Fontana, who each used color, shape, and line to create dynamic forms. Schön's pieces transformed a wearer into a walking work of optical art. As *The New York Times* declared in 1973, she did not "make clothes for shrinking violets." Schön remained actively involved in the label until her death in 2008. The brand continues to operate today, centered on the same signature pillars of tailoring and color. —*E. M.*

"I created clothes like I wanted them—without lining, with the inside just like the outside; double-faced fabric gave me the idea of order and cleanliness." — MARIA SCHÖN

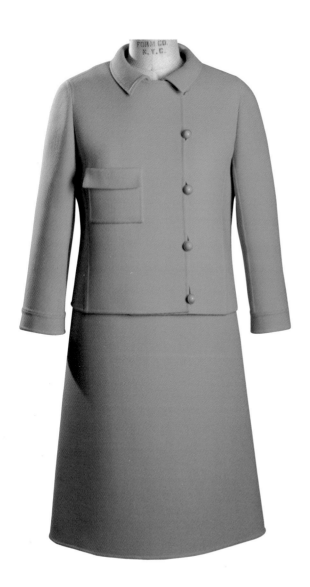

PREVIOUS SPREAD
Mila Schön
Dress and coat: Blue
double-faced wool
Italy, 1968

LEFT
Mila Schön
Suit: Green double-faced wool
Italy, ca. 1970

OPPOSITE
Mila Schön
Dress: Yellow and orange
double-faced wool
Italy, ca. 1968

Raf Simons

RAF SIMONS (B. 1968) is one of the most directional designers working today. Since the late 1990s, his menswear has been a pitch-perfect blend of youth culture and classic menswear. Simons's visibility and subsequent influence have risen considerably since his surprising recruitment in 2005 by the Jil Sander label. While reviewing his fall 2007 collection, fashion journalist Cathy Horyn noted that "a little-known Belgian designer named Raf Simons had the full attention of the fashion world. Mr. Simons's collection for Jil Sander, his third since becoming creative director eighteen months ago, was perfect. It will make everything else, I bet, seem a little contrived, a little clunky, a little silly."

Belgium-born Simons studied industrial design before becoming a menswear designer in 1995. Initially, he worked with Walter Van Beirendonck, and was also influenced by the work of Martin Margiela and Jean Paul Gaultier before launching his own menswear label Raf by Raf Simons in 1995.

Menswear has also had an impact on Simons's work for Jil Sander. Journalist Sarah Mower has praised his "unflinching Belgian pragmatism regarding the need for upper-echelon career clothes" as well as his "calm conceptualism." By spring 2011 his Jil Sander line, with its explosive blocks of color and strong, bold silhouettes, was deemed the collection of the season, and Simons was being hailed as the progenitor of a new couture aesthetic. Simons was named artistic director at Christian Dior (2012–2015) and shortly after was appointed chief creative officer at Calvin Klein (2016–2018). In 2020, he joined Prada as co-creative director. —*P. M.*

"The first fashion show Raf Simons ever saw was Martin Margiela's third collection in 1991. He was so moved he cried, and right then and there he decided he wanted to be a fashion designer, too."
— TIM BLANKS, JOURNALIST

PREVIOUS SPREAD
Jil Sander (Raf Simons)
Dress: Blue-and-white
stripe silk
Italy, 2011

LEFT
Raf Simons
Man's suit: Gray, green,
and black windowpane-check
wool, navy merino wool
Belgium, 2010

BELOW
Jil Sander (Raf Simons)
Man's suit: Chartreuse
wool, navy wool
Italy, 2011

OPPOSITE
Raf Simons
Man's ensemble: Beige synthetic
fleece, Velcro, beige and black
cotton, black wool, leather
Belgium, 2010

Anna Sui

ANNA SUI (B. 1964) Anna Sui's lively fashions express her passion for art, history, and music. Fashion writer Tim Blanks, noting Sui's affinity for research, has referred to her as a "cultural archeologist." Although she often references the styles of the 1960s and 1970s, her interests are widely varied, including cheerleaders, storybook characters, rococo painters, and surfers. Sui's talent for blending references ensures that her designs are never merely anachronistic.

Born in Detroit to Chinese immigrant parents, Sui became interested in fashion at a young age. After high school, she moved to New York to study at Parsons School of Design. A regular of New York's downtown club scene, Sui made important connections with others working in art, design, and fashion, who encouraged her to start her own line in 1981. Her love for music shaped her earliest business aspirations, which centered on dressing rock stars and their fans. In 1991, with the help of friends Naomi Campbell, Linda Evangelista, and Steven Meisel, she presented her first runway collection. In contrast to the more extravagant styles of fashion leaders such as Christian Lacroix and Gianni Versace, Sui's style was flirty and girlish, and it quickly caught on among a young, hip clientele.

Sui's business has since expanded into an empire that includes accessories, cosmetics, fragrance, and shoes. She still owns the rights to her own name—a rarity in today's fashion world—and, as a campaigner to save New York's garment district, she is committed to the preservation of the American design industry. In 2009 the Council of the Fashion Designers of America honored her with its Lifetime Achievement Award. —*C. H.*

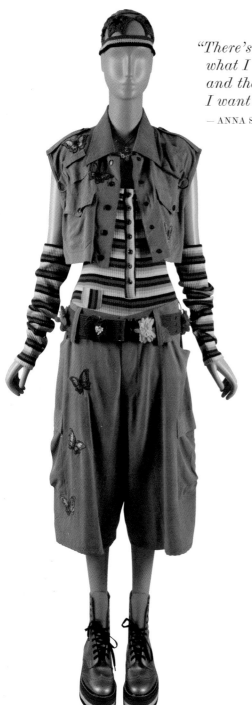

"There's always a sense of humor in what I do. There's a vibrancy to the color and the prints. I just like that energy. I want to entertain people."
— ANNA SUI

"Over the years, Anna's vision has remained unchanged. It still revolves around creating fashions that are hip, young, and feminine."
— **Steven Meisel, photographer**

LEFT AND PREVIOUS PAGE
Anna Sui
Ensemble: Army green silk, multicolor acrylic knit, multi-color cotton, and black leather
USA, spring 1993

OPPOSITE
Anna Sui
Ensemble: Blue silk taffeta, velvet, and denim
USA, 1999–2000

FOLLOWING SPREAD
Anna Sui for Ruffo
Coat: Red suede and printed shearling
USA, 1997

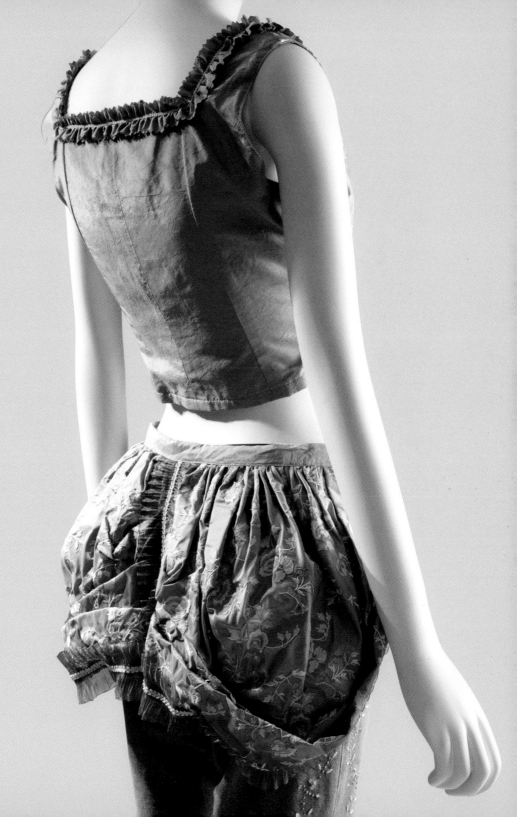

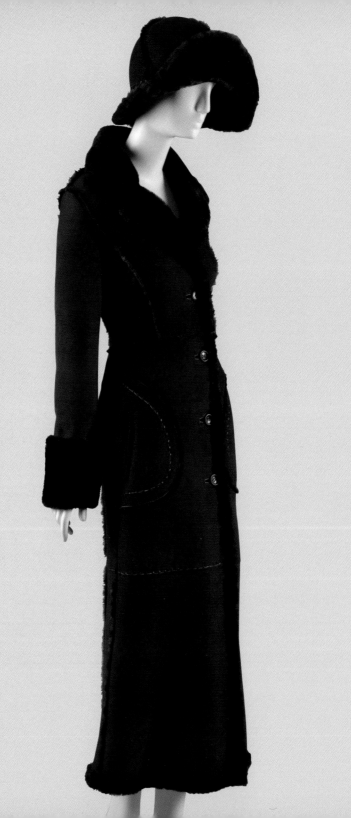

Vivienne Tam

VIVIENNE TAM (B. 1957) "I believe in cross-cultural design," Vivienne Tam told *The New York Times* in 1995 after her now-famous Mao collection. Indeed, "East meets West" and "cross-cultural" are some of the most common descriptors of Tam's work, a position she embraces. "I love Chinese culture," she has explained, "and I thought that maybe I can use fashion as a vehicle to bring Chinese culture to the world."

Tam was born in China but raised in Hong Kong after her parents emigrated to escape the political climate of the communist regime. Upon graduating from college she tried to get a job as a designer in Hong Kong, but found that there were not many creative opportunities. Instead, she went to New York and founded her label, East Wind Code, in 1982, which she renamed Vivienne Tam in 1994. The Mao collection brought her wide recognition. Tam collaborated with artist Zhang Hongtu to create satirical images of communist figure Chairman Mao Zedong. Hongtu reimagined Mao's official portrait to show the Chairman with pigtails, in clerical garb, with a bug on his nose, and wearing sunglasses. Tam transformed these images into a print and then used it to cover dresses, sparkly T-shirts, and suits. It was a direct rebuke of restrained communist revolutionary clothing.

Tam has continued to embrace Chinese influences but always with a playful approach and an eye toward experimentation. She was one of the earliest designers to engage with digital technology, launching her "digital clutch" (a handheld laptop that mimicked the look of a high-end handbag) in 2009, a year before the first iPad. —*E. M.*

"I wanted to do something in my collections to challenge Chinese people who are only looking to the West for fashion influence. We should look to ourselves. We have a deep culture and resources." — VIVIENNE TAM

"I had a strong conviction that anyone who saw my designs would like them."
— **Vivienne Tam**

PREVIOUS SPREAD
Vivienne Tam
Suit: Black-and-white jacquard
USA, 1995

LEFT
Vivienne Tam
Dress: Multicolor printed
nylon mesh
USA, 1995

ABOVE
Vivienne Tam
T-shirt: Printed white
cotton and sequins
USA, 1995

OPPOSITE
Vivienne Tam
Dress: Multicolor printed
nylon and black jersey
USA, spring 1998

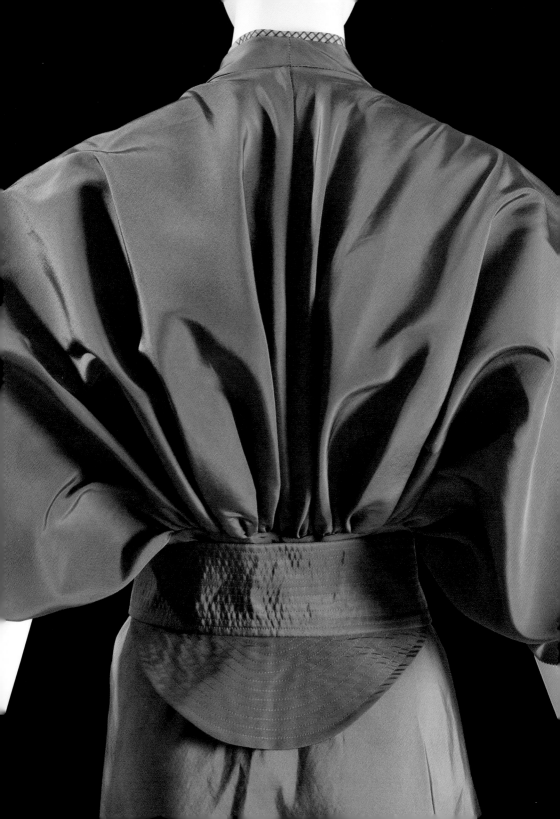

Isabel Toledo

ISABEL TOLEDO (1960–2019) Fashion insiders lauded Isabel Toledo as one of the most creative forces on the contemporary fashion scene when she began her career in the mid-1980s. With the appearance of her "lemongrass" ensemble—made for First Lady Michelle Obama to wear at her husband's inaugural ceremony in January 2009—Toledo's name recognition skyrocketed.

Toledo's production output was tiny and her work sold with little fanfare. Rather than focus on building a name brand, the Cuban-born and New York–based Toledo remained a "dressmaker" and "engineer"—labels she preferred—whose rigorous aesthetics, innovative range, and meticulous crafts-manship remain rare in fashion today. Toledo always stressed her commitment to craftsmanship as the starting point for everything she designed. Of equal if not more importance, her aesthetic vision grew and was enhanced by her three-and-a-half decade relationship with artist Ruben Toledo, her husband and collaborator. Ruben was also born in Cuba and came to America as a child. Isabel often asserted that Ruben was her prime motivator, partner, and inspiration.

When Toledo's work is viewed cumulatively, the most striking aspect is the incredible range of creative styles, techniques, and materials she embraced. Draped jersey dresses, structured woolen coats, billowing quilted skirts, fine and feathery lace dresses, and ruched-silk evening ensembles are but a tiny sampling of her output. In an effort to describe her unique style, Isabel and Ruben created a set of categories: Origami, Suspension, Shadow, Shape, Liquid Architecture, Organic Geometry, and Manipulated Surfaces. These names stressed her reliance for inspiration on disciplines other than fashion, such as mathematics and engineering.

Although her range of design styles was broad, all of Toledo's work possessed an exquisiteness that is akin to haute couture. At the same time, her garments were char-acteristically American in their ease of movement and comfort. After more than three decades of success, Toledo died of breast cancer in 2019. —*P. M.*

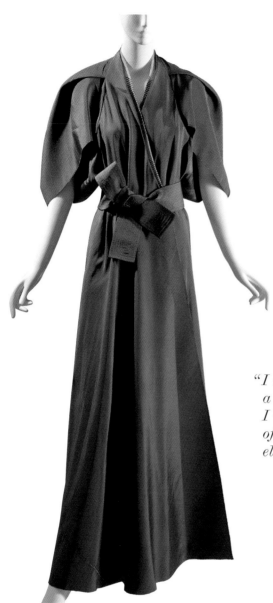

"I never thought of myself as a designer, I'm a seamstress. I really love the technique of sewing more than anything else." — ISABEL TOLEDO

"Isabel has a dialogue with a woman's body. She studies it on herself. She is her customer." — **Julie Gilhart, fashion director, Barneys New York**

PREVIOUS SPREAD AND ABOVE
Isabel Toledo
"Cocoon" dress:
Taupe silk faille
USA, 2002

OPPOSITE
Isabel Toledo
Dress and shrug:
Burgundy silk taffeta
USA, 2005

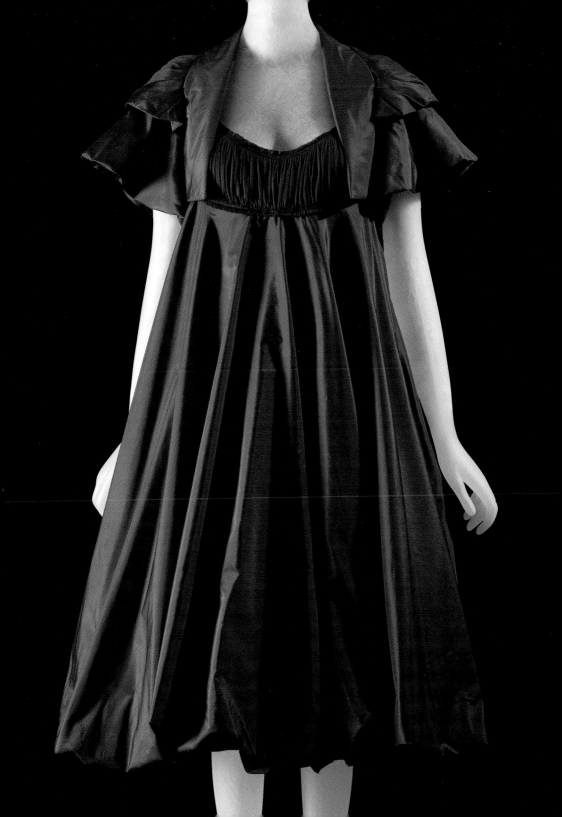

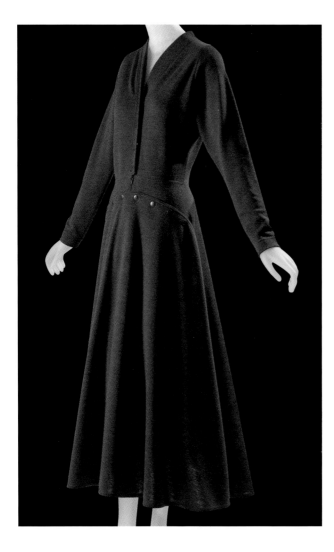

LEFT
Isabel Toledo
Dress: Royal blue wool jersey,
metal snaps
USA, 1992

BELOW
Isabel Toledo
"Hermaphrodite" dress:
Red, black shot-silk taffeta,
silk cord
USA, 1988

This evening dress is the result
of the designer's innovative
experiments with tension and
the effects of gravity on cloth.

OPPOSITE
Isabel Toledo
"Packing" skirt, top:
Black knit, red, black linen
USA, 1988

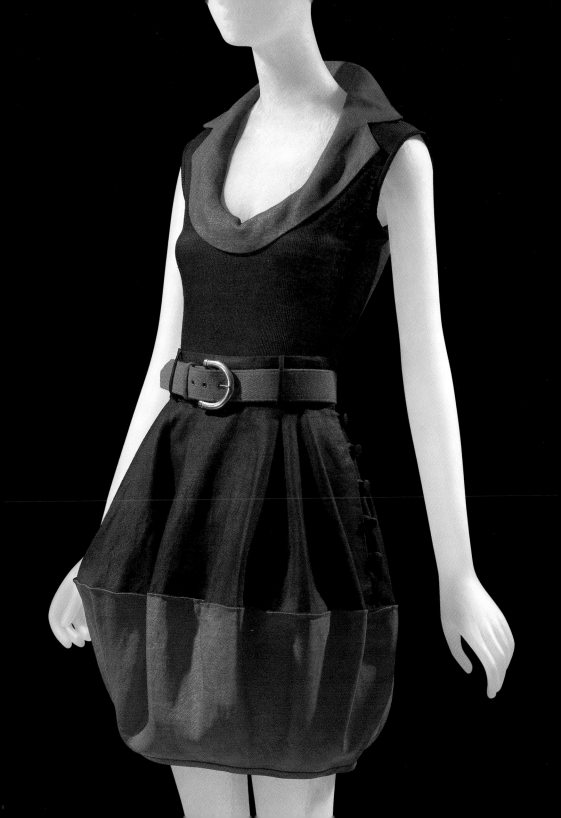

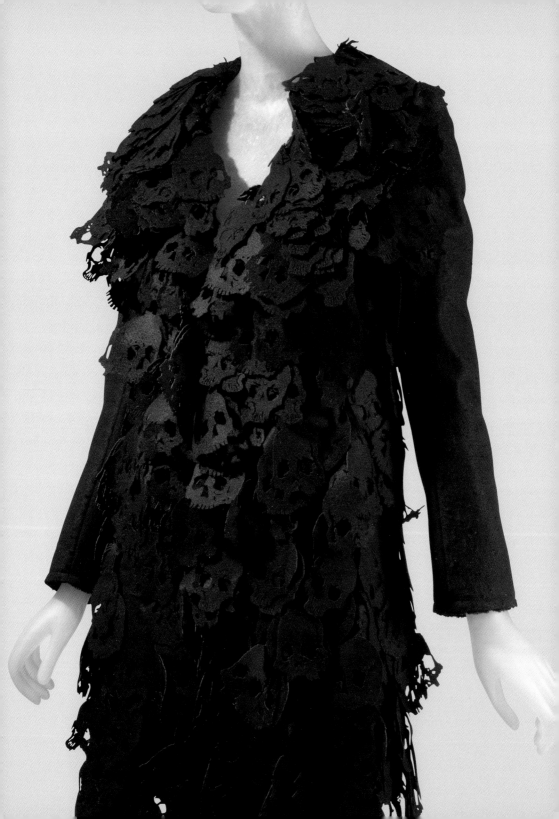

Undercover

JUN TAKAHASHI (B. 1969) Creator of the cutting-edge label Undercover, Jun Takahashi has been called "the essence of Japanese cool" and "a powerful new fashion force." He once described his designs as "cute but scary, beautiful but ugly." Certainly, he sometimes explores the dark side of fashion in a way that is both disturbing and romantic. Following in a line of Japanese avant-garde designers, Takahashi transcends classic notions of beauty. "Life is beauty, but it's pain as well," he has remarked.

Takahashi attended Tokyo's Bunka Fashion College, where he divided his time between studying and singing for a punk-rock band called the Tokyo Sex Pistols. While a student, he launched his own fashion label, Under Cover (later spelled Undercover) and sold his punk-inspired designs to small boutiques. In 1993 Takahashi opened Nowhere, his first retail shop, in Harajuku, with his friend Nigo (founder of the label A Bathing Ape). The following year, he showed his first Under Cover collection in Tokyo, and opened his first Under Cover shop in 1998.

Takahashi won the support of veteran designer Rei Kawakubo early in his career, and it was Kawakubo who encouraged him to show in Paris in 2002. Takahashi's Paris debut collection, entitled *Scab*, featured garments violently deconstructed— torn, shredded, and reassembled using haphazard red stitching. The inspirations for Takahashi's collections have varied greatly from season to season, but it is his perverse logic that unifies his work. His paradoxical world is filled with unsettling imagery. Buttons resemble eyeballs, dresses can sprout tendrils of hair, and what first appear to be flowers are actually skulls. For spring 2004, Takahashi's models appeared as identical twins, one a "visual meltdown" of the other. Although he has received numerous awards, Takahashi says, "I'm never satisfied with my work. I always have the desire to make something new, something wearable, something strong." —*M. M.*

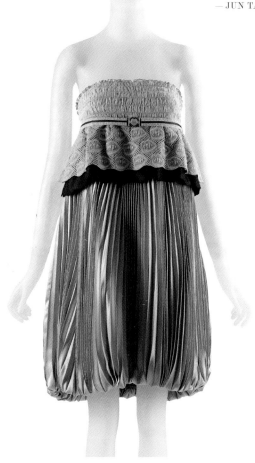

"In my head, there is always something beautiful and something ugly, which are equal."
— JUN TAKAHASHI

"Fashion shouldn't just be about, 'oh that's beautiful' or 'that's a cool silhouette'—you can express many interesting ideas through clothes."
— **Jun Takahashi**

PREVIOUS SPREAD
Undercover (Jun Takahashi)
Coat: Black wool felt
Japan, 2005

ABOVE AND FOLLOWING SPREAD
Undercover (Jun Takahashi)
Dress: Gray pleated silk, peach silk, cotton lace
Belt: Blue-and-white cotton, elastic, enamel, metal
Japan, 2008

OPPOSITE
Undercover (Jun Takahashi)
Ensemble: Gray wool, chiffon, satin, striped cotton, glass and mother-of-pearl embellishments, cotton novelty trim
Japan, 2005

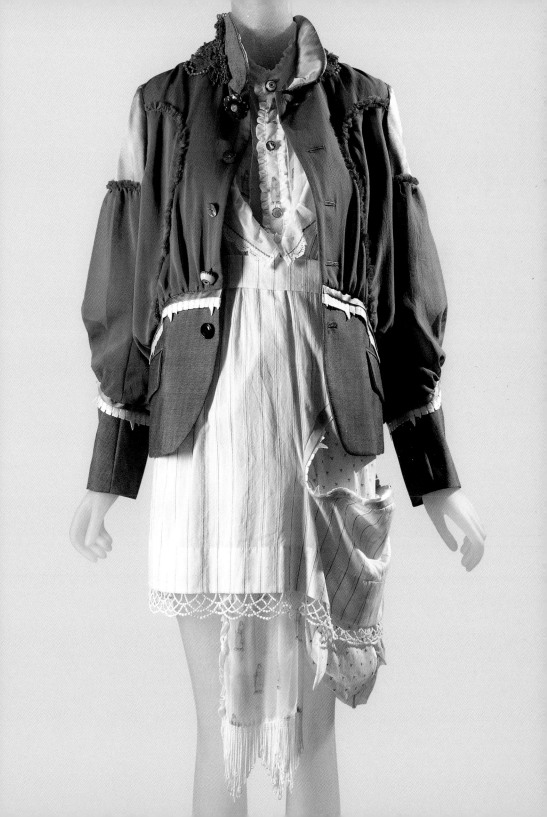

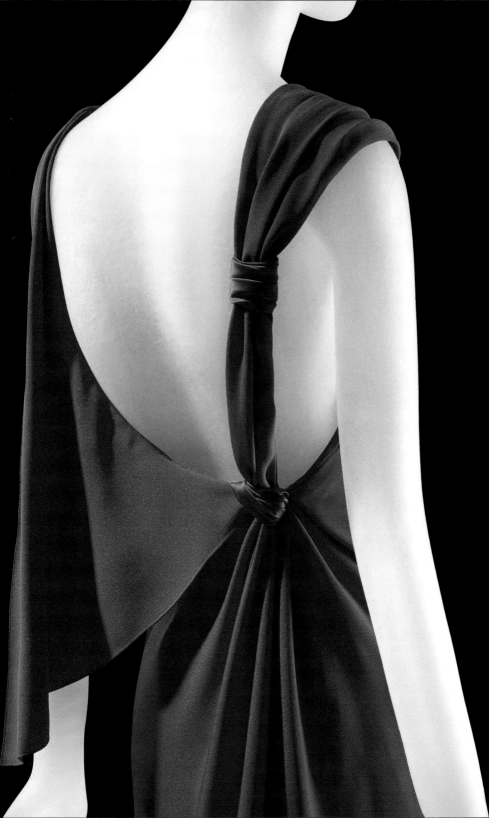

Valentino

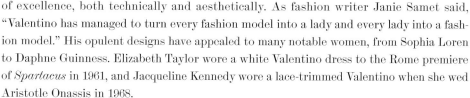

VALENTINO GARAVANI (B. 1932) For over four decades, Valentino Garavani, known professionally as Valentino, cultivated a brand of glamour devoted to opulence and femininity. A true artist of luxury, he is one of the few Italian designers to successfully imbue the Italian *alta moda* with the prestige of haute couture—producing garments of seemingly effortless luxury and timeless beauty. Throughout his career, Valentino remained consistently loyal to high standards of excellence, both technically and aesthetically. As fashion writer Janie Samet said, "Valentino has managed to turn every fashion model into a lady and every lady into a fashion model." His opulent designs have appealed to many notable women, from Sophia Loren to Daphne Guinness. Elizabeth Taylor wore a white Valentino dress to the Rome premiere of *Spartacus* in 1961, and Jacqueline Kennedy wore a lace-trimmed Valentino when she wed Aristotle Onassis in 1968.

Valentino studied at the Chambre Syndicale de la Haute Couture in Paris before opening his own *alta moda* house in Rome in 1959. His atelier was based on the French model of haute couture, focusing on handmade garments with great emphasis on luxury materials and details such as beading, embroidery, and pleating. Prior to opening his atelier, Valentino apprenticed with couturier Jean Dessès for five years and Guy Laroche for two. His first major fashion show, in 1962 at the Pitti Palace in Florence, gained him international recognition. It wasn't long before he abandoned this venue in favor of showing his collections at his salon in Rome, where his presentations became glamorous social events. In 1975 Valentino was one of the first designers to introduce his ready-to-wear collections in Paris; in 1989 he showed his couture collections there for the first time. His second Paris couture collection, inspired by the Wiener Werkstätte, drew great acclaim, and he became the first Italian designer to successfully transition to Paris.

The hallmarks of Valentino's designs are many. Valentino Red, his signature shade, became a staple of every collection. He is known for his use of black and white, often in extravagant patterns and textures. Lace, ruffles, polka dots, elaborate embroideries,

new interpretations of animal prints, and scalloped hems and trims are recurring elements in Valentino's work. Shortly after his forty-fifth anniversary, Valentino announced his retirement from fashion. His longtime accessories designers, Maria Grazia Chiuri and Pierpaolo Piccioli, designed for the house until Chiuri left for Dior in 2016. Today Piccioli is the sole creative director at Valentino. —*M. M.*

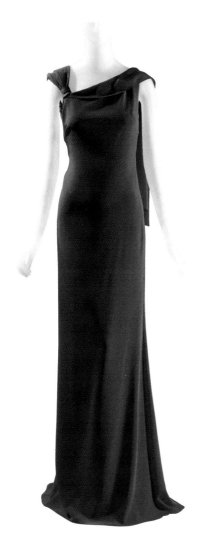

"I believe only in high fashion. I think a couturier must establish his style and stick to it."
— VALENTINO

PREVIOUS SPREAD AND LEFT
Valentino Garavani
Evening dress: Red silk
Italy, 2008

Valentino Red, the designer's signature shade, became a staple of every collection. This dress was featured at the end of Valentino's last haute couture show, which ended with a parade of models wearing his signature color.

OPPOSITE
Valentino Garavani
Evening dress: White cotton lace, rhinestones, wood beads, silver metallic mesh
Italy, ca. 1965

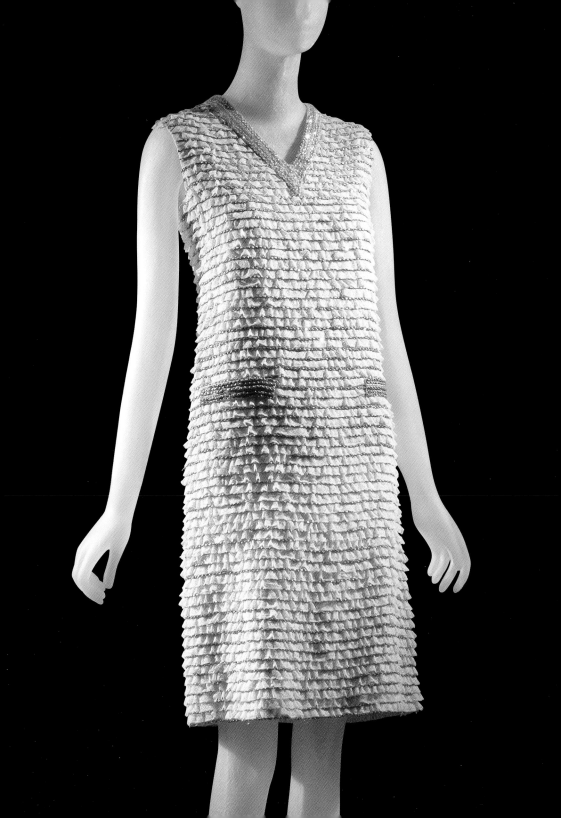

"Rome and Paris will always be in my heart because those two cities made it possible for me to work and express my one and only passion in life—fashion."
— **Valentino**

BELOW LEFT
Valentino Garavani
Evening dress and coat:
Pink silk satin
Italy, ca. 1962

BELOW
Valentino Garavani
Evening bag: Silver metal discs, leather
Italy, 2004

OPPOSITE
Valentino Garavani
Coat: Black wool, leopard skin
Italy, ca. 1974

"His clothes are feminine and glamorous, and modern at the same time."
— JACQUELINE DE RIBES, *W*

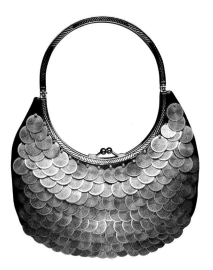

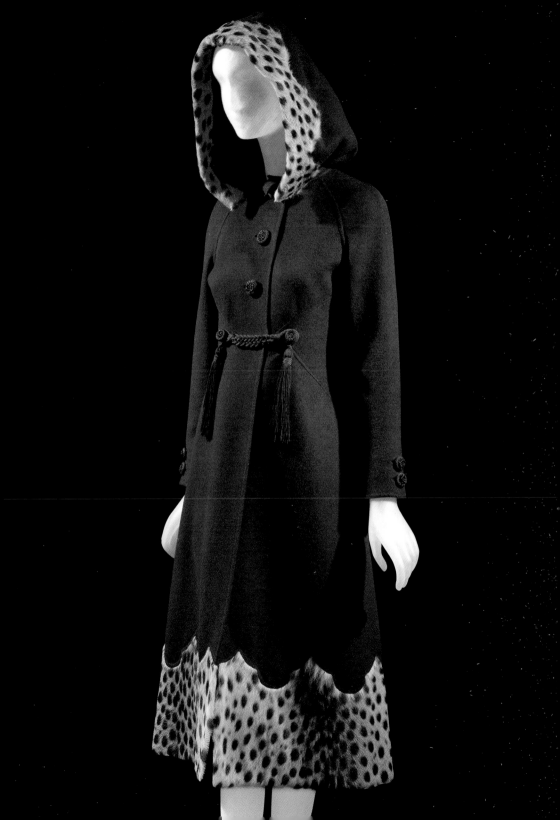

LEFT
Valentino Garavani
Evening dress: Black silk
chiffon, lace
Italy, 1993

BELOW
Valentino Garavani
Coat: Cream double-face wool
Italy, ca. 1968

OPPOSITE
Valentino
(**Maria Grazia Chiuri and
Pierpaolo Piccioli**)
Dress: Ivory silk organza,
black-and-white cotton
floral appliqué
Italy, 2011

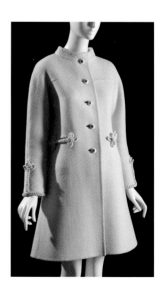

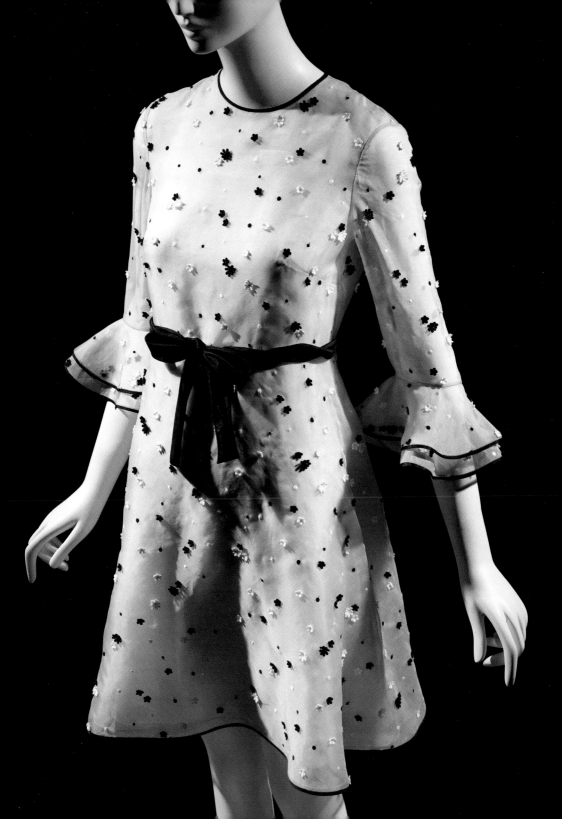

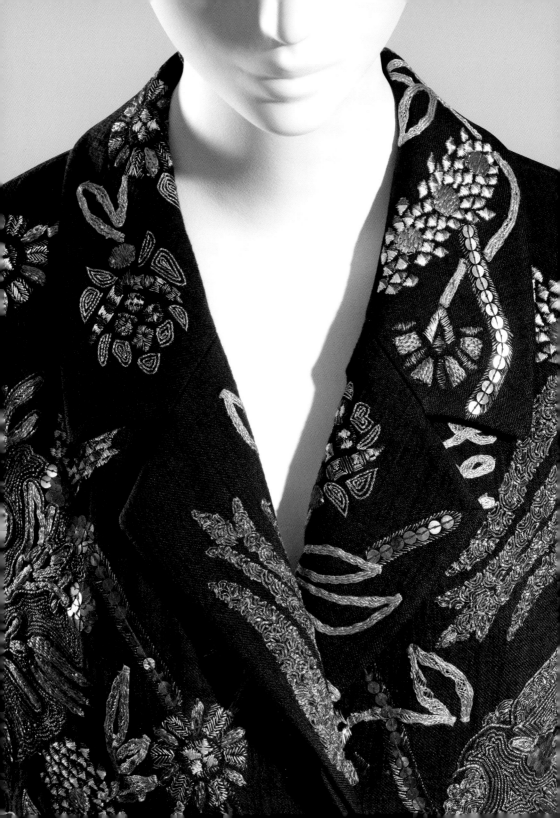

Dries Van Noten

DRIES VAN NOTEN (B. 1958) Beautifully shaped silhouettes made from brilliantly printed and lavishly embroidered textiles have become the signature look of Dries Van Noten. *The New York Times* described Van Noten as "one of fashion's most cerebral designers," and his contemporary riff on bohemian chic has become instantly recognizable. During a thirty-year career, Van Noten's work has evolved to become the most perfectly executed balance of construction and ornamentation in fashion. Menswear-inspired jackets and coats for women, vintage-style pleated skirts, and puff-sleeved tunic dresses emerge onto the runway each season covered with an array of embroidery patterns culled from cultures around the world.

After graduating from Antwerp's Royal Academy of Fine Arts in 1980, Belgian native Van Noten began his career as part of the celebrated avant-garde collective the Antwerp Six. His business, still based in Antwerp, grew slowly and now includes four annual collections (two each for his men's and women's lines), and boutiques located in cities from Hong Kong to Paris. Like the media-shy designer himself, the Dries Van Noten company is private and does not advertise, yet the designer continues to steadily gain attention and win internationally recognized fashion awards.

Although Van Noten designs exquisite garments, he insists that his work is not just for display; it is practical, as well. He believes that all of his runway designs must be accessible to the client. He says, "I'm a little naïve but I don't like the idea of showing things that you don't sell in a store." —*P. M.*

"Dries's clothes have a transformative effect: the wearer becomes a more interesting, enigmatic, intriguing person." — SIMON DOONAN, CREATIVE DIRECTOR, BARNEYS NEW YORK

PREVIOUS SPREAD
Dries Van Noten
Coat: Gold bullion; red, gold thread; sequin-embroidered black linen
Belgium, 2006

LEFT
Dries Van Noten
Suit: Gray-chartreuse-and-tan floral-printed cotton sateen, floral-printed silk, embroidered cord, ribbon
Belgium, 2004

BELOW
Dries Van Noten
Suit: Black-and-white wool-spandex tweed
Belgium, 2000

OPPOSITE
Dries Van Noten
Suit: Gray, black, tan, and burgundy rabbit fur; blue-and-cream printed silk; velvet
Belgium, 2004

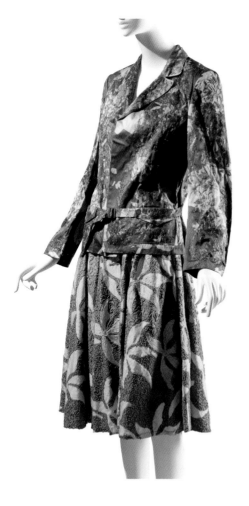

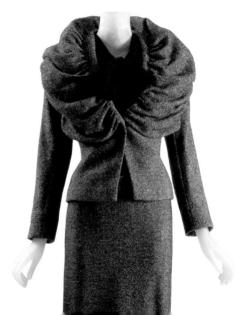

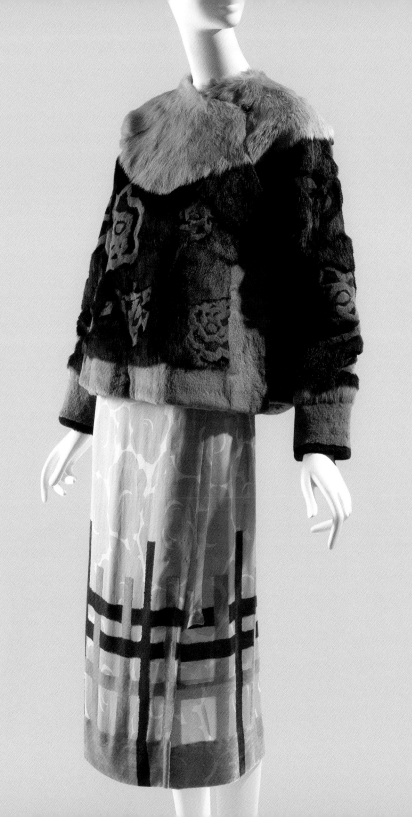

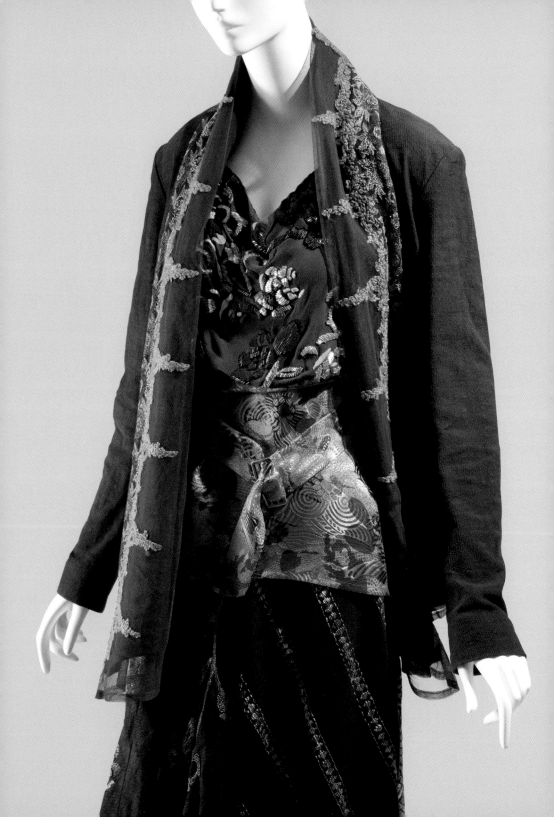

OPPOSITE
Dries Van Noten
Jacket: Gray polyester and
viscose, brown net, floral
embroidery, grosgrain ribbon
Top: Gold metallic printed
jacquard, embroidered black
chiffon crêpe, multicolor
embroidery and bugle beads
Skirt: Black linen and wool,
gold metallic embroidery,
seed beads
Belgium, 2003

The Belgian designer Dries
Van Noten has been profoundly
influenced by non-Western
aesthetics, which he identifies
with a new way of seeing.

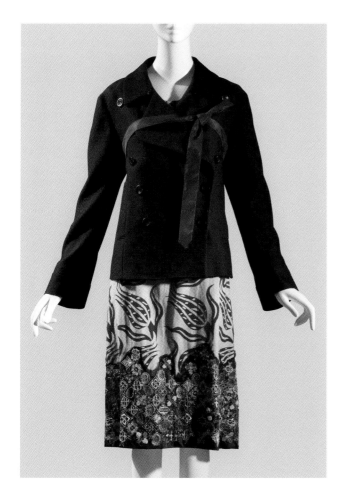

LEFT
Dries Van Noten
Ensemble: Black burlap,
printed tan linen, red velvet,
metallic threads, cord, beads
Belgium, 2006

ABOVE
Dries Van Noten
Ensemble: Gray and beige
beads, printed natural linen
knit, ochre cotton,
gold patent leather
Belgium, 2007

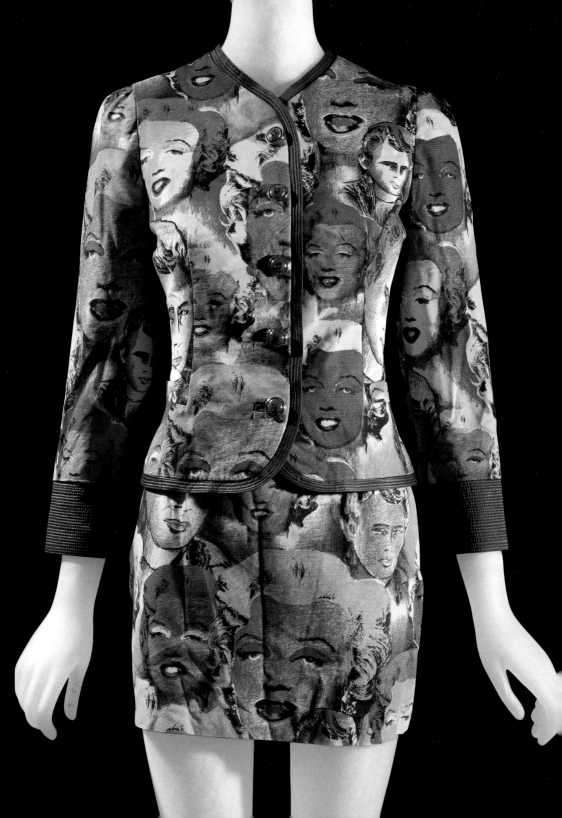

Versace

GIANNI VERSACE (1946–1997) The clothes of Gianni Versace were sensual—even at their most conservative. At other times, they could be overtly sexual. Versace's work elicited strong reactions: he was called a genius, and he was often accused of going over the top. As fashion historian Richard Martin observed, "Unlike more polite designers, he is always willing to risk vulgarity . . . Versace knows—like any great artist or designer—that pleasure resides in aesthetic risk." Still, Gianni Versace dealt in pleasure.

Versace began to develop his respect for construction at an early age. His mother was a custom dressmaker in Reggio di Calabria, Italy, and it was from her that Versace learned his trade. During the 1970s, he designed for the labels Genny, Complice, and Callaghan, and in 1978 he debuted his ready-to-wear collections. His first couture collection, as well as the secondary line, Versus, appeared in 1989.

So prolific was Versace that it is nearly impossible to single out one design as his most memorable: perhaps his safety-pin dress, famously worn by Elizabeth Hurley; or his influential leather ensembles, which were strapped, studded, and bondage-inspired; or the colorful, exuberant Versace prints that revealed his unabashed love of art. Versace was bold, sometimes baroque. He brought the theatricality of costumes he designed for stage and ballet to his runway collections, and while his references were often historical, he dismissed the idea that he was nostalgic. "I have a sense of the future that pervades my fashions," he said.

In 1997 Versace was murdered outside his Miami home. His grief-stricken sister, Donatella Versace, assumed design control of his company. Donatella had long been a trusted advisor, a collaborator, and, some say, Versace's muse. Following in her brother's footsteps has not been easy. She has received both criticism and praise for her interpretation of the Versace woman, but as she told *Harper's Bazaar* in August 2000, she wanted to honor, not imitate, her brother. Her work for Versace may be "less sexpot," but it is still "sexy." —*J. F.*

"When Gianni started, fashion was about being safe, being sophisticated. The word glamour didn't exist. Gianni invented glamour. It meant women not being afraid to embrace femininity and sensuality. I make sure glamour stays."
— **Donatella Versace**

PREVIOUS SPREAD
Gianni Versace
Suit: Multicolor-printed cotton and silk, rhinestone buttons
Italy, 1991

Versace was often inspired by pop culture and art. This suit is inspired by Andy Warhol's portraits of Marilyn Monroe and James Dean.

BELOW
Gianni Versace
Bag: Green suede, gold metal
Italy, ca. 1992

The mythological Medusa has been the Versace logo since 1989.

OPPOSITE
Gianni Versace
Suits: Black wool, black leather, gold metal
Italy, 1992

"I design for the woman who does not wear clothes like a suit of armour, but adapts them to her own personality." — GIANNI VERSACE

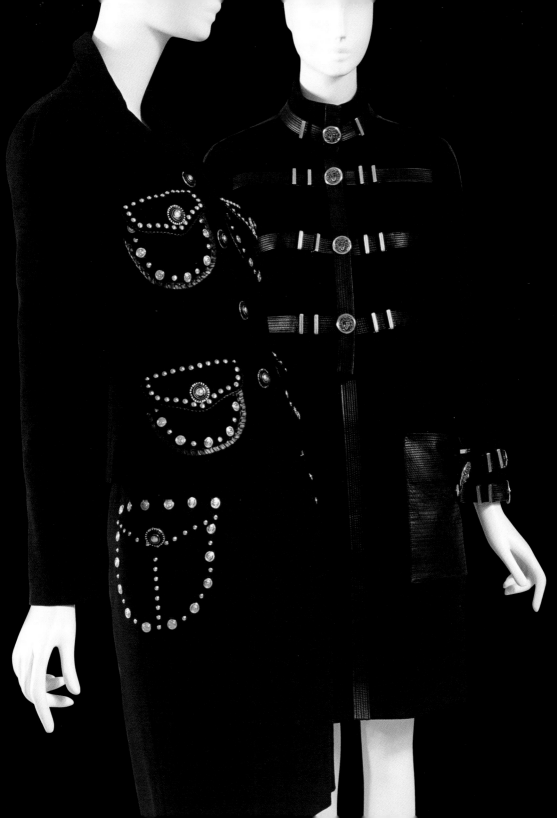

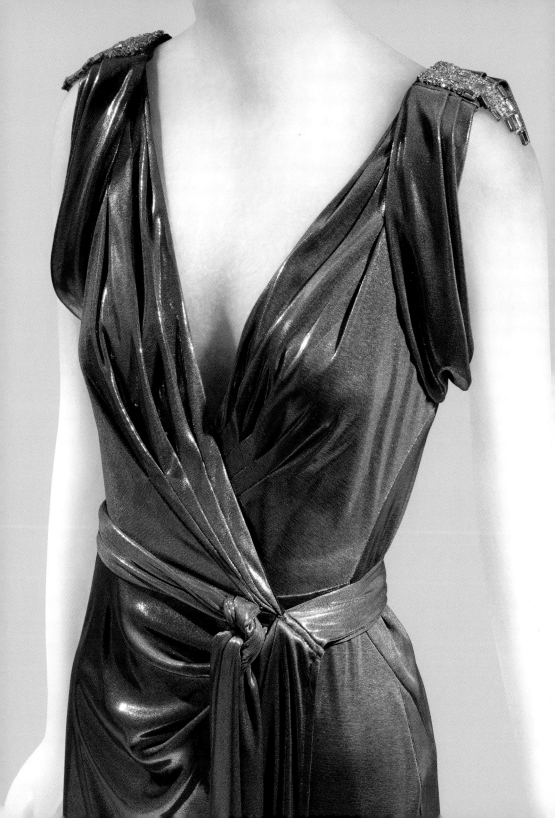

Diane von Furstenberg

DIANE VON FURSTENBERG (B. 1946) is a fashion designer who is also a celebrity with a larger-than-life persona. She is so recognizable that many know her simply by her initials, DVF. The garment that made her famous, a vibrantly printed jersey wrap dress, debuted in 1973. Consumers found the wrap dress so timeless and functional that it is still made today with little modification. It can even be found in the collection of the Costume Institute of the Metropolitan Museum of Art. That simple yet iconic dress allowed von Furstenberg to create a dynamic and ever-expanding fashion company.

Born Diane Simone Michelle Halfin in Brussels, Belgium, she was the daughter of immigrant parents from Romania and Greece. She studied economics at the University of Geneva in Switzerland, and while there met Prince Egon von Fürstenberg, whose title dates back to the golden age of the Holy Roman Empire. They married, had two children, and later divorced. In 2001 she married business mogul Barry Diller.

Even before her first marriage, von Furstenberg knew she wanted to become a designer. In 1970, with a $30,000 investment, she began designing women's clothes. "The minute I knew I was about to be Egon's wife, I decided to have a career. I wanted to be someone of my own, and not just a plain little girl who got married beyond her deserts."

Along with her extensive philanthropy, which includes assisting nonprofits that focus on women's causes and the arts, von Furstenberg has played an even larger role in the fashion world. From 2006 to 2019, she served as elected president of the CFDA. —*P. M.*

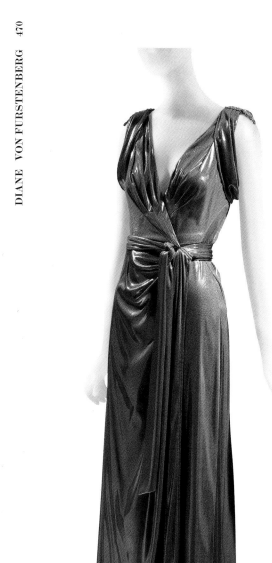

"I like to think that my style and the clothes I design are effortlessly elegant and sexy. I think the word 'effortless' is very important. I think that creates an ease and a confidence, because I think there's nothing more beautiful than a woman who's confident."
— **Diane von Furstenberg**

PREVIOUS SPREAD AND LEFT
Diane von Furstenberg
Evening dress:
Copper synthetic jersey,
rhinestones
USA, 2008

OPPOSITE
Diane von Furstenberg
Dress: Multicolor
printed acrylic knit
USA, 1973

Diane von Furstenberg was featured on the cover of *Newsweek* magazine in 1976 wearing her signature wrap dress. The original design consisted of a wrap top and skirt.

"I was sure there was a need for simple little sexy dresses that made women feel like women."
— DIANE VON FURSTENBERG

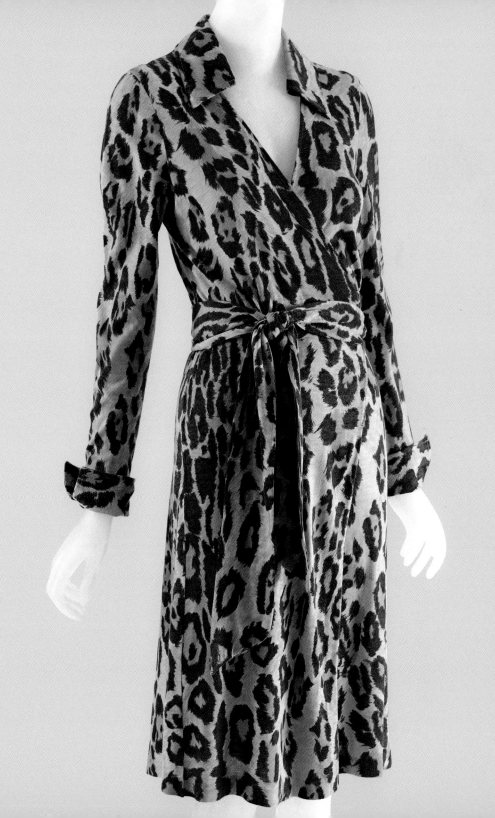

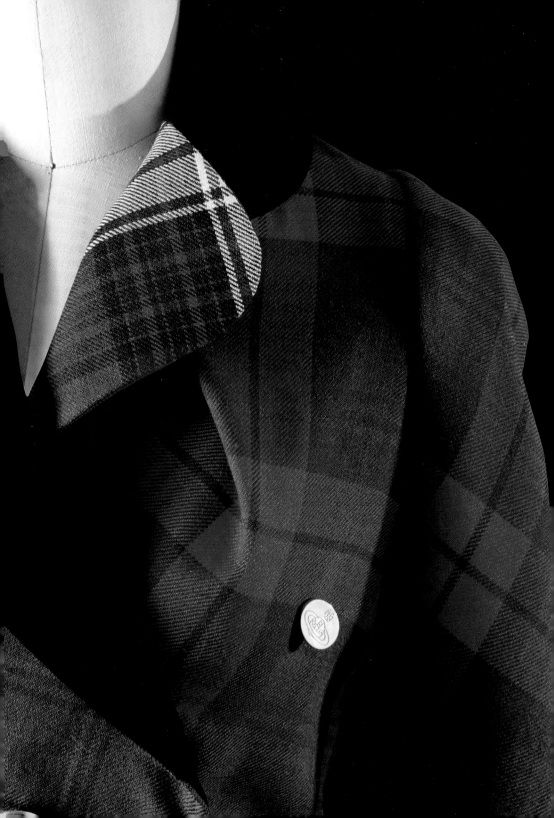

Vivienne Westwood

VIVIENNE WESTWOOD (1941–2022) Over her forty-year career, Vivienne Westwood was known as the grand dame of British fashion—a remarkable transition from her roots as a purveyor of punk style, although those anarchistic designs continue to have tremendous influence on contemporary fashion. The clothing she created was at once playful, provocative, and sophisticated. Westwood always remained true to her progressive mentality and was recognized as a powerful advocate for human rights and environmental responsibility.

Vivienne Isabel Swire was born in Derbyshire, England. In 1965, she met a young art student named Malcolm McLaren. They opened their first shop in 1971, specializing in 1950s-inspired clothing. Over the course of the 1970s, Westwood and McLaren's radical antiestablishment creations distinguished them as originators of London punk style. Their work was characterized by rips, chains, pornographic imagery, and even chicken bones — a look perhaps best exemplified by the Sex Pistols, the quintessential punk band that McLaren managed.

In the early 1980s, the work that Westwood and McLaren created for their label World's End began to focus on loosely fitted, romantic styles inspired by historical fashion and world cultures. They presented their first runway collection, *Pirates*, in 1981, followed by equally imaginative collections with names like *Savage* and *Buffalo Girls*. Westwood and McLaren's clothing was becoming more and more successful, but they always remained one step ahead of trends. "I do take influence from the street," Westwood admitted. "But I give more than I take."

Westwood and McLaren ended their partnership by 1984, and Westwood began to experiment with a more feminine style. In 1985 she presented her first major solo collection, *Mini Crini*, which featured short, flirty skirts based on the nineteenth-century cage crinoline (hoop skirt). Westwood's fascination with historical dress also led to a revival of the corset, and her form-fitting designs showcased her mastery of cut and construction. Westwood claimed that "there is nothing more subversive

than to be orthodox," and she began to champion traditional British fabrics such as tartan and Harris Tweed.

In 1990 Westwood was named British Designer of the Year by the British Fashion Council. Her increasingly opulent, historically inspired designs were in direct contrast to 1990s minimalism, yet her work continued to be influential. In 2006 she was futher honored when she received the title of Dame Commander of the Order of the British Empire. Vivienne Westwood died at the end of 2022 at the age of 81. —*C. H.*

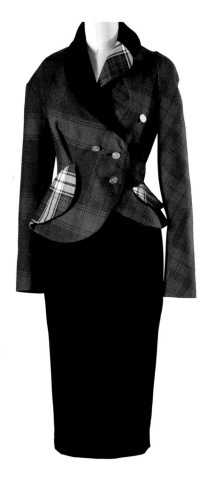

"Vivienne Westwood's personal conception of fashion has always ensured that she would be surrounded by controvesy—whether it's with the nation's law enforcers or its style councillors." — IAIN R., *WEBB BLITZ*

"The majority of people on the street look quite dreadful, as they would prefer to say nothing through their clothes than make a mistake....My clothes, on the other hand, allow someone to be truly individual."
— **Vivienne Westwood**

PREVIOUS SPREAD AND ABOVE
Vivienne Westwood
Suit, *Anglomania* collection:
Multicolor tartan wool,
black velvet
England, 1993

OPPOSITE
Vivienne Westwood
"Statue of Liberty" ensemble,
Time Machine collection:
Silver leather, pink leather,
silver lamé, ivory silk tulle
England, 1988

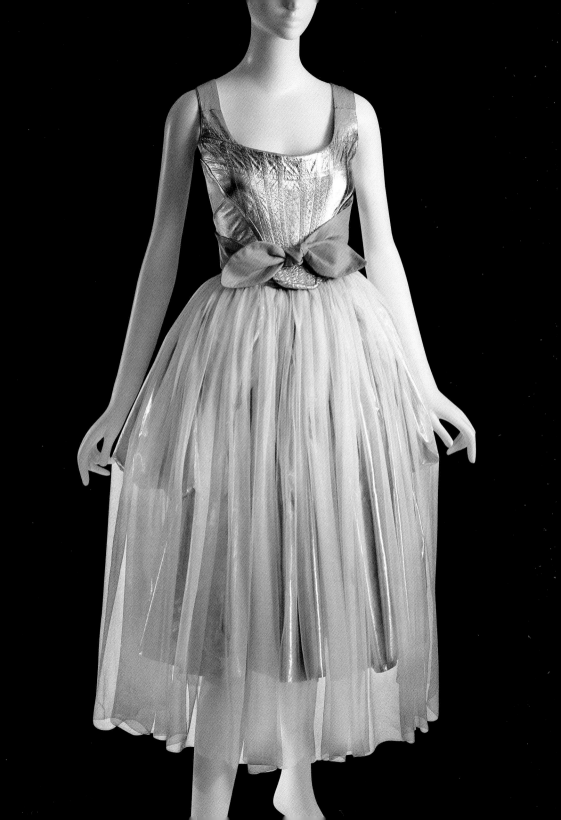

"Some might laugh at Westwood. Others may dismiss her as a crackpot. She is not. Her unorthodoxy, like her intelligence, is genuine and acute." — SALLY BRAMPTON, *ELLE*

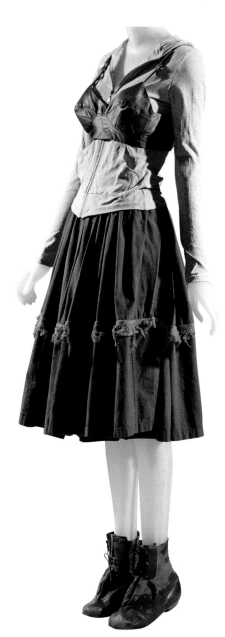

LEFT
World's End
(Vivienne Westwood and
Malcolm McLaren)
Ensemble, *Buffalo/Nostalgia of Mud* collection: Brown silk satin, brown printed cotton, brown suede and leather, gray crochet knit
England, 1982

BELOW
Vivienne Westwood
Elevated platform shoe, *Anglomania* collection: Multicolor tartan silk twill, black patent leather
England, 1993

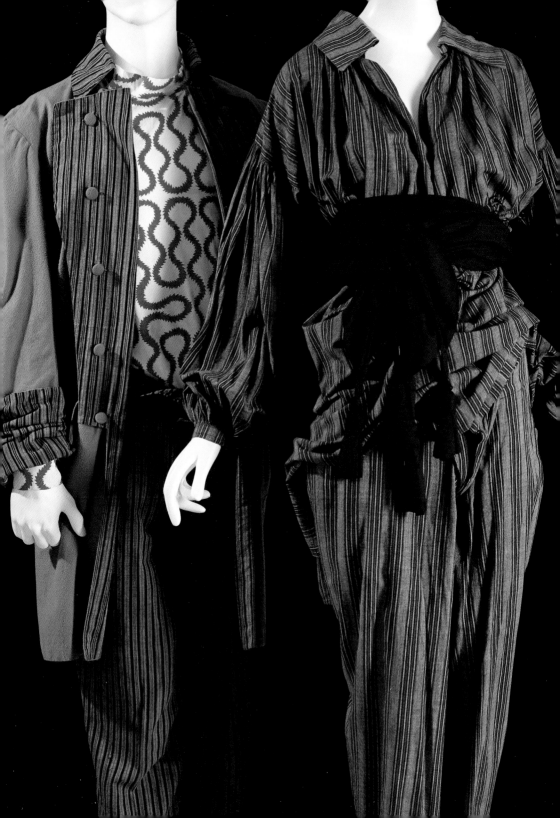

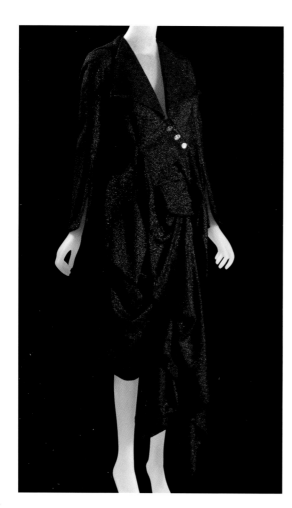

Vivienne Westwood
Suit: Black wool, silver Lurex
England, 1994

BELOW AND OPPOSITE
Vivienne Westwood
Man's ensemble, *Time Machine*
collection: Multicolor tartan
wool, black velvet, white cotton,
black leather, brown fur
England, 1988

PREVIOUS PAGE, LEFT
Vivienne Westwood and
Malcolm McLaren
(World's End)
Man's suit: multicolor striped
cotton, gray flannel
England, 1980
T-shirt: white-and-red printed
cotton knit
England, ca. 1991

PREVIOUS PAGE, RIGHT
Vivienne Westwood and
Malcolm McLaren
(World's End)
Ensemble: Multicolor striped
cotton, black cotton
England, 1981

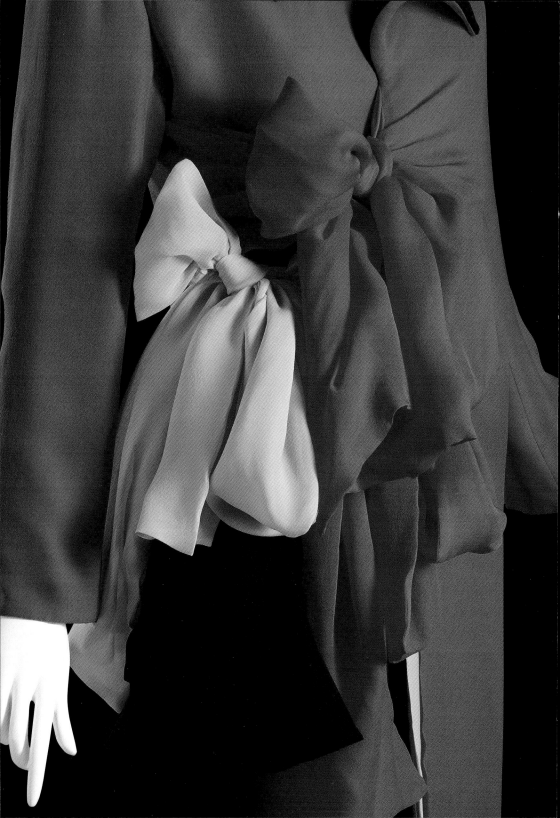

Yohji Yamamoto

YOHJI YAMAMOTO (B. 1943) Since his 1981 Paris debut, Yamamoto has been closely aligned aesthetically to his compatriot, Rei Kawakubo. Because of his technical dressmaking prowess and his interest in reconstructing historical Western dress, Yamamoto's work is less conceptual than Kawakubo's. While Yamamoto has retained the deconstructed elements and the dark color palette, his collections since the mid-1990s have been sweepingly lyrical and even romantic. He has often combined recognizable Western silhouettes such as bustled coats and crinolined dresses with unorthodox materials—felt that covers billiard tables or striped silks that resemble mattress ticking—to create the most beautiful of avant-garde fashions.

Yamamoto was raised by his war-widow mother, Yumi, a dressmaker by trade. He graduated with a law degree from Keio University but never practiced—the lure of becoming a designer pulled Yamamoto into fashion. Like his mother, he began as an anonymous creator, then formed his company in 1972. Over the course of more than thirty years, Yamamoto won prestigious awards and was even the subject of a 1989 film by director Wim Wenders entitled *Notebooks on Cities and Clothes*. When his company faced bankruptcy during the global economic crisis in 2009, he quickly found a new backer, but contracted his global retail presence.

Even though his work has often embraced the sweeping romanticism of postwar Parisian haute couture, Yamamoto's historical re-contextualizations contrast sharply with the work of marquee Western designers. Deliberately absent have been the requisites of a contemporary high-fashion wardrobe: high heels, rising hemlines, plunging necklines, and sheer fabrics. The lack of such gender-specific characteristics connects the aesthetics of his gowns to his beloved trademark suits.

Yamamoto's dark, masculine suits and coats, sometimes paired with his famous white shirts (for both men and women), have long been among his most compelling products. The suits and shirts display his virtuoso tailoring skills as well as his love of vintage styles. —*P. M.*

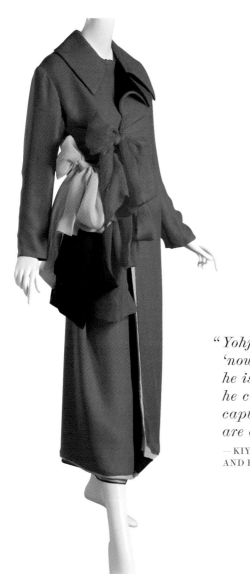

"*Yohji Yamamoto often says that 'now' is transient. Perhaps because he is able to look at things this way, he can touch the fleeting 'now' and capture the very moment when things are destroyed and disappear.*"

— KIYOKAZU WASHIDA, PHILOSOPHER AND FASHION CRITIC

"People talk about the Japanese as if they're together in some kind of designers' mafia. In Japan, maybe they're popular somewhere at the far edge of things, but it's got nothing to do with ordinary people."
— **Yohji Yamamoto**

PREVIOUS SPREAD AND ABOVE
Yohji Yamamoto
Coat: Fuchsia, pink, and black silk chiffon
Japan, 2005

OPPOSITE
Yohji Yamamoto
Dress: Black stretch rayon knit
Japan, 1999

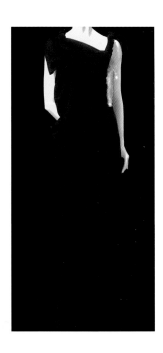

OPPOSITE
Yohji Yamamoto
Ensemble: Black silk crêpe,
plastic boning
Japan, 2006

The relationship between body
and dress is weirdly reversed
with this extraordinary
ensemble, which evokes an
external ribcage.

ABOVE
Yohji Yamamoto
Ensemble: Woven paisley wool
and silk, black padded silk,
coyote fur, velour
Japan, 2000

RIGHT
Yohji Yamamoto
Dress: Black sheer polyester,
opalescent paillettes
Japan, 1998

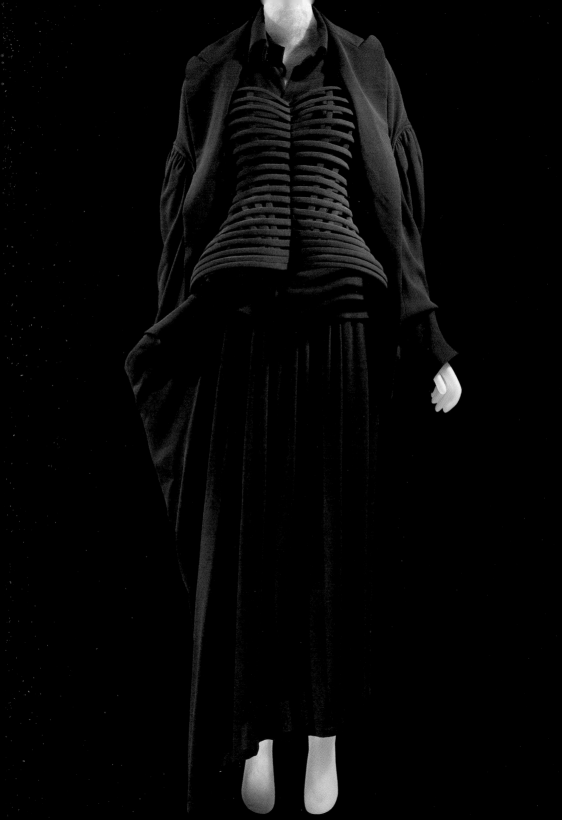

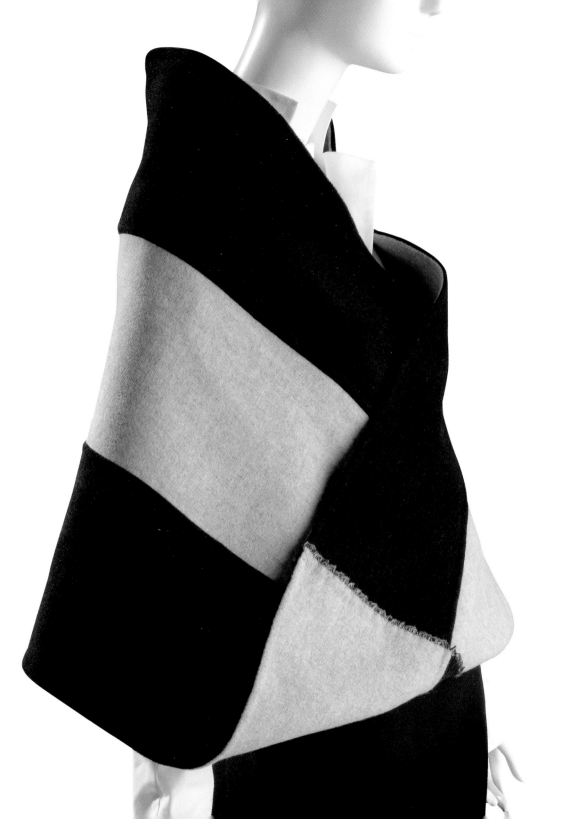

Yeohlee

YEOHLEE TENG (B. 1951) "Clothes have magic. Their geometry forms shapes that can lend a wearer power." These words have been Yeohlee's mission statement throughout her forty-year career. She is a modernist whose clean-lined, functional clothing is the result of combining a honed, mathematical approach to design with an economical use of materials. Urban and urbane, the Yeohlee aesthetic eschews frivolous ornament and instead relies on innovative geometric cuts to give her garments shape and form. Many have described her work as architectural.

It is not surprising, therefore, that architecture has long been a source of inspiration for Yeohlee. She was born Yeohlee Teng to a family of architects in Malaysia. Rather than take up that discipline, Yeohlee moved to New York and studied fashion at Parsons. Fittingly, just a couple of years after she debuted her namesake line, Yeohlee was one of the featured designers in a seminal 1982 exhibition at MIT entitled *Intimate Architecture: Contemporary Clothing Design*.

Yeohlee's judicious use of raw materials and her strong focus on function have proven to be prescient. As early as the 1980s, far ahead of the green movement in fashion, Yeohlee hand-cut a single garment from a three-yard swath of fabric, and had no leftover pieces. This is a remarkable feat in a design field long known for its wastefulness.

She is a firm believer in clothing that fits the needs of contemporary life. While many other designers also speak in support of that belief, few of them make functional design a central focus of their work. Yeohlee is an advocate of clothing that shelters, that is understated in order to be "proper" in nearly all occasions, and that can move with its wearer in nearly all situations. Yeohlee's vision earned her work the moniker "supermodern" and her clients the title "urban nomads." —*P. M.*

*"Geometry... is the unifying language of
her work and is reflected in both the construction
and ornamentation of her clothes..."*
— ANDREW BOLTON, CURATOR

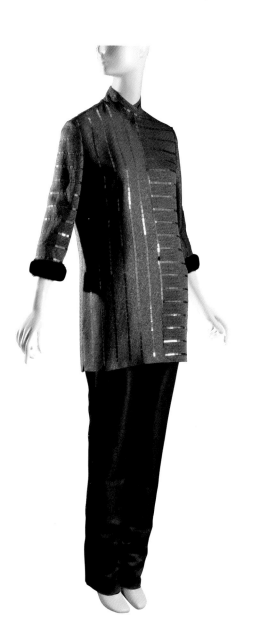

PREVIOUS SPREAD
Yeohlee
"Mobius Strip" wrap: Black,
gray wool double-cloth
Femme Mao shirt:
White cotton stretch poplin
Empire trouser:
Black polished cotton
USA, 2006

Yeohlee founded her fashion
company in 1981. Best known
for creating functional clothes
for the modern urban nomad,
she draws inspiration from
diverse fields such as geometry,
science, and architecture.

LEFT
Yeohlee
Evening pantsuit: Gold metallic
and black silk with gold sequins
and sable; brown silk satin
USA, 1997

OPPOSITE
Yeohlee
"Ovoid" jacket, "Empire"
trouser: Gray stretch wool
USA, 2007

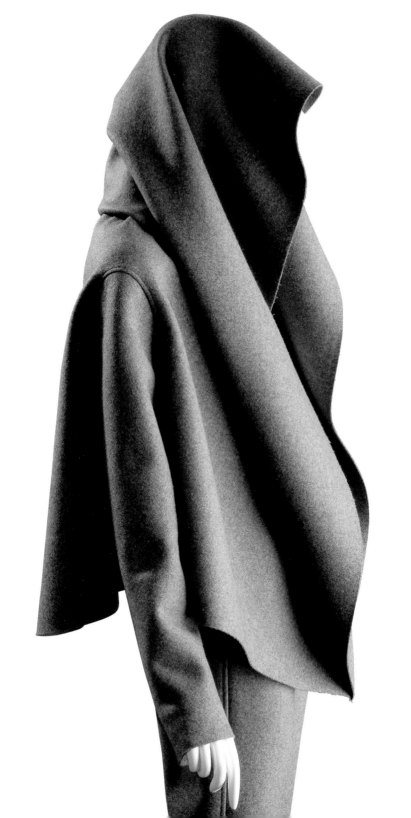

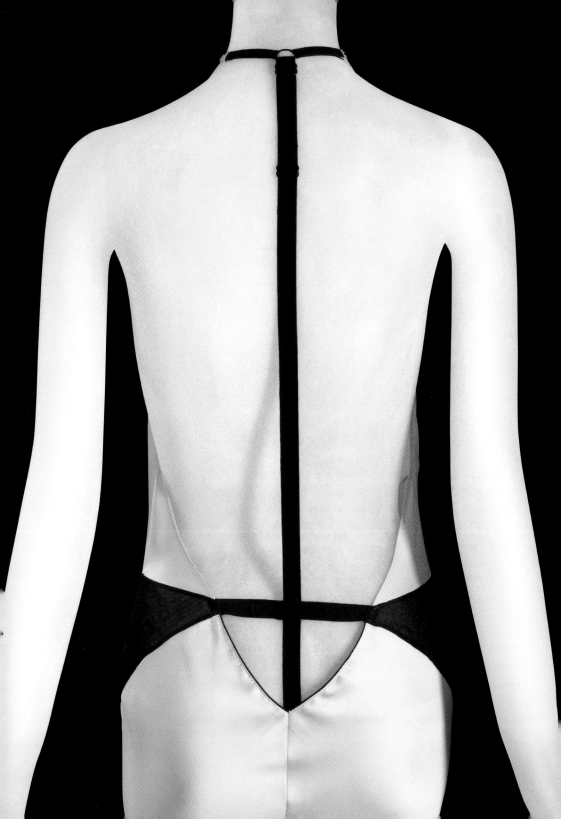

Yu

JEAN YU (B. 1968) Jean Yu is an anomaly in the annals of American ready-to-wear design, as well as in the international realm of contemporary fashion marketing. This New York–based designer does not create seasonal runway collections, and she has carved out a career and a following in the narrowest of fashion niches—exquisite handcrafted lingerie. Yet fashion insiders covet her work. Universally lauded for her refined taste and maniacal attention to detail, Yu irreverently describes her "Restraint" bras and "Captive" panties as "vulgar." She likes the lingerie she designs to have an edge that is perhaps slightly indecent—maybe even a little obscene.

Yu was born in South Korea, and her family immigrated to Los Angeles when she was still a child. She began her career in the 1990s as a designer of jeans, then started to focus on lingerie in 2004. Since then, Yu has designed more than just bespoke undergarments. Today she produces a line of robes and has embarked on a lower-priced line of separates being produced in India, called Jean Yu 180.

However, the most spectacular works in the Yu oeuvre are her evening dresses and daywear. Like the great couturiers she reveres, such as Madeleine Vionnet, Yu uses clothing construction as a primary point of departure. Each of her creations is a blend of traditional handwork (she drapes each of her own unique designs), rigorous aesthetics (clean modernism in the vein of modernist architects like Robert Mallet-Stevens), and either breathtaking bareness or overt focus on specific areas of the body, such as the bottom (culled from her specialization as a maker of exquisite lingerie). The finished creations are pale silk gowns, punctuated with black geometric insets and suspended from harnesses of black grosgrain ribbon, and suits cut from geometric shapes and molded into soft pyramids and cones—marvels of mobile engineering that beautifully caress the female form. —*P. M.*

PREVIOUS SPREAD AND RIGHT
Jean Yu
Dress: Champagne silk
charmeuse, sheer black
organza, grosgrain ribbon
USA, 2008

OPPOSITE
Jean Yu
Dress: Black, white matte
silk jersey; black grosgrain
ribbon
USA, 2006

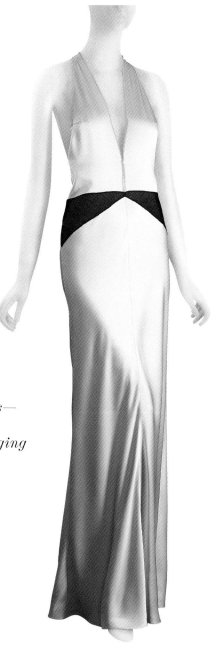

*"My passion for design is rooted in
a quest to build something that endures—
an object of desire that stands the test
of time and yet competes with the changing
nature that is fashion."* — JEAN YU

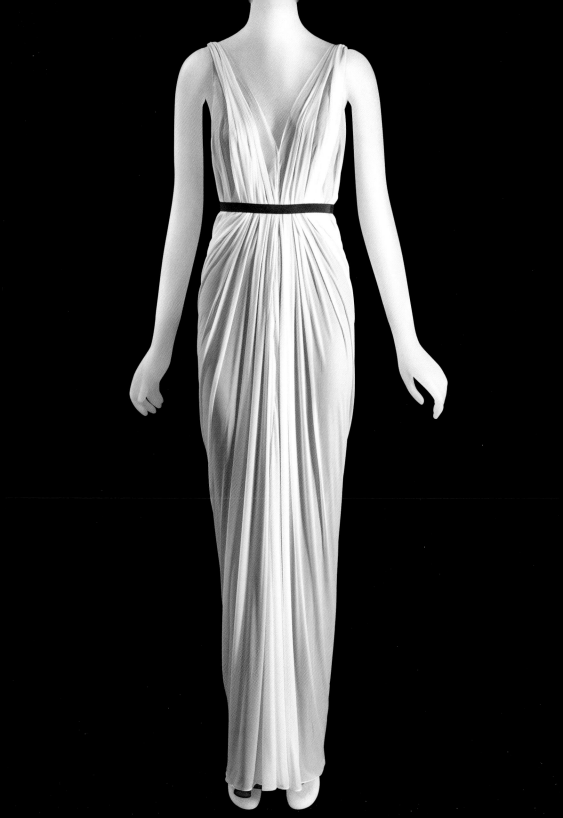

Appendix

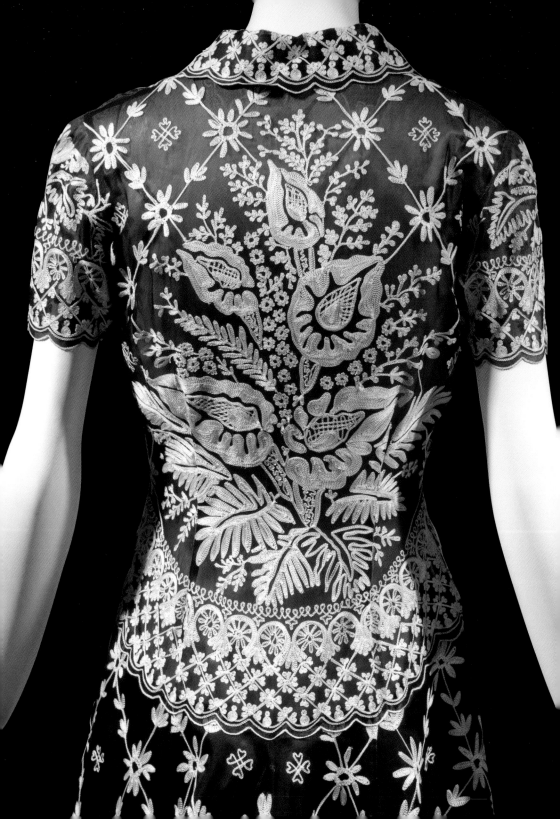

INDEX

Numbers in *italics* refer to pages with images.

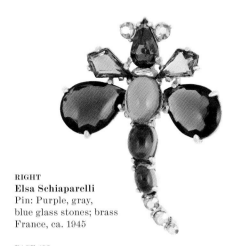

RIGHT
Elsa Schiaparelli
Pin: Purple, gray,
blue glass stones; brass
France, ca. 1945

PAGE 496
Balmain (Oscar de la Renta)
Evening dress: Black silk
organza, white embroidery
France, 2002

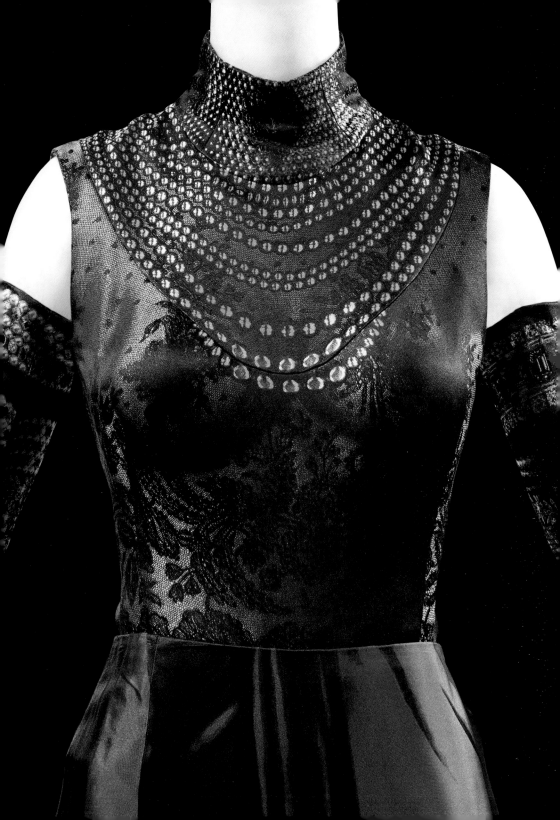

COLLECTION CREDITS

All garments and accessories featured in the book are from the collection of the Museum at FIT unless otherwise noted. The accession numbers and collection credits follow.

2: 82.3.1 / Gift of Frederick Supper
3: 84.125.7 / Gift of Mrs. F. Leval
4: 2011.8.1 / Gift of Givenchy by Riccardo Tisci
5: 72.112.36 / Gift of Rodman A. Heeren
6: 2009.60.1 / Museum Purchase
7: 2007.2.1 / Museum Purchase
10: 2008.91.1 / Museum Purchase
12: 2010.61.1 / Museum Purchase
14: P82.27.1 / Museum Purchase
16: 99.79.3 / Museum Purchase
17: 71.202.16 / Gift of the Victoria & Albert Museum
19: 63.112.2 / Gift of Mrs. Irwin Strasburger
20: 2016.8.1 / Museum Purchase
21: 2008.46.2 / Museum Purchase
22: 2009.15.7 / Museum Purchase
23: 2003.100.17 / Gift of Robert Renfield
24: 2010.59.1 / Museum Purchase
25: 2010.38.1 / Museum Purchase
28, 30: 70.8.4 Gift of Metro-Goldwyn-Mayer, Inc.
31: 71.206.1 / Gift of Maybell Machris
32, 33 (left): 70.8.19 / Gift of Metro-Goldwyn-Mayer, Inc.
33: (right): P82.13.1 / Museum Purchase
34: 2008.65.7 / Gift of Veronica Webb
36 (above, jacket): 91.255.15 / Gift of The Estate of Tina Chow
36 (above, pants): 91.255.12 / Gift of The Estate of Tina Chow
36 (below): 92.34.1DE / Gift of Azzedine Alaïa
37: 92.34.1 / Gift of Azzedine Alaïa
38: 87.3.2 / Gift of Azzedine Alaïa in memory of Arthur Englander
39 (left and right): 2008.65.8 / Gift of Veronica Webb
40: 85.144.1 / Gift of Giorgio Armani
42: 85.58.7 / Gift of Mr. Jay Cocks
43: 2008.67.1 / Gift of Giorgio Armani
44, 47: 91.255.2 / Gift of The Estate of Tina Chow
48 (left): 86.142.5 / Gift of Jerome Zipkin
48 (right): 86,142.3 / Gift of Jerome Zipkin
49: 2008.2.2 / Gift of Balenciaga
50: 78.134.6 / Gift of Mrs. Ephraim Londres, Mrs. Rowland Mindlin & Mrs. Walter Eytan in memory of Mrs. M. Lincoln Schuster
51 (left): 72.81.20 / Gift of Doris Duke
51 (right): 72.81.23 / Gift of Doris Duke
52 (left): 2007.10.1 / Museum Purchase
52 (right): 2005.23.1 / Gift of Balenciaga
53: 2008.60.1 / Museum Purchase
54: 71.265.16 / Gift of Doris Duke

56: 84.125.3 / Gift of Mrs. F. Leval
57: 84.103.5 / Gift of Mrs. Roger Tuteur
58 (left): 84.125.7 / Gift of Mrs. F. Leval
58 (right): 2009.16.63 / Gift of Mrs. Martin D. Gruss
59: 2009.16.64 / Gift of Mrs. Martin D. Gruss
60: 2007.36.10 / Gift of Judith-Ann Corrente
62: 2003.72.1 / Gift of Norma Kline Tiefel
63: 2002.58.1 / Gift of Jane L. Rodgers
64: 2009.16.59 / Gift of Mrs. Martin D. Gruss
66: 85.91.1 / Gift of Bill Blass, Ltd.
67: 2001.41.3 / Gift of Mrs. Savanna Clark
68: 2010.62.1 / Gift of Burberry
71: 2010.62.2 / Gift of Burberry
72 (left): 93.54.13 / Gift of Bill Haire
72 (right): 2010.62.1CD / Gift of Burberry
73: 2006.37.1 / Gift of Burberry Prorsum
74, 76: 2002.87.1 / Museum Purchase
77: P90.2.3 / Museum Purchase
78: 70.62.1 / Gift of Lauren Bacall
80: 91.128.10 / Gift of CITICORP
81: 82.3.2 / Gift of Frederick Supper
82, 84: 99.56.1 / Museum Purchase
85: 81.157.18 / Gift of Ms. Margay Lindsey
86 (left): 2009.34.1 / Gift of Adassa Whitman
86 (right): 90.170.35 / Gift of Bonnie Cashin
87: 90.72.13 / Gift of The Estate of Bonnie Cashin
88: P83.39.8 / Museum Purchase

90: 79.18.2 / Gift of John Clancy
91: 76.185.3 / Gift of Mrs. Stephane Groveff
92: 91.255.7 / Gift of The Estate of Tina Chow
93 (above, left): 77.133.2 / Gift of Mrs. Hill Montague III
93 (above, right): 77.89.1 / Gift of Mrs. John Hammond
93 (below): 92.225.73 / Gift of The Estate of Tina Chow
94 (left): 79.197.6 / Gift of Mrs. Mary Jane Beirn
94 (right): 80.13.3 / Gift of Mrs. Georges Gudefin
95: 96.69.15 / Gift of The Dorothea Stephens Wiman Collection
96: 88.72.3 / Gift of Mrs. Elizabeth Pickering Kaiser
97 (left): 69.161.26 / Gift of Lauren Bacall
97 (right): 80.261.2 / Gift of Mrs. Walter Eytan
98: 94.115.1 / Gift of Mrs. William McCormick Blair, Jr.
99 (left): 91.231.1 / Gift of Mrs. Charles Wrightsman
99 (right): 91.255.3 / Gift of The Estate of Tina Chow
100 (left): 84.138.1 / Gift of Mrs. Constance Cartwright
100 (right): 91.255.9 / Gift of The Estate of Tina Chow
101: 91.255.9 / Gift of The Estate of Tina Chow
102, 104: 74.107.64 / Gift of Lauren Bacall
105: 87.52.1 / Gift of Barbara Hodes
106: 2005.49.1 / Museum Purchase

108: 2010.1.44 / Gift of
anonymous donor

109: 2010.1.35 / Gift of
anonymous donor /
Photography by
William Palmer

110, 111 (left):
2005.3.1 / Gift of
Rita Watnick &
Michael Stoyla,
Lily et Cie

111 (right):
2010.57.3 / Gift of
Daphne Guinness

112, 113 (left):
2009.62.1 /
Museum Purchase

113 (right):
2008.46.3 /
Museum Purchase

114 (left):
2008.65.3 / Gift of
Veronica Webb

114 (right): 2005.47.1 /
Museum Purchase

115: 2010.29.1 /
Museum Purchase

116: 78.170.5 / Gift of
Bernie Zamkoff

118: 81.132.4 / Gift
of Mrs. Phillip
Schwartz

119: 2007.46.4 /
Gift of the family
of Isabel Eberstadt,
donated in her
memory

120, 122: 91.190.2 / Gift
of Penelope Tree

123: 2005.71.3 / Gift of
Isabelle Leeds

124, 126: 70.57.48 /
Gift of Mr. Rodman
A. Heeren

127: 71.267.3 /
Gift of Mrs.
William Randolph
Hearst Jr.

128 (left): 70.57.51 / Gift
of Mr. Rodman A.
Heeren

128 (right):
92.202.1 / Gift of
Ania Kayaloff

129: 71.213.20 / Gift of
Sally Cary Iselin

130: 71.213.30 / Gift of
Sally Cary Iselin

131: 75.86.5 / Gift of
Despina Messinesi

132 (left and right):
86.56.1 / Gift of
Mary McFadden

133–135: 80.58.5 /
Gift of Mrs.
Beatrice Renfield

136 (left): 2002.15.1 /
Museum Purchase

136 (right): 2003.70.1 /
Museum Purchase

137: 2001.45.1 /
Museum Purchase

138, 140 (bustier):
P92.58.14 /
Museum Purchase

138, 140 (skirt):
2008.25.2 /
Gift of Dorothy
Schefer Faux

141: 99.61.1 / Gift of
Dolce & Gabbana

142, 144: 91.42.166 /
Gift of Perry Ellis

145: 91.42.17 /
Gift of Perry Ellis

146: 2002.10.1 /
Gift of Maureen
O'Donnell

147: 91.42.10 /
Gift of Perry Ellis

148: 2011.39.1 /
Gift of Etro S.p.A.

150 (coat): 2003.41.4 /
Gift of Etro S.p.A.

150 (shirt and pants):
2003.41.5 /
Gift of Etro S.p.A.

151: 2003.41.3 /
Gift of Etro S.p.A.

152, 154: 2007.38.1 /
Gift of Margery E.
Wood

155: 89.111.1 / Gift of
Zita Hosmer

156: 68.136.3 /
Gift of Mrs. Joseph
Halpert

157: 70.57.73 /
Gift of Mr. Rodman
A. Heeren

158: 2007.25.1 /
Gift of Fendi

160: 2007.25.2 /
Gift of Fendi

161: 91.255.6 /
Gift of The Estate
of Tina Chow

162, 164: 99.83.9 /
Gift of Gianfranco
Ferré S.p.A.

165: 99.83.10 /
Gift of Gianfranco
Ferré S.p.A.

166, 168 (dress):
83.151.1 /
Gift of Jacqueline
Weinman

168 (mantle):
2001.67.1 / Gift of
Carole K. Newman

169: 91.218.1 / Gift of
Ann Schneider

170, 172 (blouse):
P88.76.2 /
Museum Purchase

170, 172 (skirt):
P87.47.1 /
Museum Purchase

173: 98.98.1 /
Museum Purchase

174: P92.8.1 /
Museum Purchase

175 (jacket): P88.76.4 /
Museum Purchase

175 (pants): P88.76.5 /
Museum Purchase

176 (left): 2009.16.26 /
Gift of Mrs.
Martin D. Gruss

176 (right): 2009.16.27 /
Gift of Mrs.
Martin D. Gruss

177: 2009.16.27 /
Gift of Mrs.
Martin D. Gruss

178–179:
2000.23.10 / Gift of
Anne M. Zartarian

180, 182: 77.219.1 / Gift
of Ruth Deardoff

183 (left): 82.153.72 /
Gift of Mitch Rein

183 (right): 82.153.149 /
Gift of Mitch Rein

184: P87.49.3 /
Museum Purchase

185: 2003.73.1 / Gift of
Rita Watnick and
Michael Stoyla –
Lily et Cie

186–187: 75.112.5 / Gift
of Gabriele Knecht

188: 80.181.11 / Gift of
Jane Holzer

191: 71.240.4 /
Gift of Mrs. Edwin
Hilson

192: 2011.8.1 / Gift
of Givenchy por
Riccardo Tisci

193 (left): 2011.8.1 /
Gift of Givenchy
by Riccardo Tisci

193 (right): 2011.8.1CD /
Gift of Givenchy
by Riccardo Tisci

194: 98.41.3 / Gift of
Dorothy Small

197: 97.30.1 /
Gift of Gucci

198 (left): 99.64.2 /
Gift of Gucci

198 (right): 2005.54.1 /
Gift of Gucci

199: 2005.54.1 /
Gift of Gucci

200: 76.69.17 / Gift of
Lauren Bacall

202: 74.107.30 / Gift of
Lauren Bacall

203: 82.3.1 / Gift of
Frederick Supper

204: 80.128.4 /
Gift of Celanese

205 (left): 82.3.9 / Gift
of Frederick Supper

205 (right):
81.250.2 / Gift of
Mrs. Jane Holzer

206–207: 2007.56.16 /
Gift of Elizabeth
Graham Weymouth

208 (left): 88.29.39 /
Gift of Elizabeth
Pickering Kaiser

208 (right): 88.29.2 /
Gift of Elizabeth
Pickering Kaiser

209: 82.193.4 /
Gift of Mrs.
Sidney Merians

210: 2002.96.18 /
Gift of Laura
Solomon in memory
of Sally Solomon

213: 2010.91.1 /
Gift of Hermès

214 (left): 76.196.24 /
Gift of Fernanda
Munn Kellogg

214 (right): 2010.91.2 /
Gift of Hermès

215: 2010.91.2 /
Gift of Hermès

216: 88.105.10 /
Gift of Carolina
Herrera, Ltd.

218: 2005.48.8 /
Gift of Carolina
Herrera, Ltd.

219: 2005.41.1 /
Gift of Carolina
Herrera, Ltd.
220, 222 (left):
2004.17.1 / Gift
of Marc Jacobs
International
222 (right):
2005.53.1 / Gift of
Louis Vuitton
223: 2010.89.1 / Gift of
Marc Jacobs
224: 91.241.126 / Gift
of Robert Wells in
memory of
Lisa Kirk
226: 91.241.134 / Gift
of Robert Wells in
memory of
Lisa Kirk
227: P77.1.7 /
Museum Purchase
228 (left): 71.265.13 /
Gift of Doris Duke
228 (right):
92.145.1 / Gift of Jill
Anson Szarkowski
229: 91.241.131 /
Gift of Robert
Wells in memory of
Lisa Kirk
230: 96.11.11 / Gift of
Roz Gersten Jacobs
232: 2011.41.1 / Gift of
Donna Karan
233: 2011.41.2 / Gift of
Donna Karan
234, 236: 2016.48.1 /
Museum Purchase
237: 2010.30.1 / Gift of
Gloria Steinem
238 (left): 93.159.43 /
Gift of Ady
Gluck-Frankel
238 (right): 2016.82.17 /
Gift of Bjorn G.
Amelan and
Bill T. Jones
239: 98.90.2 / Gift of
Ms. Julia Szabo
240: 87.64.1 / Gift of
Ms. Miriam Ross
243: 2011.35.2 /
Gift of Kenzo
244–245: 2011.35.1 /
Gift of Kenzo
246: 94.143.1 /
Gift of Kelly Klein
248: 2009.30.1 / Gift of
Calvin Klein, Inc.

249: 2008.42.1 / Gift of
Calvin Klein, Inc.
250 (left and right):
2010.93.1 / Gift of
Calvin Klein, Inc.
251: 84.171.1 / Gift of
Rose Simon
252: 2004.59.2 /
Gift of Céline
254: 2004.59.1 /
Gift of Céline
255: 94.22.1 / Gift of
Michael Kors
256, 258: 97.93.1 / Gift of
Christian Lacroix
259: 2009.16.21 /
Gift of Mrs.
Martin D. Gruss
260–261: P87.24.1 /
Museum Purchase
262 (left): P90.59.1 /
Museum Purchase
262 (right):
2004.14.6 / Gift of
Roz Gersten Jacobs
263: 2009.16.23 /
Gift of Mrs.
Martin D. Gruss
264–265: 2009.16.24
Gift of Mrs.
Martin D. Gruss
266, 268: 95.99.1 Gift of
Alumni Association
of F.I.T.
269: 2001.63.8 / Gift of
Pauline Tsui
270: 2011.18.10 / Gift of
Diane A. Fogg
271: 2011.18.9 / Gift of
Diane A. Fogg
272, 274: 2009.32.21 /
Gift of HL – art
275: 2009.32.16 /
Gift of HL – art
276 (left): 2009.32.3 /
Gift of HL – art
276 (right): 2009.32.6 /
Gift of HL – art
277: 2009.32.2 /
Gift of HL – art
278: 2007.59.1 /
Gift of Caroline
Rennolds Milbank
281: 74.36.17 /
Gift of Mrs.
Katheryn Colton
282 (left): 2011.2.1 /
Gift of Lanvin
282 (right): P82.28.1 /
Museum Purchase

283: 81.24.19 / Gift of
Mrs. Sally Iselin
284, 286: 2012.1.1 / Gift
of Ralph Lauren
Corporation
287: 2012.1.2 / Gift
of Ralph Lauren
Corporation
288: 89.54.18 / Gift of
Sylvia Slifka
290: 80.13.19 / Gift
of Mrs. Georges
Gudefin
291: P91.25.1 /
Museum Purchase
292 (jacket): 97.45.1 /
Gift from the
private collection of
Ms. Rebecca Pietri
292 (skirt): 97.82.1 / Gift
from the archives of
La Maison Martin
Margiela, Paris
294: 91.175.1 / Gift of
Richard Martin
295: 2008.91.1 /
Museum Purchase
296: 76.173.1 / Gift
of Mr. and Mrs.
Adrian McCardell
298 (activewear
ensemble): 72.61.60 /
Gift of Mr. and Mrs.
Adrian McCardell
298 (boots): 72.61.60CD /
Gift of Mr. and Mrs.
Adrian McCardell
299 (romper):
76.33.40 / Gift of
Sally Kirkland
299 (belt): 75.226.1 /
Gift of Elegant
Leather Goods
300 (left): 76.33.11 / Gift
of Sally Kirkland
300 (right): 72.61.91 /
Gift of Mr. and Mrs.
Adrian McCardell
301: P92.9.1 /
Museum Purchase
302, 304 (left):
2010.46.1 / Gift of
Stella McCartney
304 (right):
2010.46.1BC / Gift of
Stella McCartney
305: 2010.46.3 / Gift of
Stella McCartney
306: 2010.77.1 /
Museum Purchase

308: 2009.16.6 /
Gift of Mrs.
Martin D. Gruss
309: 2010.61.1 /
Museum Purchase
310: 98.36.1 /
Museum Purchase
311: 2008.47.1 /
Museum Purchase
312: 2003.52.2 /
Gift of Missoni
314: 88.79.1 /
Gift of Catherine
di Montezemolo
315: 84.122.4 /
Gift of Helen Rolo
316: 87.12.1 / Gift of
Krizia Co.
318: 99.34.1 / Gift of
Nancy J. Murakami
319: 97.44.1 / Gift
of Issey Miyake
Pleats Please Issey
Miyake, Guest
Artist Series #1,
Yasumasa Moriura
On Pleats Please
320, 322: 2010.80.1 /
Museum Purchase
323: 2010.78.1 /
Museum Purchase
324: 2009.1.4 /
Museum Purchase
326: 2004.23.1 / Gift of
Anonymous Donor
327: P89.87.1 /
Museum Purchase
328: 95.69.1 /
Museum Purchase
329: 94.106.1 /
Gift of Moschino
330, 332: 2011.13.1 /
Museum Purchase
333: 2011.36.1 /
Museum Purchase
334 (left): 99.80.1 /
Museum Purchase
334 (right): 96.92.4 /
Gift of Martine
Trittoléno
335: 2004.49.4 /
Gift of Clarins
Fragrance
Group / Thierry
Mugler Perfume
336, 338: 68.143.6 / Gift
of Lauren Bacall
339 (left): 89.163.91 /
Gift of Mortimer
Solomon

455: 96.84.1 / Gift of
Mary Russell
456 (left):
2009.16.29 /
Gift of Mrs. Martin
D. Gruss
456 (right):
71.254.32 / Gift of
Lauren Bacall
457: 2011.4.1 / Gift of
Valentino
458: 2010.97.47 / Gift of
Dries Van Noten
460 (left):
2010.97.39 / Gift of
Dries Van Noten
460 (right):
2004.29.1 / Gift of
Dorothy Lieberman
461: 2010.97.42 / Gift of
Dries Van Noten
462: 2010.97.26 / Gift of
Dries Van Noten
463 (left):
2007.47.2 / Gift of
Dries Van Noten
463 (right):
2007.47.1 / Gift of
Dries Van Noten
464: 2010.56.1 / Museum
Purchase

466: 98.101.1 / Gift of
Judith Corrente and
Willem Kooyker
467 (left): 98.20.5 / Gift
of Judith Corrente
and Willem Kooyker
467 (right): 98.20.7 /
Gift of Judith
Corrente and
Willem Kooyker
468, 470: 2008.34.2 /
Gift of Diane von
Furstenberg
471: 2008.34.1 /
Gift of Diane von
Furstenberg
472, 474: 2001.79.1 /
Museum Purchase
475: P89.60.1 /
Museum Purchase
476 (left): 2003.97.4 /
Museum Purchase
476 (right):
98.119.1 / Gift of
Vivienne Westwood
477 (left, suit):
88.63.8 / Gift of
Alan Rosenberg
477 (left, T-shirt):
2001.44.10 /
Gift of Francisco

Melendez A.K.A.
François
477 (right): 87.52.5 / Gift
of Barbara Hodes
478 (left): 96.36.11 /
Gift of Timothy
Reukauf, Stylist
478 (right): P88.45.2 /
Museum Purchase
479: P88.45.2 /
Museum Purchase
480, 482: 2006.14.1 /
Museum Purchase
483: 2010.37.2 /
Museum Purchase
484 (left, coat):
2010.37.7 /
Museum Purchase
484 (left, skirt):
2010.37.8 /
Museum Purchase
484 (right): 99.100.2 /
Gift of Barneys
New York
485: 2007.2.1 /
Museum Purchase
486: 2011.24.1 /
Gift of Yeohlee
Teng, Yeohlee /
Photography by
William Palmer

488: 99.43.2 / Gift of
Yeohlee New York
489: 2011.24.2 /
Gift of Yeohlee
Teng, Yeohlee /
Photography by
William Palmer
490, 492: 2008.87.1 /
Museum Purchase
493: 2009.60.1 /
Museum Purchase
494: 2009.16.63 / Gift
of Mrs. Martin D.
Gruss
499: P83.30.1 / Museum
Purchase
500: 2009.16.26 / Gift
of Mrs. Martin D.
Gruss
506: 2001.44.13 / Gift of
Francisco Melendez
A.K.A. Francois
507: 2008.76.3 / Gift of
Šárka Šišková
509: 74.125.2 / Gift of
Sally De Marco
510: 70.15.38 / Gift
of Mrs. Benjamin
Hinkley Riggs
511: 2010.77.1 / Museum
Purchase

PAGE 2
Halston
Evening dress: Red
silk, red nylon, red
bugle beads, beige silk
USA, 1979

PAGE 3
**Balmain
(Oscar de la Renta)**
Evening dress:
Black silk organza,
white embroidery
France, 2002

PAGE 4
**Givenchy
(Riccardo Tisci)**
Ensemble: Black leather,
chiffon, metal buckles
France, 2011

PAGE 5
Madeleine Vionnet
Dress: Pink, white
polka-dot silk faille
France, ca. 1932

PAGE 6
Jean Yu
Dress: Black,
white matte silk
jersey, black
grosgrain ribbon
USA, 2006

PAGE 7
Yohji Yamamoto
Ensemble:
Black silk crêpe,
plastic boning
Japan, 2006

PAGE 10
Martin Margiela
Tunic: Beige linen
Belgium, 1997

PAGE 12
Alexander McQueen
Evening dress:
Black vinyl, white silk
faille, black silk tulle
England, 2008

PAGES 26–27
Christian Lacroix
Evening dress (detail):
Orange silk faille,
orange silk satin,
rhinestones
France, 2005

PAGES 494–495
Paul Poiret
Evening dress (detail):
Pink, white,
orange bugle beads,
gold silk chiffon
France, ca. 1926

PAGE 500
Jean Paul Gaultier
Ensemble:
Printed Lycra,
teal-and-black silk
France, 2002

PAGE 508
Ruben Toledo
"Fashion Wheel"
USA, 2001

PAGE 509
Norman Norell
Cocktail dress: Pink
warp-printed silk taffeta
USA, ca. 1950

PAGE 510
Designer unknown
Dress: Magenta silk
brocade, velvet,
satin, lace
USA, ca. 1894

PAGE 511
Alexander McQueen
Dress, *Plato's Atlantis*
collection: Multicolor
reptile patterned digital-
printed silk chiffon
England, 2010

**EACH AND EVERY TASCHEN BOOK
PLANTS A SEED!**
TASCHEN is a carbon neutral publisher. Each
year, we offset our annual carbon emissions with
carbon credits at the Instituto Terra, a reforesta-
tion program in Minas Gerais, Brazil, founded
by Lélia and Sebastião Salgado. To find out more
about this ecological partnership, please check:
www.taschen.com/zerocarbon
Inspiration: unlimited. Carbon footprint: zero.

To stay informed about TASCHEN and our
upcoming titles, please subscribe to our free
magazine at www.taschen.com/magazine, follow
us on Instagram and Facebook, or e-mail your
questions to contact@taschen.com.

© 2023 TASCHEN GmbH
Hohenzollernring 53, D-50672 Köln
www.taschen.com

Original edition: © 2012 TASCHEN GmbH

Printed in Bosnia-Herzegovina
ISBN 978-3-8365-8756-3

RIGHT
Chanel
Gloves: Blue cotton velvet,
kid suede
France, ca. 1939

OPPOSITE
Šárka Šišková
"Goddess" evening gown
Czech Republic, 2008
From the *Seduction*
exhibition

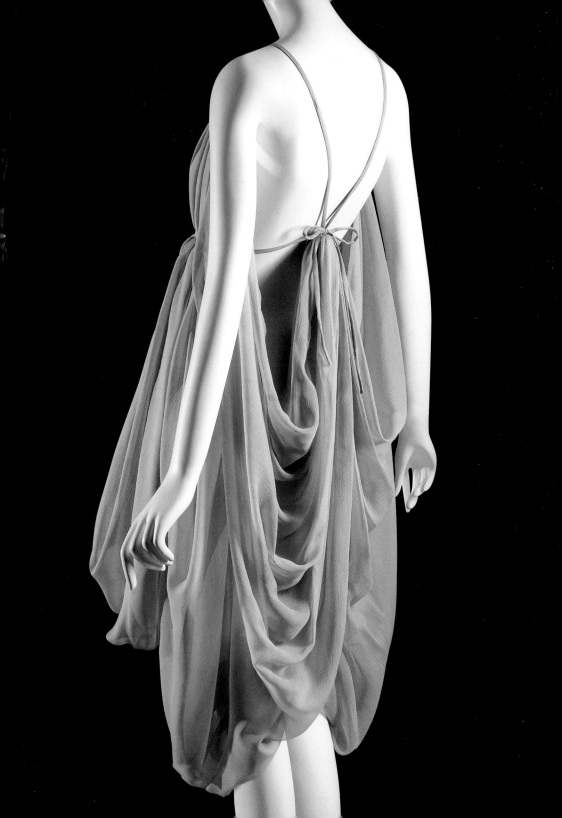

As with any project of this magnitude, many people helped make this book possible. As always, we are grateful to Dr. Joyce F. Brown, president of the Fashion Institute of Technology, for supporting the Museum at FIT. We also wish to thank the members of the Couture Council of the Museum at FIT, especially Elizabeth Peek, Yaz Hernandez, and the other members of the Couture Council board. Sincere thanks to the Museum at FIT team, especially Melissa Marra, who served as project manager; Fred Dennis, who oversaw costume selection; Eileen Costa, museum photographer; and Patricia Mears, Colleen Hill, and Jennifer Farley, who contributed essays. Other colleagues who provided significant assistance to this project include Varounny Chanthasiri, Julian Clark, Ann Coppinger, Sonia Dingilian, Jill Hemingway, Marjorie Jonas, Tanya Melendez, Gladys Rathod, Thomas Synnamon, and Vanessa Vasquez. Thank you also to MFIT interns who provided assistance: Alison Bazylinski, Marie Monster Dollner, Laurie Filgiano, Shane Thompson, and Rebecca Young. A very special thank you to all the designers and fashion houses featured in this book, most notably, Albert and Peter Kriemler of Akris, Veronica Etro, Stella McCartney, Angela and Luca Missoni and the entire Missoni family, Miuccia Prada, and Diane von Furstenberg, who, in support of the Museum, donated the thousands of meters of fabric used to bind each copy of its first printing. Supporting this generosity were the efforts of Anne Urbauer of Akris, Alessandra Tirolo of Etro, Carolina Brodasca of Stella McCartney, Maddalena Aspes of Missoni, Jenny Kim of Prada, Ellen Levinson Gross, and Monty Shadow of Richemont.

Thanks as well as the many individuals who have generously donated to the museum over the years, and to photographer William Palmer and artists Robert Nippoldt and Ruben Toledo for contributing images to this book. Thanks to Karen Cannell and her staff at the Special Collections Department of the Gladys Marcus Library at the Fashion Institute of Technology and to Margret Hayes at the Fashion Group International Foundation. Finally, our sincere gratitude to Benedikt Taschen and his team: our editors Nina Wiener, Victoria Birch, and Kathrin Murr; designer Anna-Tina Kessler and art director Josh Baker, production managers Stefan Klatte and Javier Boné-Carboné; fashion advisor Margit J. Mayer; proofreaders Anna Skinner and Anna Walker; and Mallory Farrugia and Amanda Horn for additional editorial support.

— **Valerie Steele,** Director and Chief Curator, the Museum at the Fashion Institute of Technology

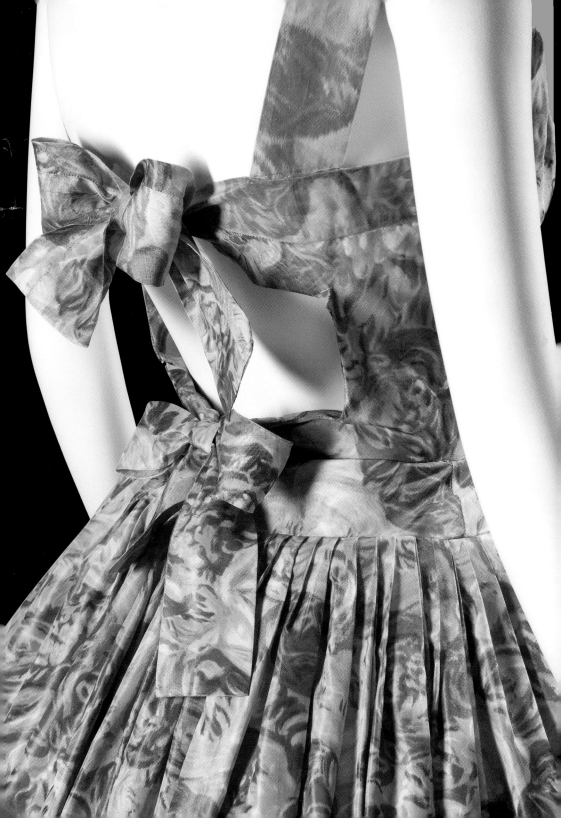

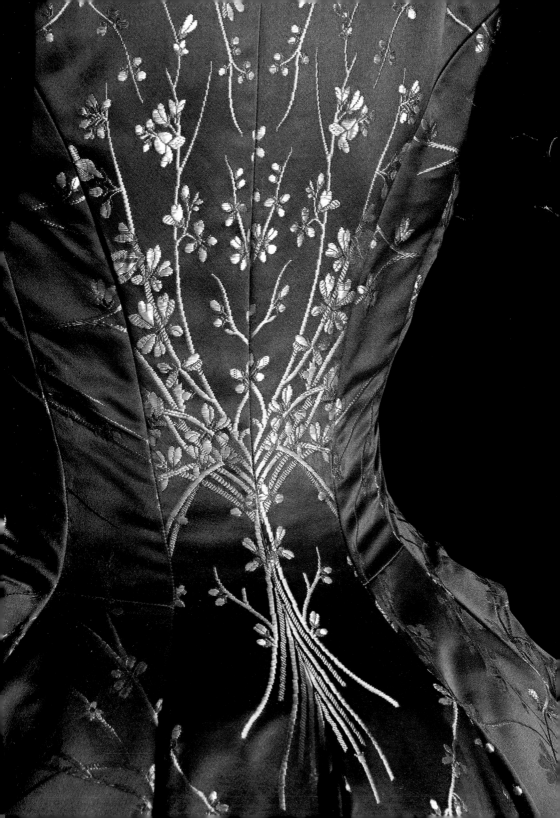